Laugh Lines

Caricaturing Painting in Nineteenth-Century France

Julia Langbein

BLOOMSBURY VISUAL ARTS
LONDON • NEW YORK • OXFORD • NEW DELHI • SYDNEY

BLOOMSBURY VISUAL ARTS
Bloomsbury Publishing Plc
50 Bedford Square, London, WC1B 3DP, UK
1385 Broadway, New York, NY 10018, USA
29 Earlsfort Terrace, Dublin 2, Ireland

BLOOMSBURY, BLOOMSBURY VISUAL ARTS and the Diana logo
are trademarks of Bloomsbury Publishing Plc

First published in Great Britain 2022

Cover design by Tjaša Krivec
Cover image: André Gill, Gill-revue. Le Salon pour rire.
Paris, 1868. Private collection. Photograph by Damian Griffiths.

A catalogue record for this book is available from the British Library.

A catalog record for this book is available from the Library of Congress.

ISBN: HB: 978-1-3501-8685-9
 ePDF: 978-1-3501-8686-6
 eBook: 978-1-3501-8687-3

Typeset by Integra Software Services Pvt. Ltd.
Printed and bound in Great Britain

To find out more about our authors and books visit www.bloomsbury.com
and sign up for our newsletters.

Contents

Illustrations

Plates

Figures

Acknowledgments

This book began as a PhD dissertation at the University of Chicago under the supervision of Martha Ward and it would not have come to fruition without her guidance and support, for which I am very grateful. I also thank my dissertation committee members W.J.T. Mitchell and Ralph Ubl whose invaluable input helped to set the course of this project from the outset.

I rewrote most of the book and undertook important archival research as a Junior Research Fellow at Trinity College, Oxford, between 2014 and 2018. Because of the legacy of Francis Haskell, his archives, and his former students (many of whom I met via the department), the Art History department at Oxford was the ideal place to expand my thinking about this subject. I thank Clare Hills-Nova for facilitating my research in the Haskell collection, and I thank the members of the department for engaging with me so helpfully about this project among other things.

I have benefited from the expertise of librarians and archivists, too many to cite, in the United States, the UK, and France. I must mention Valérie Sueur-Hermel and the staff at the Cabinet des estampes at the BnF, where I did the majority of my research. Many thanks to Pauline Clement-Bayer and Jean-Michel Buck at Musée du vieux Montmartre for sharing the Gill archives with me and Claire Martin for help with images at the Petit Palais. In the United States, I thank Nancy Spiegel at the University of Chicago Library and Yuri Long at the National Gallery of Art Library in Washington, DC.

One of the greatest pleasures of researching this book has been getting to know, in person or virtually, museums and collections all over France and Belgium—I am grateful to the many institutions that provided me with images and many more who helped me source paintings and drawings along the way. I particularly want to thank Jean-Loup Leguay at Musée de Picardie for going out of his way to help me find images pertaining to Court.

I have benefited from many opportunities to share this work over the years. I wish to thank in particular the group of graduate students convened by Nancy Thebaut and Thomas Pavel at the University of Chicago Paris Center in 2016 for a pivotal workshop. Thanks to Jennifer Greenhill, Alastair Wright, and

Ségolène Le Men for opportunities to test my research in the classroom. I thank Ian Bourland, Ros Holmes, and Jennifer Johnson for reading chapters. I thank Tobias Czudej and Taber Coletti for helping me to reconceive of my research material as an exhibition, which had a major and positive impact on the text. I thank the press's anonymous readers for their excellent suggestions.

Katherine Desplanques, Camille Mathieu, and Aurélie Petiot found, helped me find, or tried to help me find things in the archives. Thanks to Jean-Philippe Lemée for help with jokes—and for introducing me, as a high school student in France, to art history as a field of study in which the hilarious and the profound were often intertwined. I have benefited enormously from—and greatly enjoyed—conversations with David Kunzle and Tom Gretton, and I thank them for their generosity. Margaret MacNamidhe has been very kind about all my Delacroix queries. Anna Lee was a great help with photography.

I did the final revisions for this book under lockdown conditions in Dublin, and I am indebted to the library staff at Trinity College Dublin, who mailed a good portion of the stacks to my home when Covid restrictions would not permit library access. Thanks to Rachel Coombes for help with the manuscript during that difficult time.

I am very grateful to the many people at Bloomsbury who shepherded this manuscript to publication with such care and insight through an unstable market and often difficult pandemic working conditions, including Frances Arnold, April Peake, Yvonne Thouroude and Ross Fraser-Smith.

I thank the Visiting Committee to the Department of Art History at the University of Chicago for a generous publication grant.

I am grateful for the long-term and multidimensional support of my parents. The journey from dissertation to book took a couple detours to the maternity hospital. I non-ironically thank my daughters for momentarily making me a stranger to, and therefore a better critic of, my own work. Finally, I thank my husband. I would not have been able to finish this project without his patience, encouragement, and—aptly enough—humor.

Note on Translations

Unless otherwise indicated, all translations in the book are by the author.

Introduction

In early May 1875, André Gill (Louis Alexandre Gosset de Guînes, 1840–1885) passed through the stone facade of the Palace of Industry on the Champs-Élysées and into its soaring, open-plan nave, the sun pouring down through the iron-and-glass roof. He faced a lawn crossed with paths, potted with palms and flowers, strewn with sculpture. Above him, two stories of aisles wrapped around the central court, crammed with pictures. Of the 4,152 works of art at the Salon that spring, perhaps Gill had already decided, based on hearsay or studio visits, which to select, or perhaps, perambulating through the crowds, Gill looked to laugh.

The Palace of Industry, just two decades old, was designed to display everything from locomotives to livestock (a horse show had occupied the Palace the month before) and had to be jerry-rigged with temporary partitions to suit the display of painting. As Gill circulated through the makeshift galleries, he faced a ledge at about thigh height above which canvases filled the wall in a gapless, asymmetrical mosaic (Figure I.1). His eyes scanned a jumble of styles and genres: portraits of women in the newest dresses, elbows on the mantle; two peasants shearing; eighteenth-century genre scenes in the French mode; seventeenth-century genre scenes in the Spanish mode; an episode from a famous battle; a cavorting satyr.

Whether he sketched *sur place* or merely made mental notes, Gill surely called upon the old muscle memory of his days training as a painter at the Académie des beaux-arts, where he had learned to draw in part by looking closely at classical paintings and copying them in small-format sketches on paper.[1] Gill, like many painters, draftsmen, press artists, and amateurs, thought of exhibitions not merely as occasions for viewing but as habitats for copyists, like those who, benefiting from a special entry permit, snuck Gill into the Musée du Luxembourg in his youth.[2]

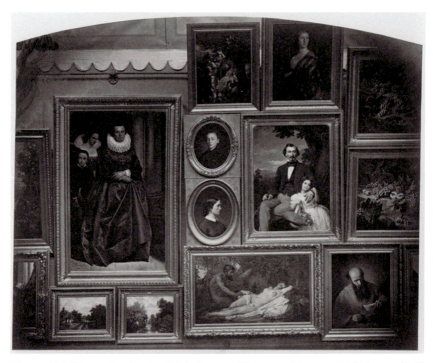

Figure I.1 Pierre Ambroise Richebourg, *Photographies par Richebourg* [hall des sculptures et cimaises du Salon de 1861], 1861. Photograph. 42 × 53 cm. Bibliothèque nationale de France

Within a little more than a week's time, Gill drew—and painted—a composition of six caricatures arranged around a hovering painter's palette for the cover of the comic journal *L'Éclipse* (Plate 1). The black-and-white armature was either drawn on transfer paper or photographed for transfer to a zinc plate for relief etching. Those process-engraved prints were the basis for two different editions, a hand-painted one that copied Gill's vibrant colors precisely and a color-printed one in three wan washes (Plate 2). Gill's "Le Salon de 1875—Distribution des récompenses" ("Salon of 1875—Distribution of Awards") landed in the salons, cafés, kiosks, and reading rooms of Paris,[3] alongside caricatures by his colleagues at *La Vie parisienne*, *Le Journal amusant*, *Le Monde illustré*, *Le Chronique illustré*, *L'Esprit follet*, and others. By the 1870s, the French reading public had come to anticipate that in the spring, at the opening of the central, state-sponsored exhibition of fine arts in the capital, journal pages would flood with caricatures of painting, and, to a lesser extent, sculpture. This genre was known as *le Salon pour rire* (the Salon to laugh at) or *Le Salon caricatural* (Salon caricature).

Salon caricature developed apace with the satiric press.[4] It emerged in a few embattled journals and a handful of albums in the 1840s, despite the July Monarchy's intense distrust of caricature. Salon caricature spread to new illustrated journals and albums in the 1850s and established its conventions as a genre. In the 1860s, particularly in the concessionary period of Napoleon III's reign after 1866, and again accelerated by innovations in reproductive technology (particularly the relief-etching of which Gill's "Salon de 1875" is an example), Salon caricature multiplied across dozens of new comic journals. It appeared in general-interest papers and cultural gossip sheets, oppositional organs, ephemeral leaflets, and the bulletins of insular artistic circles. Its seasonal publication in the press and in albums continued into the 1890s.

A few caricaturists, including Cham (Amédée de Noé, 1818–1879) and Bertall (Charles Albert d'Arnoux, 1820–1882), made the genre their specialty, but a wide range of caricaturists—some also writers, painters, etchers, photographers—tried their hands at this pictorial, comic re-view of contemporary fine art. Salon caricature appeared in quickly scrawled lithography and in lavish hand-tinting, in one-off issues like *Belphégor au Salon* (1869) (Figure I.2) and in the same journal for thirty-plus years.[5] Salon caricature was the private passion of an anonymous amateur, who filled an unpublished scrapbook with attempts at little comic canvases,[6] while at the same time, it reached a broad readership in general-interest newspapers and magazines with print runs in the tens, and eventually hundreds, of thousands.[7]

Salon caricature adopted different formats according to its intended use. When it appeared as one of many diversions in a comic journal, particularly in a large-format journal with a subscriber base,[8] Salon caricature was surely intended to be read at home or in shared spaces like cafés and reading rooms. But from its earliest appearances, Salon caricature also took the form of portable stand-alone albums, which could be carried around the exhibition as an antic, illustrated version of the official exhibition catalogue or *livret*.[9]

These small albums may have been sold outside the exhibition.[10] The cover of a one-off *Salon pour rire* published in 1890[11] shows a street vendor hawking his album to a crowd queuing at the entrance of a Salon (figured as an oven, baking "crusts," or botched paintings) (Figure I.3). Wherever they were consumed, caricatures of the exhibition were almost never published alongside faithful reproductions[12] but rather had to be compared to the originals at the exhibition, to a memory of firsthand contact with original works, or to reproductions published elsewhere.

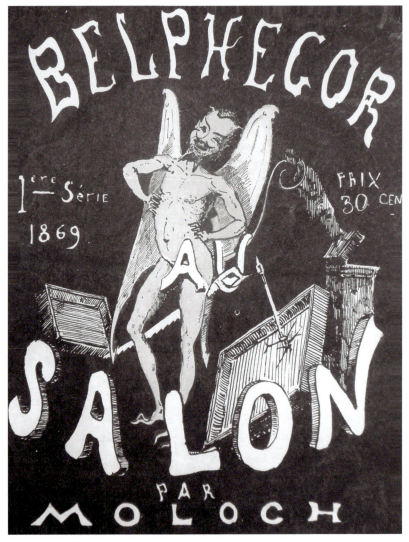

Figure I.2 Moloch, *Belphégor au Salon*, 1869. Bibliothèque nationale de France

Salon caricature certainly relied on the public's preexisting awareness of the conventions of painting, acquired in part through reproductions. But in an era before the viability of photographic reproduction in the press (which only occurred in the last two decades of the century), these warped graphic interpretations of the canvases on display in the capital also diffused knowledge of the Salon to readers in Paris and in the provinces. Because Salon caricaturists published their caricatures rapidly, often relied on fewer middlemen than

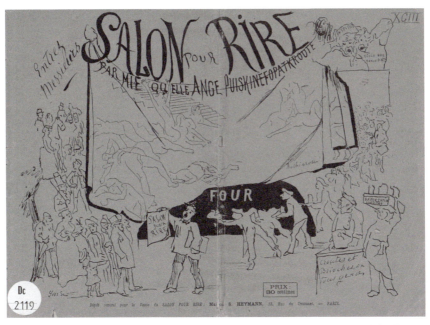

Figure I.3 *Salon pour rire par Miequellangepuiskinefopatkroute*, 1890. Bibliothèque nationale de France

precise reproduction and covered many canvases in a given journal spread or album, it is likely that comic versions of fine art were frequently the first wave of information about new painting to reach journal-reading audiences. (Gill's hand-painted "Salon de 1875" gave viewers a glimpse of five notable works only eight days after the May 1 opening of the Salon; by comparison, the finely detailed wood-engravings-after-photographs published in the bourgeois weekly *Le Monde illustré* appeared in a trickle of two or three per week from May through June. For information-value, both *L'Éclipse* and *Le Monde illustré* paled in comparison to Stop at *Le Journal amusant*. In May-June of that year, he caricatured nearly fifty works per weekly issue, an astonishing 220 works in all.) People in the second half of the nineteenth century not only laughed at these comic versions of the paintings they had seen in person or seen in reproduction elsewhere, but they came to know a great deal about painting in the first place through caricature.

It did not constitute a minor note of misbehavior, an aberrant moment of misunderstanding, to encounter painting as something mixed up with the comic, perhaps even to laugh at painting in person or via a handheld paper miniature.

Rather, Salon caricature is evidence—long ignored as such—that comedy was endemic to the public life of painting in nineteenth-century France. This fact is corroborated by the warnings and laments of written critics, increasingly vocal in the years of Salon caricature's proliferation, about the risibility of the Salon. Comedy was described variously as a result of decadence among painters, as a sign of the ignorance of an expanding public for art, and as the side effect of the exhibition's increasingly chaotic, bazaar-like display.

This study interrogates Salon caricature for the first time as a representation not only of painting, but of painting and spectatorship within a particular exhibition context. I argue that Salon caricature provides important evidence of the problems of spectatorship that plagued the Salon in its last decades, as debates about the accessibility of high art to a broad public reached a fever pitch. The canvases in Gill's "Salon de 1875" are not images of images in a void, but caricatures of an experience of reception at the Salon, a complex sensory, social, and symbolic event. Gill, both caricaturist and painter, offered the tiny telescope at the bottom of the "Salon de 1875" (Plates 1 and 2) to his readers as a visual aide, to help them locate his own canvas in the cavernous Palace, where it hung at a disadvantageous height. With this exhortation that his readers look through the telescope, Gill asked them to imagine journal-reading as spectatorship.

For reasons of clarity and accuracy, in this book I describe Salon caricature as "comic" rather than addressing it as "parody," "satire," or "humour."[13] In the *Salon pour rire*, "pour rire" or "for laughter" is the imprecisely translatable two-word signpost that surged in nineteenth-century print culture for what we would call "comic" in English—intending to make laugh. "Parody" gets at Salon caricature's comic imitation, and "satire" invokes the long graphic tradition in which Salon caricature surely falls, but both terms are inappropriately loaded. Parody has primarily been associated with literary genres,[14] while satire instrumentalizes the comic "to expose … prevailing immorality or foolishness, esp. as a form of social or political commentary."[15] My aim is to move away from reading caricature as "commentary," reducible to phrase or opinion, and instead to focus on Salon caricature's pictorial relations. Salon caricature could have literary, political, and ethical dimensions, but it is first and foremost a repicturing intended to make laugh—a comic image. Throughout the book, laughter will be characterized and historicized differently as an aesthetic response, a nervous symptom, and a social practice, but we start with the premise that Salon caricature's overriding aim was to remake painting graphically for laughs.

"Comic" in my analysis does not entail merely light or popular, but indeed a category of art and visual experience that became highly contested in the years

I cover. In 1867 Émile Zola described "blind laughers and gawpers" at the Salon who "look at art like children look at images: for amusement, to have a little fun."[16] Through the period the book covers, the description of public laughter was used by some critics to identify a discredited class of art consumers. *Laugh Lines* shows how a narrow interpretation of laughter as a sign of ignorance took shape, forming a profile of modernist and avant-garde inaccessibility. Instead, I explore how comic responses positively constituted a range of sophisticated relations within visual culture. For example, by the 1870s, if an artist drew a comic version of a painting, it might signify that he possessed intimate knowledge about that painting, reviving caricature's early modern roots as an art of portraiture between intimates. Indeed, the week after *L'Éclipse* published Gill's caricatural "Salon de 1875," his colleague Hadol (Paul Hadol, 1835–1875) published another "Salon comique" in which he caricatured some of the same paintings and some new ones—including canvas No. 915, *Un joyeux compagnon* (A Merry Fellow), by André Gill.[17]

To fully understand how caricature constituted a range of relations to painting, my approach situates caricature within nineteenth-century image culture more widely. My subject, as an art about art, provides rich opportunities to see caricature's self-positioning in this economy. Gill's "Salon de 1875," for example, is not only a representation of painting in caricature, but a valuation of it. In relation to the life-size palette, the little paper canvases, casting thin shadows, appear miniaturized—belittled, even. Yet the hand-painted version of this issue of *L'Éclipse,* in vibrant, saturated colors, sold for three times the price of the version color-printed in three pale washes. So even while Gill depicted painting as comic, trivial, and paper-thin, the journal put a premium on painterliness, which Gill's sopping palette played up seductively.

L'Éclipse's economic valuation of paint described above is bound up with social characterizations of the journal consumer as print connoisseur and of Gill's dual status. Like a superior, he hands out awards to painters; yet at the same time he is himself an unfortunate victim of the exhibition, helpless as his unseen canvas idles in Salon Siberia. While this study veers away from direct social caricature, I nevertheless attend to the ways that Salon caricature's self-positioning reveals complex characterizations of artists, critics, and readers alike.

Salon caricature was a phenomenon of the press, indebted to evolving image technology, embedded in a mixed culture of artists and writers high and low, as variable as its many participants and, like the exhibition that engendered it, susceptible to historical change. And yet the image of Salon caricature that has come down to art historians is narrow and unchanging, not so much a

phenomenon of the press as a disembodied rejection of painting, not so much drawing as jeering. In fact, the two names associated most with Salon caricature are not Cham and Bertall, lifetime caricaturists, but the painters Édouard Manet and Gustave Courbet. As recently as 2011 scholars claimed that the "artists most quantitatively significant" later became "the great heroes of the modernist and formalist interpretation of modern art," specifically Courbet and Manet.[18]

So let me address this study's relation to modernism. It is not true that caricatures after canvases by painters valorized by modernist art history, particularly Courbet and Manet, were the most quantitatively significant, although they are certainly the most quantitatively reproduced and cited today. They were originally scattered among a sea of caricatures after painters of all types and genres. Look at Gill in 1875, the year Manet's *Argenteuil* produced such scandal: he finds comic potential in a realist-influenced pair of wrestlers by sculptor-painter Alexandre Falguières; a modern landscape with nudes that owes much to Frédéric Bazille and Manet, by Carolus-Duran, better known as a society portrait painter; and a Dutch-style comic genre scene by Jehan-Georges Vibert.[19] The cumbersome taglines required by these artists remind us of the range of hybrid categories art history has neglected—they are not merely avatars of stasis in contrast to a self-conscious modernity found elsewhere.[20] The attentions of caricaturists show us how much more there is to say about these and other frequent targets like neoclassical genre painter Jean-Louis Hamon, biblical-mythological painter Émile Bin, battle painters Adolphe Yvon and Alexandre Protais, and "painter of women" Charles Marchal, to name just a handful, not for their heroic modernity but for the very strangeness of the hyphenated strategies they were forced to pursue.[21]

This study quickly disproves the assertion that Salon caricaturists presciently identified future modernists by voicing public incomprehension of and hostility to the aesthetic challenges they presented. At the same time, I explore why it is that many Salon caricaturists were particularly insightful about artists who have proven important to later artists, art historians, and museum culture, for example, Eugène Delacroix, Manet, Jean-Léon Gérôme, and Pierre Puvis de Chavannes.

I also address modernism in this study as a matter of historiography, because Salon caricature primarily entered art-historical literature in accounts of modernist painters. Particularly the final chapter, "Salon Caricature and the Making of Manet," grapples with caricature's place in art historiography, a place dictated in large part by Manet criticism. I do not argue that caricature played a role in establishing Manet's place in the modernist canon, rather that caricature

was later recruited, wrongly in my view, as evidence that Manet's modernism was hermetic and publicly inaccessible.

My method in this study is to explore the shared ground between caricature and the painting it cannibalized in graphic line for laughter, consuming painting's media in its own kindred techniques.[22] At times, my language shadows the terminology of modernism. I will show that on occasion Salon caricaturists were drawn to evident surface qualities of paint, qualities we associate with "medium-specificity." Likewise, *gillotage* and other relief-etching technologies that entered the press in the 1850s will be described as importing a new "flatness," a value in modernist criticism that was identified as coming to prominence in the painting of Manet and his followers precisely in these years.

In using this language, my point is not to argue that pictorial modernism developed in the illustrated press. Rather, I show that the qualities that modernist critics later identified as important—including flatness and a naked display of medium—had a range of values across painting and press art in nineteenth-century French visual culture. Gill's "Salon de 1875," as I've discussed, drew attention to its own paintedness but did so as part of a complex strategy of self-positioning in a marketplace. Likewise, Gill presented four smaller canvases as completely flat, continuous with the print surface, while two larger canvases were given beveled frames, which cast shadows on the print page. This game of differential flatness was entirely Gill's invention (Salon regulations required all canvases framed), a way of importing to the journal page the differences in valuation and visibility conferred by placement at the Salon. In other words, "flatness" here did not obtain in painting's modernity but in the representation of its embattled reception by a distant viewer.

The image's self-positioning is bound up with Gill's own role not so much as artist in the modernist sense—individual and original—but as a hybrid painter, draftsman, and guide. In press art, the "hand" of the artist is an aggregate of layered input from various artist-technicians, from Lefman, the line-block setter (he signs within the lower-right caricatured canvas) or the unnamed hand-colorists. As much as possible, I bring Salon caricature's collective facture to bear on my analysis of the images.

If authorship was technically aggregate, it was also often playfully oblique. One of Salon caricature's most important features is its play with fractured, fictional authorship. Its makers posed as buffoons, imps, and devils—Count de Noé, an aristocrat, studio-trained, repressed his skill at chiaroscuro to scrawl as Cham, while Alphonse Hector Colomb (1849–1909), as Moloch, took on the persona of Belphégor, a demon whose inky silhouette leaped between canvases (Figure I.2)[23]

These gestures gave on to the antic culture of self-disaggregation developed by the left-bank societies of fin-de-siècle Paris, but also, in their own time, permitted Salon caricature's fundamental relation to the original as something other than reproduction—instead, as a comic-fictional coexistence of paint and print.

I should address a few omissions. This book focuses on the relation between caricature and painting, putting aside in large part the question of sculpture as a target. This is for two main reasons. First, Salon caricaturists spent the vast majority of their energy on painting, usually addressing sculpture in their albums and journal coverage lastly and little. Second, the caricature of painting played off the reproduction of painting, its expectations, its failures, and its pretensions. Meanwhile, the pictorial reproduction of sculpture in the nineteenth century was arguably less fraught. Photography, for example, had early success in representing sculpture, while the photographic reproduction of painting remained elusive, debated, and disruptive to print culture through the 1880s.[24]

Courbet does not occupy a central role in this study. That is because readers interested in Courbet's relation to comic art and the press have a rich bibliography to explore.[25] More importantly, Courbet fashioned a singular media persona in nineteenth-century France, a persona that attracted caricatural attention as much as his paintings themselves.[26] Courbet's complex relation to comic media, therefore, deserves to be considered apart.

My study focuses on the period of 1840–1880—from the genre's emergence to the end of the Salon as a state-sponsored event.[27] I regret that this scope seems to follow an art historical pattern that disregards Salon art of the fin-de-siècle and early twentieth century, whereas in fact the production of comic Salon coverage through the century attests to the Salon's continued cultural relevance. However, after around 1880, there is a notable shift in the production of Salon caricature. As images appeared more widely in general-interest newspapers and magazines but also books, posters, post cards, brochures, and so on, exhibition caricature (as there were multiple Salons) competed with and increasingly resembled other kinds of print material. After the last oppressive press laws were abrogated in 1881, the development of a mass press transformed the market for art writing.[28] Salon caricature after 1880 also reacted to the development of exhibition parody on and off the page, notably Les Incohérents, whose first exhibition took place in 1882.[29] In short, Salon caricature in the last decades of the century merits a study that positions it in new print-cultural and avant-garde networks.

Finally, the first Salon caricature by a woman that I have found is Gyp's *Bob au Salon* (1888). This comic novella and its author—a prolific anti-Semite and right-wing agitator—represent a late and inauspicious entry for women into the

genre. Decades after women were occasionally gaining recognition as painters, entering studios, and writing serious criticism, caricature remained an almost exclusively masculine sphere. As late as 1906, Paul Gaultier wrote in *Le Rire et la caricature* that the "total" absence of female caricaturists was evidence that women were "closed to irony"; they were, he argued, too wounded by caricature's distortions to experience the enjoyment it should provoke.[30] While the ideological barriers for women's entry to comic art were evidently high, one of the most important aspects of Salon caricature is its comic recuperation of qualities negatively associated with female spectatorship. Indeed John Grand-Carteret, whom I turn to repeatedly as the only nineteenth-century critic to take up Salon caricature in depth, characterized Salon caricature as something like a feminized formalism.

The book begins by tracing, in the first two chapters, the establishment of Salon caricature in the press between 1840 and the early years of the Second Empire. Chapter 1, "Comic Reproduction in July Monarchy Paris," traces the emergence of Salon caricature in a series of experiments in *Le Charivari* in the early 1840s. Lithographic reproductions began to disobey their role and to animate and warp the painting. Immediately they provoked a response from the caricaturist Bertall, whose *Salon de 1843* can be seen as the first album of Salon caricature.

Chapter 2, "Dueling and Doubling: The Antagonism of Salon Caricature," situates Salon caricature's emergence in an era when caricature was defined legally, politically, and morally as an act of violence. Caricature developed an absurd antagonism on the model of the *duel pour rire* or joke duel. Baudelaire's theories of comic form, written between 1846 and 1855, identified the essence of comic art as *dédoublement* or "doubling," the ability to be self and other in the same stroke, crucifier and collaborator.

The third chapter, "Salon Caricature and the Physiognomy of Paint," argues that physiognomy laid the groundwork for Salon caricature's legibility as a comic-critical genre. Physiognomy, a post-enlightenment pseudoscience popular in France from the 1820s through the end of the century, claimed to extract inner character from outward facial features. The first illustrated comic journals in France in the 1830s exploited readers's familiarity with physiognomy, twisting physiognomic techniques and vocabulary to comic ends. Understanding the physiognomic underpinnings of Salon caricature helps to explain why it targeted certain painters, including those valorized by modernist art history.

The fourth chapter, "Salon Caricature in the Age of Reproduction," traces how the changing technology available to caricaturists in the illustrated press shaped

its relation to painting. In contrast to accounts of nineteenth-century media which emphasize lithography and photography as the primary agents of change, this chapter shows how relief-etching processes such as *gillotage*, developed in the 1850s and further refined over the next two decades, provided new registers for Salon caricature's comedy.

Chapter 5, "Gravity and Graphic Medium in Cham and Daumier," revisits the long-standing comparison—invented rivalry, even—between Honoré Daumier and Cham, colleagues who caricatured side by side for the influential comic journal *Le Charivari* for nearly thirty years. In comparison to Daumier's tactile lithography, Cham understood the image in a way that we might compare to our own experience of the digital, as dematerialized and convertible, and he encouraged the reader's own manipulation and intervention. A remarkable document, an unpublished album of amateur Salon caricature modeled after Cham's albums, helps us understand how Salon caricature invited active interventions like coloring-in and cutting-out.

Chapter 6, "Caricature and Comic Spectacle at the Paris Salon," mines Salon caricature for a new understanding of the public art exhibition as a troubling, and troublingly comic, event in the second half of the nineteenth century. Focusing on the Salon caricature of Nadar, who famously experimented with such modern technologies of vision as hot-air ballooning and photography, this chapter illustrates how Salon caricature fashioned itself not just as a press genre but as a visual technology (recall André Gill offering his readers, through Salon caricature, a tiny telescope).

Chapter 7, "Salon Caricature and the Making of Manet," describes how the first art critics and historians to posthumously establish Édouard Manet as the leader of the French School and the founder of a new modern art propagated the idea that Manet had been a singular object of hostile public laughter. For some, notably Théodore Duret, Salon caricature incarnated that public laughter. This chapter argues on the contrary that already in the 1860s and 1870s, the caricature of Manet used laughter as a shibboleth to identify communities of like-minded individuals and to express belonging and insider knowledge.

There is plenty to be said about modernist and avant-garde debt to the culture of the comic journal and to Salon caricature in particular; yet it is strange that Salon caricature attracts the conflicting accusations of reactionary (hostile to innovation)[31] and revolutionary (prescient, propaedeutic):[32] How can a single genre represent a public left behind by modernist innovation, until suddenly it is ahead of its time? An overarching aim of the chapters that follow—an aim amply rewarded by the richness of these comic images—is to attend to relations

between the caricature, the journal, the wider graphic image economy, and the canvas itself, not as antimodern or prescient, but in their own time. That time begins in the July Monarchy, two decades before Manet's first canvas entered the Salon. The first chapter tells the story of how, already in the early 1840s, a handful of graphic artists in the illustrated press began, with subtle deviations, occasional innuendo, and a new understanding of the comic possibilities of medium itself, to get a laugh out of painting.

Notes

1 Some of Gill's undated copies of Old Master and other works from before entering the EBA are held at the Musée du vieux Montmartre, Folder I—Années de jeunesse—1851–1860.

2 André Gill, *Vingt années de Paris* (C. Marpon et E. Flammarion, 1883), 13.

3 *L'Éclipse,* like many Parisian journals, also had subscribers in the provinces, although precise figures are not available. On the development of readership in Paris and the provinces, see Gilles Feyel and Benoît Lenoble, "Commercialisation et diffusion des journaux au XIXe siècle," in *La Civilisation du journal: Histoire culturelle et littéraire de la presse française au XIXe siècle*, ed. Dominique Kalifa, Philippe Régnier, Marie-Ève Thérenty, and Allain Vaillant (Paris: Nouveau Monde, 2011), 181–212 and André-Jean Tudesq, "La Presse Provinciale de 1814–1848," in *Histoire de la presse française, tome II* (Paris: PUF 1969), 149–94.

4 On the history of the French satiric press in the latter half of the century, see Philippe Roberts-Jones, *La presse satirique illustrée entre 1860 et 1890* (Paris: Institut français de presse, 1956) and Fabrice Erre, *Le pouvoir de la satire: deux siècles de presse satirique, de la Révolution à Charlie* (Paris: Dargaud, 2018). On the history of caricature in the press, see Bertrand Tillier, *A la charge! La caricature en France de 1789 à 2000* (Paris: les Éditions de l'Amateur, 2005); Tillier, *la Républicature: la caricature politique en France, 1870–1914* (Paris: CNRS, 1997); Jacques Lethève, *La caricature et la presse sous la IIIe République* (Paris: Armand Colin, 1986); and Philippe Roberts-Jones, *De Daumier à Lautrec. Essai sur l'histoire de la caricature française entre 1860 et 1890* (Paris: Les beaux-arts, 1960).

5 *Le Charivari* published Cham's Salon caricature from 1845 through 1878; *Le Journal pour rire*, later retitled *Le Journal amusant* published Salon caricature between 1849 and 1899.

6 Anonymous, "*Le Salon de 1861 par Cham et un Amateur*," unpublished, undated (1861?). Yale Special Collections Art Library, N5066 C43 (LC). Discussed in depth in Chapter 4.

7 For example, by the mid-1860s, *Le Monde illustré* (founded 1857) reached print runs of over 30,000, which entailed many more than 30,000 readers, as copies were read

publicly, shared, even sub-let. *Le Figaro*, which published Salon caricature in the 1890s, then printed over 100,000 copies.

8 E.g., *Le Journal pour rire*, 1848–1855, which had a large format of 61 cm × 43 cm.

9 On the livret, see *Documenting the Salon: Paris Salon Catalogs 1673–1945*, eds. John Hagood, Yuriko Jackall, Kimberly A. Jones, and Yuri Long (Washington: National Gallery of Art Library, 2016) and Ed Lilley, "On the Fringe of the Exhibition: A Consideration of Some Aspects of the Catalogues of the Paris 'Salons,'" *Journal for Eighteenth Century Studies* 10, no. 1 (March 1987): 1–12.

10 David Kunzle suggests that when *Le Charivari* first took up Salon caricature in 1845, its special double issue was published for distribution outside the Louvre. Kunzle, "Cham, the 'Popular' Caricaturist," *Gazette des beaux-arts* 96 (1980): 214–24, 221.

11 The Salon having been abandoned by the state after 1880, the exhibition caricatured is the 1890 Salon of the Sociéte des artistes français. See the *Catalogue illustré du Salon de 1890, publié sous le direction de F.-G. Dumas* (Paris: L. Baschet, 1890).

12 Denys Riout notes a single exception. See Riout, "Les Salons Comiques," *Romantisme* 75 (1992): 51–62, 52.

13 On taxonomy of comic terms, see Margaret Rose, *Parody: Ancient, Modern and Post-Modern* (Cambridge: Cambridge University Press, 1993) and Rose, *Pictorial Irony, Parody and Pastiche: Comic interpictoriality in the arts of the 19th and 20th centuries* (Bielefeld: Aisthesis Verlag, 2011).

14 For example, Bertrand Tillier discusses Cham's caricatures of novels as parody. Tillier, *Parodies littéraires: précédé par Cham, le polypier d'images* (Paris, Jaignes: Phileas-Fogg, La Chasse au Snark, 2003). On the evolution of the term see Daniel Sangsue, *La Parodie* (Paris: Hachette, 1994).

15 Satire, according to the Oxford English Dictionary, is "[a] poem or (in later use) a novel, film, or other work of art which uses humour, irony, exaggeration, or ridicule to expose and criticize prevailing immorality or foolishness, esp. as a form of social or political commentary." "satire, n." OED Online. Accessed December 2021. Oxford University Press. The association of "satire" with political caricature particularly results from the foundational scholarship on British graphic satire. E.g., M. Dorothy George, *Hogarth to Cruikshank: Social Change in Graphic Satire* (London: Allen Lane, Penguin, 1967).

16 " … ce groupe de badauds et rieurs aveugles …." "Il [le public] regarde des œuvres d'art, comme les enfants regardent les images: pour s'amuser, pour s'égayer un peu." Émile Zola, "Édouard Manet. Étude biographique et critique," *La Revue du XIXe siècle*, Jan 1, 1867. Reprinted in Émile Zola, *Écrits sur l'art*, ed. Jean-Pierre Leduc-Adine (Paris: Gallimard, 1991), 141–69, 164–5.

17 Hadol (Paul Hadol), "Le Salon comique, par Hadol," *L'Éclipse*, 19 May 1875, 4.

18 "Il faut d'ailleurs relever que les œuvres et les artistes auxquels revient la place la plus significative quantitativement au sein de ce corpus sont aussi ceux qui essuient les charges les plus vives. Or il n'est pas difficile de s'apercevoir que les intéressés sont devenus les grands héros de l'interprétation moderniste et formaliste de l'art

moderne et de son développement téléologique." Laurent Baridon and Martial Guédron, "Caricaturer l'art: Usages et fonctions de la parodie," in *l'art de la caricature*, ed. Ségolène Le Men (Paris: Presses Universitaires Paris Ouest, 2011), 87–108, 96.

19 The works caricatured are *Portrait de M. H …* (no. 97), Jules Bastien Lepage; *Respha protège les corps de ses fils contre l'oiseau de la proie* (no. 125), Georges Becker; *Roses de mai* (no. 409), Charles Chaplin; *Fin d'été* (no. 739), Carolus Duran; *Lutteurs* (no. 782), Alexandre Falguière; *La Cigale et la Fourmi* (no. 1951), Jehan-Georges Vibert.

20 Exemplary analysis of such under-examined figures includes Hollis Clayson, "Jean-Alexandre-Joseph Falguière: Sculpting Resistance," in *Paris in Despair: Art and Everyday Life Under* Siege *(1870–71)* (Chicago: University of Chicago Press, 2002), 273–83 and Marc Gotlieb, *The Deaths of Henri Regnault* (Chicago: University of Chicago Press, 2016).

21 In his foundational study on Salon caricature, Thierry Chabanne argued that a broad aesthetic and ideological range of painters was equally "caricaturable," carrying out a sustained comparison of Courbet and Charles Marshal. Chabanne, *Les Salons caricaturaux* (Paris: Éditions de la Réunion des musées nationaux, 1990).

22 Denys Riout has argued that Salon caricature's importance lies in its use of a shared semiotic system with painting. Riout, "Les Salons Comiques," 60. Margaret Rose has explored "comic interpictoriality" broadly across modern visual culture, touching briefly on Salon caricature. Rose, *Pictorial Irony*, 53–6.

23 According to an 1863 compendium of folklore, Belphégor was a god of ingenious invention; he was also sometimes employed as the Devil's ambassador to France. Jacques-Albin-Simon Collin de Plancy, *Dictionnaire infernal: répertoire universel des êtres, des personnages, des livres … qui tiennent aux esprits, aux demons […]*, 6th ed. (Paris: H. Plon, 1863), 89, 186.

24 On photography's relation to sculpture, see Geraldine Johnson, *Sculpture and Photography: Envisioning the Third Dimension* (Cambridge: Cambridge University Press, 1998). See also Anne McCauley, *Industrial Madness: Commercial Photography in Paris, 1848–1871* (New Haven and London: Yale University Press, 1994), 268–70.

25 Petra Ten-Doesschate Chu, *The Most Arrogant Man in France: Gustave Courbet and the Nineteenth-Century Media Culture* (Princeton: Princeton University Press, 2007); Denise Delouche, "Le tableau et sa caricature: les oeuvres de Courbet vues par les caricaturistes," in *L'Image par l'image* (Rennes: GRAC, Université de Rennes-II, 1983), n.p.; Klaus Herding, *Courbet: to Venture Independence*, trans. John William Gabriel (New Haven and London: Yale University Press, 1991); and Thomas Schlesser and Bertrand Tillier, *Courbet face à la caricature: Le chahut par l'image* (Paris: Kimé, 2007).

26 The first and still most comprehensive anthology of Courbet caricatures contains more images of his person than of his canvases. See Courbet *selon les caricatures et les images*, ed. Charles Léger (Paris: P. Rosenberg, 1920). See also Frédérique

Desbuissons, "La chair du Réalisme: Le corps de Gustave Courbet," in *Courbet À Neuf!* ed. Mathilde Arnoux, Dominique de Font-Réaulx, Laurence des Cars, Stéphane Guégan, and Scarlett Reliquett (Paris: Éditions de la Maison des sciences de l'homme, 2010), 65–82. Bertrand Tillier argues that with Courbet, caricature was often interested in the "non-pictorial." Tillier, "La signature du peintre et sa caricature: l'exemple de Courbet," *Sociétés & Représentations* 25, no. 1 (2008): 79–96.

27 The state abandoned control of the Salon to artists in 1881. See Pierre Vaisse, "Réflexions sur la fin du Salon officiel," in *"Ce Salon à quoi tout se ramène": Le Salon de Peinture et de sculpture, 1791–1890*, ed. Pierre Vaisse and James Kearns (Bern, Switzerland: Peter Lang, 2010), 117–38 and Patricia Mainardi, *The End of the Salon: Art and the State in the Early Third Republic* (Cambridge: Cambridge University Press, 1993).

28 Martha Ward, "From art criticism to art news: journalistic reviewing in late nineteenth-century Paris," in *Art Criticism and Its Institutions in Nineteenth-Century France*, ed. Michael Orwicz (Manchester: Manchester University Press, 1994), 162–81.

29 Launched by Jules Lévy, Arts Incohérents exhibitions took place between 1882 and 1893. See *The Spirit of Montmartre: Cabarets, Humor and the Avant-Garde 1875–1905*, ed. Phillip Dennis Cate and Mary Shaw (New Jersey: Rutgers, 1996); Catherine Charpin, *Les Arts Incohérents (1882–1893)* (Paris: Éditions Syros, 1990); and *Arts incohérents, académie du dérisoire*, ed. Luce Abélès and Catherine Charpin (Paris: Editions de la Réunion des musées nationaux, 1992).

30 "Si les femmes sont fermées à l'ironie, rien ne le démontre mieux que l'absence, pour ainsi dire totale, de femmes caricaturistes." Gaultier reports that he only knows of one, Mme Lamy, whose existence can be explained by her belonging to the circle of her brother, celebrated comic artist Albert Guillaume. Paul Gaultier, *Le rire et la caricature* (Paris: Hachette, 1906), 46, n. 1.

31 E.g., George Heard Hamilton called Salon caricaturists "lightning rods for opposition," *Manet and His Critics* (New Haven: Yale University Press, 1954), 17.

32 Riout argues that Salon caricature was a "privileged terrain of experimentation" ("terrain d'experimentation privilégié") for twentieth-century avant-gardism, "Salons Comiques," 60.

1

Comic Reproduction in July Monarchy Paris

The series of experiments that launched Salon caricature began in the illustrated comic journals *La Caricature* in 1840 and *Le Charivari* in 1841 at the hands of Honoré Daumier (1808–1879). It is somewhat surprising to find Daumier at the origins of Salon caricature because after contributing two prints caricaturing painting to the journal that year, Daumier never touched the genre again.[1]

This is not to say that painting had never appealed to caricaturists as a subject, although examples of comic renditions of Salon paintings from before the July Monarchy are rare.[2] Nor does 1840 mark the beginning of comic responses to the exhibition. From the Salon's inception as a public event in the mid-eighteenth century, the exhibition provoked written parody, vaudevillian humor, and reports of laughter, although this material was often anonymous; had limited circulation; and, most importantly, was not illustrated.[3] In what follows, I describe the first elaboration of the caricature of paint in the press, not as a student pastime, studio game, or one-off print but as new aspect of the regular communication between Paris's first successful illustrated comic journal[4] and its cultivated public.[5]

King versus Kin

Daumier's "Ascension de Jésus-Christ" ("Ascension of Jesus Christ") first appeared in *La Caricature* in 1840 under the series title "Salon de 1840" and reappeared in *Le Charivari* the next year (Figure 1.1).[6] To understand how radically "Ascension" departed from July Monarchy journal caricature, compare it to the caricature for which Daumier was perhaps best known, "Gargantua,"

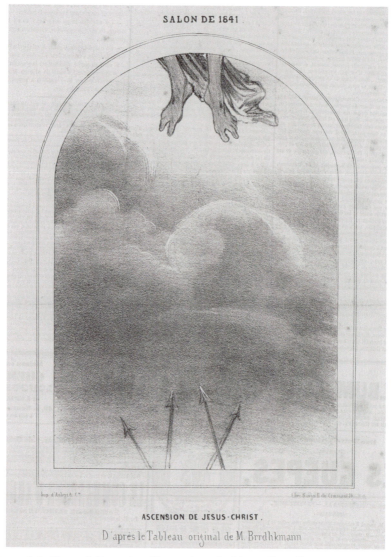

Figure 1.1 Honoré Daumier, "Ascension de Jésus-Christ," 1840. Lithograph. Courtesy National Gallery of Art, Washington. Corcoran Collection (Gift of Dr. Armand Hammer)

which depicted King Louis-Philippe as Rabelais's ravenous giant (Figure 1.2). "Gargantua" earned Daumier a six-month sentence for "inciting hatred against the king" in November 1832. It has become one of his most reproduced caricatures, a symbol of powerful, figural, political French lithography. It seems to have attained this symbolic status right away, as Daumier wrote that shortly

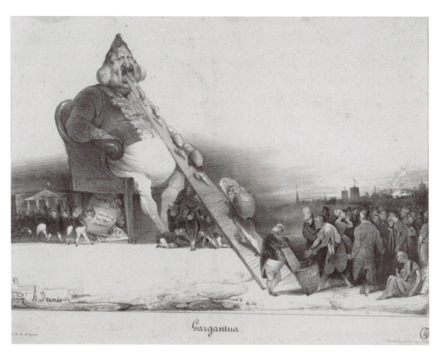

Figure 1.2 Honoré Daumier, "Gargantua," 1831. Lithograph. Courtesy of the Robert D. Farber University Archives & Special Collections Department, Brandeis University

after the caricature's publication, when he arrived to serve his sentence at Sainte-Pélagie, the other inmates insisted on calling him "Gargantua."[7]

"Gargantua" expresses a clear moral idea, the judgment that shortly after the king's installation on the throne, he defends the privileges of the wealthy few at the expense of the starving many. We read this through articulate physiognomic figuration—the exaggeration of select features of the face and body to reveal inner character. From the pre-war psychoanalytic theories of Gombrich and Kris to more recent scholarship, the emergence of caricature in the sixteenth century has been attributed to the rise of a modern conception of the individual as a stable and consistent subject for comic distortion.[8] The 1835 *Dictionnaire de l'Académie française* described "caricature" as the grotesque depiction of social actors, exemplifying its figurative usage to describe a character in a play.[9] In "Gargantua," warped bodies and faces enact the story: the pendulous bellies of the favored, glowing egg-white against the smudged black sky mirror the king's own grotesque gut. The image has no caption and needs none.

How stark, in comparison, is the absence of a portrait subject in "Ascension of Jesus Christ," where the body has vanished. Already its contours announce that "Ascension" is a different kind of comic image. Its arched frame mimics those of religious paintings destined for architectural installation in churches, suggesting that this "Ascension" is a reproductive print. Taken together, its layout, framing, and titling ("Salon de 1840/1841" at the top, "*d'après*" at the bottom) cite the faithful reproductions of Salon painting that ran in *Le Charivari* for the duration of the exhibition's opening in the spring.

"Ascension" is not a proposition about actors in the world, but a performance of images in the world—reproductions of paintings and paintings themselves. This degree of distance from representing social and political actors demands a different kind of analysis than the usual mining for what Charles Baudelaire called the *comique significatif* in caricature:[10] its wealth of observation about daily life, its data-rich archive of the ephemeral. A reader will search in vain for an articulate body, a face *chargé* or overloaded with expression that will reveal something about, say, servants or lawyers, husbands or wives, the French or their king.

Whereas "Gargantua" expresses a clear moral idea, "Ascension" expresses neither idea—it rebuffs narrative—nor moral. The image requires a caption, and a rather complicated one: "D'après le Tableau original de M. Brrdhkmann" ("After the original canvas by M. Brrdhkmann"). The idea is unclear, and the moral determination equally cloudy; one possibility put before the reader is that the subject of mockery might be Christ and the physiognomic narrative denied may be that of the crucifixion.

In "Gargantua," Daumier emphatically exploits lithography's capacity for tonal contrast by darkening the haggard, foregrounded crowd at the bottom right and the black-coated aristocrats at the far left to create layered recession into space. Exploitation of both the medium of lithography and the chiaroscuro and foreshortening of academic painting plays into the heroism of "Gargantua," in which the tools of high academicism are turned by a popular medium against the mighty.

In contrast, the "Ascension" lacks the depth and tonal contrast of which Daumier was such a master, the majority of the print's surface a mid-tone gray, Christ's feet and the soldiers's spears occupying the same frontal plane. Further, in another caption published originally under the image in *La Caricature*— "L'ascension (Caricature sur le Salon)"—the "sur le Salon" rather than "du Salon" is surely a deliberate suggestion of "l'ascension [de la] caricature sur le Salon" or "the ascension of caricature over the Salon." Not only does lithography in this instance forget its capacities, it forgets its place in the hierarchy of media,

bumptiously contesting high-status oil painting rather than harnessing the power of its representational techniques.

Finally, "Gargantua" was so famous that it could signify Daumier by name, while "Ascension" was published anonymously. While the former assumes its throne in the pages of Daumier literature in the form of frequent reproduction,[11] "Ascension" has, like its central Christ figure, floated away from the record almost entirely.[12]

Philipon, the publisher of both images, defended caricature against accusations of violence in 1830, not denying that violence but justifying it on ethical-political grounds: "We use [caricature] in turn to make a mirror for the ridiculous, a whistle for the stupid, a whip for the wicked."[13] If caricature was a whip, whom was Daumier's "Ascension" whipping (certainly not Christ)? Philipon articulated caricature as a tool ("We *use* caricature"). But caricature's utility was questionable when it came to Brrdhkmann, a fake painter whose name cannot be uttered.

If Daumier helped to launch Salon caricature, he also abandoned it immediately after "Le Salon de 1840." As I discuss in depth in Chapter 5, Daumier often returned to caricaturing the Salon, but as a scenography of spectatorship. Perhaps he recognized that when caricature played at reproduction, it demoted the caricaturist's skill at physiognomic articulacy and forced the space of the lithographic stone into a depiction of flatness—a picture of a picture—while as Gargantua exemplifies, Daumier specialized in conferring volume to bodies in space.

"Ascension" and "Gargantua" were produced for the same journals and consumers, in the same medium, by the same artist, just eight years apart. It becomes clear, when we compare them, that the nature of caricature shifts fundamentally when it pretends to reproduce, as do its moral stakes. Its intent becomes troubling. How does one gage success or failure of a reproduction without a referent? Why would caricature turn on its own proximate community of artists (painters, even invented ones), targeting kin over king? Was Daumier attacking painting, and if so, was that callous or petty? And most importantly, what about painting was funny, or ripe to be made funny, in these years?

Comic Reproduction: Pelez and the Animation of Paint

Only a year after Daumier's "Ascension" appeared in *Le Charivari*, the same journal published a short series of comic reproductions by Raymond Pelez after

three paintings and one sculptural group from the Salon of 1842,[14] an effort that clearly took inspiration from Daumier's "Salon of 1840." If viewed outside the context of the journal and held up against the canvases they mock, Pelez's comic reproductions would read as callous or petty. An odalisque is turned into a working-class prostitute, Christ becomes a puppet show, and an allegory of Charity is given a luxurious rump. These transformations could hardly honor the talents of the artists they reproduce.

But reinserted into the context of *Le Charivari*, these comic reproductions can be understood as playful engagements, even tests, of the readers's attention, sophistication, and participation as viewers of painting and connoisseurs of print. At the same time, through what I describe as the print's animation of painting, these comic reproductions develop a graphic self-awareness about the temporalities and conditions of painting versus lithography and of making versus viewing. In doing so, they raise questions about the required competences of viewers and therefore of critics in general, in an era of rising skepticism about the role of the art critic.

Le Charivari had a reliable format, one its readership knew to expect: four pages, mostly text with some wood-engraved vignettes, except the third page, which almost always contained a single, nearly full-page image, usually in high-quality lithography. This third page was a showcase; the term is particularly apt considering the lithographs published there were often also sold at Maison Aubert, the print shop part-owned by Philipon, *Le Charivari*'s publisher.[15]

Although *Le Charivari* was a comic journal, it aimed to bring readers a variety of images including fashion, monuments, actors, politics, and paintings that "attract notice in various exhibitions."[16] The Salon, still the most important forum for the fine arts in France and still held at the Louvre as it had been since 1699, had opened on March 15 that year, and hosted an estimated million visitors.[17] In May of 1842, almost a third of *Le Charivari*'s page-3 images were lithographic reproductions after works shown at the Salon. Under the series title "Salon de 1842" high-quality full-page lithographic reproductions of paintings began to appear. For example, on May 5, readers saw a *Petit Pêcheur au bord de la mer* (Little Fisherman by the Sea) (Figure 1.3), a softly webbed lithograph by the painter Louis Coignard[18] after his own canvas, a genre mélange of figure study and seascape. On May 9, the journal published a reproduction of a landscape by Salon debutant Louis Desjobert. And two days later, still under the unchanging series title "Salon de 1842"—no hint of *pour rire*, or *caricatural*—readers encountered "Un Bain à Domicile. Fantaisie aquatique de M. Court" ("A Bath at Home. Aquatic Fantasy by M. Court") (Plate 3).

SALON DE 1842.

Petit Pêcheur au bord de la mer

COIGNARD.

Figure 1.3 Louis Coignard, "Petit Pêcheur au bord de la mer," *Le Charivari*, May 5, 1842. Lithograph. Bibliothèque nationale de France

The lithograph was, at first glance, a reproduction of Joseph-Désiré Court's *Baigneuse algérienne* (Algerian Bather) known today through a copy (Plate 4). Court's orientalist portrait was not reproduced in Salon albums or illustrated journals that year, nor did critics write much about it. In fact, to compare the caricature to the original, one would have to go so far as to attend the Salon, journal in hand. The absence of widespread awareness of Court's painting raises questions about why Pelez caricatured it for *Le Charivari's* readership. If a reader has not seen the original, how is she to understand where the painting ends and the caricature begins? What is mockery of the original, and what is mere invention?

It is possible that the comedy of Pelez's "Fantasy" worked at a pre-pictorial level. A student of Gros, Court had taken the Rome prize in 1821 and early Salon submissions like his *Mort de César* (Death of Caesar, 1827) had been ambitious, serious subjects that also hinted at anti-Bourbon animus. But in later years, Court seemed to have cashed in, trading powerful subjects for wealthy portrait commissions and erotic larks like the *Algerian Bather*. In a liberal journal that, along with *La Caricature*, had hosted incendiary political caricature in recent memory, perhaps Pelez selected Court in part because the painter had betrayed the journal's principles or had fallen out of favor with its constituents and become risible more generally.

However, a more complete answer lies in the publication context of the caricature. Pelez's "Aquatic Fantasy" does not require familiarity with the original. The bather is comic not only in relation to the original but in relation to the series of prints that precede and follow it. As I have described, the caricature appeared in a series of *faithful* lithographic copies—it was slipped in among the series, identical in framing and presentation to the "serious" reproductions such as Coignard's *Little Fisherman*. The reader would have encountered Pelez's print fully expecting a faithful representation of Court's canvas. Therefore, part of the caricature's comedy is the dawning on the reader that something here is wrong or skewed. If, as Ted Cohen has described, jokes are conditional upon shared knowledge,[19] then the shared knowledge called upon by Pelez's "Aquatic Fantasy" is not only "what Court's painting looks like" but "what Salon reproductions look like."

The ornate tiling and exotic headwear of the painting were, in Pelez's version, believable and well described.[20] Elements such as these, rendered in the print's overall highly skilled lithography, were part of this game in which the reader, at some point, discovered the comic intent. Perhaps this occurred once the reader's attention landed on the sponge or the callus grater, unorthodox equipment for the naturalized seductions of the genre. Perhaps it was the wall-eyed glare or the unlovely bosom (more on this in a moment) that finally exceeded the possibilities of an alluring female nude in the orientalist tradition.

Once the reader encountered the verse under the image, the betrayal of faithful representation was undeniable: Instead of romantic poetry, the caption, possibly set to a popular tune, announced in unvarnished fashion the arrival of a lover ("Oscar is coming tonight").[21] This was just a contemporary Parisian, drawn from the ranks of marginal women who traded their affections for money (well represented in print culture),[22] having a smoke in the tub. Part of Pelez's strategy was to provide a reproduction just plausible enough that the timing of this realization detonated a punchline of its own.

There is a further layer to the comedy of Pelez's "Fantasy," not tied to the original canvas or to the series in which the print appeared but anchored in the image's internal dynamics, a self-contained ticking mechanism. Pelez has added an element that appears nowhere in the painting: the cord and plug from the bathtub, floating up to the surface. Unlike her Algerian counterpart, the Parisian bather has pulled the plug and the waterline is declining, to the point where it is about to reveal what Pelez clearly wants to suggest is an undesirable body. In a related substitution, Pelez replaces Court's incense burner with a cigarette, billowing smoke as it burns down.

This substitution and addition—cigarette, plug—both activate an awareness of temporality within the image. Pelez animates the still image, sets the waterline moving, the cigarette shrinking, the clock ticking. If we return to the comparison between "Gargantua" and "Ascension," we see that Daumier's floating Christ has a similar sense of temporality that is, like the receding waterline, rooted in a comedy of physiognomic revelation and denial. Christ was in the process of rising when the painter/caricaturist depicted the scene. Both Daumier's "Ascension" and Pelez's "Fantasy" emphasize, even require, the rapidity of the graphic artist. A painter would have missed Christ entirely or, returning to Pelez's "Aquatic Fantasy," would have been faced with the indecorous subject of a naked woman in an empty tub.

This sense of urgent, lived time is different from the circulating action of "Gargantua," in which bodies cycle up the ramp and out through the *chaise percée*, an intact circuit within the image, looping and continuous. The last thing one imagines, looking at "Gargantua," is that the king will float away or run out of gold to gobble. In other words, "Gargantua" did not make the viewer as aware as these comic reproductions did of the temporality of the artist making the print (the difference between the speed of drawing and painting) or the viewer viewing the print (inserted into a fleeting moment, one in which a woman's, possibly a prostitute's, body will be imminently revealed).

Although Pelez's lithography is skilled enough to convince a reader at first glance that it is a faithful reproduction, Pelez nevertheless activates the drawn line in a manner that is at odds with the stasis of the reproductive print. Turn again to Coignard's *Little Fisherman*, published just six days earlier than Pelez's "Aquatic Fantasy" under the same title of "The Salon of 1842" in *Le Charivari*. The value of a reproductive copy made by the painter himself lay in the copy's authenticity, its proximity to the painting assured by the hand of the artist. Lithography's capacity for the expression of rapidity or verve is not exploited; the soft webbing and the gently undulating chiaroscuro of the central figure approximate the tonal coherence of painting. The waves are suspended behind the nude boy, who is in turn suspended in time and psychologically vacant.

Pelez's bather and Coignard's fisherman are the products of identical processes of lithographic drawing, inking, and impression on paper. But Pelez emphasizes drawing over printing as he changes tone, breaking the soft stasis of the reproductive print with, for example, the harsh, black hair, falling in unmodulated black strokes, the jabs along the surface of the bath water, or the conversion of Court's thin, still filament of oil passing between the bather's hands to a rapid pour, made with both drawing-in and scratching-out.

I am describing, between the games of recognition, timing, and self-awareness that Pelez puts into play, the manner in which the print animates the painting. We understand the print as animated because there is a still image, a painting, from which this print disobediently departs, even if the viewer of the print does not have access to the painting. I began this chapter comparing the caricatural "copy" of a non-existent painting ("Ascension") with an example of effective political caricature ("Gargantua"), raising the question of how caricature signifies when its referent is supposedly another image. In that comparison, Daumier's comic reproduction could not benefit from political caricature's moral justification, its narrative clarity, its comedy of figural distortion—it seemed limited by its pretense of reproduction. But rather than be limited by its status as an image *of an image*, Pelez's bather uses the comparative stasis of painting as a point of departure, a thing in contrast to which it can be consciously different, even self-consciously disobedient.

The idea of the work of art coming to life has a long history in Western mythology and philosophy.[23] Any illusionistic work of art invokes the thinness of the threshold between the artificial image and the world it pretends to share. But this instance of the caricatural animation of the painting also belongs to a history of the relations between "old" and "new" media.[24] If one looks ahead only fifty to sixty years, the "Enchanted Picture" genre of early silent cinema will fixate on bringing painting to life, as Lynda Nead has described. "Enchanted Picture" films took place in galleries where the canvases on the walls suddenly came to life, their protagonists leaping into action, usually to mischievous purposes. As Nead writes, "[i]n order to demonstrate its own mastery … film had to keep returning to the still image—the basic component of its own modern life— and show its power to transform stasis into motion," at times a "self-conscious process."[25] In these films, frequently female subjects of classical paintings burst out with chaotic sexual energy, as if animation itself has given them a body of which they are newly aware.

Similarly, the relatively "new" medium of lithography (these first lithographically illustrated journals were scarcely a decade old), in Pelez's hands, animates Court's *Bather,* highlighting lithography's rapidity and contemporaneity in contrast to the timelessness and stasis of painting and its copies. It does so with the device of the self-aware female nude, now naked, no longer an aesthetic object or a site for the display of artistic skill but a body put to imminent use ("Oscar is coming"). Her disobedience regarding the rules of female vacuity and availability—her come-hither glare, her pulling the plug—is analogous to the lithographer's disobedience in the role of painting's subordinate and helpmate.

In *Tradition and Desire: From David to Delacroix*, Norman Bryson argues that within an iconographically closed system like the production of painting in the French Academy, the gulf is particularly wide between the temporalities of viewer and maker. "Viewing" entails the pleasurable recognition of references to past art and "making" entails the narrowing ability to rearrange such references. The viewer "enjoys being flooded by the past," while the artist is "condemned to work within time." If the painter "yields to the flood of the past he will be that which he must always fight to overcome: only a viewer."[26]

Importantly, while the viewer is steeped in pleasure, the artist wrestles with anxiety. This is the thrust of Pelez's animation: it pollutes the plenary, instantaneous pleasurable intake of the viewer with the anxieties of the painter. The transcendence of viewing is broken by a forced self-awareness as the living gaze of the bather pins the viewer to a scenario of embodied time, while the mobile frankness of Pelez's drawing disturbs the staid coherence of the reproductive print. And, finally, Pelez transforms the viewer's comfortable aesthetic enjoyment of the nude into an erotic encounter rife with anxiety. The viewer meets the nude not in the halls of orientalist fantasy but in Paris, not in the sanitized zone of aesthetic appreciation but in the economic zone of sexual transaction.

The anxiety of this economic encounter is the anxiety of painting itself, transactional, risky, a series of choices by an individual in a marketplace. Instead of merely enjoying the images, the painter has to make a living from them. Within that awareness, Pelez's "Aquatic Fantasy" tempts the viewer to consider, for example, the complications of transacting with a female model.[27] Similarly, the bather's bonnet, intended in the original as a colorful token of a vague ethnicity, appeared in Pelez's caricature as an absurd prop.

"Aquatic Fantasy" shows that already in its germinal stages, Salon caricature as a genre develops the capacity to bridge the subjectivities of the artist and those of the viewer. Nadar, whose Salon caricature will be discussed at length in Chapter 6, wrote in his Salon-caricatural album of 1853, "They say that in art, time has nothing to do with it; this is certainly very true for he who looks at a work and did not have to execute it."[28]

Prometheus Changed

Pelez's next comic reproduction in the series was published three days after his "Aquatic Fantasy" and again slipped in among faithful Salon reproductions under the title "Salon of 1842." It played even more explicitly on the anxieties

underlying the erotics of painting and the choices faced by painters, taking up the mythological subject in place of the orientalist. Pelez converted Paul Jourdy's *Promethée enchaîné sur le rocher* (Prometheus Chained to the Rock) (Plate 5), which hung in the Salon of 1842, into "Prométhée changé en outre" ("Prometheus Changed Furthermore") (Plate 6).

Like Court's *Algerian Bather*, Jourdy's *Prometheus* was not widely discussed or reproduced. Jourdy had studied under Ingres and won the Rome prize in 1834. His *Prometheus* was consistent with the serious, multi-figure biblical and classical subjects in which he had been trained. Pelez's print plays up the original canvas's staging of Prometheus akimbo among a strange cohort of distraught nude women (the latter, as one critic pointed out, appear nowhere in Aeschylus). Jourdy's was an ambitious canvas by a student attempting to satisfy the demands of history painting while at the same time standing out in a post-Romantic Salon. These demands pulled him in contradictory directions. The canvas was classical in story but sensational in execution (the nudes), crisply contoured but dramatic (the lightening bolt), and traditional in the centrality of the figure but hyperbolic in its figuration (chiseled Titan, fleshy suppliants).

Although very little is known about Pelez's early life and education,[29] it is likely that he had spent time training in a painter's studio given his skill at drawing. Even without firsthand experience of academic studio training, nevertheless as a working artist familiar with the canvases exposed at the Salon, he saw the ridiculous solution Jourdy had reached under the joint pressures of French academic decorum and popular appeal. Pelez sees in Jourdy the narrowing of choices and subjects that Bryson describes as inherent to a closed iconographic system like French Academic painting.

Jourdy's scattering of action left one central focal point: the precarious cloaking of its central figure's groin. Pelez's comic re-titling of the canvas ("Prometheus changé en outre" or Prometheus "changed furthermore") is a play on words. *Outre* also means "wineskin," hinting that Prometheus clings to the rock out of drunkenness. As a rounded, fluid-filled vessel, *outre* also draws attention to the inflated anatomy that Prometheus thrusts outward. The subtitle, "Amplification d'échine," **échine** in boldface, is hardly subtle innuendo. *Échine* most often meant spine but could refer to a cut of meat (spare rib). Pelez underscores his innuendo by departing from the original canvas in molding the drape around the giant's genitals.

Pelez can toy with vulgarity (below-the-belt humor was rare in *Le Charivari*) because the rest of the print displays such evident pictorial sophistication. As in the case of his "Aquatic Fantasy," Pelez excels, in passages, at lithographic technique,

for example in the play of shadows on Prometheus's sinewy, stocky thighs, the foreshortening of the figure seen from below, and the variation in surface texture between the undulating hashing of the rocks and the soft graduation of the sky. The quality of the print—we might even say the exaggeration of quality, looking at Pelez's overwrought display of anatomy-drawing skills in Prometheus's bursting muscles—was at the same time truly desirable in a print, and part of the joke.

Just as Pelez's bather was embedded in a game of made-you-look, so the seductive surface of "Prometheus Changed" is part of a game in which the viewer is lured into lingering over looking and is then caught staring. If so much nineteenth-century painting permitted, as Jourdy's did, an erotics of viewing packaged as the chaste appreciation of historical or mythological narrative, then Pelez's caricature punctures this perspective. Prometheus's dead-on glare and his precarious rag force a recognition on the part of the viewer of the erotic mechanisms at work.

It is easy to think, looking at Jourdy's canvas now, that critics must have picked up on the undeniable hilarity of the barely repressed eroticization of Greek mythology (at a 2017 exhibition of Salon caricature, viewers laughed at a photographic reproduction of Jourdy's canvas *before* seeing the caricature).[30] However, Pelez's caricature articulated in drawing what no written critic wrote. What criticism there was of Jourdy's canvas tended to cite its harsh contouring. The Academy, upon receiving the canvas from Rome, disliked almost everything but particularly the way each figure was isolated and seemed to exist in relation to the viewer, with no sense of "common thought" tying them together.[31] *Le Charivari* published written Salon criticism, as is often true of the journals that later published Salon caricature regularly, including *Le Journal amusant, La Vie parisienne*, and others. Yet Pelez's experiment with comic reproduction did not illustrate the journal's existing lines or language of criticism. On the contrary, in the above example and as so often in the genre of Salon caricature that developed after, the caricature of painting expressed precisely that which *salonniers* did not see or could not say.

Critical Doubt

The critic is the exemplary viewer who not only makes sport of the plenary, instantaneous pleasure of viewing but makes a profession of it. Daumier and Pelez's experiments in *Le Charivari* in the 1840s distill concerns that were widely articulated in the art and cultural press. Since the first public art

criticism of the Salon and the Academy's attempts to suppress it, debates had raged about who had the right to criticize French painting, whether skill as a painter was a requirement, to whom and for what purposes criticism should be written.[32]

As the Salon expanded in size,[33] the critical coverage of the event expanded along with it, beyond those with obvious interest (artists, wealthy patrons, the state). Salon reviews began to appear in women's journals and sports papers.[34] The model of Étienne-Jean Delécluze, the revered critic who had emigrated from the studio of Jacques-Louis David to the pages of *Le journal des débats* in the 1820s and represented practice-based authority, faced increasing competition in the marketplace. Critics wondered whether there was a market for expertise in painting, or whether the role of art critic increasingly was to be occupied by journalists who brought to bear nothing but, at best, writerly panache and, at worst, personal prejudice.[35]

Le Charivari published a harsh account of journalistic criticism among its Salon reviews for 1839 by the artist and writer Laurent-Jan (now most remembered as an anti-Ingres agitator) under the pseudonym Ralph, republished as a lavishly illustrated album the same year.[36] He described the new professional journalists's deadly effect on sincere painters. These painters pour themselves into their work and then "a man arrives, and under the pretext that he shapes a nice sentence, takes it, your work, and rips it to pieces ... because he has to judge: That's his job."[37] In what could be a formalist credo, he writes that "the execution is everything and the subject is nothing; style, character, color, poetry, it all comes from the execution, exactly the one thing the writer cannot judge."[38] Only artists should judge other artists; anything else, he suggests, is calumny.

I am not suggesting that Pelez sympathizes with Laurent-Jan's strict divisions in artistic and critical competence, nor his assertion that subject should be mere pretext for form. But Laurent-Jan's complaints, in Pelez's own journal and in recent memory, make clear the extent to which the new reach of art criticism as a job, as a genre not merely of literature but of journal copy, has electrified the question of what kind of competences make a critic. This conjuring of the illegitimacy of the public as viewers (Laurent-Jan went further than most: "Art is not made for you, you don't need it")[39] will recur throughout the century in an unabashedly élitist, formalist school of criticism. It is important to note here that while nineteenth-century critics like Émile Zola and Théodore Duret (examined in depth in Chapter 7), writing only a few decades later, identified the illegitimate consumers of art—those who "don't need it"—with laughter, Laurent-Jan

publishes his 1839 screed in a comic journal. Laurent-Jan can still, at this point, have a theoretical audience that was imagined by its editor and contributors to laugh, to laugh at fine art specifically, and to consume and appreciate it with taste and intelligence. These things are not yet in conflict.

Pelez's comic reproductions are situated in a period of intense scrutiny of the very space between artistic and critical competence, a gap that Pelez's "Salon of 1842" activates. Pelez addressed the question of criticism's purpose obliquely, by setting up a situation in which the viewer of the caricature was enticed to think like a critic, if "critic" means not the press hack but the insider, who knows something of the temporalities of making and viewing, who has experienced the anxieties of the studio, who thinks about the naked realities behind the mythical nudes. The viewers of Pelez's caricatures behave like artists or critics trained to look analytically as they compare paint and print, carrying out a kind of localized, comic-image version of the source-hunting considered de rigueur in an informed critic. Instead of hunting for references to the history of Western art, considering the painter's balancing of homage and overthrow, the viewer hunted within the source image for what the caricature preserved and distorted, its comic version of homage and overthrow.

And yet at the same time, Daumier and Pelez transformed the viewer of the reproductive print from a transcendent viewer of an aesthetic object to an engaged participant in a comically animated transaction, someone whose judgment of the image was suddenly beside the point. The reproductions would not remain stable objects for analysis, as they stared back, threatened to leave, or told a dirty joke. The painting itself had come to life as something self-possessed. In doing so, just as it denied the possibility of a pure viewer, comic reproduction denied the possibility of a "pure" critic, one who might see and judge the work clearly.

The Value of Comic Reproduction

There was yet another layer to the self-awareness that Pelez's caricatural reproduction provoked in the reader/viewer. Pelez, to whom we will return shortly, in conjunction with the editors of *Le Charivari*, saw that they could deliver a high-quality, faithful, graphic representation of the Salon to their readers, while at the same time using that representation as a setup for scattered caricatural punches. These sophisticated dynamics of testing readers about the nature of their attention tied directly to Philipon's financial strategies.

The savvy publisher regularly made viewers aware of different levels of quality in prints.[40] In his series of caricatural reproductions, Pelez awakened in the reader a self-regard from which Philipon's sales strategies would profit. Pelez's comic reproductions were published in *Le Charivari* on newsprint, which was thin and through which one could perceive the text on the verso. But the same images could be purchased at the Maison Aubert as stand-alone prints on high-quality card paper.[41] This luxury version of Pelez's "Salon of 1842" series shows that Philipon understood that Pelez's prints were not merely jokes or mockery, and that excised from the suite of faithful reproductions that had originally set up a comic ambush in the journal, they possessed value as high-quality stand-alone images for collection or even display in the home of the print consumer.[42]

Philipon continued to publish large, single-image, high-quality caricatures of paintings in *Le Charivari* for one more year (1843) and then he stopped entirely, never to take the format back-up. But in 1843, Pelez's game was up. The comic lithographs, still interspersed among faithful ones, possessed a new series title: "SALON CARICATURAL DE 1843."[43] This title surely was intended to promote the series as a whole, so that buyers could collect all ten numbered prints at 50c each. The result of this announcement of the "SALON CARICATURAL" was that it no longer fell upon the reader to discern the comic reproductions from the faithful.[44]

Why did 1843 mark the end of large-format, single-image comic reproduction? Yin-Hsuan Yang has suggested that these comic reproductions may have been seen as unwanted competition for Maison Aubert's own faithful reproductions,[45] yet the comic series consisted only of a few prints, not enough to threaten the market for reproductions. We might look instead to the increasing availability of non-comic reproductions of Salon paintings in the press during the July Monarchy.

Le Journal des artistes and *L'Artiste*, revues of literary, theater, and beaux-arts events, had reproduced paintings since their foundings in 1827 and 1831, respectively, but sought a narrow, educated clientele, with small print runs carrying high-quality lithographs and engravings.[46] By the mid-1840s, notably with the founding of the successful, wood-engraved general-interest *L'Illustration* in 1843, straight copies were more widely available. This shift in the availability of reproductions elsewhere expanded the shared knowledge of Salon-exposed work, in effect making painting a widely available subject for caricature. As Bertall would demonstrate in 1843, this new ground for caricatural comedy opened the way for albums and journal spreads that provided comic encounters with dozens of works of art at a much better value. While Pelez's prints sold at 50c

per image at Maison Aubert—the whole series would cost a whopping 5 francs, a full day's wages for a roofer, for example[47]—Bertall's *Salon de 1843*, containing twenty-eight caricatured canvases, sold for 30c. Pelez's prints, combining luxury and comedy, could not compete.

Bertall's *Salon de 1843:* The Graphic *Charge* of Painting

Like Pelez, Bertall found comedy in a new proximity between caricature and painting. At only twenty-three, Bertall was just beginning to establish himself as an illustrator in 1843,[48] when he produced what in many ways might be thought of as the first album of Salon caricature, the *Salon de 1843 ...*, as an explicit riposte to comic reproduction by Pelez published in *Le Charivari* in 1842–1843. This album fundamentally reoriented the comic depiction of painting, removing the caricaturist as *interpreter*—as reproductive artist—and reinventing him as a vicarious viewer, a comic portal to a direct experience of the painting.

Bertall is an ubiquitous figure in nineteenth-century illustration, and yet not a particularly exalted one.[49] Asked to contribute notes to a biography of the artist, Nadar's praise was faint—"he's made as many [puns] as drawings in his life."[50] While it's true that Bertall lacked the wit and inventiveness of some of his confreres, especially Cham, he was among the most dedicated lifelong Salon caricaturists, notably for the *Journal pour rire* (after 1856 *Journal amusant*) between 1849 and 1871.[51] Although there is some evidence that Bertall, born into great wealth, had reactionary taste in art,[52] as the author/illustrator of the first dedicated album of Salon caricature, he was brilliantly innovative.

Bertall's album defined itself in contrast to the comic reproductions that appeared in *Le Charivari* the year before. Bertall ensured readers with a long, faux-pompous title that they would not encounter the kind of games that Pelez had played:

> *The Salon of 1843 (not to be confused with that of the artist-publisher Challamel, publisher-artist). Appendix to the livret, represented by 37 copies by Bertal [sic].*[53]

The reference to *Le Charivari* is specific here, as the faithful reproductions that *Le Charivari* printed were often taken from Pierre-Joseph Challamel's albums of Salon reproductions.[54]

Bertall's album proposed a new proximity to the experience of viewing. Since the *livret* was purchased and carried around the Louvre as an often-necessary explanatory guide, this small, inexpensive pamphlet sold itself as something that

could be carried around the galleries. Pelez's comic lithographs were grounded in practices of print, while Bertall's album relies on an experience of place. Just under the title and prolix subtitles, the album reads, "Studies made at the gates of the Louvre, March 15, 1843."[55] Bertall assures readers that he was *sur place* on the opening day, watching the painters as they jostled to locate their canvases.

Bertall draws on the tradition, going back to the *ancien régime*, of the comic written récit that consisted of dialogue on the part of meandering Salon-attending characters.[56] Bertall's album is structured as a kind of promenade, with a narrative that flows through observation after observation, punctuated by caricatures of painting, sculpture, and viewers. Where Pelez lavished time and energy on a single image, Bertall dashes through many. And where Pelez used lithography to manipulate the viewer's attention—to flicker between copy and caricature, to engage the close looking of the print connoisseur as a comic technique—Bertall on the contrary deploys scratchy, rapid wood engraving to make an instant joke of painterly style.

Among the aspects of the coalescing genre of the *Salon pour rire* that Bertall initiated in this album, the most significant is the manner in which Bertall uses caricature. Though not applied consistently, there is a new attention in Bertall's *Salon de 1843* to the possibilities of caricaturing *paint itself*, of representing differences in individual style or facture through caricatural depiction.

Papety's Private Dream

Although the album generally intersperses text and caricature, Bertall emphasizes one caricature in particular by devoting an entire page of the album to it: a caricature of Dominique Papety's painting *Rêve de bonheur* (Dream of Happiness) (Plates 7 and 8).[57] Papety's *Dream* took pride of place in the album for obvious reasons. It was a large, prominently displayed, and highly discussed canvas that year.

In his desire to counter *l'art pour l'art* with crisp pedagogical visions of modern social harmony, the young Fourierist painter Papety had inserted a steam engine and a hot air balloon in the background of his antique paradise. As to be expected, Bertall seizes on the obvious conflict between arcadian classicism and modern technology, giving the whole scene a contemporary Parisian dialect (the toga is a butcher's apron, the priest is a drunk, the philosophical tract a Paris newspaper). One would imagine that, searching for the element to caricature in Papety's canvas, the caricaturist's eyes might land with glee on the steam engine powering through paradise. Yet Bertall does not make these items the

thrust of his caricature. In fact they are relatively minor aspects of the final wood engraving, appearing as lightly sketched and barely exaggerated vehicles in the otherwise vacuous center of the image.[58]

Surprisingly, Bertall finds comedy in another aspect of the painting: the unabating crispness of Papety's style. Papety's foregrounded figures lounge in a harsh, frontal, even light, which particularly turns their copious drapery into sequences of stripes. Every tendril of Papety's lapidary foliage can be picked out as the landscape recedes with uniform clarity.

Papety's glaring white figures and togas with their folds in perfect, parallel striations lend themselves to an exaggerated use of wood engraving, a medium that, in its cheaper application in the press, has difficulty with rounded modeling of form and must approximate half-tones with carved striation. Wood engraving could of course produce sophisticated and nuanced reproductions, but Bertall's innovation was to exaggerate the weaknesses of wood engraving, so that its perceived primitiveness acts as a formal hyperbole or *charge* of Papety's flat clarity.

Bertall's caption for "Dream of Happiness" identifies the comic elements in the painting as Papety's, and not as Bertall's interpretation of them. "The author brought together all of the joys that he dreamed"[59]: Papety's authorship is on display here in the non-sequiturs of his nocturnal imagination (boots and pumpkins hang from trees). This is Papety's own private, capricious dream, and not a social utopian vision. We access this view to Papety's painting through Bertall, as a perceptual vehicle. Bertall's graphic joke is that the striated shading of the bottle at left, the foregrounded babies empty but for outline, and the trees made up of cellular and distinct leaves are all the hand of Papety.

Yin-Hsuan Yang, who likewise sees Bertall as a key generator of Salon caricature, concludes that in this image, via "contrast between the classical subject and the modern vision, by a sort of desacralization of the work of art, caricature shows that it can constitute a powerful weapon in the service of art criticism."[60] There is no question that one aspect of Bertall's caricature is its relocation of Papety's paradise in Paris, a tactic we saw already in Pelez's Parisian relocation of a fantasized Algeria.

But with this album, Bertall does not initiate the "desacralization" of Salon painting—Salon painting had been a comic subject since the *ancien régime*. Rather, Bertall wants his reader to tour the galleries with him imaginatively and to "see" Papety through Bertall's hand. Bertall in this mode does not emphasize caricature as a critical weapon but as a perceptual mode, given the new level of

graphic union between Bertall's caricatural delivery and Papety's painterly style. He melds his graphic exaggeration with Papety's own formal qualities, returning to the essential technique of caricature as a *charge* or exaggerated depiction. Bertall uses this technique not on the traditional caricatural subject of figures in a scene but on how the scene has been painted, a *portrait-charge* of paint.

Bertall is inconsistent in his application of this technique. His caricature of Jean-Louis Petit's *Vue de la Hugue; marine, effet de nuit* (View of the Hague; seascape, night) (Figure 1.4) is in part a textual joke, turning the "*effet de nuit*" of the title into a complete blackout. In the context of the album's caricatural attention to painting, although Petit's original is now lost, we can guess that Bertall's all-black version nevertheless exaggerated real qualities of the painted *nocturne*.[61]

Figure 1.4 Bertall, *Le Salon de 1843 (ne pas confondre avec celui de l'artiste-éditeur Challamel, éditeur-artiste.) Appendice au livret, représenté par 37 copies par Bertal* [*sic*], 1843, page 95. Wood engraving. Houghton Library, Harvard University

Without access to the original canvases, it is hard to know precisely to what extent the other caricatures on the page engage features of style or facture. His caricature of Charles-Louis Muller's *Combat des centaures et des Lapythes* (Combat of Centaurs and Lapiths) plays on the title, turning the "Combat" of its protagonists into a combat of lines, pure linear aggression. Already, this graphic re-picturing replaces the subject (mythical creatures) with its means of depiction (pure, comically hyperactive line). The last canvas on the page is of Adolphe Roger's *Noël, une vision* (Christmas, a Vision), the subject of which was, according to the *livret*, "Baby Jesus appears in the sky"[62] Bertall retitled it "Steeple-chase of angels" and turned it into a horse race in white against black, exploiting what were likely stark tonal contrasts of bright holy bodies against a dark night.

If it seems I am describing something momentous or strange in the idea that a caricature of a painting is offered as direct access to the painting itself—as an image that can simultaneously be an original and reproduction—it is nothing more than a joke: "Look what Papety made" [holds up rigid exaggeration]. Bertall's aim here was surely not to explore the conceptual simultaneity of paint and print but rather, to pretend that this thing, this cheap and diminutive wood engraving, is paint itself, that the wood engraver's gouges and swipes are the work of the ambitious painters Papety, Petit, or Roger. He had found a new way to wring a laugh out of Salon painting.

Bertall's album's innovations were driven in part by a desire to cater to the July Monarchy taste for illustrated panoramic anthologies.[63] Indeed Bertall's Salon de 1843 was published amidst a series called Les Omnibus satirizing literature, Greek tragedy, and "un peu de tout." The idea of accessing painting directly via the caricature was surely informed by such anthologies, which often provided fantastical visual access to Parisian sites, both public and private.

Further, the proposition that the caricature is not Bertall's interpretation of a painting but a vicarious encounter with the original recalls marginal genres in the history of art, such as the Collection Picture or Cabinet Picture that emerged in Dutch art of the seventeenth century. Such pictures represented a room of artworks, usually in highly detailed oil paint. While there was considerable range in the intent of such images, from the classificatory to the sensuous, they nevertheless made viewing the painting a proxy for viewing the objects "inside" the painting.[64] For example, American painter Samuel Morse's version of a Collection Picture, his *Gallery of the Louvre* (1831–1833) (Figure 1.5), under the rubric of pedagogy, puts its viewers in simulated contact with Old Master painting. The palette and glazing of Morse's picture imitated those of

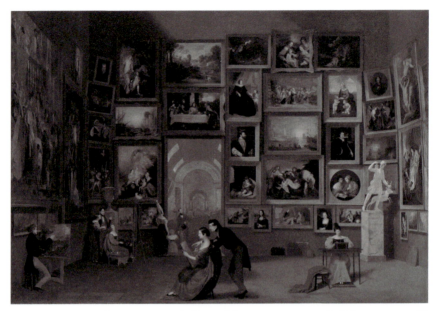

Figure 1.5 Samuel F. B. Morse, *Gallery of the Louvre*, 1831–33. Oil on canvas. 73 3/4 × 108 in. (187.3 × 274.3 cm), Terra Foundation for American Art, Daniel J. Terra Collection, 1992.51. Photography ©Terra Foundation for American Art, Chicago

the Renaissance works (Titian, Leonardo) they contained,[65] heightening the viewers's sense that they apprehended those canvases directly.

Prints depicting exhibitions have often made strange compromises in order to give the spectator a sense of direct access to the works on view. For example, *L'Illustration*'s wood engraved "Première Vue" ("First Look") at the recently opened Salon of 1843 at the Louvre meant only to report, not to caricature (Figure 1.6). The print had two conflicting aims: first, to depict the populated scene at the Louvre, and second, to make each individual painting visible in miniature. Rather than depict the physiognomy of the crowd in sharp focus and leave the background paintings in a generalized haze of activity (as we see, for example, in Daumier's exhibition scenes), the artist has attempted simultaneously to deliver detailed access to the paintings. Papety's *Dream of Happiness* appears at the center, scratchy, hyper-linear, crammed into a tiny space, and accidentally de-idealized; it is almost a caricature.

In the case of *L'Illustration*'s "First Look," the attempt to provide detailed visual reporting on each canvas, within the limited space allowed by the exhibition scene, resulted in passages that recall the comic strategies that Salon caricature would regularly pursue. Look for example at the scrawny limbs of the Grecian-style nudes, the coal-dot eyes of portrait subjects, and the accidentally irreverent

Figure 1.6 "Beaux-arts. Salon de 1843. Première Vue du Salon carré," *L'Illustration,* March 25, 1843. Wood engraving. University of Chicago Library

treatment of religious subjects. In the reproduction of no. 842 at top left of a deposed Christ,[66] the flattened depiction of figures in space glues faces from the background to Christ's awkward body, so that his legs look like arms. This creates the illusion that Christ is being "wheelbarrow-walked" down the mount. As coverage of the fine arts spread to new platforms such as *L'Illustration,* its failures, limits, and accidents surely fueled Bertall and other caricaturists.

Ingres, Challamel, Bertall

Just as Pelez's "Salon de 1842" responded to growing disquiet about who had the right to criticize art, Bertall's *Salon de 1843* also addressed the problem of critical capacity. Bertall concluded the album with a one-page spread entitled "Physionomies" ("Physiognomies") (Figure 1.7) portraying the various kinds of people who attend the Salon. Bertall compared two opposing groups: "Those who go to the Salon every day," which included "Ingres, Challamel … Bertal [*sic*] et compagnie,"[67] and those who attended only on Sunday, the day the Salon was free and therefore attracted the widest audience.

Figure 1.7 Bertall, *Le Salon de 1843 (ne pas confondre avec celui de l'artiste-éditeur Challamel, éditeur-artiste). Appendice au livret, représenté par 37 copies par Bertal* [*sic*], 1843, page 104. Wood engraving. Houghton Library, Harvard University

Bertall opened the album by opposing himself to Challamel, author of popular lithographic Salon albums, but he closes it by grouping himself *with* Challamel. Importantly, Bertall is not among the Sunday group, who are either inattentive (the woman at left, asleep) or overwhelmed (the man at right, agog). In contrast to those many who are lost and incompetent at the Salon, Bertall counts among those in the orderly tophats (seriousness is coded male) who all

face the canvas, wrapt. This is a frequent motif in social caricature of the Salon: bafflement versus communion. On the one hand, Bertall's is a comic album—he has shown us painters who blacked out their canvases and turned angels into racehorses. On the other hand, Bertall is giving his credentials as a legitimate viewer, as someone who, along with artists themselves, squares up to the canvas and sees it clearly. If some have the right to criticize and others do not, Bertall puts himself among the legitimate critics, demonstrating as did Pelez's "Salon de 1842" the compatibility, in the early 1840s, of the comic with contemplation and communion, laughter with quality spectatorship. In Bertall's Salon, insiders laugh.

Bertall was not interested in using caricature as a weapon. His self-portrait among Ingres and Challamel signals that he is at the Salon to look closely, like the painters and printmakers at his flanks. However, during the early 1840s, Salon caricature's emergence was often described as a new kind of weapon or attack. This chapter has shown how Salon caricaturists used their tools to bring caricature and painting closer together, to activate one through the other. Yet there is no question that the notion of a pictorial critic struck commenters as dangerous during the genre's embryonic years. The next chapter takes up the question of how this new genre of Salon caricature veered between a reputation for violence and continued rapprochement with painting.

Notes

1 "Salon caricature" is defined here as in the introduction: the caricature of specific works of art concurrently exhibited at the Salon. Daumier did caricature the Salon as site, as discussed in Chapter 5.

2 E.g., Auguste Jal, *Esquisses, croquis, pochades, ou, tout ce qu'on voudra sur le Salon de 1827* (Paris: A. Dupont, 1828). This 550-page account of the Salon, half-satiric but mostly serious, contains faithful lithographs of key paintings but closes with a single lithographic caricature by Henry Monnier of a painting titled *Le Cauchemar* (The Nightmare). For earlier examples, see Laurent Baridon and Martial Guédron, "Caricaturer l'art: usages et fonctions de la parodie," in *L'art de la caricature*, ed. Ségolène Le Men (Paris: Presses Universitaires de Paris Ouest, 2011), 87–108.

3 See Richard Wrigley, *The origins of French art criticism: From the Ancien Régime to the Restoration* (Oxford: Clarendon Press, 1993) and Bernadette Fort, "The Voice of the Public: The Carnavalization of Salon Art in Prerevolutionary Pamphlets," *Eighteenth-Century Studies* 22, no. 3 (Spring, 1989): 368–94.

4 Previously, *Le Nain jaune*, *Le Miroir*, *Le Pandore*, and *Le Petit mercure* had published caricature but inconsistently; *La Silhouette* (1829), the first weekly satiric journal

to publish illustrations, only published caricature as single-sheet supplements outside the text. John Grand-Carteret, *Les moeurs et la caricature en France* (Paris: À la librairie illustrée, 1888), 600. See also "Du journal à l'illustré satirique," in *La Civilisation du journal: Histoire culturelle et littéraire de la presse française au XIXe siècle,* ed. Domique Kalifa, Philippe Régnier, Marie-Ève Thérenty, and Alain Vaillaint (Paris: Nouveau Monde, 2011), 418–35.

5 *Le Charivari*'s circulation figures did not pass a thousand until 1837 and hovered between 2,000 and 3,000 until 1869 although readership numbers are higher since an issue often passed through several readers's hands at cafés or *cabinets de lecture.* On *Le Charivari*'s readership, see David S. Kerr, *Caricature and French Political Culture 1830–1848: Charles Philipon and the Illustrated Press* (Oxford: Clarendon Press, 2000), 126–8; Elizabeth Childs, *Daumier and Exoticism: Satirizing the French and the Foreign* (New York: Peter Lang, 2004), Appendix I; and Patricia Mainardi, *Another World: Nineteenth-Century Illustrated Print Culture* (New Haven and London: Yale University Press, 2017), 62–71. In 1820, there were thirty-two public reading rooms; by 1840 there were 194. See Françoise Parent-Lardeur, *Les cabinets de lecture: La lecture publique à Paris sous la Restauration* (Paris: Payot, 1982). For an overview of shifting journal-reading habits across the century, see Judith Lyon-Caen, "Lecteurs et lectures: les usages de la presse au XIXe siècle," in *La Civilisation du journal*, 23–60.

6 Honoré Daumier, "Le Salon de 1840. Ascension de Jésus-Christ," *La Caricature*, April 26, 1840. Republished in *Le Charivari*, April 1, 1841.

7 Pierre Courthion, ed., *Daumier raconté par lui-même et par ses amis* (Genève: P. Cailler, 1945), 32.

8 E.H. Gombrich and Ernst Kris, "The Principles of Caricature," *British Journal of Medical Psychology* 17 (1938): 319–42. See, e.g., Amelia Rauser, *Caricature Unmasked: Irony, Authenticity, and Individualism in Eighteenth-Century English Prints* (Newark: University of Delaware Press, 2008). Discussed further in Chapter 3.

9 "Image satirique dans laquelle l'artiste représente d'une manière grotesque, bouffonne, les personnes ou les événements qu'il veut tourner en dérision …. *Le principal personnage de cette pièce n' est qu' une caricature.*" "Caricature," *Dictionnaire de l'Académie française, Sixième édition, T.1* (Paris: Didot, 1835).

10 Charles Baudelaire, "De l'essence du rire et généralement du comique dans les arts plastiques," *Œuvres complètes*, t. 2, Nouvelle éd., Bibliothèque de La Pléiade (Paris: Gallimard, 1976), 525–43.

11 On the iconographic life of "Gargantua," see Bertrand Tillier, "Gargantua, géant de papier? Migrations visuelles et jeux d'échelles," *Romantisme* 187, no. 1 (March 2020): 28–43.

12 An exception is Ed Lilley, "Daumier and the Salons of 1840 and 1841." Lilley comments on the longer caption that attached to the image upon its second publication in 1841, which identifies Brrdhkmann as a student of Overbeck and

a painter of the fictitious "Saxe-Hildburghausen School." Lilley finds it doubtful
that Daumier's "Salon of 1840" referred to any particular canvas but rather to the
increased visibility of religious art and the increased controversy surrounding
landscape art in the 1830s. Ségolène Le Men briefly addresses the "Salon of
1840" series, suggesting that the "Ascension" mocked Louis-Philippe's decorative
program for church interiors. Le Men, "The Caricatural Salon of 1840," in *Daumier,
1808–1879*, ed. Henri Loyrette et al. (Ottawa: National Gallery of Canada, 1999),
201. Thierry Chabanne identified a possible target for "Ascension" in a painting by
Jean-Louis Bézard shown in the Salon of 1840 described in the livret as dispersing
episodes from the life of Christ to the four corners of the canvas. This would be
a highly oblique reference, particularly as the Ascension was not among Bézard's
subjects. Chabanne, *Les Salons caricaturaux* (Paris: Editions de la Réunion des
musées nationaux, 1990), 50.

13 Robert Justin Goldstein, *Censorship of Political Caricature in Nineteenth-Century
France* (Kent, OH: Kent State University Press, 1989), 34.

14 Caricatures published under the series title "Salon de 1842" in *Le Charivari*:
"Une Tentation: Silhouette à grand spectacle imitée des ombres chinoises par M.
Edouard [sic] Bertin," April 4, after *La tentation du Christ; paysage historique*, by
Édouard Bertin; "Un bain à domicile: Fantaisie aquatique de M. Court," May 11,
after *Baigneuse algérienne* by Joseph-Désirée Court; "Prométhée changé en outre:
Amplification d'échine par M. Jourdy," May 14, after *Prométhée enchaîné* by Paul
Jourdy; "Sculptures amusantes," May 21, after sculptures by Louis-Joseph Daumas,
Joseph Lescorné and Auguste-Louis-Marie Ottin.

15 On the relationship between Philipon and the Maison Aubert, see James Cuno,
"Charles Philipon, the Maison Aubert, and the Business of Caricature in Paris,
1829–41," *Art Journal* 43, no. 4 (1983): 347–54.

16 "…des principaux tableaux des musées publics et particuliers, et de ceux que leur
mérite aura fait remarquer dans les différentes expositions …." Charles Philipon,
prospectus for *Le Charivari*, cited in Patricia Mainardi, *Another World*, n. 125, 253–4.

17 In 1841 the journal *L'Artiste* reported 1 million visitors; similar estimates were made
through the 1840s. Cited in Wrigley, *The origins of French art criticism*, 80.

18 Louis Coignard (1812–1880) studied in Paris with François-Édouard Picot,
submitted to his first Salon in 1838, and met with some success. A posthumous
auction catalogue of his affairs describes him as a landscapist in the ranks of
Daubigny, Corot, and Troyon. *Vente après décès de Louis Coignard: tableaux, études,
esquisses, dessins … garnissant son atelier … 12 Février 1885* (Paris: Hotel Drouot
1885), n.p.

19 Ted Cohen, *Jokes: Philosophical Thoughts on Joking Matters* (Chicago: University of
Chicago Press, 2001), 12–32.

20 Pelez's lithographic copy resembles in many of its choices a partially completed,
unpublished non-comic lithograph after the painting. *Grande étude aux deux*

crayons, n° 4, by Bernard-Romain Julien after J.-D. Court. Cabinet des estampes, Bibliothèque nationale de France DC-187(A)-FOL, 1842–2607.

21 "Oscar viendra ce soir," *Le Charivari*, May 11, 1842, 3.

22 E.g., Louis Huart, *Physiologie de la grisette* (Paris: Maison Aubert, 1841). Jillian Lerner discusses the *grisette* as among the social types not merely identified but generated by graphic culture. Jillian Lerner, *Graphic Culture: Illustration and Artistic Enterprise in July Monarchy France 1830–1848* (Montreal: McGill-Queen's University Press, 2018), 12, 69–98.

23 See, e.g., Victor Stoichita, *The Pygmalion Effect: From Ovid to Hitchcock*, trans. Alison Anderson (Chicago: University of Chicago Press, 2008); *Dead or Alive! Tracing the Animation of Matter in Visual Culture*, Gunhild Borggreen, Maria Fabricius Hansen, and Rosanna Tindbaek, eds. (Aarhaus: Aarhaus University Press, 2020); and David Freedberg, *The Power of Images: Studies in the History and Theory of Response* (Chicago: University of Chicago Press, 1989). For Freedberg, academic neglect of this history of animism in image relations comes from its continuing power, not its disappearance. "We refuse ... to acknowledge the traces of animism in our own perception of and response to images," animism "in the sense of the degree of life or liveliness believed to inhere in an image," 32. W.J.T. Mitchell has explored pervasive animisms in modern image relations and similarly argued that contemporary viewers manage a "double consciousness" regarding those relations, attributing the magical, mystical, or animstic to "primitives, children, the masses, the illiterate, the uncritical, the illogical, the 'Other.'" Mitchell, *What Do Pictures Want? The Lives and Loves of Images* (Chicago: University of Chicago Press, 2005), 7.

24 Jay David Bolter and Richard Grusin describe "remediation" as the dialectical re-representation of "old" media within "new" media (e.g. digital media). *Remediation: Understanding New Media* (Cambridge: MIT Press, 2000).

25 Lynda Nead, *The Haunted Gallery: Painting, Photography, Film c. 1900* (New Haven: Yale University Press, 2007), 93.

26 Norman Bryson, *Tradition and Desire: From David to Delacroix*, Cambridge Studies in French (Cambridge: Cambridge University Press, 1984), 5.

27 On the use of models in nineteenth-century studios, see Susan Waller, *The Invention of the Model: Artists and Models in Paris, 1830–1870* (New York: Ashgate, 2006). Waller argues that class, gender, and ethnic dimensions of studio models were increasingly a palpable presence and powerful force in the erosion of classical ideals in the period I discuss.

28 "On dit beaucoup qu'en l'art le temps ne fait rien à l'affaire: c'est assurément très-vrai pour celui qui regarde une œuvre et qui n'a pas eu à l'exécuter." Nadar, *Nadar Jury au Salon de 1853: album comique de 60 à 80 dessins coloriés, compte rendu d'environ 6 à 800 tableaux, sculptures, etc.* (Paris: J. Bry aîné, 1853), 6.

29 Born in Cordoba in 1815, Pelez became active in Paris in the 1840s, and is now known primarily for his contribution to an album of Salon caricature discussed in

the next chapter *Le Salon de 1846 en vers et contre tous,* and to the multi-volume *Les Français peint par eux-mêmes.* He is the father of the painters Raymond Pelez (1838–1894) and Fernand Pelez (1848–1913).

30 "Sturtevant and the *Salon pour Rire,*" curated by Julia Langbein and Tobias Czudej, Chewday's, London, March 31–May 6, 2017.

31 "… son principal défaut est de n'offrir, dans ses divers personnages, aucun motif qui les rattache entre eux; les figures sont isolées, éparpillées, sans rien qui les lie à une pensée commune." After more criticism, the conclusion was "Quant à l'effet général du tableau, il est nul, comme la couleur …." "Rapport sur les ouvrages envoyés de Rome par les pensionnaires de l'Académie royale de France pour l'année 1839," *Procès-verbaux de l'Académie des beaux-arts, Tome 7ème,* ed. Jean-Michel Leniaud, (Paris: École des Chartes, 2007), 577–8.

32 On the contested expansion of Salon criticism, see Thomas Crow, *Painters and Public Life in Eighteenth-Century Paris* (New Haven: Yale University Press, 1985); *La Critique d'art en France 1850–1900: Actes du colloque de Clermont-Ferrand 25, 26 et 27 mai 1987,* ed. Jean-Paul Bouillon (Clermont-Ferrand: Université de Saint-Étienne, 1989); *La Promenade du critique influent: Anthologie de la critique d'art en France, 1850–1900,* ed. Jean-Paul Bouillon (Paris: Hazan, 1990).

33 In 1827 there were 1,833 works on display at the Salon; by the 1840s there were regularly over 2,100 works. The unjuried Salon of 1848 included over 5,100 works but numbers returned to pre-Revolution levels shortly after.

34 On the expansion of Salon criticism in the July Monarchy see Neil McWilliam, ed. *A Bibliography of Salon Criticism from the July Monarchy to the Second Republic, 1831–1851* (Cambridge: Cambridge University Press, 1991). On Second Empire Salon criticism, see Martha Ward and Christopher Parsons, eds., *A Bibliography of Salon Criticism in Second Empire Paris* (Cambridge: Cambridge University Press, 1986).

35 On the question of specialization of art criticism in the journalistic landscape, see *L'écrivain et le spécialiste: écrire sur les arts plastiques au XIXe et au XXe siècles: [actes du colloque, Paris, Maison de la recherche de l'Université de Paris-Sorbonne, 22–23 janvier 2009],* ed. Dominique Vaugeois and Ivanne Rialland (Paris: Éd. Classiques Garnier, 2010).

36 Ralph [Laurent-Jan], "Le Salon de 1839," *Le Charivari,* March 23, 1839. Republished as Laurent-Jan, *Le Salon de 1839* (Paris: Beauger & Cie, 1839).

37 " … un homme arrive et, sous le prétexte qu'il pétrit agréablement la phrase, il la prend, votre œuvre, et la dépèce, tableau, statue, partition, peu importe, car il faut qu'il juge: c'est son métier." Laurent-Jan, *Le Salon de 1839,* 1.

38 "… en peinture, l'exécution est tout et le sujet rien; style, caractère, couleur, poésie, tout ressort de l'exécution, justement la seule chose que l'écrivain ne peut juger." Laurent-Jan, *Le Salon de 1839,* 2.

39 "L'art n'est pas fait pour toi, tu n'en a pas besoin." Laurent-Jan, *Le Salon de 1839,* 2.

40 For example, Philipon addressed subscribers as collectors and communicated with readers about print quality distinctions. See Kerr, *Caricature and French Political Culture*, 22–3.

41 Bibliothèque nationale de France, département des Estampes et de la photographie, Kc MAT 11a.

42 On the business strategies of the Maison Aubert, see H. Hazel Hahn, *Scenes of Parisian Modernity: Culture and Consumption in the Nineteenth Century* (New York: Palgrave Macmillan, 2009), 20–8 and Lerner, *Graphic Culture*, 82–5.

43 Dates on which *Le Charivari* published faithful Salon reproductions and installments of the "Salon caricatural" in 1843 ("Salon caricatural" is italicized): *March 29*, April 10, *April 13*, April 20, *May 1*, *May 7*, May 8, *May 11, May 13, May 21*, May 27, June 3.

44 The series title was not the only difference. In 1843, Pelez did not sign the caricatures. They were published anonymously. Yin-Hsuan Yang assumes they are the work of Pelez based on stylistic continuity, but Philipon had a large network of graphic artists at his disposal, and it seems plausible that he could have asked another one of them to work in the same vein as Pelez. See "Les premiers Salons caricaturaux au XIXe siècle," in *L'art de la caricature*, 73–86.

45 Yang, "Les premiers Salons caricaturaux au XIXe siècle," 78.

46 On these journals, see Nancy Ann Roth, "'L'Artiste' and 'L'Art Pour L'Art': The New Cultural Journalism in the July Monarchy," *Art Journal* 48, no. 1 (April 1, 1989): 35–9.

47 Jean Elleinstein, ed., *Histoire de la France contemporaine 1789–1980* (Paris: Éditions sociales, 1978–1981), 30.

48 See, e.g., his contributions to Alphonse Karr's *Les Guêpes* (Paris: Bureau du Figaro, 1839–1849). For Bertall's role in Balzac's *Comédie Humaine*, see Tim Farrant, "La vue d'en face? Balzac et l'illustration," *L'Année balzacienne*, 12, no. 1 (2011): 249–71.

49 There is no modern biography of Bertall. Henri Béraldi wrote an appreciative account of his œuvre in *Les graveurs du XIXe siècle: guide de l'amateur d'estampes*, T.2 (Paris: L. Conquet, 1885), 45–9.

50 "Il fait trop de calembours. Il en fait presque autant qu'il a fait de dessins dans sa vie …." Bibliothèque nationale de France, Fonds Nadar, NAF 24262 – MF 16604, letter 422, no date.

51 Bertall illustrated the March 1847 installment of Alphonse Karr's *Les Guêpes,* effectively an album of Salon caricature, narrated by Karr, entitled *Les Guêpes au Salon* (Paris: J. Hetzel, Warnod & Cie, 1847). Bertall authored a four-issue series of albums of Salon caricature as a supplement to the satirical journal *Le Grelot* in 1872. *Le Grelot au Salon: le Salon de 1872 / dépeint et dessiné par Bertall* (Paris: n.p., 1872).

52 Laurent Baridon and Martial Guédron follow Bertrand Tillier in suggesting that Bertall's aristocratic origins, along with Cham's, were responsible for a conservatism that "incited them to parody innovative work" ("les incitaient à parodier les œuvres novatrices.") Baridon and Guédron, "Caricaturer l'art: Usages et fonctions

de la parodie," in *L'art de la caricature*, 95 and Bertrand Tillier, "Cham, le polypier d'images," in *Parodies littéraires: précédé par Cham, le polypier d'images* (Paris, Jaignes: Phileas-Fogg, La Chasse au Snark, 2003), 13. Klaus Herding suggests that Bertall was hostile to Realism in *Courbet: to Venture Independence* (New Haven: Yale University Press, 1991), 22.

53 *Le Salon de 1843 (ne pas confondre avec celui de l'artiste-éditeur Challamel, éditeur-artiste). Appendice au livret, représenté par 37 copies par Bertal* (Paris: Ildefonse Rousset, 1843).

54 *Album du Salon de 1843 : collection des principaux ouvrages exposés au Louvre reproduits par les peintres eux-mêmes ou sous leur direction ... ; texte par Wilhelm Ténint* (Paris: Challamel, 1843). Challamel's albums were also sold at the Maison Aubert.

55 "Études faites aux portes du Louvre, le 15 mars 1843," *Le Salon de 1843 ...*, 1.

56 E.g., Louis-Abel Beffroy De Reigny, *Marlborough au Salon du Louvre* (Paris: Académie royale de peinture et de sculpture, 1783).

57 For a thorough account of Papety's canvas and its reception, see Neil McWilliam, *Dreams of Happiness: Social Art and the French Left, 1830–1850* (Princeton, NJ: Princeton University Press, 1993).

58 Papety subsequently painted over these conspicuous technologies and replaced them with a figural group and a temple.

59 "L'auteur a su rassembler ici tous les bonheurs qu'il a rêvés" Bertall, *Le Salon de 1843 ...*, 94.

60 "Par le contraste entre le sujet classique et la vision moderne, par une sorte de désacralisation de l'œuvre d'art, la caricature montre puissamment qu'elle peut aussi constituer une arme efficace au service de la critique d'art" Yang, "Les premiers Salons caricaturaux au XIXe siècle," 73–86, 81–2.

61 Raphael Rosenberg, also noting that Bertall had no intention to attack the work of the painter, agrees that Bertall's new deployment of caricature to represent real canvases likely responded to an "excessive darkness" ("l'obscurité excessive") in Petit's seascape. Raphael Rosenberg, "De la blague monochrome à la caricature de l'art abstrait," *L'art de la caricature*, 27–40, 31.

62 "L'Enfant-Jesus apparait dans les airs, la nuit de sa nativité." *Explication des ouvrages de peinture, sculpture ...* (Paris: Vinchon, 1843), 128.

63 On panoramic literature see *Les Français peint par eux-mêmes: Panorama social du XIXe siècle*, ed. Ségolène Le Men, Luce Abélès, and Nathalie Preiss-Basset (Paris: Réunion des musées nationaux, 1993). On panoramic literature's development of its consumer market, see Lerner, "Marketing Vision: Publishers, Posters, Parisian Types," in *Graphic Culture*, 69–98. On panoramic literature's precinematic modernity, see Margaret Cohen, "Panoramic Literature and the Invention of Everyday Genres," in *Cinema and the Invention of Everyday Life*, ed. Leo Charney and Vanessa R. Schwartz (Berkeley: University of California Press, 1995), 227–52.

64 For an overview of recent approaches to Collection Pictures, see *Intellectual History Review* vol. 20, no. 1 (2010), special issue "Picturing collections in Early Modern Europe."

65 Jennifer W. Olmsted, exhibition review of Samuel F.B. Morse's "Gallery of the Louvre and the Art of Invention," *Nineteenth-Century Art Worldwide* 17, no. 2 (Autumn 2018), web.

66 Canvas no. 842, Marquis (no forename listed in *livret*), *Christ au Tombeau*.

67 "Ceux qui vont au Salon tous les jours." *Le Salon de 1843* …, 104.

2

Dueling and Doubling: The Antagonism of Salon Caricature

In the years of Salon caricature's emergence at the end of the July Monarchy, caricature possessed a reputation for political violence and oppositional power. In this chapter, I describe how Salon caricature, crystallizing as a genre in the turbulent period between 1847 and 1852, negotiated a new relation to caricatural opposition, taking up the model of the *duel pour rire* or joke duel. Caricaturists navigated modes of non-opposition in opposition, evacuated attack, and antagonism that was a requirement of the form but only formal.

The truth is that oppositional political caricature under the July Monarchy represented a fraction of lithographic output. The majority, as under the Second Empire, was given over to a vast array of imagery, much of it social caricature and *scènes de mœurs*.[1] However, famous episodes of conflict, notably the trials and imprisonment of Charles Philipon, Daumier and other publishers, printers and caricaturists, and the extraordinary quality of the caricatures themselves contributed to the outsize visibility of the republican oppositional caricature of the July Monarchy and to the idea that caricature was inherently a popular political weapon.[2]

This chapter argues that Salon caricaturists in the aftermath of the July Monarchy, aware of this reputation for oppositional violence, articulated with particular clarity a new role for caricature. Instead of directing oppositional animus, it would exploit oppositional structure. Charles Baudelaire's essay "On the Essence of Laughter," published in 1855 but in progress since at least 1846, described that structure as internal to comic art, which was necessarily split into and structured by two mutually opposing forces. For Baudelaire, the comic artist possessed the special skill of *dédoublement* or doubling, the ability to be two things at once—laugher and victim of laughter, attacker and attacked.

Caricature was bound up with ideas of violence, both political/social and structural/formal; yet, caricaturists played with expectations of violence or antagonism, subverting and exploiting those expectations. If Salon caricature exemplifies caricature's move away from political violence and oppositional power in midcentury France, then it also shows how that move was not merely a step toward impotence and frivolity (a charge levied at caricature in the Second Empire and after). In containing and exploiting oppositional relations, Salon caricaturists also expanded the horizons of possibility for caricature as an amoral, ambiguous, and fractured form.

Dueling for Laughter

Bertall, whose 1843 album of Salon caricature[3] helped to set the genre's course toward a new attention to painting's facture, drew one of the most famous and often-reproduced caricatures of the nineteenth century. Entitled "République des Arts" ("Republic of the Arts") and published in Charles Philipon's *Journal pour rire* on July 28, 1849, the caricature depicts the painters Jean-Auguste Dominique Ingres and Eugène Delacroix, the putative heads of the "School of Line" and "School of Color," jousting outside the Académie française, the former carrying a spear-like *porte-crayon* and the latter a paintbrush.[4] An elaborate caption pegs the artists to the conservative and socialist leaders in the National Assembly, Ingres the "Thiers of line," Delacroix the "Proudhon of color."

As the "Republic of the Arts" has circulated and multiplied through reproduction, it has shed its original publication layout and been addressed as a single, excised scene of the two artists battling.[5] Yet for this image's fame, it has gone without notice that it originally appeared at the center of a page of Salon caricature (Figure 2.1). "Republic of the Arts" appeared within a special pullout section entitled "Comic Review of the Salon of Painting, Sculpture, Architecture, etc. ..." ("Revue Comique du Salon de peinture, de sculpture, d'architecture, etc. ...").[6] To see the original caricature *in situ* in the *Journal pour rire* is to experience something of a shock. The *Journal pour rire* as it was published in 1849 was extremely large—61 cm high by 43 cm across, poster-sized to modern readers— and Bertall's "Republic of the Arts" occupies only about a quarter of the surface area at the center the page while the majority is given over to densely worked, distinctly framed canvases-in-caricature.

Reinserting the figure of two artists battling, their weaponized tools crossed, as a vignette framed by Salon caricature fundamentally alters the reading of the

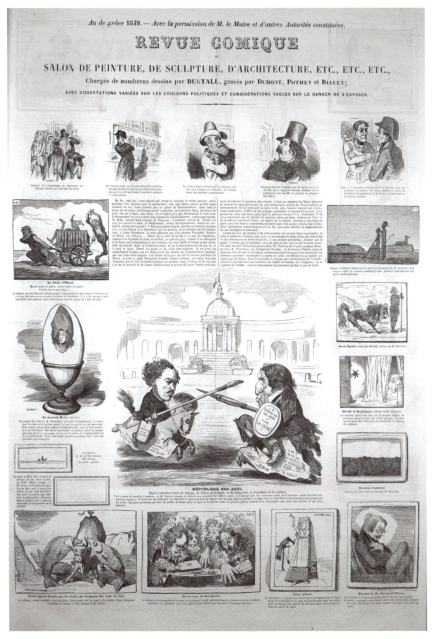

Figure 2.1 Bertall, "Revue comique. Salon de peinture, de sculpture, d'architecture, etc., […]," *Journal pour rire,* July 28, 1849. Wood engraving. 61 × 43 cm. Graphic Arts Collection, Special Collections, Princeton University Library

image. Ingres bears the *porte-crayon* because it is the tool of the draftsman, but it is also the tool of the caricaturist, frequently represented in the caricaturist's hand or as a metonym for his profession. All twelve caricatured works surrounding "Republic of the Arts" are paintings, leaving sculpture and architecture for the reverse side.[7] To set the scene of *porte-crayon* warring with paintbrush within a "Comic Review" caricaturing paint implies that Salon caricature itself is at war with painting.

The suggestion of such an attack might be supported by the qualities of the caricature, as wood engraving belittles painting, converting its sensuous color into mechanically reproduced line. Hanging over those qualities was also an experience of caricature's role in the preceding years as a bearer of oppositional intent.

In 1843, the first year of its publication, the weekly magazine *L'Illustration* had excerpted the 23-year-old Bertall's album of Salon caricature, an important introduction of the journal's comparatively large readership to the genre.[8] The journal prefaced the excerpt with a profile of Bertall as a "cruel young man"—"a young artist who must inspire serious fear in his compatriots; … this formidable critic does not write, he draws; but his victims are only that much more to be pitied."[9] For the journal, it was "cruel" for an artist to attack art, combining the revelatory eye of the portrait caricaturist with the vitriol of the disparaging critic. The result was a particularly terrifying hybrid for his "victims."

The idea of Salon caricature as a form of attack has had strong sway in part because caricature as a category of image was understood to possess inherent danger. With only a few revolutionary ruptures, caricature was described as dangerous and caricaturists morally suspect in French legal discourse from 1820 to 1881. Legal debates about censorship following the 1835 attempt on the king's life explicitly linked caricature's exhortations to the commission of crime and resulted in a crackdown on the press.[10] The harsh censorship imposed on caricature by the September Laws of 1835 asserted that illustrators could publish their thoughts in written form, because "words address only the mind," but that "when opinions are converted into acts" by the publication of drawings, "that is more than the expression of opinion, that is a deed, an action a behavior."[11] In other words, caricature was not metaphorically violent but a real act of aggression. While freedom of the press had been restored by the Provisional Government in 1848, Bertall's "Revue Comique" appeared in the summer of 1849, as censorship was gradually reinstated.

Returning to Bertall's "Revue Comique," the central duel and its wreath of Salon caricature play with the terms of caricature's legal and moral threat,

splitting the discursive and pictorial, "opinions" and "acts." Putting on the tone of a partisan *Ingriste*, Bertall's caption applauds the painter Nicolas-Auguste Galimard (1813–1880) for understanding "with great intelligence" that "the straight line is preferable to the cork-screwed one for Greek subjects."[12] The caricature of Galimard's painting *Junon jalouse* (Jealous Juno) (Plates 9 and 10) converts the figure with her hieratic pose into a mechanical doll, hinging at the joints, hardly a classical ideal. The image defies the text's partisan certainty, infantilizing and industrializing her production as a toy, making her linearity a function of cheap manufacture and not academic doctrine. Ultimately the reference to appropriateness of line or color, the parroting of an academician's approval, is merely a setup for a completely incompatible pictorial review which cannot put the picture in either Ingres's or Delacroix's camp.

Bertall caricatures two canvases by Delacroix in his 1849 "Comic Review." In the case of *Othello et Desdemona* (Othello and Desdemona) again Bertall scripts an authoritative caption ("This canvas is sublime"),[13] knowingly using a romantic catchword and complimenting Delacroix's astute choice of a moment of high drama.[14] As in his caricature after Galimard, Bertall's image contradicts the caption, where precisely the choice of "moment" is off—all we see is Othello's hand, as if Delacroix had chosen to paint the scene a few seconds *before* the dramatic confrontation (Plate 11). If the authorities feared that caricature could constitute a dangerous "behavior," here it merely misbehaves. It fails to arrive on the verbal cue, showing up its instability against written criticism's fixed terms.

The second caricature after Delacroix has no caption besides the picture's unedited title (*Arabe-syrien avec son cheval* [Syrian Arab with his Horse, Plate 11]). One is left to dwell on the furious linear activity within the frame, which looks at first glance like an assault on (the painter's) color by (the caricaturist's) line. In such close proximity to the caricatured Delacroix bearing his soaked brush, the scratchwork *Syrian Arab* points to the absurdity of the high-stakes conflict at the center of the page. Ready to die for color in his comic portrait, the Delacroix who created *Syrian Arab* is really a manic scribbler of line.

Salon caricature, Bertall insists, will not articulate the terms of an opposition: it will make opposition itself absurd. This new kind of criticism is appropriate to what Bertall's comic critic describes as a flabby new tolerance in the visual arts. In the textual preamble above his "Comic Review," Bertall writes that he misses the old monarchic jury whose central, royal authority had stoked partisanship and given life to robust criticism. That jury was replaced in 1849 by a new, technocratic jury of artists who, some complained, turned the Salon into

a display of pluralism.[15] For example, one 1849 Salon review in the *Revue des deux mondes* regretted that "there are no more schools, because schools require a spirit of systematic exclusion, and our tolerant aesthetic admits, on the contrary, the most diverse expressions of thought."[16]

Bertall's comic critic misses the old pitched battles, framing the duel at center as a nostalgic fantasy of the rigor and clarity of bygone partisanship—a hankering for the monarchic amid the new "Republic of the Arts."[17] This use of Salon caricature to frame critical and political opposition as historically past and currently absurd must be understood in the context of caricature's reformed role in the new Second Republic. Laura O'Brien has shown that after February 1848, the formerly oppositional journals *Le Charivari* and *Le Journal pour rire* found themselves on the side of the provisional government, propagating the image of the Republic as polite, cohesive, and moderate.[18] O'Brien describes various strategies by which caricature propped up the Republican ideal, mounting a concerted project of "othering" the far left (including the once-heroic figure of the worker) as a way to promote the vision of a stable regime, built on conciliation and class harmony.[19]

Caricature in the 1848–1851 period did not voice opposition or truth to power as it promoted this image of a coherent middle ground. This image did not reflect a reality in which expedient alliances, notably those forged by moderate republicans who constituted much of the press including *Le Charivari*, eroded into bitter class conflict. Marx's *18 Brumaire*, written in 1851–1852, is a scathing account of moderate republican cowardice following the overthrow of Louis-Philippe, a bourgeois abandonment of class solidarity with workers for financial security and self-interest.[20] The visual coding of social life that underpinned caricature became unstable, as Parisians hid signifiers of economic status and political affiliation or deployed false ones. (Public displays of wealth disappeared; people with little revolutionary sympathy strategically wore red.)[21]

The violence of caricature had been justified, under Louis Philippe, by the wickedness of its monarchic enemy.[22] Bertall's "Republic of the Arts" accepts a new reality of flattened, comic moral equivalences: of political and critical conviction as laughable. It trains readers not to find themselves on the "right" side of aesthetic or political lines. The new genre of Salon caricature, as Bertall presents it, is not the "cruel" image-text alloy that *L'Illustration* had feared six years earlier.

The vision of caricature on display in Bertall's "Comic Review" is in many ways an honest and pragmatic one. As a technique, caricature's reliance on typology and physical distortion has made it particularly effective for racist,

sexist, anti-Semitic, and other derogatory or deliberately propagandist aims.[23] To thematize caricature's own equivocation undermined the arguments of those who defended it on the grounds of its moral justification, what Philipon had called in 1831 its "useful and popular purpose."[24]

But Bertall does not forecast a withering-away of caricature in the absence of aesthetic/political certainties. It will not offer critical judgments; it will offer new relations between art and viewer. In his written preamble to his "Comic Review" Bertall likens his Salon caricature to a kind of universal suffrage (electoral expansion had been one of the key gains of the Republic), a delegation of the burden of judgment. Salon caricature will bypass the critic, bringing the canvases to meet the adjudicating gaze of the public: "Let us content ourselves with showing the canvases with exactitude that our draftsman has copied at the salon [*sic*], and offer them to the public to judge by itself."[25]

Dual Authors

There is one canvas that fulfills this new critical promise more than the others in Bertall's "Comic Review": his caricature after Delacroix's *Syrian Arab with His Horse* is the only caricature without a caption. Above, I described the caricature as a transformation of the chromatic unity of (Delacroix's) painting into tangled circuits of (caricatural) line. But looking closely at the original painting (Plate 12), Delacroix conjures the horse's pelt with dry, matte, multidirectional brushstrokes of white against dark underpainting. The splaying of Delacroix's brittle brush scratches fine, swirling lines through the white to the dark ground, creating a densely linear effect. Bertall's multidirectional scrawl, then, exaggerates the scratched, linear splay of Delacroix's brushwork. Instead of projecting qualities onto Delacroix's canvas which were not there (converting painterly Delacroix into an artist of line), Bertall made visible nuanced qualities that *were* there, a linear ground that formed a chromatic impression only with distance.

Bertall possesses multiple relations to the original. On one level, Bertall scrambled the clear coding of Delacroix-Colorist-Radical, staging a caricatural "attack" on the painter's color with line. But, on another level, as an academically trained painter himself, Bertall was interested in making comically visible his knowing detection of Delacroix's own scumbly linearity. In the end, these two aims are compatible. There are layered readings available, one to the habitual journal reader who understands Delacroix as "Chief Colorist," another to the painter, amateur, or Salon-spectator who has closely analyzed Delacroix's range

of techniques. Both readings of Delacroix—as caricature's victim or as its muse—reinforce the absurdity of the line-color duel.

The coexistence of these readings shows how Salon caricature's pictorial criticism allows for artful and layered self-positioning by the caricaturist. As an artist, Bertall "humbly" apologizes for his "hardly academic pencil" in his preamble. And yet his captions, as I've discussed, take on a different voice entirely, those of a self-assured conservative critic. Knowing and ignorant, painter and "inexpert" copyist, slanderer and student of Delacroix, Bertall is a wealthy count posing as an agent of universal suffrage. Bertall's "Comic Review" has a telling subtitle, punning on the verb *s'exposer* as both to exhibit a work of art and to expose one's self: "Varied dissertations on political colors and vague considerations on the danger of exhibiting/exposing one's self [*s'exposer*]."[26] The comic critic could hold multiple positions ("varied dissertations") without ever exposing his convictions. Caricature had played with anonymity and polyvocality since its earliest days, but Bertall's "Republic of the Arts" positions this new genre of Salon caricature as exemplary of the ability to simulate opposition as a comic conceit.

Barricades and Brewers's Sons

When censorship resumed with the establishment of the Second Empire in 1851 and anti-government caricature was out of the question, caricature's reputation suffered. Some critics in the Second Empire and after described a once-powerful art form reduced to snickering at subjects like the bourgeois home, leisure activities, and celebrities. Baudelaire's gendered description of this enervation, first published in 1857, was particularly influential. In it he described Honoré Daumier's political caricature as serious, violent, "full of blood and fury,"[27] while Gavarni, mirroring the coquettish women and fashion plates for which he was famous, flattered and cajoled his readers.[28]

Champfleury, one of the admirers of Philipon's circle in its war with Louis Philippe, wrote in 1865 that "caricature is only meaningful in periods of revolt and insurrection."[29] Using a revolutionary term, he described caricature as "le cri des citoyens"[30]—always on the side of the people. After "les citoyens" had voted for autocracy and Second-Empire caricature could not be openly oppositional, Champfleury, ignoring caricature's incontrovertible proliferation, declared that it "seemed dead."[31]

In 1888, John Grand-Carteret, one of the most sensitive and informed writers on nineteenth-century French caricature, explicitly named exhibition caricature

as a symptom of caricature's feminization in the Second Empire. Censorship, he wrote, turned caricature away from politics and toward "the woman and … Parisian news."[32] Multiplying across new journals it would "note with malice or flagellate" the trivialities of society at large, from "sugar lost in the sugarbowl to the canvases hung on the wall."[33]

In picking petty fights, in flagellating grocers, porters, or indeed the "canvases hung on the wall," was caricature no longer a crusade but a petty attack? Lyrical defenses of character are a cliché in biographical accounts of caricaturists active in the second half of the century: he "had no sentiment of anger or hatred,"[34] he "loved the bourgeois,"[35] was "without rancor"[36] and "without venom."[37]

Félix Ribeyre undertook in his 1884 biography of Cham a particularly revealing moral defense of the caricaturist, who had died five years earlier. He declares that he must rectify Cham's reputation by elucidating once and for all the details of a famous incident that has provoked criticism of the artist. He recounts that one day an arrogant brewer's son arrived in the studio of the painter Paul Delaroche where Cham studied. He challenged Cham to a game of wits and Cham, with faux-indignation, challenged the boy to a "duel pour rire" or a joke duel.

> [C]ombatants, witnesses and friends arrived at Charenton. … The newcomer … approached Cham and said to him, a little worked up, "But after all, are we really going to fight?" And then Cham said, "Certainly … but you seem upset. Let's sit down to lunch and we'll fight after." What was said was done. The quarrel subsided and everyone feasted joyfully. Then they made their way back to Paris. On the way, the newcomer … asked his friends … to report to those who had stayed in Paris that the duel had been serious, that he had really fought Cham, and even that he, the newcomer, had been wounded. They bandaged his arm in a scarf.[38]

Cham's studio-mates all conspired to pretend that a duel had occurred. But a few days later, the brewer's son in his play-bandages died. According to Ribeyre, a judicial inquiry was made, which concluded that the brewer's son had been a drunk and died from intestinal inflammation. Yet the perception persisted among his studio-mates and among a broader public—Ribeyre would have us believe that it haunted Cham's reputation, although I have not seen it mentioned elsewhere—that the caricaturist had killed the boy in the course of the joke.

By the middle of the century, the genre of the *duel pour rire* was a cliché, the absurd duel as a comic trope in vaudeville plays and in caricature itself,[39] exemplified by Bertall's "Republic of the Arts" and its long life in the French imaginary.[40] Dueling lent itself to comic representation for several reasons. First, it combined absurd provocations with fatally high stakes (Eugène Labiche had a

stage success in 1850 with *Embrassons-nous Folleville!*, in which two sixteenth-century bourgeois duel over a duck). Further, it lent itself to representation since dueling was a ritualized engagement, with a set of fixed rules—genre conventions ready-made—including the requirement of witnesses. A real duel was therefore, by necessity, also a spectacle. A duel could only be carried out between peers, so the duel, like a neat, momentary visual equation, valued the variable of each opponent's social status in terms of the other's.

Felix Ribeyre's account of this particular *duel pour rire* in Cham's biography is a fable about the popular miscomprehension of comic form and its creator. Ribeyre suggests that almost as a superstition, despite all evidence, Cham's studio peers—painters in training—and the public alike believe the caricaturist to be a "cruel devil" indeed, culpable for violent acts, even murder, through his jokes. The painter Jean-Léon Gérôme, a friend of Cham's, repeatedly stressed in his foreword to a posthumous anthology of Cham's caricatures the artist's goodness, charity, and lack of ill will, reporting that Cham had the habit of saying "Man is not mean, only funny."[41] Perhaps the dueling incident explains why Gérôme included a report that Cham, famously tall and thin, claimed he was too tall to fence anywhere in Paris.[42] If it seems strange that caricaturists needed to be defended against vague associations with real violence, recall that caricature had been considered an act, a deed: "there is nothing more dangerous," said the French Minister of Commerce in 1835, "than these seditious images [which] produce the most deadly effect."[43]

Bertall's "Comic Review" of 1849 had a *duel pour rire* at its heart, but it also asked its readers to understand Salon caricature as a *duel pour rire:* it invoked high stakes and yet came to absurd conclusions. It posited a momentary parity of status between paint and caricature (it promised to represent painting with "exactitude") and it turned conflict into a ritualized spectacle. Looking at the way art critics in the later nineteenth and twentieth centuries used Salon caricature as evidence of public hostility,[44] we might say that Salon caricature was a *duel pour rire* that has often been misunderstood as duel for real.

Two Beings Present

Baudelaire, as we've seen in his description of caricature's formal enervation under the Empire, was acutely aware of caricature's association with political opposition, moral superiority, and real violence. Baudelaire made dualistic conflict essential to his theory of the comic in art, laid out in "On the Essence

of Laughter and Generally on the Comic in the Plastic Arts" (the title was deliberately grandiose) published in 1855 but undertaken in 1846.[45] In doing so, he gave new life to caricature's oppositional qualities, rescuing it from what he saw as the degradation of political pluralism and commercial pandering. Instead Baudelaire reoriented opposition, describing it as internal and structural, an essential engine of the comic artist's multifarious creations.

Baudelaire's was the first modern study of caricature, not accounting for caricature historically[46] or as method[47] but representationally. He left the visual analysis of caricature for a separate set of essays,[48] instead focusing on the subjectivity of the comic artist himself, and the conditions necessary for an artist to provoke laughter.

Although his theories of laughter and the comic have attracted attention,[49] Baudelaire collaborated on an album of Salon caricature published in 1846, the year he undertook to write about laughter and the comic, and as yet it has escaped scholarly attention that these projects might inform each other. My contention here is that the two projects—Baudelaire's essay on the comic and his album of Salon caricature—illuminate how Salon caricature staged itself as a *duel pour rire* in this period.

Baudelaire's theory of the comic is at the very heart of his writing on modernity and modern art and occupied him throughout his career. He had already announced an essay on the comic in the preface to his 1845 *Salon*— he calls it "a kind of obsession"[50]—and the concepts that he plants in the essay, particularly the importance of duality, will come to full fruition in later works, notably "The Painter of Modern Life" ("Le Peintre de la vie moderne," 1863).[51] The comic, which finds modern beauty in ugliness, is, for Baudelaire, a model for modern art in general; the caricaturist likewise a model for the modern artist. Baudelaire's "painter of modern life," Constantin Guys, was not a painter but a graphic artist and a press illustrator. Baudelaire evidently consumed and appreciated the ephemera of the Parisian press, opening his "Salon de 1846" with a reference to a Gavarni caricature from *Le Charivari*.[52] That essay, famous for its repetitive deadpan apostrophizing of the bourgeois, curiously resembles *Charivari's* Salon coverage from the previous year by Cham and Louis Huart.[53]

The *Caricatural Salon* of 1846: Toward and Against

Baudelaire collaborated on an 1846 album of Salon caricature with Raymond Pelez, the artist who had produced the first experiments in comic reproduction

following Daumier in *Le Charivari* in 1842–1843 (the subject of the prior chapter). It is thought that Baudelaire contributed the prologue, epilogue, and captions, in collaboration with the poets Theodore de Banville (1823–1891) and Vitu (Auguste-Charles-Joseph Vitu, 1823–1891), while Pelez created the sixty wood engravings of *Le Salon caricatural, critique en vers en contre tous* (The caricatural Salon, criticism in verse and against all).[54] The title puns on *en vers*, meaning "in verse," but is also a homonym of *envers*, "toward." So the album is *In verse/ toward and against all.* Although the *Salon caricatural* announced that it would reappear the next year, it was never repeated.[55] While the album stands out in the history of the genre for its captions in verse throughout and for the quality of its wood engravings, my analysis, which focuses on the album's misalignment of the critical and comic, may help explain why its authors abandoned the project.

The album, particularly the prologue and epilogue by Baudelaire, nevertheless puts into practice Baudelaire's ideas from "On the Essence of Laughter" about how the comic artist contains both attacker and victim, subject and object of laughter, at the same time. Baudelaire provides a poetic sketch of the comic/ caricatural critic of painting as existing in infinite relativity, never fixed as *envers* or *contre.*

For Baudelaire's philosophical precedents on laughter, including Bossuet and Joseph de Maistre, comedy was a moral problem. Laughter was condemnable as weak, mad, and diabolic, a consequence of the Fall. Like these precedents, Baudelaire put the Fall of Man at the heart of his theory, sapping it of its condemnability but retaining the central idea that laughter must emerge from a relation between two beings. Man's irresolvable relation to an ideal in God and fallenness in himself is relocated to the everyday theater of urban life, and reincarnated as two strangers in the street, where fallenness is comically literal:

> To take one of the most common examples in the world, what is so delightful in the sight of a man who falls on the ice or the pavement, or who trips at the edge of a sidewalk, that the countenance of his brother in Christ should contract in such an unruly manner, and the muscles of his face suddenly begin playing like a clock at midday or a jack-in-the box?[56]

The upright man laughs at the fallen man, but his laughter becomes ridiculous—his own face contorts and explodes, providing for the reader a comic scene that may enchain a similar reaction (I might see the laugher, and laugh). Importantly, the man who trips is himself the comic event, but the comic *effect* resides in the laugher, not the laughed-at. This is of crucial import to any art whose aim is to make laugh: the comic must inhere not in the object alone

but in a relation between an object and a subject. Therefore, it requires "two beings present," including the "spectator" in whom "the comic lies."[57]

In nature, the being that provokes the comic reaction must not be self-aware. In art, however, the comic effect must be induced: "[I]n relation to this law of ignorance, one must make an exception for men who have made a craft of developing in themselves the feeling of the comic and of extracting it from themselves for the amusement of their kind."[58] The comic artist cultivates what Baudelaire will go on to describe as doubleness or *dédoublement* and wields it with an extreme self-awareness that appears as self-ignorance, a precursor to the *naïveté* of the painter of modern life. He can contain the relational pair—the "two beings present"—within himself, "a permanent duality, the power to be at the same time self and another,"[59] inferior and superior, fallen and standing, victim of laughter and laughing subject.

Returning to the 1846 album, the *Salon caricatural*'s punning title ("toward and against") prefigured a conflicted relation to its subject, immediately addressed by a poetic prologue, attributed to Baudelaire.[60] A *Prologre* (Prologue-ogre) with sharp white teeth glistening under a wiry black moustache (Figure 2.2) holds bundles of dangling artists like braces of birds in each hand. "To see my saw-like teeth and my large jaws," says the ogre, "[y]ou would say that I must, in my cruel duties, / Slake myself with their blood, new Polyphemus, / and quell my hunger with the juice of their brain."[61] In addition to his sinister spoils, the ogre wields a dagger-like quill and pen in each hand, ready to weaponize them as Bertall would three years later in the hands of Ingres and Delacroix.

The transformation of the tools of the caricaturist into weapons was a recurring theme in the illustrated press, outside Salon caricature. But the Prologre admits right away that "[m]y weapons are all peaceful weapons, / Quills, pens, a palette; also / I am, sirs, one of those whom thankless fate / Forces to provoke an eternal madness, / And make others share their crazy laugh."[62]

The threat of violence evaporates. The ogre/caricaturist's torment of painters is a comic compulsion intended, in turn, to provoke laughter in others. (Those others, in turn, losing their composure, might become comic objects for another laughing subject, and so on.) The ogre recognizes that this enchainment of laughter has a market value, and the "the torment of caricature" may in fact make the painter richer. He admits that his attack is a spectacle for others, like a *duel pour rire* where he plays both parties. Like the man who laughs at the falling man in the street, the ogre cruelly participates in the fall of the artist (his "brother in Christ"); yet ultimately, it is he whom fate "forces to provoke" laughter in others.

LE PROLOGUE.

C'est moi, messieurs, qui suis le terrible Prologue¹,
Cicérone effroyable, et taillé comme un ogre ;
Je porte à chaque main, grimaçants et tordus,
Des trousseaux gémissants de peintres suspendus.
A voir mes dents en scie et mes mâchoires larges,
Vous diriez que je dois, dans mes cruelles charges,
M'abreuver de leur sang, Polyphème nouveau,

Figure 2.2 *Le Salon caricatural. Critique en vers et contre tous, illustrée de soixante caricatures dessinées sur bois,* 1846, page 1. Wood engraving. Getty Research Institute

Baudelaire's poetic ogre puts into practice—one might say puts into motion, given the concatenation of cause and effect that the comic artist initiates—the idea of *dédoublement* or doubleness in which no link in the chain is ever purely superior or purely inferior. No one is only the victim and no one is only the tormentor (laugher). In calling himself a "new Polyphemus," the ogre identifies his caricaturing of paint as a form of cannibalism, but at the same time forecasts his victimhood as the lumbering foe who'll be outwitted by painters.

But if the prologre articulates how *dédoublement* works, the pages of Salon caricature that follow are harder to understand in relation to "On the Essence of Laughter." The album's drawings target paintings that are often difficult or impossible to identify. They frequently lack adequate references to the real canvases exposed

concurrently at the Salon, either the name of the artist, the name of the canvas, or the number of the canvas. The poetic captions rarely include the name of the painter, and even when they do, it is not clear which canvas is targeted. Although the album was physically small and cost only 1franc—more than thrice the price of Bertall's 1843 wood-engraved album, but standard for many illustrated albums—it would have been nearly impossible to use at the Salon as a comic *livret*. Even for readers who did not attend the Salon but had access to reproductions elsewhere, pairing the caricature with its target would have been a frustrating exercise. Obscurity of the caricatural reference is not just the result of historical distance. There is a caricature after Horace Vernet's *Prise de Smala* (Battle of Smala), for which the viewer would search in vain—it hung at the Salon the previous year.

Among the most reliable and consistent traits of Salon caricature—perhaps the single most visually distinctive feature of Salon caricature, setting it apart from caricature of social life, literature, or theater—is the separation of each caricatured canvas by frame, already crucial to Daumier's 1840 "Ascension" and visible in Bertall's *Salon de 1843* (Figure 1.4).[63] As we'll shortly see, Cham had already begun developing his version of Salon caricature as one in which frames distinguished canvases on the page. In contrast, in Baudelaire's *Salon caricatural* the absence of titles and frames around each canvas leaves the reader in confusion as to whether the vignette is a canvas or a physiognomic caricature of people at the Salon.

This is no small distinction. As I elaborated in the prior chapter, these two modes of caricature, the caricature of people in the world, versus the caricature of images, demand fundamental shifts in the reader's relation to the image. See, for example, page 6 of the album (Figure 2.3), in which the "Le public des jours réservés" ("The Public of the Reserved Days") and the "illustre épée" ("Illustrious Swordsman") both appear as physiognomic portrait subjects in the space of the Salon/album, while in fact one is a portrait and the other a caricatured painting. The corpulent woman at the center of the "Public of the Reserved Days" vignette is comic because the greed of her class is read into her body ("In Paris these people live fat and pampered; For their ugliness in Sparta they would all be drowned"[64]). In the case of the portrait subject beneath her ("AN ILLUSTRIOUS SWORDSMAN"), the caption plays on color as symbolic/real (He "defended the French colors / We won't defend his …").[65] But as to the caricature, it is unclear whether the long nose, pitted face, and absurd collar refer to the swordsman himself or the manner of his depiction. Was the caption a self-contained joke that exploited the jargon of painting in general, or did it point to something in the canvas, an unnamed portrait among the 2,400 works?

Figure 2.3 *Le Salon caricatural. Critique en vers et contre tous, illustrée de soixante caricatures dessinées sur bois,* 1846, page 6. Wood engraving. Getty Research Institute

While it is impossible to recapture or reconstruct entirely the comedy of a historical text, the *Salon caricatural* is comparatively far more coded and abstruse, and far more cruel or ad hominem, than Bertall's or Cham's parallel experiments. Comedy comes from this cruelty, as the sophisticated hilarity of the poetic captions and the lyricism of rhyme give elegant structure to accusations of ugliness, in spectators and canvases alike.

In contrast, Salon caricature as it was concurrently evolving in the hands of Cham and Bertall used captions to help identify canvases or aspects of their narratives, activate puns, or parody critical language. (For example, recall, in contrast, how Bertall's captions in 1849 read as snippets of exaggerated academic analysis, or even praise.) Instead of working against each other, in Baudelaire's

Salon caricatural, image illustrates text. The wood engravings are directed by the poetry of the captions and not by the comic opportunities of the canvas.

As both illustrator and engraver,[66] Pelez maintains a unified and unifying stylistic elegance. In the last chapter, I argued that Salon caricature, beginning with Bertall, developed a pretense that the caricature *was* the painting, viewed vicariously via the caricature—caricatural style shifts visibly from one canvas to another, adapting to each painting. Pelez is uninterested in that pretense here. His artful wood engravings emphasize the work of interpretation and parallel the poetics of the captioning with their own calligraphic elegance.

Finally, a major difference between this album and the genre of Salon caricature we see coalescing in the hands of Cham and Bertall is the absence in Baudelaire's album of a guide or persona through whom the reader sees the Salon. The ogre of the Prologue returns for an Epilogue ("I kept my oath; I've eaten no one")[67] but has existed as an allegorical framing device whose voice disappeared in the body of the album. The authors realized this weakness in the 1846 album, as the advertisement for the never-published 1847 follow-up *Salon caricatural* emphasized a new guide: *Text in Prose and Against All by Horace Crouton upon His Return from Rome.*[68] The authors planned to abandon poetry in favor of prose and made this a selling point.

The *Salon caricatural* is best understood as an attempt to reconcile the thinking behind two conflicting texts. At the same time that Baudelaire was drafting his "On the Essence of Laughter," he published his "Salon of 1846," in which he suggested responding to the Salon in verse. Baudelaire's famous critical credo in 1846 argued that "to be fair, which is to say to have a reason to exist, criticism must be partial, passionate, political, that is to say formed from an exclusive point of view, but from the point of view that opens the most horizons."[69] His engagement with Salon caricature in the *Salon caricatural* shows the difficulty of assimilating Baudelaire's theories of criticism and his theories of comic art. The former had to be personal and unitary, while the latter had to be relational and divided. The former had to be passionate and partisan, while the latter's very art consisted in a feigned self-ignorance. The critic must speak from an "exclusive point of view," and yet as Bertall's 1849 "Comic Review" would demonstrate, Salon caricature was best at mocking partiality, not expressing it. Ventriloquizing multiple, conflicting points of view was among Salon caricature's fundamental techniques. Baudelaire described critical partiality with the metaphor of a fixed point in space that opened onto a wide horizon; Salon caricature roved through an imagined, uprooted Salon, its instances of viewing induced one after another on the flat continuum of the page.

In order to produce comic images, Baudelaire imagined that the artist would have to contain within himself both parts of the relational pair, the superior being and the inferior one, the laugher and the object of laughter. Despite the self-description of the Prologre, who positions himself as split victim-and-tormenter, the *Salon caricatural* demonstrates what Salon caricature might look like if the comic critic tried to maintain superiority, refusing to be laughed at while laughing at his victim. Put another way, it is how Bertall's 1849 "Comic Review" might have looked if his caricatures had tried to act out the critical conviction of his captions, instead of cutting against them.

Baudelaire's "On the Essence of Laughter" was not published until 1855, by which time Salon caricature was a well-established genre, so I am not suggesting that Bertall or others knowingly adopted Baudelaire's notions of doubling. Rather, Bertall intuited the necessity for the split subjectivity of the comic critic, the ever-relational comic persona, at the same time that Baudelaire was theorizing the importance of this split. Bertall (and not Comte Charles d'Arnoux), Cham (and not Amédée de Noé), and other pseudonymous comic artists would approach the subject of fine art with insider knowledge and skill, yet they would at the same time concoct a false ignorance. Their readings would be presented as misreadings, so that they could maintain this relative position to painting, repicturing it in an "attack" that was void of ill will, a staging of a duel *pour rire*.

Anonymous and pseudonymous criticism had been a major problem in the *ancien régime* and had been battled and suppressed by the academy for permitting vicious attacks without accountability.[70] But pseudonymity for Salon caricature was not about permission to attack, nor did it serve to deny an author. Rather, it created an author/illustrator—more accurately a guide or persona—with the freedom to be contradictory. Hiding the specificities of class, political, and other identity factors maintained an antagonism that was infinitely relational.

Cham and Louis Huart in *Le Charivari*, 1845–1847

In 1845 Cham took up Salon caricature with blustery dueling and comic doubling. Cham, who became the defining caricaturist of the Salon, entered the genre with three consecutive years of Salon caricature in *Le Charivari* (1845–1847),[71] co-authored with Louis Huart. In this three-year suite, Cham takes the

role of illustrator to the narrative penned by Louis Huart (1813–1865), who had written for *Le Charivari* since 1835, contributed captions to many of Daumier's caricatures, and went on to write regularly for other satiric illustrated journals. What passes into the expected conventions of the genre by the Second Empire is, in these years, explored openly.

Above other regularly controversial or remarked-upon painters, like Horace Vernet, Ernest Meissonier, and Thomas Couture, Delacroix was the most prominently caricatured painter across the three years. In 1847, Cham and Huart's attention to Delacroix culminates in a caricature of Delacroix's *Le Christ en croix* (Christ on the Cross) (Plates 13 and 14), shown at the Salon of 1847. The text around the caricature reads, "We have not yet spoken of Delacroix; but a crucifixion is the occasion of our duty."[72] The textual joke turns on the subject matter of the painting ("our duty" is recalled by a crucifixion), while Cham sketches a graphic version of Delacroix's composition as a whole. Cham studies Delacroix's canvas. He sees that the agitated sky behind the cross carries much of the expressive burden of the painting. The visible whorls of Delacroix's brushstrokes attribute a corporeality to the atmosphere that rivals that of the Christ.[73]

The text around Cham's version of the painting continues, "The sketch below, in which one finds all the qualities of Delacroix combined with those of Cham, represents faithfully the religious painting inspired by the death of Christ."[74] Crucifixion becomes collaboration; Cham's intent to nail Delacroix to the cross becomes instead an act of representational faith. The "combination" of Cham's and Delacroix's qualities produces a densely hashed composition, where visible cuts stand in for visible brushstrokes. In Cham's version, the dynamic curvilinear whorls of Delacroix's atmosphere (emphasized, in the canvas, by their juxtaposition with the rectilinear cross) take the form of a rash matrix of vertical and horizontal slashes, in comparison to which the Christ figure's depiction is comically scant and vacant.

If the caricature itself reads as a brutal belittlement of the canvas, Christ turned into a messy cutout, Huart had already the previous year asked readers of this new genre to understand him/Cham as critics/duelists *pour rire*:

> [I]f the style and the drawing of Eugene Delacroix lend themselves admirably to caricature, it's that from the sublime to the ridiculous is only a step, and our profession of *critique pour rire* is to further narrow the gap. But one must not for this reason regard us as enemies of the head of the romantic school. By the devil! Romanticism has its partisans who don't joke around, and duels have a crazy cost.[75]

Huart distances his and Cham's comic criticism from what the Minister of Commerce had called the "deadly effect" of caricatural damage. Crucially, Huart describes their relation to Delacroix not as attack, but as response to a demand made by Delacroix, who comes to meet them on the terrain of caricature. The painter "lends himself" to Cham and Huart particularly well because of his "style and drawing." Cham, caricaturing not only Delacroix but the intermediary art of burin engraving (more on this in Chapter 4), positions himself as a partner to Delacroix, on the model of the famous painter-engraver partnerships like Rubens-Bolswaert or Ingres-Calamatta.

With Cham's crucifixion of/collaboration with Delacroix, we can take the measure of Salon caricature's distance from the first experiment with comic Salon reproduction in 1840, Daumier's 1840 "Ascension of Jesus Christ" (Figure 1.1) (discussed in depth in Chapter 1). Cham's version of Delacroix's *Christ on the Cross* and Daumier's "Ascension" both represent the crucifixion. Their jokes about vacant Christs are related: Daumier's gray screen depicts only background atmosphere and denies the physiognomic subject, just as Cham hashes a dynamic sky and a vacant Christ.

But Daumier's caricature did not, in fact, have a specific target—it made comic a general idea of religious painting. Lithography served in that caricature to approximate the style of a believable Salon reproduction in a high-quality illustrated journal. Meanwhile, in Cham's *Christ on the Cross,* Delacroix attracts Cham for what we have come to call "medium specificity." Cham evinces a new interest in medium, in constructing the comedy of the caricature as a textual and visual joke about wood engraving as burin engraving as painting. Cham's is a caricature that requires a specific painting to remake, specific formal qualities (distinctly visible strokes of the brush) to repicture. We might call this wood engraving's comic ability to be self and other—its own graphic medium unified with its object's, or as Huart wrote, "all the qualities of Delacroix combined with those of Cham."

In conclusion, Salon caricature often declared an oppositional or threatening stance to painting—it weaponized its tools, threatened to "gobble its brains" and to bring to bear a cruel new critical alloy of image and judgment. But as we've seen in these important foundational years, early Salon caricature established attack as a formal engagement of painting, a ritualized *duel pour rire* necessitated in part by the shifting reputation of caricature for violence, powerful and political or merely petty.

The next chapter further develops the question of what Salon caricature sought in its targets, and why it targeted certain painters over others. However,

the next chapter inserts Salon caricature's method into a fuller history of caricature's relationship to pictorial judgment. Going back as far as caricature's origins in the sixteenth century, we will consider caricature as comic vision through the method of physiognomy. The next chapter builds on the notion of Salon caricature's doubleness, as the science of physiognomy also based its revelatory powers on an ability to bind two contradictory qualities: distortion and truth.

Notes

1 Beatrice Farwell notes that Philipon's journals were an outlier to a mainstream market of single-sheet social caricature. Farwell, *The Charged Image: French Lithographic Caricature 1816–1848* (Santa Barbara: Santa Barbara Museum of Art, 1989), 11. Patricia Mainardi stresses the early nineteenth century's broad range of lithographic subject material in *Another World: Nineteenth-Century Illustrated Print Culture* (New Haven and London: Yale University Press, 2017), 13–71. Jillian Lerner redresses a "false isolation" implied by the attention given to July Monarchy political caricature by restoring a view of a broader cultural and commercial field of images. Lerner, *Graphic Culture: Illustration and Artistic Enterprise in Paris, 1830–1848* (Montreal: McGill-Queen's University Press, 2018), 10. See also Paul Allard, "Satire des moeurs et critique sociale dans la caricature française de 1835–1848," in *La Caricature entre république et censure: L'Imagerie satirique en France de 1830 à 1880: Un discours de résistance?* ed. R. Rütten, R. Jung, and G. Schneider (Lyon: Presses Universitaires Lyon, 1998), 171–81.

2 Robert Justin Goldstein suggests that in comparison with other European countries, periods of relative press freedom before 1848 permitted French caricature to develop; therefore caricature was "more politically threatening and controversial than elsewhere in Europe," and more frequently debated as such. Goldstein, "Nineteenth-Century French Political Censorship of Caricature in Comparative European Perspective," *Law and Humanities* 3, no. 1 (2009): 25–44, 42.

3 *Le Salon de 1843 (ne pas confondre avec celui de l'artiste-éditeur Challamel, éditeur-artiste). Appendice au livret, représenté par 37 copies par Bertal* [sic]. (Paris: Ildefonse Rousset, 1843). The album is discussed at length in the previous chapter.

4 The struggle between partisans of line and color developed around conceptions of Platonism in the end of the fifteenth century and again animated aesthetic debate in the seventeenth century. See Bernard Teyssèdre, *Roger de Piles et les débats sur le coloris au siècle de Louis XIV* (Paris: La Bibliothèque des Arts, 1957) and Jacqueline Lichtenstein, *The Eloquence of Color: Rhetoric and Painting in the French Classical Age*, trans. Emily McVarish (Berkeley: University of California Press, 1993).

Andrew Carrington Shelton discusses the Ingres/Delacroix dichotomy (and Bertall's "République des Arts") as more a function of caricature than a vital critical conflict in the 1840s. For Shelton, as in my own analysis, "the *form* of contemporary political and artistic discourse ... is being mocked here as much as—if not more than—its content." Andrew Carrington Shelton, "Ingres Versus Delacroix," *Art History* 23, no. 5 (December 2000): 726–42, 737.

5 See, for example, Yale Library catalogue, listing a "Caricature of Ingres and Delacroix," Visual Resources Collection, Portfolio Item ID 167581, catalogue link http://hdl.handle.net/10079/digcoll/1885589. Academic monographs and articles have similarly circulated the excised caricature, and it can be purchased on posters and refrigerator magnets.

6 The 1849 "Revue Comique" was a continuation of Bertall's experiments with Salon caricature as explored in 1843 (see Chapter 1) and again in 1847. See Bertall, *Les Guêpes* (Paris: Hetzel, 1847), a ninety-six page album containing forty-two caricatured works.

7 Canvases caricatured, from top left across the bottom to top right: No. 646, Louis Duveau, *La Peste d'Elliant*, now at the Musée des beaux arts de Quimper. No. 178, Biennoury, *Le Mauvais Riche,* now at the Musée d'art et d'archéologie, Troyes. Canvases no. 1931–1935, de Tournemine, a series of Breton landscapes. No. 1246, Jules Laure, *Milton aveugle dictant le Paradis perdu à ses filles,* now at the Musée d'art et d'histoire, Lisieux. Unidentified canvas, probably no. 1030, M. Herment, *Vache égarée surprise par des loups*. No. 490, Hippolyte Debon, *Les Joueurs de lansquenet*. No. 817, Nicolas-Auguste Galimard, *Junon jalouse,* now at Musée des beaux-arts, Narbonne. No. 1995, Marcel Verdier, *Portrait de M Ferdinand Flocon*. No. 1780, Théodore Rousseau, *Terrains d'automne*. No. 507, Eugène Delacroix, *Othello et Desdemona*. No. 508, Delacroix, *Arabe-Syrien avec son cheval*. No. 801, Félix-Nicolas Frillié, *Bergers chaldéens observant les astres et la planète de M Leverrier*.

8 *L'Illustration,* April 23, 1843. *L'Illustration* published between 12,000 and 20,000 copies per issue, in comparison to *Le Charivari,* whose print runs were around 3,000. On *L'Illustration,* see Thierry Gervais, "L'Illustration photographique. Naissance du spectacle de l'information, 1843–1914," PhD thesis, EHESS, 2007 and Jean-Noël Marchandiau, *L'Illustration 1843–1944. Vie et mort d'un journal* (Toulouse: Éditions Privat, 1987). On *L'Illustration'*s genre of wood-engraved weekly magazine, see Patricia Mainardi, *Another World*, 73–116.

9 "... cruel jeune homme," "un jeune artiste qui doit ... inspirer des craintes sérieuses à ses concitoyens; ... ce redoutable critique n'écrit pas, il dessine; mais ses victimes n'en sont que plus à plaindre ... " *L'Illustration,* May 13, 1843, 173.

10 Goldstein, "Nineteenth-Century French Political Censorship of Caricature in Comparative European Perspective," 33.

11 Cited in Robert Justin Goldstein, *Censorship of Political Caricature in Nineteenth-Century France* (Kent, OH : Kent State University Press, 1989), 6.

12 "M. Galimard a compris avec beaucoup d'intelligence que la ligne droite est préférable à la ligne tire-bouchonnée pour les sujets grecs."

13 "Ce tableau est sublime."

14 "Le moment choisi est celui où le farouche Othello se présente exaspéré par une atroce jalousie, pendant que sa dame dort avec vertu et tranquillité."

15 For a detailed account of Salon administration in this period see James Kearns, "Pas de Salon sans Louvre? L'exposition quitte le musée en 1848," in *"Ce Salon à quoi tout se ramène": Le Salon de peinture et de sculpture, 1791–1890*, ed. James Kearns and Pierre Vaisse (Bern: Peter Lang, 2010), 45–71. On Second Republic art and journalism, see James Kearns, *Théophile Gautier, Orator to the Artists: Art Journalism in the Second Republic* (London: Legenda, 2007).

16 "Il n'y a plus d'écoles, car qui dit école dit esprit d'exclusion systématique, et notre esthétique tolérante admet, au contraire, les expressions les plus diverses de la pensée." F. de Lagenevais (Frédéric de Mercey), "Le Salon de 1849," *Revue des deux mondes*, Tome 3 (1849), 559–93, 559. On de Mercey, a powerful figure in the beaux-arts administration of the Second Republic, see Kearns, *Theophile Gautier*, 38–9, 91–2, n. 36.

17 The phrase "République des Arts" had circulated in the aftermath of the 1848 revolution as part of an idealistic arts program; by summer 1849 that program's signature projects had become public and critical failures, charging "République des Arts" already with irony or risibility. Marie-Claude Chaudonneret and Neil McWilliam, "1848: 'La République des Arts,'" *Oxford Art Journal* 10, no. 1 (1987): 59–70.

18 Laura O'Brien, *The Republican Line: Caricature and French Republican Identity, 1830–1852* (Manchester: Manchester University Press, 2015), 57–91.

19 O'Brien, *The Republican Line*, 74. *Le Journal pour rire* was founded in December 1847 as an explicitly apolitical organ. Nevertheless, from the period of Louis-Napoleon's election to the presidency in December 1848 to the 1851 coup, Philipon's caricaturists, including Bertall, produced sophisticated anti-Napoleonic caricature in the *Journal pour rire*. Michela Lo Feudo, "De président à empereur: Louis-Napoléon Bonaparte dans *Le Journal pour rire*," *Sociétés & Représentations* 36, no. 2 (2013): 35–50.

20 Karl Marx, *The Eighteenth Brumaire of Louis Bonaparte*, reprinted in *Marx's "Eighteenth Brumaire": (Post)modern Interpretations* (London: Pluto Press, 2002), 19–112.

21 William Fortescue, *France and 1848: The End of Monarchy* (London and New York: Routledge, 2005), 81. T.J. Clark describes the second Republic's struggle to find stable or adequate symbolic representation in *The Absolute Bourgeois: Artists and Politics in France, 1848–1851* (London: Thames and Hudson, 1973).

22 Goldstein, *Censorship of Political Caricature in Nineteenth-Century France*, 34.

23 See, e.g., Sharrona Pearl, "Caricature Physiognomy: Imaging Communities," *About Faces: Physiognomy in Nineteenth-Century Britain* (Cambridge, MA: Harvard University Press, 2010), 107–47 and Elizabeth Childs, *Daumier and Exoticism: Satirizing the*

French and the Foreign (New York: Peter Lang, 2004). Darcy Grimaldo Grigsby has noted that following the final abolition of slavery in the French colonies in 1848, "skin color surfaces again and again as *the* issue in caricature." Grigsby, "Cursed Mimicry: France and Haiti, Again (1848–1851)," *Art History* 38, no. 1 (2015): 68–105, 75.

24 Goldstein, *Censorship of Political Caricature in Nineteenth-Century France*, 34.

25 "Contentons-nous d'exposer avec exactitude les tableaux que notre dessinateur a copiés au salon, et offrons les au public qui jugera par lui-même."

26 "Dissertations variées sur les couleurs politiques et considérations vagues sur le danger de s'exposer."

27 "En effet, ces dessins sont souvent pleins de sang et de fureur." Baudelaire, "Quelques caricaturistes français," *Œuvres complètes*, t. II (1976): 544–63, 550.

28 Jillian Lerner has addressed the gendered criticism of commercial imagery in *Graphic Culture*, 11–12. Patricia Mainardi argues that such gendered readings have shaped the historiography of nineteenth-century print culture. As political caricature was "coded male" and social caricature "coded female," the former became a major genre and received the lion's share of early scholarship. Mainardi, *Another World*, 37.

29 "La caricature n'est significative qu'aux époques de révolte et de disruption," Champfleury, *Histoire de la caricature moderne* (Paris: Dentu, 1865), viii.

30 Champfleury, *Histoire de la caricature moderne*, vii.

31 "J'écris ces lignes à l'heure où la caricature, à peu près disparue en France, semble morte." Champfleury, *Histoire de la caricature moderne*, viii.

32 " … vers la femme et vers l'actualité parisienne." John Grand-Carteret, *Les mœurs et la caricature en France* (Paris: A la Librairie Illustrée, 1888), 336.

33 "C'est dans cette société dans laquelle tout a été compté et rangé symmétriquement depuis les morceaux de sucre perdu dans le sucrier jusqu'aux tableaux accrochés au mur, que les observateurs … vont noter avec malice ou flageller comme elle le mérite." John Grand-Carteret, *Les moeurs et la caricature en France*, 220.

34 Ludovic Halévy, "Cham," preface to *Cham, Douze années comiques* (Paris: C. Lévy, 1882), 6.

35 Baudelaire, "Quelques caricaturistes français," in *Œuvres complètes*, t. II (Paris: Gallimard, 1976), 544–63, 549.

36 Ibid., 549.

37 Jean-Léon Gérôme, "Cham," in *Les folies parisiennes: quinze années comiques 1864–1879* (Paris: C. Lévy, 1883), 7–16.

38 "[C]ombattants, témoins et camarades arrivent à Charenton ….Le nouveau venu … s'approche de Cham et lui dit un peu troublé:— Mais enfin, est-ce que nous allons décidément nous battre?— Certainement … mais vous me paraissez ému ….Allons nous mettre à table, nous nous battrons ensuite. Ce qui fut dit fut fait …. Enfin la querelle s'apaisa, et l'on festoya joyeusement. Puis on reprit la route de Paris. En chemin, le nouveau … demanda aux camarades … de laisser croire

aux autres élèves restés à Paris que le duel avait été sérieux, qu'il s'était réellement battu avec Cham, et même que lui, le nouveau, avait été blessé …. [O]n lui mit le bras en écharpe." Félix Ribeyre, *Cham : Sa vie et son œuvre* (Paris : Librairie Plon, 1884), 68–9.

39 On the *duel pour rire*, see Jean-Noël Jeanneney, *Le Duel. Une passion française, 1789–1914* (Paris: Seuil, 2004), 56.

40 See "Une petite guerre," Charles Vernier and Édouard Morin, *Journal pour rire*, November 25, 1850, in which Charles Philipon, armored in issues of the journal and using *porte-crayon* as épée, duels with the silhouette of Louis-Napoléon. Bertall reprised the motif of the Ingres-Delacroix duel in a caricature in *Le Journal amusant*, January 12, 1856, in "Les Dessus de Panier, dessiné par Bertall après l'Exposition de 1855," page 2. Ingres and Delacroix face off in a denuded landscape, while in the background Napoleon III rides off on a donkey.

41 "'L'homme n'est pas méchant, avait-il coutume d'affirmer dans sa philosophie souriante; il n'est que drôle … '" Gérôme, "Cham," 9.

42 Gérôme, "Cham," 8.

43 Cited in Robert Justin Goldstein, *Censorship of Political Caricature in Nineteenth-Century France*, 9.

44 See Chapter 7.

45 Charles Baudelaire, "De l'essence du rire …," 525–43.

46 Jacques-Marie Boyer-Brun, *Histoire des caricatures de la révolte des Français* (Paris: Imprimerie du Journal du Peuple, 1792) and Auguste Jaime, *Musée de la caricature* (Paris: Delloye, 1838).

47 Francis Grose, *Rules for Drawing Caricatures with an Essay on Comic Painting* (London: Samuel Hooper, 1789), published in Paris as *Principes de caricature, suivis d'un Essai sur la peinture comique* (Paris: Antoine-Augustin-Renouard, 1802).

48 Baudelaire, "Quelques caricaturistes français," *Œuvres complètes*, t.2, 544–63 and "Quelques caricaturistes étrangers," *Œuvres complètes*, t.2, 564–74, both originally published in 1855.

49 Michèle Hannoosh, *Baudelaire and Caricature: From the Comic to an Art of Modernity* (University Park, PA: Penn State Press, 1992). On the relation between Baudelaire's theories of the comic and his poetry, see Ainslie Armstrong McLees, *Baudelaire's Argot Plastique* (Athens, GA: University of Georgia Press, 1989).

50 " … une espèce d'obsession," Baudelaire, "De l'essence du rire," 525.

51 See Françoise Melzer, *Seeing Double: Baudelaire's Modernity* (Chicago: University of Chicago Press, 2011). Baudelaire's *dédoublement* has attracted literary theorists for its formulation of ironic and self-aware reception. See Paul de Man, *Blindness and Insight: Essays in the Rhetoric of Contemporary Criticism*, 2nd ed. (London: Routledge,

2005); and Sonya Stephens, "The Prose Poem and the Dualities of Comic Art," *Baudelaire's Prose Poems* (Oxford: Oxford University Press, 2000), 108–59.

52 "Salon de 1846," *Œuvres complètes*, t.2, 415–96, 418. On Baudelaire's consumption of print material, see Claire Chagniot, *Baudelaire et l'estampe* (Paris: Presses de l'Université Paris-Sorbonne, 2016).

53 Cham and Louis Huart, "Revue véridique, drolatique et charivarique du Salon de 1845, illustré par Cham," Le Charivari, April 19, 1845, 2. Passages of the review take the form of an ironic appeal the bourgeois, prefiguring Baudelaire's "Salon de 1846," with its sarcastic/heroic address to the bourgeois. Excerpt from the "Revue véridique ... ": "Au *bourgeois*, bien plus qu'aux infortunés artistes, nous devons assurément une foule de *poses* plus prodigieuses les unes que les autres. Le *bourgeois* commande, l'artiste obéit. Le vrai *bourgeois*, c'est l'homme qui traite les arts terre à terre,—qui se sert, pour raisonner peinture—sculpture—poésie—musique, etc., du même *raisonnoir* qu'il emploie tous les jours à ses affaires de boutique ou de ménage. Ce n'est pas comme les artistes le pensent, tout homme qui n'admire pas leurs chefs-d'œuvres, mais—c'est triste à dire,—le *bourgeois* se retrouve un peu beaucoup partout." Italics in original.

54 *Le Salon caricatural, critique en vers et contre tous, illustrée de soixante caricatures dessinées sur bois* (Paris: Charpentier, 1846). Reproduced in Baudelaire, *Œuvres complètes*, t.2, 497–524. Origins and attribution of authorship are discussed in Marie-Claude Chadefaux, "Le Salon caricatural de 1846 et les autres Salons caricaturaux," *La Gazette des beaux-arts* (March 1968): 161–76.

55 A poster advertising the "Seconde année" of the Salon caricatural is held at the Musée de la Publicité, inv. 9153. Reprinted in *L'affiche de librairie au XIXe siècle*, ed. Ségolène Le Men and Bargiel Réjane (Paris: Réunion des musées nationaux, 1987), cat. no. 9.

56 "Pour prendre un des exemples les plus vulgaires de la vie, qu'y a-t-il de si réjouissant dans le spectacle d'un homme qui tombe sur la glace ou sur le pavé, qui trébuche au bout d'un trottoir, pour que la face de son frère en Jésus-Christ se contracte d'une façon désordonnée, pour que les muscles de son visage se mettent à jouer subitement comme une horloge à midi ou un joujou à ressorts? Ce pauvre diable s'est au moins défiguré, peut-être s'est-il fracturé un membre essentiel." "De l'essence du rire ... ," 543. The translation is Hannoosh's, *Baudelaire and Caricature*, 29.

57 " ... il faut qu'il y ait deux êtres en présence; – que c'est spécialement dans le rieur, dans le spectateur, que gît le comique." "De l'essence du rire," 543.

58 " ... relativement à cette loi d'ignorance, il faut faire une exception pour les hommes qui ont fait métier de développer en eux le sentiment du comique et de le tirer d'eux-mêmes pour le divertissement de leurs semblables " "De l'essence du rire," 543.

59 " ... qui rentre dans la classe de tous les phénomènes artistiques qui dénotent dans l'être humain l'existence d'une dualité permanente, la puissance d'être à la fois soi et un autre." "De l'essence du rire," 543.

60 Chadefaux, "Le Salon caricatural," 164.

61 "À voir mes dents en scie et mes mâchoires larges, / Vous diriez que je dois, dans mes cruelles charges, / M'abreuver de leur sang, Polyphème nouveau, / Et repaître ma faim du suc de leur cerveau." *Salon caricatural*, 1.

62 "Toutes mes armes sont des armes pacifiques / Des plumes, des pinceaux, une palette; aussi / Je suis, messieurs, de ceux que le sort sans merci / Force de provoquer un éternel délire / Et de faire aux passants partager leur fou rire." *Salon caricatural*, 2.

63 Patricia Mainardi has noted Salon caricature's use of framing as a distinctive aspect of the genre, particularly important as a development in the history of comics. "The Invention of Comics," *Nineteenth Century Art Worldwide* 6, no. 1 (Spring 2007), n.p. www.19thc-artworldwide.org/spring07/145-the-invention-of-comics.

64 "A [*sic*] Paris ces gens-là vivent gras et choyés; / Pour leur laideur à Sparte on les eût tous noyés." *Le Salon caricatural*, 6.

65 "Digne des époques anciennes, / Ce héros criblé de douleurs / A défendu les trois couleurs / Nous ne défendrons les siennes." *Le Salon caricatural*, 6.

66 Pelez likely designed and engraved the illustrations, as no engravers's signatures are to be found except "RP."

67 "J'ai tenu mes serments; je n'ai mangé personne." *Salon caricatural*, 25.

68 *Texte en prose et contre tous par Horace Crouton à son retour de Rome.*

69 "[P]our être juste, c'est-à-dire pour avoir sa raison d' être, la critique doit être partiale, passionnée, politique, c'est-à-dire faite à un point de vue exclusif, mais au point de vue qui ouvre le plus d'horizons." "Salon de 1846," 418.

70 On anonymity in *ancient régime* criticism, see Richard Wrigley, "Censorship and Anonymity in Eighteenth-Century French Art Criticism," *Oxford Art Journal* 6, no. 2 (1983): 17–28.

71 Cham and Louis Huart, "Revue véridique, drolatique et charivarique du Salon de 1845, illustré par Cham," *Le Charivari,* April 19, 1845; "Revue drolatique du Salon de 1846 illustré par Cham," *Le Charivari,* April 17, 1846; "Le Salon illustré par Cham," *Le Charivari,* April 1, 1847; "Le Salon de 1847 illustré par Cham," *Le Charivari,* April 9, 1847. All were special eight-page editions except the 1847 issue was split into two four-page installments.

72 "Nous ne vous avons pas encore parlé de Delacroix; mais nous voici qu'un crucifiement nous rappelle à notre devoir." "Le Salon de 1847 illustré par Cham," *Le Charivari,* April 9, 1847, 4.

73 Cham's joke points to the "depiction of inaction" at the heart of Delacroix's canvases that Margaret MacNamidhe has indentified as a "proprietary trait" of the painter and a recurring problem for critics. MacNamidhe, *Delacroix and His Forgotten World: The Origins of Romantic Painting* (London: I.B. Tauris, 2015), 37.

74 "Le croquis ci-dessous, dans lequel on retrouve toutes les qualités de Delacroix combinées avec celles de Cham, nous représente fidèlement le tableau religieux inspiré par la mort du Christ." "Le Salon de 1847 illustré par Cham," April 9, 1847, 4.

75 "Du reste, si le style et le dessin d'Eugène Delacroix prêtent admirablement à la caricature, c'est que du sublime au ridicule il n'est qu'un pas, et notre métier de critique pour rire est de rapprocher encore la distance. Mais il ne faut pas pour cela nous regarder comme les ennemis du chef de l'école romantique. Diable! le romantisme a des partisans qui ne badinent pas, et les duels sont à un prix fou." Cham and Louis Huart, "Revue drolatique du Salon," *Le Charivari*, April 17, 1846, p. 4.

Salon Caricature and the Physiognomy of Paint

John Grand-Carteret's *Les mœurs et la caricature en France* (1888) is the only nineteenth-century consideration of Salon caricature at length and as a distinct object of study.[1] Grand-Carteret approached Salon caricature in terms of "the considerable place that painting has in caricature from day to day."[2] He considered the deep connection between painting and caricature as a structural given, and this sensitivity led him to a key insight about Salon caricature: it was alone in targeting objects and not people. He compared the caricature of painting to the caricature of theater, another popular genre throughout the nineteenth century. In a caricature of the "dramatic arts, the subject disappears before the man"; but when the subject was painting, "for the caricaturist, the work is everything, the man does not exist."[3] This passage comes at the end of a nearly 600-page tome tracing the relationship between French social and political life and its graphic representation in the press across the century. As Grand-Carteret had just demonstrated to his reader, caricature was a genre of portraiture, an intensely figural art. And yet in Salon caricature, there is no human subject. It is replaced by an object: "The man does not exist."

With this phrase, Grand-Carteret identified an oddity of Salon caricature that this chapter addresses. How can a portrait art, trained to articulate *via the face and figure*, represent an object (a painting)? The first chapter discusses the example of Daumier's "Ascension of Jesus Christ"[4] (Figure 1.1), in which the denial of the body is the very joke of the caricature. It was an apt beginning for Salon caricature, which, as a genre, denies caricature the portrait subject that gave rise to it.

It becomes clear, when held up against the history of caricature as a form and against the practices of caricature that surrounded it, how anomalous and strange Salon caricature is—how appropriate its borders, its tendency

to be sequestered seasonally within journals or materially in stand-alone albums. This difference has to be considered on the side of the producer and consumer. Salon caricaturists like Cham, Bertall, Nadar, and Gill only produced Salon caricature during the exhibition's opening in the spring. They spent most of their energies on projects that either explicitly employed or satirized physiognomy. To take only a small sample one could point to Bertall's illustrations for Balzac's *Comédie humaine* and the panoramic anthology *Les Français peints par eux-mêmes*, Nadar's pantheons of *portrait-charges*, and Cham's signature one-franc albums covering everything from the Assemblée nationale to *Les Zouaves*. How did the caricaturist's habits of looking and composing, gorged on physiognomy's figural distortion, translate when applied to a complex painted composition? If physiognomy used external traits to produce knowledge about internal character, could caricature unlock the meaning of a work of art with the same knowing eye? Did it presume or dramatize the same epistemological depth or availability, the same relationship of coded exterior to veiled interior?

Portrait caricature had also conditioned the reader's expectations about caricature's relation to its subject. How had physiognomy trained readers to approach the spatiotemporal mise-en-scène of the journal page, to conceive of the identity and role of the caricaturist as viewer/depicter, and to read signifiers of class and character borne habitually in crinoline or goiter? Salon caricature, training its focus on a class of object, both invoked and challenged these expectations.

In what follows, I consider this anomalous quality of Salon caricature—it is the only genre of nineteenth-century French caricature dedicated to a category of object—in the context of physiognomy.[5] Physiognomy is defined today as "[t]he study of appearance" or "[t]he study of the features of the face, or of the form of the body generally, as being supposedly indicative of character; the art of judging character from such study."[6] But in France in the first half of the nineteenth century, it was particularly associated with the writings of one man, Swiss philosopher Johann Caspar Lavater (1741–1801). When French caricature became a robust public form with the development of the illustrated press in the early nineteenth century, physiognomy was understood not merely as "the study of appearance" but as a Lavaterian method for judging character and for drawing it. Physiognomy evolved alongside caricature, simultaneously providing a method of reading character and depicting it. Long exposed as pseudoscience, physiognomy nevertheless retained urgency and vitality for artists and writers throughout the nineteenth century, in the realist novel,[7] in

press and album caricature,[8] and in the work of critics like Baudelaire, Théophile Thoré, and Edmond Duranty.[9]

Physiognomy also had an important legacy for artists in the second half of the nineteenth century. As John House describes, Degas, like a "modern Lavater," believed that interiority could be indicated with particularities of face and figure, as well as movement, dress, and domestic environment, while Manet undermined physiognomic codes, assembling "clues and signs" that "did not add up" to a legible subject.[10] House's key point is that physiognomy could be productive as failure. Manet's steely faces refuse to signify physiognomically yet nevertheless testify to the painter's awareness that viewers possessed and wanted to use their physiognomic fluency. A factor in physiognomy's longevity and importance in the nineteenth century derives from its eclecticism, adaptability, and utility even as a relic of a failed science.

In this chapter I propose that Salon caricature's pictorial criticism has a Lavaterian engine. Salon caricaturists are not believers in Lavater. Rather, like the painters discussed by House, caricaturists worked with physiognomic reading and against it, troped it, and paraded its findings and its failings. Nevertheless physiognomic discourse shaped the legibility of Salon caricature as a comic genre and art-critical method.

Instead of reading human form, as Lavater's *fragments* instructed, Salon caricature read and misread the painting as if it were a face or body, performing Lavater's methods. These methods include the refusal to see the whole individual/painting as a compelling illusion. Instead, the physiognomer breaks down the whole into its component parts, selecting and isolating features as data. For Lavater and the practice of popular physiognomy that he inspired, the act of drawing takes on central importance as an epistemological aid, helping to essentialize experience for analysis.

Caricature: A Physiognomic Art

Caricature originated as *ritrattini carichi* or loaded little portraits, in the language of its inventors, the Carracci brothers, for whom these simple line drawings, selectively distorting the features of their subjects, were a light yet sophisticated private diversion from their Bolognese art academy. As many commenters on caricature have observed,[11] the proximity of the academy—as in the institution that safeguards and transmits some kind of orthodoxy in artistic expression—is a persistent condition under which caricature thrives. Grand-Carteret emphasized

this point as well, remarking that many "serious" artists, ones trained in, embraced by, even instructors in academic institutions, including Pierre Puvis de Chavannes and Jean-Léon Gérôme, engaged in caricature while they were students.[12] He cited the famous murals in the *loges* of the Académie des beaux-arts, where students sequestered in boxes during competitions covered the walls in comic versions of academic art.[13]

The word "caricature" became misleading as it bled from Italian into English usage, and by the late eighteenth century it applied to almost any comic image.[14] Although there is still some debate about how early one can properly speak of "caricature," and whether it is coeval with certain forms of modernity, it is now largely understood as exaggerated physiognomic depiction.[15]

Physiognomy pretended to adhere to but in fact utterly contradicted the advances made by thinkers from Hume to Kant who had wrestled with the rational grounds for universally defensible statements of aesthetic judgment. Physiognomy happily channeled intuition and subjective response into "verifiable" public statement, which in fact most often took already-agreed-upon judgment (Plato had a vivid sense of honesty) and read it back into the evidence of the portrait drawing (Plato had a firm gaze).[16]

Physiognomy has an ancient and uneven pedigree. It dates back to the pseudo-Aristotelian *Physiognomica*, and persisted in medieval medical treatises, which employed the reading of features as a diagnostic tool.[17] At the end of the eighteenth century its history became intertwined with that of caricature. Physiognomy fell out of favor as a serious philosophical or diagnostic method during the Enlightenment but reemerged in the nineteenth century largely because of the works of Johann Caspar Lavater.

Lavater, a Zwinglian minister who entertained aristocratic visitors to his home in Switzerland in the 1780s and 1790s by performing character readings, published the first editions of the *Physiognomische Fragmente* in Zurich and Leipzig between 1775 and 1783, and English and French editions soon followed. The first French edition (1781–1803) was an in-quarto illustrated luxury item, but subsequent editions, beginning with the 1806–1809 in-octavo compiled by the French physician Moreau de la Sarthe, were increasingly accessible and widely reviewed. Reeditions were published continuously in France until 1909. Physiognomic literature as a category exploded, as Lavater's fragments produced a massive corona of related texts.[18] In what follows, unless otherwise noted, I refer to the 1820 French edition by Moreau.

Lavater's fragments (and illustrations) varied with different translators and editors—Moreau, for example, was keen to repress religious content. His

broad popular appeal as much as his vulnerability to criticism derived from a philosophical eclecticism. The practice of physiognomy drew seemingly without conflict on Bacon and Locke, Herder and Goethe, Plato and Christian theology. Lavater imitated, even plagiarized precedents, including illustrations from Charles Le Brun's *Conférence sur l'expression*, the treatise codifying the depiction of the expressions for students of the Académie française first delivered around 1670 and published in 1698.[19] (*The Conférence* is another stitch in the seam between caricature and academic training.) Through personal charisma and a genius for performing seriousness while avoiding rigor, Lavater managed to galvanize physiognomy such that by the turn of the nineteenth century it was Lavaterian. It was never as associated with any other single name.[20]

Lavater: Judgment and Drawing

Lavater died in 1801, aware of a burgeoning practice called caricature, which he understood to mean the deliberate distortion of faces in order to make them ugly. He was hostile to this pursuit, which obscured God's goodness rather than revealing it, as his abhorrence of Hogarth reveals.[21] Yet it is in laying out drawing's epistemological function that Lavater unwittingly articulates a method for caricature. Methodologically, judging and drawing are constantly imbricated in Lavater's fragments: "The more finesse acquired by the sense of observation, the more the language will become enriched, the more one draws, the more physiognomy becomes scientific."[22] If the physiognomer "wants to be sure of his judgments, if he wants his determinations to bear the mark of solidity, the art of drawing is indispensable to him."[23]

Physiognomic drawing entailed breaking down the whole into parts, which could be analyzed. This was "the only way to render sensible an infinity of signs."[24] A drawing created data out of experience. For this reason, the simplest contour drawing was the most telling. Line drawing, free of shading, cross-hatching or color omitted superfluous and potentially misleading effects—hence the emergence of the silhouette chair, extant since the seventeenth century as a parlor game but repopularized by Lavater. The silhouette chair reduced the face to a shadow contour and permitted anyone a basic competence in this analytic method.

The physiognomic reduction of the individual to its features was an analytic method but could also be used to compose drawings.[25] The sequential division of the face into its components may have been suggested to Lavater from the preexisting format of drawing manuals like Alexander Cozens's *Principles of*

Beauty Relative to the Human Head.[26] Many of the illustrations Lavater used as examples, which he presented as true to life, have a caricatural exaggeration. In illustrating how features bore character, the *fragments* exaggerated features to the extent that one might find in a caricature, as in a plate of nine pairs of eyes that progress from unexpressive to bursting out of their sockets (Figure 3.1).[27] A bony nose, squinty eyes, a high front—these signs were selected and exaggerated in the schematic illustrations Lavater provided for readers.

Much of Lavater's *fragments* and other physiognomic texts were given over to readings of portrait heads, drawn for the purpose or taken from elsewhere, including from the history of art (depictions of Christ's apostles by Van Dyck are reduced to schematic outline and examined for character, like any individual[28]).

Figure 3.1 Illustration from Johann Caspar Lavater, *L'art de connaître les hommes par la physionomie*, tome 2, plate 65. Engraving. Bibliothèque nationale de France

Lavater invoked the burgeoning science of connoisseurship for his project, promising that physiognomy would endow readers with the "expert eye of the connoisseur."[29]

Physiognomy's connoisseurship of the soul already opens the way for its later application to the comic reading of images. It differentiated between real and counterfeit qualities in human subjects, but as to the images that he used, Lavater did not emphasize distinctions between original and copy, person and picture. He defined physiognomy as reading the exterior of man "in the original or in a representation."[30]

Lavater's treatment of the drawing is a mixture of pseudo-cartesian mechanics, where the individual is broken down into component parts for rational analysis and a belief that could be characterized as devotional, as if the drawing moved with the spirit of its model. Lavater was, after all, a self-described scientist and an ordained minister. So Van Dyck's portrait of Matthias for example allows the physiognomer to diagnose the apostle's "nervous character" as a trait of the man and not as an effect of the depiction.[31] Similarly, Salon caricature enjoyed a non-problematic doubling of painting and caricature, original and copy. Its treatment of the painting as if it were present in the caricature suggests that readers had been trained in, or had at least become familiar with, this Lavaterian treatment of the image as simultaneously schematic graphic reproduction and living presence, Van Dyck's representation of Matthias and Matthias himself.

Philipon and the Joke of Physiognomy

French caricature in the illustrated press in the first half of the nineteenth century adapted and troped Lavaterian language and a Lavaterian status of the image. Caricaturists expected among their readers familiarity with the relations between drawing and knowing that physiognomic literature demonstrated.

The short-lived caricature journal *La Silhouette*, founded in 1829 with support from Philipon, featured contributions from Philipon's future collaborators including Honoré Daumier, J.-J. Grandville, and Henry Monnier. In the title vignette by Henri-Gérard Fontallard (Figure 3.2) an allegorical figure transcribes the shadow of a young, flamboyantly dressed bourgeois on a screen. This screen is a version of the silhouette or Lavater chair, set up to permit the physiognomer to trace a reductive shadow contour.

But the silhouette of *La Silhouette* does not model a science of the soul. Compare the engraving of the Lavater chair made by Thomas Holloway for the

Figure 3.2 Henri-Gérard Fontallard, title vignette, *La Silhouette*, 1829. Bibliothèque nationale de France

1792 English-language edition of Lavater's *Essays in Physiognomy* (Figure 3.3). In Holloway's engraving, the strong and evident light source, the entrapment in space of the observed female subject (pinned like a frog for dissection, observes Barbara Stafford[32]), and the invisibility of the physiognomer underscore the diagnostic effort of the process.[33]

La Silhouette's title vignette replaces dry diagnostics with light erotics, where silhouette-drawing is intimate, decorative game-playing. The female subject is now liberated from the chair as she takes the pen in hand. In Fontallard's bohemian mise-en-scène of the artist's studio with its screens, frames, and props, the silhouette drawing is both an empirical record (the dandy will enter the social catalogue along with his geometrically stylized precedents on the screen) and a deliberate distortion. The sitter proudly participates in this distortion, even delighting in his shadow, its pointy beard stretched to devilish proportions. Fontallard held on to the Lavaterian concept of the silhouette but transformed the method for which it stood from a science to a representational process, from drawing as a way of seeing, to drawing as a game of seeing comically. Lavater's silhouette revealed the divine, while Fontallard's released a comic devil.

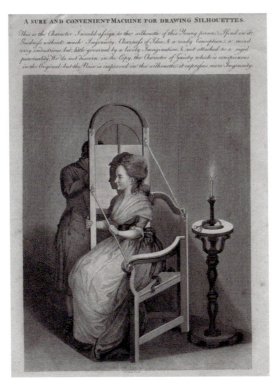

Figure 3.3 Thomas Holloway, "A Sure and convenient machine for drawing silhouettes," 1792. Line engraving. 27.3 cm × 21.1 cm. © National Portrait Gallery, London

Philipon's interest in Lavater percolated through his activities in the 1830s and 1840s.[34] Philipon published "Le dedans jugé par le dehors" ("The Interior Judged by the Exterior"), a six-page Lavaterian satire with caricatures by Trimolet (Louis-Joseph Trimolet, 1812–1843) in his weekly illustrated arts-focused journal *Le Musée Philipon* in 1841 (Figure 3.4).[35] Judith Wechsler calls "Le dedans jugé par le dehors" Philipon's "little treatise" on physiognomics.[36] In it, he lists exterior trappings of everyday Parisians (there is a subsection on canes) and explains their surefire relation to character.

But the certainty in Philipon's reading of inborn character through accessories like hats and canes as a fixed alphabet satirizes concepts like the "judicious nose" that even Lavater's own French editor, Moreau, found risible.[37] Philipon's reading of godliness in the face of man in "The Interior" sounds more like the promises of advertisers on the back page of the *Charivari*: "As for abundant hair that does not gray, it is the stamp of a perfectly calm spirit. It is of these happy

Figure 3.4 Charles Philipon and Louis-Joseph Trimolet, "Le dedans jugé par le dehors," *Le Musée Philipon*, vol. 2, no. 10, 1841, page 76. Wood engraving. University of Chicago, Special Collections

heads that it is said in Scripture: 'THE KINGDOM OF HEAVEN BELONGS TO THEM.'"[38] Trimolet's caricatures provide this blissfully clear moral and spiritual alphabet (bellowed idiotically in capital letters) with incongruous, messy visual demonstration. Unlike Lavater's evacuated contour drawings, Trimolet's busily crosshatched caricatures have a shabby materiality that exceeds the aphoristic reading. In their chaotic activity, Trimolet's caricatures body forth urban life lived—as if the texture of the heavily hashed wood engraving were that of a threadbare overcoat, countering, in its tatters, the possibility of schematic ideals or dependable data.

To suggest that the physiognomic was an overarching classificatory impulse in the arts misses the way that physiognomy could be at the same time a reading of social type and a satire of legibility; a "little treatise" on the semiosis of strangers's hats and canes, and a semiotic demonstration of the deep reading

undone by the surface description of caricature; interior judged by exterior, Philipon's words judged by Trimolet's line. As symbolized in the title vignette to *La Silhouette*, Philipon's refraction of Lavaterian language through his prism of comic illustration entailed physiognomy as a graphic distortion, training readers in reading and consuming caricature as much as providing humane guidance in the navigation of the metropolis. Lavaterian judgment was both the template and the satirical object, a vernacular game of constituting and deciphering the comic image.[39]

Salon Caricature's Pictorial Criticism and Lavaterian Judgment

As discussed in previous chapters, Philipon held the field in satiric illustrated journals until the Second Empire. The journals with the earliest and longest record of publishing Salon caricature are Philipon's *Le Charivari* and *Le Journal pour rire* (renamed *Le Journal amusant* in 1856) by Cham at the former and Bertall at the latter. These two caricaturists conceived of Salon caricature in this period during which physiognomic depiction was not only the dominant mode, but a recurring and explicit motif.

Having considered physiognomy in Lavater and as a comic mode under Philipon, we can return to the problem that Grand-Carteret noticed: How can a physiognomic art depict an object? What would the physiognomy of a canvas entail?

According to John Grand-Carteret, the Salon caricaturist's process, one "glimpsed by Lavater," is "simple and known":[40]

> It is therefore, if you will, a "parody by pencil" which started, as we've seen, by first following strictly, line for line, the caricatured subject, and which, little by little, took on more verve [*plus d'allure*], more liberty, while guiding itself according to the original to arrive at comic effects.[41]

In chapters 1 and 2 of the present volume I traced caricaturists's discovery of this method, their turn from generalized caricature of art to a specific distortion that began with close looking ("following strictly, line for line"). When Salon caricature underwent this important change from generalized comedy to a caricatural representation of vision or reception, targeting specific paintings, its graphic relation to the painting changed radically. Instead of inventing canvases that mocked Salon conventions, it reduced and essentialized the "the canvas itself," as Grand-Carteret observed, "the canvas in all its accessories, with all its

strengths or weaknesses in drawing, in color."[42] In Salon caricature these formal elements "are travestied, exaggerated with pleasure."

For Grand-Carteret, "travesty" ("*travestir*") meant to dress a person in clothes that did not match their sex or social position.[43] Despite the absence of female practitioners of the genre, for Grand-Carteret, Salon caricature's intense interest in the canvas's formal elements was a kind of feminine and feminizing attention to costume or disguise. Just as *La Silhouette* presented caricature as a bohemian game of dress-ups (Figure 3.2)—it is the woman who traces her physiognomic vision of the seated man—Grand-Carteret cast Salon caricature as playful attention to "accessories." And again recalling the intimacy of *La Silhouette*'s encounter, Grand-Carteret interpreted caricature's exaggeration not as an exercise in dry abstraction or negative judgment, but as a game of giving pleasure (*outré à plaisir*).

In Grand-Carteret's description, it is as if Salon caricature's faux-naïveté has turned the negative qualities attributed to women as spectators into a comic method. Those qualities were stereotypical in the illustrated press: self-involvement, credulousness, and attention to minor, superficial details, all on display in Hadol's 1874 "Pourquoi les femmes vont au Salon" ("Why Women go to the Salon") (Figure 3.5).[44] Note the top central vignette, a woman heaped with ridiculous accessories (fabric and fruit) who has come to "make comparisons." Grand-Carteret's feminizing of Salon caricature indicates a broader ideological alignment of women with superfice, with captivation by painting's most immediate qualities and convincing by its illusions. These qualities, for Grand-Carteret, attach to Salon caricature's own disobedience—graphically self-involved, deliberately credulous, methodically attracted to materiality.

Eighteen years after Grand-Carteret's description of Salon caricature, Théodore Duret also made a link between comic responses to painting and female Salon spectatorship. In his major study on Manet, he described women reacting to Manet's paintings: " [A]ll the women began to look at how their dresses were fashioned, which they declared horrible …. Then they passed to the accessories, to find them ridiculous. To go laugh at [Manet's] *The Balcony* had become one of the pleasures of the Salon."[45] The similarity to Grand-Carteret's description of Salon caricature is remarkable: Attention to the painting is replaced by attention to dress, soon reduced to scrutiny of accessories. This method of looking is a search for laughter: they go to the Salon for this pleasure. Like Grand-Carteret's caricaturists, Duret's women call upon their particular expertise as artists of the superficial, only their laughter and their pleasure are illegitimate, while Grand-Carteret recognizes the caricaturists as privileged guides.

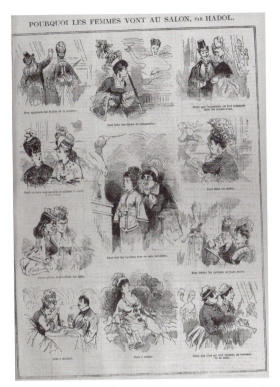

Figure 3.5 Hadol, "Pourquoi les femmes vont au Salon," *Le Charivari,* May 8, 1874. Gillotage. Bibliothèque nationale de France

The Canvas, in All Its Accessories

I stress that Grand-Carteret read into Salon caricature a *faux*-naïveté: the attention to superfice, to "accessories," could reveal depth of knowledge and inform or deepen the reader/viewer's understanding of the canvas. Take for example Cham's selection and exaggeration of the doctors's feet in his caricature of Théodule Ribot's *Le Christ et les docteurs* (Christ and the Doctors) from *Le Salon de 1866 photographié par Cham* (The Salon of 1866 photographed by Cham) (Plates 15 and 16).[46]

Looking at the original canvas by Ribot, Cham began with the copyist's or the art-student's observation, just as Grand-Carteret described. Ribot highlighted the triangle of the doctors's and Christ's feet against the dark ground in order to map out spatial depth in the composition. Ribot wanted the viewer to be

compelled by the humble Christ child mastering the wise experts, portrayed in an earthy palette that grounds Christ in a familiar material world. For such a viewer, the triangle of highlighted feet plots out a recession into that material world, constructing the space as inhabitable.

As a student of painting, Cham knows exactly the effects Ribot desires; as comic physiognomer, he refuses to see the narrative. (Cham's caption: "Where are the doctors?"[47]) He refuses to believe the illusion of space (the feet are big because they're overgrown, not because they're in the foreground). Instead Cham reveals the hidden "truth" by the tell-tale feature of oversized feet—which the caption exhorts the viewer to see ("Rather see their feet".)[48] Cham's caricature makes the reader aware of the feet as perspectival *device*. If the reader then returns to the original canvas, it is difficult to shake awareness of the device and at the same time to "unsee" the comic surplus in the blanched, ungainly feet.

Grand-Carteret's characterization of Salon caricature's faux-naïveté as a game of playing dress-ups may have been informed by caricaturists's frequent attention to literal costume and accessories. In a general satire of portraiture from Cham's Salon caricature album of 1868[49] (Figure 3.6), the caricature acts out the process of selecting the canvas's comic features. A mischievous artist displays a portrait of a lady that includes only three items hovering in the pictorial space: dentures, a wig, and an undergarment. Cham takes the physiognomic imperative to break the portrait down into its parts literally, dismantling the whole into its constituent elements, equating the features and devices of illusionistic painting with the accessories and aids of female self-fashioning.

Physiognomy emphasized "features" as elements that could be discerned via line drawing, but when Salon caricature took the principle of feature-selection and applied it to the canvas, it identified pre-iconographic qualities such as size (Ernest Meissonier's small canvases and Horace Vernet's enormous ones made for repeated Salon-caricature jokes) and color. Bertall's covers for *Le Journal pour rire* in the 1850s used vibrant washes to make jokes in this way. The "feature" Bertall selects in Millet's *Un berger; effet du soir* (known as Shepherd and Flock at the Edge of the Forest, Evening) from the Salon of 1853 is the muddy brown of the woods (Plates 17 and 18).[50] Bertall ignores the complexities of the golden sunset bleeding through the foliage, and instead "sees" only the one hue, spread over the canvas's surface like chocolate (caption: "In the evening, according to M. Millet, shepherds take on a chocolate hue, which they kindly share with their flock and with the landscape").[51]

The physiognomic reading, looking past illusion, often alerted the reader to painting's thickness and materiality, as in the example of Millet's chocolate

Portraits-fragments de la baronne de P...

Figure 3.6 Cham, *Salon de 1868. Album de 60 caricatures,* 1868. Wood engraving. National Gallery of Art, Washington, DC

paint—sticky, milky, complicated by associations with taste, smell, and touch. Conversely, recurring Salon-caricature jokes pointed to illusions of immateriality or flatness, as in Cham's caricature of Puvis de Chavannes's *L'an 732, Charles Martel secourant la chrétienneté par sa victoire sur les sarrasins près de Poitiers* (The Year 732, Charles Martel saving Christianity with his victory over the Saracen near Poitiers) (Plates 19 and 20), from *Le Charivari* in 1874.[52]

Puvis developed a mode of large-scale painting that adapted the light palette and spatial compression of the Italian fresco tradition to modern allegories. This painting is typical of Puvis's in that it represents a patriotic, not to say xenophobic, subject and was intended for public installation (it is still on display as a mural at the Hôtel de Ville in Poitiers). Using deliberate spatial archaism, Puvis depicts recession into space as vertical stacking. Uninterested in Puvis's narrative and feigning not to understand Puvis's construction of space, Cham's caricature misreads Puvis's tree in the background as occupying the same plane as the axe in the foreground. The relocation of Puvis's canvas to the small-scale,

mobile, paper album activates for the reader a further flattening of the picture. Puvis's public frescos were in fact painted on canvas, shown at the Salon and then finally glued into their architectural home, like a giant print, excised and pasted in an album. Cham reversed the direction of travel, peeling the canvas off the Salon wall and putting it into circulation in the album. This gesture draws attention to the strangeness of Puvis's mobile frescos, painted as if according to the demands of a site-specific public work, but free to stop by the marketplace of the Salon.[53]

Puvis became a longstanding object of caricatural attention (and indeed of later exhibition parody),[54] submitting to the salon well into the Third Republic. Although a range of artists in the fin-de-siècle period, particularly the neo-impressionists, looked to Puvis for the flatness and spatial archaism Cham exaggerated,[55] my analysis makes clear that Cham's attraction to flatness had nothing to do with prescience about, or hostility to, Puvis's modernism. On the contrary, as we saw in the last chapter, Cham articulated that some painters "lend themselves" to caricature; surely Puvis became a tempting subject for physiognomic misreading's faux-naïveté, as Puvis himself feigned an intellectual naiveté in deploying pre-perspectival spatial construction (Cham's caption: "Charles Martel refuses to obey the laws of perspective … ").[56]

There is more to say about Salon caricature's physiognomic misreading as a faux-naïve formalism. For example, this description suggests links wth Impressionism, which, coeval with Salon caricature's expansion in the press in the 1870s, self-consciously explored an optical ideal of naïveté. Edmond Duranty, who also wrote about caricature, theorized Impressionism as a physiognomic science,[57] given Impressionism's emphasis on a return to child-like, pre-cognitive vision.

In conclusion, Salon caricature drew from physiognomy a method for comically binding judgment, drawing, and seeing, and in doing so heightened its attention to exterior and surface, pre-iconographic elements and formal devices, subverting or denying the painting's intended narrative or sentiment. This, as we will see, is completely contrary to the interpretation of Salon caricature by early formalist critics between the 1880s and the mid-twentieth century, who claimed that caricaturists pandered to people who sought story in art, a public-at-large incapable of seeing and understanding the formal qualities of paint stripped of sentiment and subject matter. This chapter has considered Salon caricature's methods, the grounds of its comprehensibility, and the motivation behind some of its selection of canvases. The next chapter frames such considerations within the technical and material conditions of press illustration between 1840 and 1880.

Notes

1 John Grand-Carteret, *Les mœurs et la caricature en France* (Paris: A la Librairie Illustrée, 1888), 549–54. In his discussion of Salon caricature he writes that he has undertaken a study entitled "l'Art devant la Caricature" (never published), 552.

2 "…la place considérable que la peinture tient dans la caricature au jour le jour," Grand-Carteret, *Les mœurs et la caricature en France*, 549.

3 "…tandis que, dans l'art dramatique, le sujet s'efface devant l'homme, en peinture, pour le caricaturiste, l'œuvre est tout, l'homme n'existe pas." Ibid., 550.

4 Honoré Daumier, "Le Salon de 1840. *ASCENSION DE JÉSUS-CHRIST. D'après le Tableau original de M. Brrdhkmann*," *La Caricature*, April 26, 1840. Republished in *Le Charivari*, April 1, 1841.

5 Despite growing scholarly interest in physiognomy in eighteenth- and nineteenth-century Britain, the career of physiognomy in nineteenth-century France has only been the subject of one book-length study, Judith Wechsler, *A Human Comedy: Physiognomy and Caricature in 19th Century Paris* (Chicago: University of Chicago Press, 1982). For the British context see Sharrona Pearl, *About Faces: Physiognomy in Nineteenth-Century Britain* (Cambridge, MA: Harvard University Press, 2010); Amelia Rauser, *Caricature Unmasked: Irony, Authenticity, and Individualism in Eighteenth-Century English Prints* (Newark: University of Delaware Press, 2008); and M.C. Cowling, *The Artist as Anthropologist: The Representation of Type and Character in Victorian Art* (Cambridge: Cambridge University Press, 1989). In eighteenth-century France: Melissa Percival, *The Appearance of Character: Physiognomy and Facial Expression in Eighteenth-Century France* (Leeds: W.S. Maney for the Modern Humanities Research Association, 1999). For a broad range of perspectives, see Melissa Percival and Graeme Tytler, *Physiognomy in Profile: Lavater's Impact on European Culture* (Newark: University of Delaware Press, 2005). For a broad historical overview of physiognomy's relation to the visual arts, see Laurent Baridon and Martial Guédron, *Corps et arts: physionomies et physiologies dans les arts visuels* (Paris: L'Harmattan, 1999).

6 "physiognomy, n." OED Online. Accessed December 2021. Oxford University Press.

7 Graeme Tytler, *Physiognomy in the European Novel: Faces and Fortunes* (Princeton, NJ: Princeton University Press, 1982).

8 See Wechsler, *A Human Comedy*, and Ségolène Le Men, *Pour Rire!: Daumier, Gavarni, Rops: L'invention de la silhouette* (Paris: Somogy Éditions d'Art, 2010).

9 Théophile Thoré, *Dictionnaire de phrénologie et de physiognomonie: à l'usage des artistes, des gens du monde, des instituteurs, des pères de famille, des jurés, etc* (Paris: Librairie Usuelle, 1836). See Edmond Duranty on Degas as a physiognomer, in Duranty, *La nouvelle peinture: à propos du groupe d'artistes qui expose dans les galeries Durand-Ruel* (Paris: E. Dentu, 1876). Many of Duranty's ideas about

impressionism come out of his essay on physiognomy, "Sur la physiognomie," *Revue libérale* 11 (July 25, 1867): 499–523. For Duranty on caricature see "La caricature et l'imagerie pendant la guerre de 1870–71 en Allemagne, en France, en Belgique, en Italie et en Angleterre," *La Gazette des beaux-arts*, t.5, February 1 and April 1, 1872: 155–72, 322–43, and t.6, November 1, 1872: 393–408.

10 John House, "Toward a 'Modern' Lavater? Degas and Manet," in *Physiognomy in Profile*, 180–97, 191.

11 E.H. Gombrich and Ernst Kris, *Caricature* (Harmondsworth: Penguin, 1940); Werner Hofmann, *Caricature from Leonardo to Picasso* (London: John Calder, 1957); and Michel Melot, *L'oeil qui rit: le pouvoir comique des images* (Fribourg: Office du livre, 1975).

12 Grand-Carteret, *Les mœurs et la caricature en France,* 536. On Puvis's caricatures, see Aimée Brown Price, "Puvis de Chavannes's Caricatures: Manifestoes, Commentary, Expression," *Art Bulletin* 73 (March 1991): 119–40. On the caricature of Jacques-Louis David, see Albert Boime, "Jacques-Louis David, Scatological Discourse in the French Revolution, and the Art of Caricature," *Arts Magazine* 62 (February 1988): 72–81.

13 Grand-Carteret, *Les mœurs et la caricature en France,* 540. See also Étienne-Jean Delécluze's description of the students in Jacques-Louis David's studio who made caricatures on the wall, which David judged seriously. Delécluze, *Louis David, son école & son temps: souvenirs* (Paris: Didier, 1855), 46–7.

14 Constance C. McPhee and Nadine Orenstein, *Infinite Jest: Caricature and Satire from Leonardo to Levine* (New York: Metropolitan Museum of Art, 2011), 3. For an account of caricature that retains its expansive definition as figurative and comic, e.g., going back to Greek vase painting, see Laurent Baridon and Martial Guédron, *L'art et l'histoire de la caricature* (Paris: Citadelles & Mazenod, 2006). Patricia Mainardi shows that a wide variety of images, some barely comic, were labeled "caricature" well into the nineteenth century. Mainardi, *Nineteenth-Century Illustrated Print Culture* (New Haven and London: Yale University Press, 2017), 13–71.

15 For further emphasis on the definition of caricature as physiognomic, see Herbert M. Atherton, *Political Prints in the Age of Hogarth; a Study of the Ideographic Representation of Politics* (Oxford: Clarendon Press, 1974), 33 and Rauser, *Caricature Unmasked*, 15. Todd Porterfield has made the important point that physiognomic caricature is differently coded but nonetheless as coded as previous forms of visual satire. Recognizing that physiognomy depended on shared knowledge of preexisting categories and associations helps avoid "a narrative teleology of progress that supposes that visual satire evolves toward the truthful, uncoded and transparent and that caricature's rise is necessarily a story of progress." Todd Porterfield, *The Efflorescence of Caricature, 1759–1838*, ed. Todd Porterfield (Farnham, Surrey and Burlington, VT: Ashgate, 2011), 2.

16 Johann Caspar Lavater, *L'art de connaître les hommes par la physionomie*, tome 1 (Paris: Depélafol, 1820), 389.

17 For precursors of Lavater and their role in medical diagnostics, see Barbara Maria Stafford, *Body Criticism: Imaging the Unseen in Enlightenment Art and Medicine* (Cambridge, MA: MIT Press, 1991), 84–103.

18 See, e.g., Johann Caspar Lavater, *Le Lavater portatif, ou précis de l'art de connaître les hommes par les traits du visage* (Paris: Madame Veuve Hocquart, 1808). Michael Shortland writes that "the basic editions of Lavater's text were little more than an advance guard of the physiognomic invasion, for the doctrines… appeared in countless abridged, popular… forms" throughout the century. Shortland, "The Power of a Thousand Eyes: Johann Caspar Lavater's Science of Physiognomical Perception," *Criticism* 28, no. 4 (October 1, 1986): 379–408, 385.

19 On Le Brun's conférence, its langauge, use, and reception, see Jennifer Montagu, *The Expression of the Passions: The Origin and Influence of Charles Le Brun's "Conférence sur l'expression générale et particulière"* (New Haven: Yale University Press, 1994). On Le Brun and physiognomy, see Melissa Percival, *The Appearance of Character*, 41–64.

20 "By the start of the Nineteenth Century, it was clear that physiognomy was associated with one man only—… Lavater." Shortland, "The Power of a Thousand Eyes," 383.

21 Katherine Hart, "Physiognomy and the Art of Caricature," in *The Faces of Physiognomy: Interdisciplinary Approaches to Johann Caspar Lavater*, ed. Ellis Shookman (Columbia, SC: Camden House, 1993), 126–38, 131.

22 "Plus l'esprit observateur acquiera de finesse, plus la langue s'enrichira, plus on fera dans l'art du dessin, …plus…la physionomie deviendra scientifique." Lavater, *L'art de connaître les hommes par la physionomie*, tome 1, 273.

23 "S'il veut être sûr des jugements; s'il veut que ses déterminations portent une empreinte de solidité, l'art du dessin lui devient indispensable." Ibid., 332.

24 "…l'unique moyen…de rendre sensible une infinité de signes." Ibid., 332.

25 For this reason, as Ross Woodrow notes, "of all the books published in the eighteenth century, those that most resemble Lavater's essays in terms of their content, style, format and intended readership are drawing manuals." Woodrow, "Lavater and the Drawing Manual," *Physiognomy in Profile*, 71–93, 71.

26 Alexander Cozens, *Principles of Beauty Relative to the Human Head* (London: James Dixwell, 1778), discussed in Woodrow, 74. Barbara Stafford also compares Lavater and Cozens in *Body Criticism*, 150–3.

27 Lavater, *L'art de connaître les hommes*, tome 2, plate 65. Plates in which features undergo a gradual exaggeration from the first to last example also recall Swiss caricaturist Rodolphe Töpffer's method for producing comic characters in his *Essai de physiognomie* (Geneva: Schmidt, 1845). Töpffer's model of physiognomic drawing was opposed to Lavater's in that it did not give access to interiority. Rather, Töpffer presents

a structural model whereby the artist generates many faces with slight differences between them; difference and context create legibility of character within a system of signs. See David Kunzle, *Father of the Comic Strip: Rodolphe Töpffer* (Jackson, MI: University Press of Mississippi, 2007), particularly 113–17, and Rodolphe Töpffer, *Enter the Comics: Rodolphe Töpffer's "Essay on physiognomy" and "The true story of Monsieur Crépin,"* ed. and trans. E. Wiese (Lincoln: University of Nebraska Press, 1965).

28 Lavater, *L'art de connaître les hommes*, tome 6, 70–1.

29 "…l'œil exercé du connoisseur," *L'art de connaître les hommes par la physionomie*, tome 1, 284. On Lavater and connoisseurship see Melissa Percival, "Johann Caspar Lavater: Physiognomy and Connoisseurship," *Journal for Eighteenth-Century Studies* 26, no. 1 (2003): 77–90.

30 "…soit en original ou en représentation." *L'art de connaître les hommes par la physionomie*, tome 1, 223.

31 "… un caractère nerveux," *L'art de connaître les hommes par la physionomie*, tome 6, 70.

32 Stafford, *Body Criticism*, 97–8.

33 Victor Stoichita points out that the chair and screen echo the Christian confessional. Victor I. Stoichita, "Johann Caspar Lavater's 'Essays on Physiognomy' and the Hermeneutics of Shadow," *RES: Anthropology and Aesthetics* no. 31 (April 1, 1997): 128–38, 136.

34 Philipon led a step-by-step public demonstration of physiognomic principles in the famous 1831 trial over "La Poire." See James Cuno, "The Meaning of La Poire," in "Charles Philipon and La Maison Aubert: The business, politics, and public of caricature in Paris, 1820–1840," PhD dissertation, Harvard University, 1984 and Sandy Petrey, "Pears in History," *Representations* No. 35, Special Issue: Monumental Histories (Summer 1991): 52–71. On Philipon and physiognomy, see also David S. Kerr, *Caricature and French Political Culture 1830–1848: Charles Philipon and the Illustrated Press* (Oxford: Clarendon Press, 2000), 168–9.

35 Charles Philipon and Louis-Joseph Trimolet, "Le dedans jugé par le dehors," *Le Musée Philipon*, vol. 2, no. 10 (1841): 73–8.

36 Wechsler, *A Human Comedy*, 70.

37 Regarding Lavater's reading of a "nez mâle et judicieux" ("judicious and male nose") in the face of Lord Anson, Moreau notes that "*Un nez judicieux* fera sourire plus d'un lecteur…," *L'art de connaître les hommes*, tome 1, 324. Georg Christoph Lichtenberg satirized Lavater's *Fragments* immediately upon publication. See Ernst Gombrich, "On Physiognomic Perception," *Daedalus* 89, no. 1 (1960): 228–41, 228–31.

38 "Quant au cheveux abondants, qui ne blanchissent pas, ils sont le cachet d'un esprit au calme plat. C'est de ces têtes bien-heureuses qu'il est dit dans l'Écriture: 'LE ROYAUME DES CIEUX LEURS APPARTIENT.'" Philipon and Louis-Joseph Trimolet, "Le dedans jugé par le dehors," page 76.

39 Jillian Lerner comes to a similar conclusion, writing about the social taxonomy of caricature in the July Monarchy. She argues that although on the surface taxonomic

guides to the city may seem like "universally valid description of fixed or self-evident classes," instead "they showcase the qualitative, interpretive, and fundamentally subjective judgments of the artists and writers who produce them." Lerner, *Graphic Culture: Illustration and Artistic Enterprise in Paris, 1830–1848* (Montreal: McGill University Press, 2018), 88.

40 "…entrevue par Lavater,"; "Le procédé est à la fois simple et connu…." Grand-Carteret, *Les mœurs et la caricature en France*, 550–1.

41 "C'est donc, si l'on veut, une 'parodie par le crayon' qui a commencé, nous l'avons vu, en suivant d'abord strictement, trait pour trait, le sujet dont on entreprend la charge et qui, peu à peu, a pris plus d'allure, plus de liberté, tout en se guidant sur l'original pour arriver aux effets comiques…." Grand-Carteret, *Les mœurs et la caricature en France*, 551.

42 "C'est le tableau lui-même, le tableau dans tous ses accessoires, avec ses qualités ou ses faiblesses de dessin, de couleur, qui apparaît travesti, outré à plaisir." Grand-Carteret, *Les mœurs et la caricature en France*, 550.

43 The first definition of "travestir" in the late nineteenth century was "to dress in clothes that do not belong to one's sex or condition" ("Faire prendre des habits qui n'appartiennent pas soit au sexe, soit à la condition"), condition meaning class or place in the social order. (It is followed by the example of "On a travesti des soldats en paysans pour surprendre la place"). The second definition is "changer un ouvrage sérieux en ouvrage burlesque." *Dictionnaire de la langue française*, t. 4, ed. Émile Littré (Paris: Hachette, 1873).

44 Hadol, "Pourquoi les femmes vont au Salon," *Le Charivari*, May 8, 1874.

45 "C'étaient des femmes, et toutes les femmes se prenaient à regarder comment étaient façonnées leurs robes, qu'elles déclaraient affreuses… puis on passait aux accessoires, pour les trouver ridicules…. Aller rire devant *le Balcon* était devenu un des plaisirs du Salon." Théodore Duret, *Histoire de Édouard Manet et de son œuvre* (Paris: Carpentier et Fasquelle, 1906), 96.

46 Cham, *Le Salon de 1866 photographié par Cham* (Paris: Arnauld de Vresse, 1866).

47 "Où sont les docteurs?"

48 "Voyez plutôt leurs pieds."

49 Cham, "Potrait-fragments de la baronne de P…," *Salon de 1868, Album de 60 caricatures* (Paris: Arnauld de Vresse, 1868).

50 Bertall, "Le Salon dépeint et dessiné par Bertall," *Le Journal pour rire*, July 16, 1853.

51 "Le soir, suivant M. Millet, les bergers ont coutume de prendre une teinte chocolat, qu'ils partagent amicalement avec leurs moutons et avec le paysage." On food metaphors in Salon caricature, see Frédérique Desbuissons, "The Studio and the Kitchen: Culinary Ugliness as Pictorial Stigmatisation in Nineteenth-Century France," in *Ugliness: The Non-Beautiful in Art and Theory*, ed. Andrei Pop and Mechtild Widrich (London: I.B. Tauris, 2016), 104–21. Desbuissons also notes the caricatural attention to formal features: "What condemns the transformation

of painting into food is usually not subject but execution: tone, composition, and design" (110). Desbuissons's point that culinary metaphors heighten attention to the materiality of painting is an important one. However, she concludes that "[a]rt criticism, and in particular caricature, whose principal focus is ugliness, gave food a demonstrative function by turning it into a metaphor of medium without art, ignoble craft, and the corruption of aesthetic relation between artwork and spectator," 121. My analysis, which resists subsuming caricature as a negative form of "art criticism," contradicts this conclusion, particularly the idea that caricature's "focus" was "ugliness."

52 "Le Salon pour rire, par Cham," *Le Charivari*, May 10, 1874, 3.

53 A caricature after Puvis's canvases in 1863 shows similar interest in the tension between size and mobility: a prominent half-page caricature of Puvis's *Le Travail* (Work) and *Le Repos* (Rest) shows the latter buckling and peeling off the page, in contrast to the surrounding caricatures which are fixed flat. Hix and Léo Saba, "Salon de 1863.—IIe série: Les caricaturistes à l'huile," *La Vie parisienne*, May 30, 1863.

54 See for example Émile Cohl's caricature after Puvis's *Pauvre pêcheur* (Poor Fisherman), *Catalogue illustré de l'Exposition des arts incohérents* (Paris: E. Bernard et Cie, 1884), 54.

55 On Puvis's relation to fin-de-siècle modernisms, see Jennifer L. Shaw, *Dream States: Puvis de Chavannes, Modernism and the Fantasy of France* (New Haven and London: Yale University Press, 2002); Margaret Werth, *The Joy of Life: The idyllic in French circa 1900* (Berkeley and Los Angeles: University of California Press, 2002), 21–82; and Robert L. Herbert, "Seurat and Puvis de Chavannes," *Yale Art Gallery Bulletin* 25, no. 2 (1959): 22–9.

56 "Charles Martel refuse de se rendre aux lois de la perspective," *Le Charivari*, May 10, 1874, 3.

57 See note 9, above.

Salon Caricature in the Age of Reproduction

Cham's caricature of Delacroix's *Christ en croix* (Christ on the Cross) appeared in *Le Charivari*'s "Revue charivarique du Salon de 1847," the last of a three-year suite in which Cham and Louis Huart collaborated on a caricatural account of the Salon (Plate 14, discussed in Chapter 2).[1] Cham and Huart frame their caricature of Delacroix's painting not as critical attack but as a meeting of individualities, "all the qualities of Delacroix combined with those of Cham,"[2] as Huart wrote.

If Delacroix's "qualities" reside in the dynamic application of paint, and Cham's in its comic exaggeration, then what is the meaning of patches of rigid crosshatching that fill out the caricature around and beneath the Christ figure? Cham puzzlingly transforms the curvilinear whorls of the painted brushstroke into a rectilinear matrix of hashes.

Cham could have caricatured Delacroix's style with exaggerated circular swoops as Bertall would do in remaking Delacroix's *Arabe-Syrien avec son cheval* (Syrian-Arab with his Horse) in 1849 (Plate 11), and as Cham did elsewhere. Instead, his decisive vertical and horizontal slashes intentionally signified the procedures of burin or copperplate engraving, the elaborate, skilled, intaglio process that held the highest position in the hierarchy of graphic media. The hashmark is, to use William Ivins's term, the "syntax" of the burin, which can only describe form with a fixed grammar of interlocking and parallel incisions.[3]

In 1845, Huart had described Cham's caricature after Delacroix's *Sultan du Maroc* (Sultan of Morocco) as "a vague kind of sketch, a little tormented, creased, which no doubt does not draw much, but which hints at all of the beauties one wants."[4] In 1846 this same hash mark had appeared in Cham's three caricatures after works by Delacroix, but nowhere else, and Huart's text, in the case of Delacroix, again highlights Cham as a reproductive engraver who

considers himself a romantic painter: "our great artist Cham has rendered with his ordinary talent, what am I saying! extraordinary, the marvelous effects" of Delacroix's canvas.[5] Across this three-year suite, Huart draws attention to Cham as a hybrid painter-engraver, a skilled copyist who refuses to copy.

Cham and Huart focused on Delacroix but other artists also provoked reflections on the intermediary of reproduction. In their 1847 installment, Huart laments that Cham drew a *charge* of one of Diaz' (Narcisse Virgilio Díaz de la Peña, 1807–1876) "charming canvases" but "the engraver delighted in massacring it," which "deprives us of the pleasure of passing it on to posterity."[6] Even as they admit to the intermediary of a nameless wood engraver, Cham and Huart play the role traditionally given to higher-status engravers in suggesting that posterity will rely on the record of their "Salon illustré"— "I pity posterity!" concludes Huart.

As the genre of Salon caricature coalesced in the following years, this sort of commentary, in which a narrator-figure describes the intermediary acts of reproduction, disappeared. Cham abandoned Huart, the *récit* fell away, and Cham's *Salons pour rire* became gridded sequences of viewing painting. Huart's line of comic discussion would have conflicted with the fiction that emerged of Salon caricature as a direct encounter with painting, and not an experience of reproduction. However, the idea, articulated by Huart in these early years of Salon caricature, that the caricaturist's performance of other media was, in itself, a source of comedy, did not disappear in later years of the genre. Rather, it became a fundamental aspect of Salon caricature's conceit.

In training readers to understand Salon caricature's new approach to painting—precisely a reproduction that leaves much to the imagination—Cham and Huart make the discourse of printmaking a comic subject. To the extent that historians and critics have examined Salon caricature, they have seen an opposition between two forces, journal caricature and Salon art. But as the arc of Salon caricature's development suggests, and as Cham and Huart make explicit in 1845–1847, there is an important third term: the technologies of reproduction that mediated fine art and press imagery. This chapter explores how the changing image technology of the illustrated press, among other factors, shaped the comedy of Salon caricature and its value in the marketplace of images. As Huart understood in conflicted declarations about Salon caricature's legacy to "posterity," there was significant information value to caricature's rapid, warped report of French painting.

In Walter Benjamin's account of nineteenth-century image technology as expressed in "The Work of Art in the Age of Its Technical Reproducibility" (1936), photography's detachment of the original from "the sphere of tradition"

is rapid and irreversible.[7] Lithography serves as a stepping-stone in the instantaneous capitulation of the image to its photographic dematerialization: "Lithography enabled graphic art to provide an illustrated accompaniment to everyday life. It began to keep pace with movable-type printing. But only a few decades after the invention of lithography, graphic art was surpassed by photography."[8] If Benjamin's particular teleology no longer holds sway among art historians, the idea that photographic technology in the press fulfilled the promises of modernity resonates with later print scholarship, particularly that of William Ivins,[9] and with a historical perspective of photography's naturalized dominance in modern media. As Stephen Bann describes, "Benjamin ... forcibly reminds us of the degree to which the historical view of French visual culture was completely reframed in the early twentieth century."[10]

The understanding of Salon caricature suffered from this post-photographic reframing. Théodore Duret, for example, described nineteenth-century caricatures after Courbet's paintings in a 1920 anthology as completely transparent to "the public taste that they faithfully represent."[11] Chapter 7 will take up the criticism of Salon caricature in the fin-de-siècle and early twentieth century, conjured as disembodied, dematerialized, circulating at the speed of laughter (for Benjamin, photographic reproduction allowed the image to "keep pace with speech").[12] This was surely a sense of the image conditioned by the modern experience of photography and of a consumer market for images.

Much recent thinking about the history of nineteenth-century images has worked to complicate Benjamin's narrative. Bann has shed light on the "forgotten world that can be glimpsed in the interstices of these grand [Benjaminian] narratives"[13] in the domain of the reproductive print and its relation to painting. In the register of the illustrated press, Tom Gretton has explored the shifting coexistence of old and new image technologies in the second half of the century. Gretton describes a world of constant technical trial and error, where, for example, as late as the early 1890s the weekly *L'Illustration*, having adopted the halftone screen for art-reproduction (for Ivins, the moment of photographic triumph in the press), then abandoned it for a return to wood engraving.[14] Anne Ambroise-Rendu has shown that in the same magazine, between 1878 and 1889 the total number of illustrations increased by 51 percent, but even by the end of that period only 18 percent of illustrations were "d'après photographie."[15] She dates the successful publication of *L'Illustration*'s first photographic image, produced without a draftsmen or engraver, to 1891, but notes that through the first decade of the twentieth century, photographs were hand-retouched, and the journal still employed and valued highly skilled draftsmen.[16]

The development and proliferation of Salon caricature (roughly 1840–1880) traces a period of sustained tension between photography's rhetorical promise and practical reality in the illustrated press. Evidence suggests that Salon caricaturists did not work off photographs in this period (more below), and yet photography's paradigm of perfection—even if only imagined—heightened the comedy of caricature's play with reproductive foibles and failures.

The illustrated press's relationship to photography in the nineteenth century can be divided roughly into three phases.[17] Between 1840 and around 1855, the illustrated press, unable to adopt photographic technology with any regularity, still relied mostly on wood engraving and lithography.[18] In the 1850s, a series of breakthroughs in chemical and photochemical transfer techniques—notably *gillotage*—permitted lithography or any other print medium to be transferred to a zinc plate for relief etching. From these techniques emerge the photomechanical processes of the 1870s and 1880s. The final decade of the century, following the widespread adoption of the half-tone screen and other related photographic processes, saw a radical acceleration and expansion of photographic illustration in the press in general, and outside the press in books, posters, brochures, and other printed materials.

1840–1855: Salon Caricature in a Pre-Photographic Press

1839 is an important symbolic date for the establishment of the photographic paradigm in the public imagination. That year, François Arago revealed before the Chamber of Deputies in a widely circulated speech the scientific process behind the daguerreotype.[19] In this speech, Arago fantasized about the future applications of this perfect analog copy and cites the painter Paul Delaroche's opinion that photography could furnish study collections for artists more quickly and easily than with a "less perfect method."[20]

Yet "perfection"—the idea of immediate or objective transmission—existed only in the rhetoric around photography, not in its material reality. The daguerreotype was a unique image on a treated plate, like a preindustrial craft. As Mary Warner Marien has described, even after Henry Fox Talbot's calotype produced a negative and therefore could generate multiples, early photographic processes were charged with a range of aesthetic qualities at odds with mere reproducibility. The Daguerreotype had a finely detailed "mirror-like silver surface" while the calotype's paper absorbed chemicals "like a monochrome watercolor."[21]

For the illustrated press between 1840 and 1855, photography constituted an additional source of images. Photographic images, like any other, had to be relief-carved by hand or relief-etched in order to be set into the matrix for journal publication. Wood engraving long dominated press illustration because it was relief-carved and therefore typographically compatible. Thierry Gervais has noted that *L'Illustration* first used a daguerreotype as a source image in August 1843 (to illustrate a report about a fort in Mexico). But the magazine did not regularly use photographic source images—distinguishable as such only by the caption—until the 1850s, with weekly frequency only by 1858.[22]

Salon caricature began its long life in *Le Charivari* by vaunting its qualities as antithetical to the "perfect copy." Cham's antic line, anticipating Baudelaire's critique of photography, left room for the imaginary participation of the reader (Cham's copy "lets one guess at all the beauties one wants …"). The painting of Delacroix was the ideal site, in the 1845–1847 period, for the demonstration of Salon caricature's value because the painter's colorism and sketch aesthetics challenged the traditional linear syntax of engraving (it would later pose problems for photography).[23] Cham and Huart see an opening in the fact that the burin and the photograph, with claims of superiority attaching to both (the former representing the authority of the past and the latter a positivist vision of the future), stumble over modern painting. Introducing readers to the *critique pour rire*, Cham and Huart argue that rapid, incomplete, unfaithful reproduction has real value.

1855–1880s: Transfer Processes and Relief Etching

As an example of Salon caricature from the start of this period, turn to "Nadar Jury au Salon de 1859" (Plate 21), published in *Le Journal amusant* June 4, 1859. By the dawn of the Second Empire, Salon caricature had codified as a graphic press genre (in Grand-Carteret's words, it became formally "monotonous"[24]). From here until its disappearance as a press genre by the end of the century, Salon caricature largely took one of two forms: either the grid associated with Cham (e.g., Figure 5.1)[25] or the "hang" associated with most Salon caricature, including that by Bertall, André Gill, and Nadar.

The journal credits the drawings of "Nadar Jury" to "Nadar and Darjou," text to Nadar alone. More will be said about Nadar, as character and critic, in Chapter 6, but for the present purposes Nadar (Gaspard-Félix Tournachon, 1820–1910) had been contributing caricature to illustrated journals already for nearly twenty

years, while Darjou (Alfred Darjou, 1832–1874) was both an illustrator and painter who had exhibited at every Salon since 1853 and indeed whose painting of a Breton landscape hung at the Salon of 1859.[26] Like *Panthéon Nadar*, Nadar's much-publicized attempt at a series of collective portraits of famous men, of which ultimately only a single sheet was published in 1854, "Nadar Jury" gathers noteworthy figures under the rubric of his own name and fame. The title "Nadar-Jury" underscores "Nadar" as gatekeeper who, like the incessantly decried juries, selects what will be seen.

This particular issue of "Nadar Jury," an eight-page special issue, was color-printed and sold at 30 centimes more than the journal's usual 45-centime cost. Each painting can be identified securely by a combination of number tag (keyed to the number on the painting and in the *livret*), painter and/or title. Nadar's splayed cursive "N"—the logo of his carefully constructed "brand"[27]—occupies the conventional site of the painter's signature at bottom left, within the frame. Outside the frame, the captions indicate that the works are "by [Painter's Name]." At the bottom left of the cover, note the caricature of Jean-Louis Hamon's *L'Amour en visite* (Love's Visit) retitled, "Y A QUEQU'UN! Par M Hamon" ("ANYONE IN THERE? By M. Hamon").

Two weeks later, on June 18, the same journal published a special Sunday edition covering the Salon and featuring what look like soft lithographic reproductions of paintings, including Hamon's *Love's Visit,* prominently placed on the cover like its caricatural precedent (Plate 23, bottom right). This time, the journal labeled its reproduction "*Painted by* Hamon, *lithographed by* Damourette."[28]

These two versions of *Love's Visit*—the caricature and the faithful copy that followed—upend Benjaminian expectations of lithography's value. Nadar's mechanically reproduced cupid posed as the real thing ("by Hamon") claiming for itself, as comic miniature, a whiff of what Benjamin called "aura" or the value that attaches to original works of art. Never mind that paint was applied not by brush but by a mechanical process, or that it was one of many; "Nadar Jury" was the work of a famous Parisian character, posed as painting, and sold at a price that marked it as special.

For Benjamin, lithography's speed was the key to its modernity; for Ivins, it finally did away with the middleman. Yet *Le Journal amusant*'s faithful copy after *Love's Visit* was slower by two weeks to reach the reader and stressed the lithographer as an intermediary between painting and journal. Lithography, typographically incompatible and ill-suited to large print runs due to the degradation of the stone, invoked the albums and journals of bourgeois,

July-Monarchy collecting and connoisseurship—journals like *L'Artiste*, where lithographic reproductions could be pulled out and saved.[29] *Le Journal amusant* played into a taste for lithographic reproductions conditioned by this history, in which the medium adds value with its expert tonal contrasts (Troyon's backlit shepherds) and soft figuration (the fleshy cupid). Hardly harkening an imminent photographic turn, lithography pointed to an earlier, more rarefied relation to print culture.

The June 4 "Nadar Jury" and the June 18 Salon special were part of an integrated economic strategy. Just as Cham and Huart positioned the disobedience and incompleteness of their comic reproduction as an enticement, so "Nadar Jury" would only pique interest for the faithful Salon special arriving in two weeks. In offering two representations of Salon painting so close together, the journal encouraged comparison between the comic version, more starkly linear although still fleshed out with lithographic half-tones, and the softer lithographs to follow. Despite these apparent differences, the June 4 "Nadar Jury" and the June 18 Salon special issue resulted from the same process: *gillotage*, also called *zincographie* or *paniconographie*, discovered in 1850 by Firmin Gillot and adapted for use in the press by the late 1850s.[30] Philippe Kaenel describes the aesthetic and ideological consequences of *gillotage* and related processes:

> All these discoveries accelerate the loss of identity of printing techniques traditionally grouped in three broad classes: intaglio and relief processes, and chemical processes (lithography). Metamorphosed by the applications of galvanoplasty and then by photography, graphic arts enter into the reign of absolute convertibility. Beginning in the 1850s, it becomes in fact possible to translate, or rather to transfer a drawing or an engraving to almost all possible supports, in the three categories above, in the image of "paniconography" which, as its greek name suggest, implies universality. More exactly, "paniconography" is unifying in the sense that it suppresses all specificity in the works which undergo its treatment. It dematerializes the marks (the reproduction of a pen drawing has the same effect as that of a line engraving.) As in so many other processes, gillotage *flattens* them.[31]

"Nadar Jury" and the faithful Salon special were produced by *gillotage*, which converted lithographic source images into relief etchings. If one looks closely, that process has degraded the quality of the lithography: note the grittiness of the Salon special, the appearance of black specks among gray tones.[32] Kaenel's point is an important one: the technique at work in these two journal covers has put in motion a process that will make "images," flattened and stripped of their material difference, out of "lithographs" or "engravings." And yet, Salon

caricature found ample room to assert its particular value over and against the other gillotaged cover. "Nadar Jury" sold itself at a premium; its comic-imaginary encounter with "real" paint was compatible with the refined reproduction that arrived two weeks later.

The transfer process used by the *Journal amusant* in 1859 was likely chemical and not photographic. Neither did photography feature in 1859 as a source of Salon images for Nadar/Darjou. It was ill-suited to the reproduction of painting until a handful of specialists began to make headway with it in the 1860s.[33] From the early 1860s, illustrated journals did employ photographic sources for their engraved reproductions, but the copyist still required contact with the painting.[34] Given the number of canvases caricatured, the speed with which they were published, and the scant level of detail required of the caricature, it is unlikely that Salon caricaturists worked off photographs in this period. It is more likely that they caricatured works directly, or worked off a combination of direct contact and some form of graphic reproduction, for example, the copies drawn for use by wood engravers.[35]

Salon Caricature at the Threshold

We can get a fuller sense of Second-Empire Salon caricature's relation to reproduction from a maquette made for the next installment of "Nadar Jury," published in *Le Journal amusant* on July 16, 1859 (Plate 23).[36] In this maquette, Nadar and Darjou have drawn their caricatures on a lithographic stone and possibly on transfer paper, printed proofs, cut them out, watercolored some of them,[37] and then pasted them on a brown sheet of paper the size of the *Journal amusant*. On this maquette, Nadar scribbles in and fine-tunes the captions.[38]

These proofs reveal a group of skilled writer-draftsmen-painter-printers constructing a little Salon, rich with information, comedy, and color, tinted with the charisma and notoriety of "Nadar." The maquette's traces of hesitancy, change, and incompleteness; scratched-out captions; and last-minute additions evoke the orality of the workshop where the collective identity of "Nadar" was forged.[39] The caricature after canvas number 2093, Gustave-Lucien Marquerie's *Portrait du prince B ...*, is a quickly sketched place-holder that seems to be added late to fill in the row of portraits, balancing out the heftier top rows. (It was ultimately replaced with a more worked-up version with the correct orientation, Plate 24.) We can only speculate as to why the caricature after Joseph Stevens's *Les Boeufs*, top left (the most watercolored), is drawn directly on transfer paper

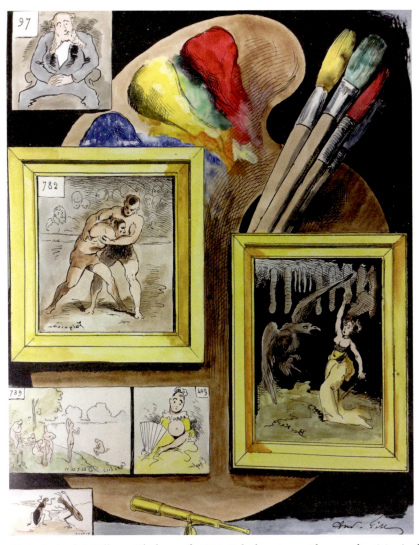

Plate 1 André Gill, untitled proof, 1875. Ink drawing with gouache. Musée du vieux Montmartre

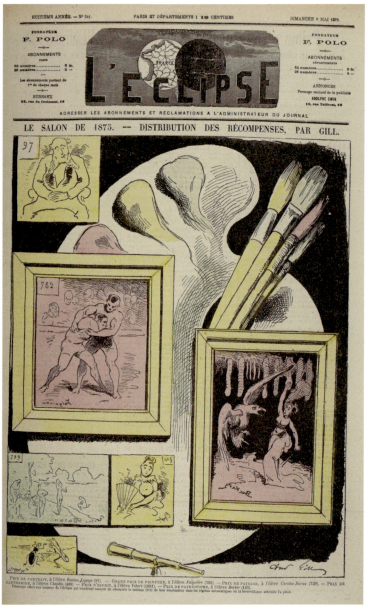

Plate 2 André Gill, "Le Salon de 1875—Distribution des récompenses," *L'Éclipse*, May 9, 1875. Bibliothèque nationale de France

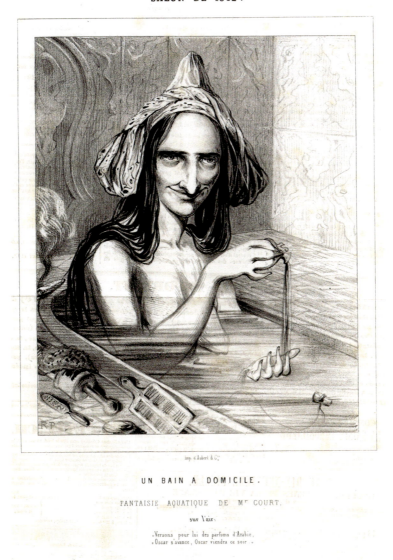

UN BAIN A DOMICILE.

FANTAISIE AQUATIQUE DE Mr COURT,

sur l'air:

«Versons pour lui des parfums d'Arabie,
Oscar s'avance, Oscar viendra ce soir.»

Plate 3 Raymond Pelez, "Salon de 1842. Un bain à domicile. Fantaisie aquatique de M. Court," *Le Charivari*, May 11, 1842. Lithograph. Private collection, Amiens

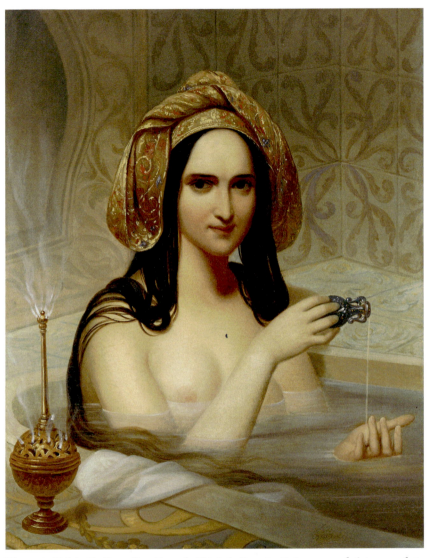

Plate 4 Fidel Gudin after Joseph-Désiré Court, *Baigneuse algérienne*, date unknown. Oil on canvas. Photograph courtesy Sotheby's, Inc © 2005

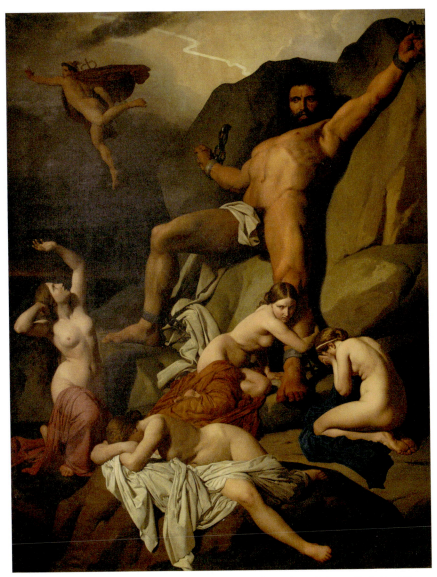

Plate 5 Paul Jourdy, *Prométhée enchaîné sur le rocher*, Salon of 1842. Oil on canvas. 290 × 377 cm. Montauban, Musée Ingres Bourdelle, photograph by Marc Jeanneteau

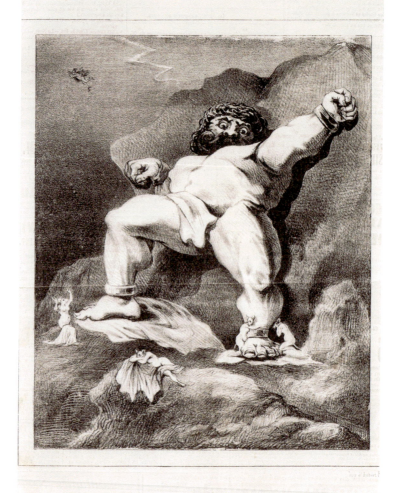

PROMÉTHÉE CHANGÉ EN OUTRE.

Amplification d'Échine par M. Jourdy.

Plate 6 Raymond Pelez, "Salon de 1842. Prométhée changé en outre. Amplification d'Échine par M. Jourdy," *Le Charivari*, May 14, 1842. Lithograph. Private collection, photograph by Damian Griffiths

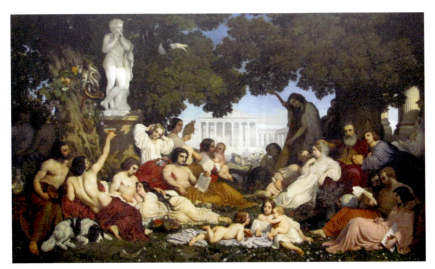

Plate 7 Dominique Papéty, *Rêve de bonheur*, Salon of 1843. Oil on canvas. © musée Antoine Vivenel, Compiègne

904. Un Rêve de **Bonheur**, tableau PAS-PETIT.

Plate 8 Bertall, *Le Salon de 1843 (ne pas confondre avec celui de l'artiste-éditeur Challamel, éditeur-artiste.) Appendice au livret, représenté par 37 copies par Bertal* [*sic*], 1843, page 94. Wood engraving. Houghton Library, Harvard University

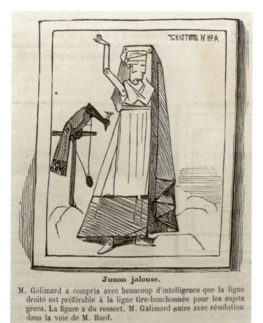

Junon jalouse.

M. Galimard a compris avec beaucoup d'intelligence que la ligne droite est préférable à la ligne tire-bouchonnée pour les sujets grecs. La figure a du ressort. M. Galimard entre avec résolution dans la voie de M. Bard.

Plate 9 Bertall, "Revue comique. Salon de peinture, de sculpture, d'architecture, etc. […]," *Journal pour rire*, July 28, 1849. Detail, caricature after Galimard, Junon jalouse. Wood engraving. Graphic Arts Collection, Special Collections, Princeton University Library

Plate 10 Nicolas Galimard, *Junon jalouse*, Salon of 1849. Oil on canvas. © Jean Lepage, Palais-Musée des Archevêques de Narbonne

Arabe-Syrien avec son cheval, tableau de M. Delacroix.

Othello et Desdemona, tableau de M. Delacroix.
Le moment choisi est celui où le farouche Othello se
présente exaspéré par une atroce jalousie, pendant
que sa dame dort avec vertu et tranquillité. Ce tableau
est sublime.

Plate 11 Bertall, "Revue comique. Salon de peinture, de sculpture, d'architecture, etc. [...]," *Journal pour rire*, July 28, 1849. Detail, caricatures after paintings by Delacroix. Wood engraving. Graphic Arts Collection, Special Collections, Princeton University Library

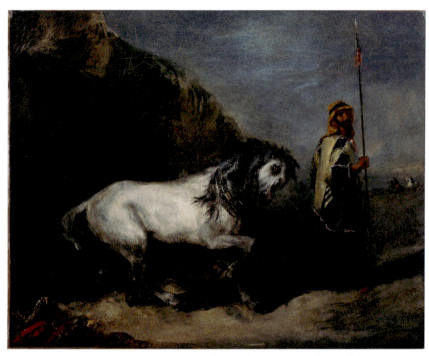

Plate 12 Eugène Delacroix, *Arabe-Syrien avec son cheval,* Salon of 1849. Oil on canvas. The National Museum of Western Art, Toky. Photo: NMWA/DNPartcom

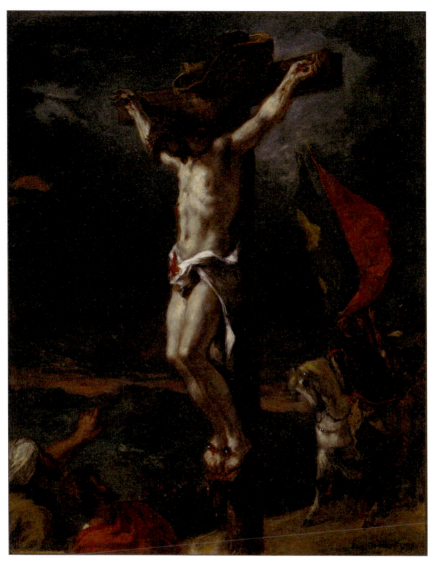

Plate 13 Eugène Delacroix, *Le Christ en croix*, Salon of 1847. Oil on canvas. 80 × 64.2 cm. The Walters Art Museum, Baltimore

Plate 14 "Le Salon de 1847 illustré par Cham," *Le Charivari*, April 9, 1847, page 4. Detail, Caricature after Delacroix, *Le Christ en croix*. Wood engraving. Bibliothèque nationale de France

M. RIBOT.

Le Christ et les docteurs. Où sont les docteurs ? Je ne vois
que des malades et des incurables encore. Voyez plutôt leurs
pieds.

Plate 15 Cham, *Salon de 1866 photographié par Cham*, 1866. Detail, caricature
after Théodule Ribot, *Le Christ et les docteurs*. Wood engraving. National Gallery
of Art, Washington, DC

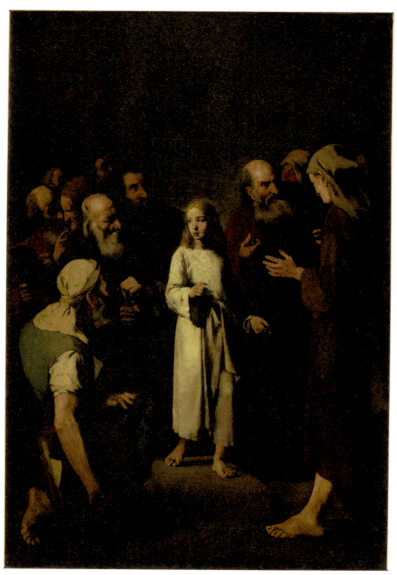

Plate 16 Théodule Ribot, *Le Christ et les docteurs*, Salon of 1866. Oil on canvas. Arras, Musée des beaux-arts. Photo © RMN-Grand Palais (Musée d'Orsay)/Hervé Lewandowski

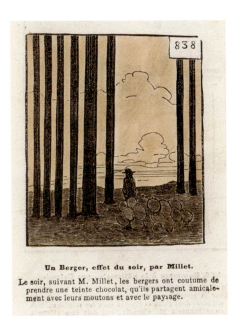

Un Berger, effet du soir, par Millet.

Le soir, suivant M. Millet, les bergers ont coutume de prendre une teinte chocolat, qu'ils partagent amicalement avec leurs moutons et avec le paysage.

Plate 17 Bertall, "Le Salon dépeint et dessiné par Bertall," *Le Journal pour rire,* May 16, 1853. Detail, caricature after Jean-François Millet, *Un berger; effet du soir*. Wood engraving. Private collection. Photograph by Damian Griffiths

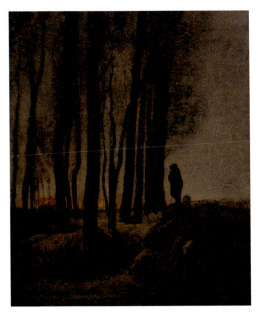

Plate 18 Jean-François Millet, *Un berger; effet du soir*, Salon of 1853. Oil on canvas. 60 × 49.5 cm. Museum of Fine Arts, Boston. Gift of Quincy Adams Shaw through Quincy Adams Shaw, Jr., and Mrs. Marian Shaw Haughton. Photograph © 2021 Museum of Fine Arts, Boston

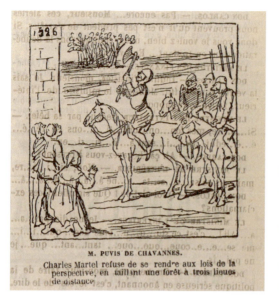

M. PUVIS DE CHAVANNES.

Charles Martel refuse de se rendre aux lois de la perspective, en taillant une forêt à trois lieues de distance.

Plate 19 Cham, "Le Salon pour rire, par Cham," *Le Charivari*, May 10, 1874. Detail, caricature after Puvis de Chavannes. Gillotage. Bibliothèque nationale de France

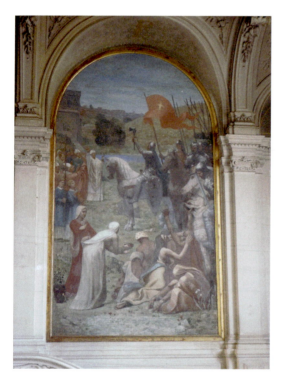

Plate 20 Pierre Puvis de Chavannes, *L'an 732, Charles Martel sauve la chrétienté par sa victoire sur les Sarrasins près de Poitiers*, Salon of 1874. Oil on canvas. Photograph by author

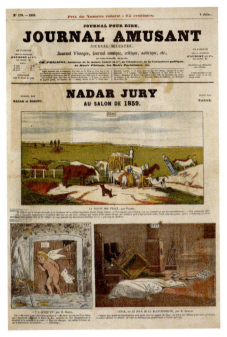

Plate 21 Nadar and Darjou, "Nadar Jury au Salon de 1859," *Le Journal amusant*, June 4, 1859, cover. Gillotage, color print. Bibliothèque nationale de France

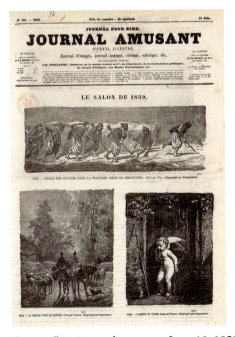

Plate 22 "Le Salon de 1859," *Le Journal amusant*, June 18, 1859, cover. Gillotage. Bibliothèque nationale de France

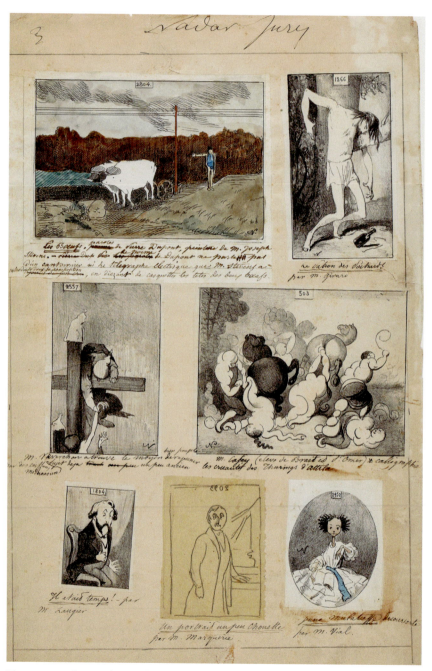

Plate 23 Nadar et al, untitled maquette, 1859. Lithography, graphite, black ink, brown ink, watercolor. 43.6 × 27.9 cm. Paris Musées/Petit Palais, Musée des beaux-arts de la Ville de Paris

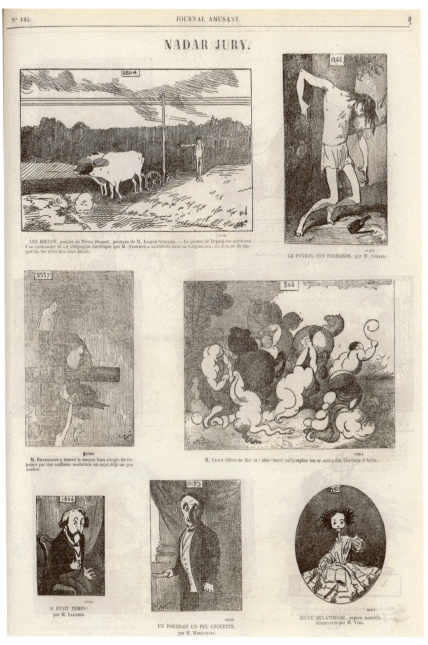

Plate 24 "Nadar Jury au Salon de 1859," *Le Journal amusant*, July 16, 1859. Gillotage. Bibliothèque nationale de France

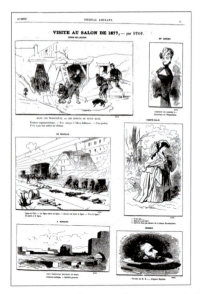
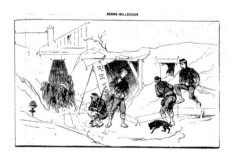

Plate 25 Left: Stop, "Visite au Salon de 1877," *Le Journal amusant*, May 5, 1877, page 5. Line-block print. Bibliothèque nationale de France. Right: Detail, caricature after Étienne Berne-Bellecour, *Dans la tranchée*

Plate 26 Étienne Berne-Bellecour, *Dans la tranchée*, Salon of 1877. Oil on canvas. 92.7 cm × 138.4cm. Art Institute of Chicago, George F. Harding Collection. © Photo SCALA, Florence

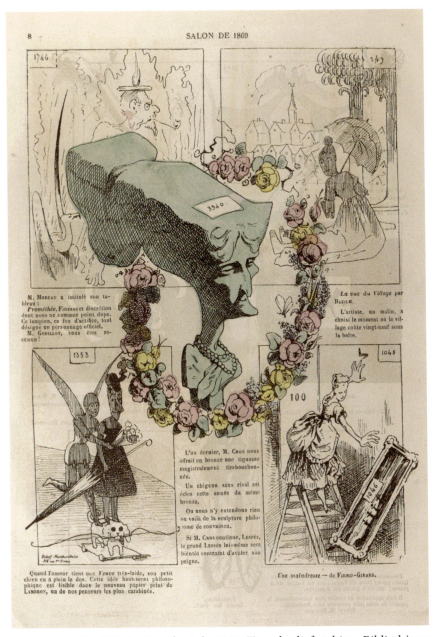

Plate 27 André Gill, *La Parodie*, July 1869. Tinted relief etching. Bibliothèque nationale de France

M. HAMON.

Un escamoteur fait voir le buste de M. Ingres à des en-
fans qui annoncent des dispositions pour le dessin.

Hamon : 1435. L'escamoteur ; quart d'heure de Rabelais.

Plate 28 "Salon de 1861 par Cham et an amateur," n.d. (1861?). Graphite, ink, pasted-in newsprint. Robert B. Haas Family Arts Library, Yale University

Plate 29 Jean-Louis Hamon, *L'Escamoteur*. Oil on canvas. Nantes, musée d'Arts. Photo © RMN Grand Palais/Gérard Blot

Plate 30 Louis Gallait, *Derniers honneurs rendus aux comtes d'Egmont et de Hornes*, Salon of 1852. Oil on canvas. Collection musée des beaux-arts de la ville de Tournai

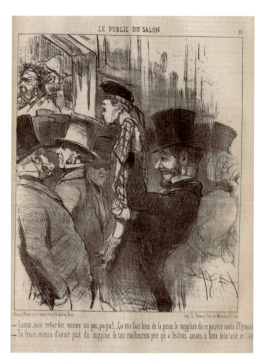

Plate 31 Honoré Daumier, "Laisse-moi regarder encore un peu, papa!… Ça me fait bien de la peine le supplice de ce pauvre comte d'Egmont! —Tu ferais mieux d'avoir pitié du supplice de ton malheureux père qui a les bras cassés à force de te tenir en l'air!" *Le Charivari*, May 29, 1852. Lithograph. Bibliothèque nationale de France

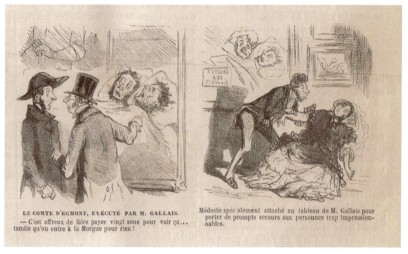

Plate 32 Cham, "Le Salon de 1852. Croquis par Cham," *Le Charivari*, April 18, 1852. Detail. Wood engraving. Bibliothèque nationale de France

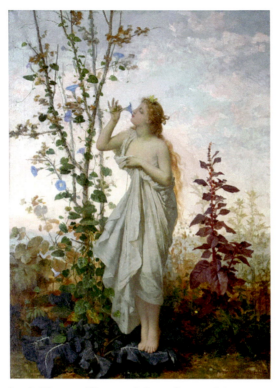

Plate 33 Jean-Louis Hamon, *L'Aurore*, Salon of 1864. Oil on canvas. 111.8 × 81.3 cm. Courtesy Robert Funk Fine Art

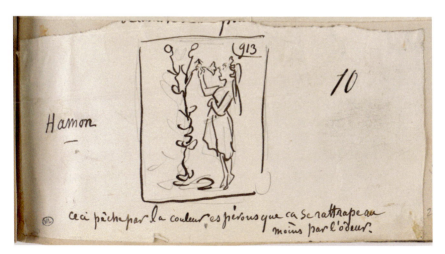

Plate 34 Cham, untitled, 1864. Graphite, ink on paper. Photo © RMN-Grand Palais (musée d'Orsay)/Tony Querrec

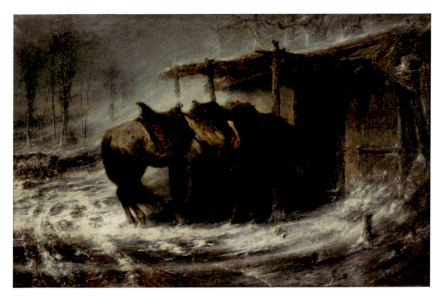

Plate 35 Adolphe Schreyer, *Chevaux de cosaques irréguliers par un temps de neige*, Salon of 1864. Oil on canvas. Musée des beaux-arts de Bordeaux, photo F. Deval

Plate 36 Cham, untitled, 1864. Graphite, ink on paper. Photo © RMN-Grand Palais (musée d'Orsay)/Tony Querrec

Plate 37 Cham, untitled, 1864. Graphite, ink on paper. Photo © RMN-Grand Palais (musée d'Orsay)/Tony Querrec

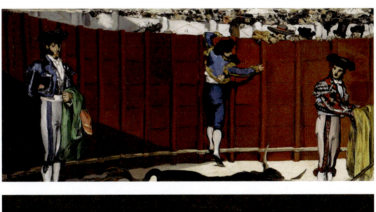

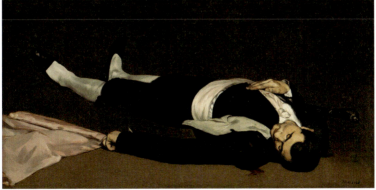

Plates 38 Édouard Manet, *The Bullfight*, 1864. Oil on canvas. © The Frick Collection; and *Le Torero Mort*, 1864 (later reworked). Oil on canvas. 75.9 × 153.3 cm. Widener Collection, National Gallery of Art, Washington, DC

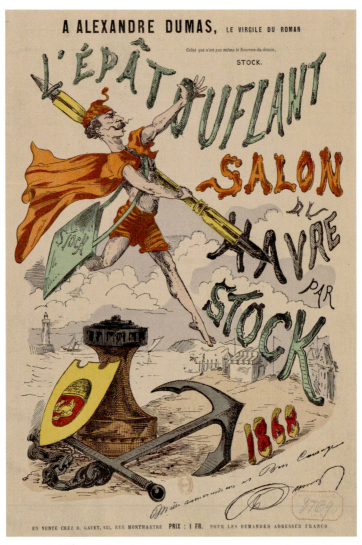

Plate 39 Stock, *L'Épâtouflant Salon du Havre*, 1868. cover. Tinted relief etching. Bibliothèque nationale de Paris

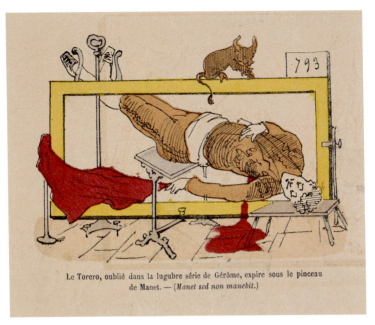

Le Torero, oublié dans la lugubre série de Gérôme, expire sous le pinceau
de Manet. — (*Manet sed non manebit.*)

Plate 40 Stock, *L'Épâtouflant Salon du Havre,* 1868, page 4. Detail. Tinted relief etching. Bibliothèque nationale de Paris

Plate 41 Stock, *L'Épâtouflant Salon du Havre,* 1868, page 8. Detail. Tinted relief etching. Bibliothèque nationale de Paris

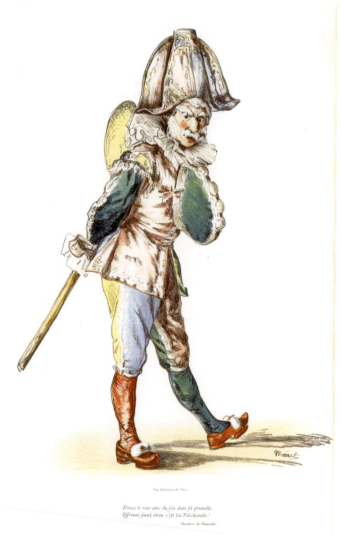

Féroce & rose avec du feu dans sa prunelle,
Effronté, saoul, divin, c'est lui Polichinelle !
Théodore de Banville.

Plate 42 Édouard Manet, *Polichinelle*, 1874. Seven-color lithograph on Japanese paper. National Gallery of Art, Washington, DC. Rosenwald Collection

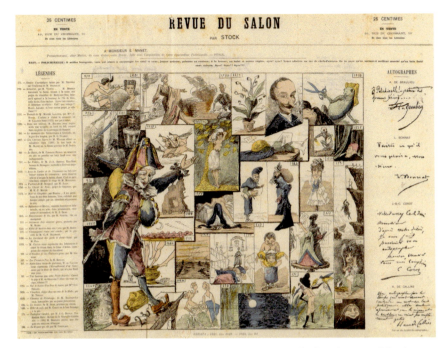

Plate 43 Stock, "Revue du Salon," 1874. Tinted relief-etching. Bibliothèque nationale de France

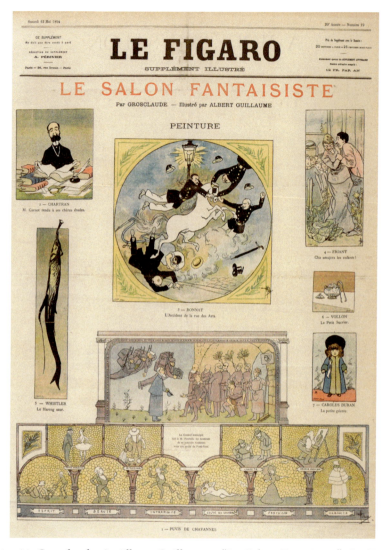

Plate 44 Grosclaude & Albert Guillaume, "Le Salon Fantaisiste," *Le Figaro, Supplément illustré*, May 12, 1894. Bibliothèque nationale de France

(it looks like a pen drawing), while the others are first printed lithographically. It seems plausible that the group was testing the effects of color when applied over transfer drawing versus lithography. Perhaps the joke of the caricature, in which Stevens has painted telegraph wires into his pasture, was better suited to the starker medium of the pen drawing while, say, Daniel Casey's massacre of young women at the hands of Attila[40] made use of lithography's volumetric capacities to exaggerate the dense heap of bodies.

Gillotage submits the pen drawing and the lithograph to the paniconographic regime of "infinite convertibility" described by Philippe Kaenel. Looking at the page as published in *Le Journal amusant* (Plate 24), the ultimate product erases differences between the processes. And yet this maquette reveals, beneath *gillotage*'s smooth conversions, the layering of lithography and relief, of print and paint. The maquette reveals that Salon caricature is still at this point a studio montage practice, defining montage as "combining several pictures or pictorial elements so that they blend with one another."[41] Here, in contrast to the juxtapositions associated with photomontage in its later revolutionary deployment, the term draws attention to the mounting of individual printed elements that the transfer process then "blends" or texturally unifies before the final step of etching.

Jillian Lerner has examined Nadar's interest in montage through the study of a montaged self-portrait—photographic head, drawn body—from around 1855.[42] She calls Nadar's play with montage an investigation of "aesthetic and technical threshold[s]."[43] I can think of no better description for "Nadar Jury," whose comedy dwells in make-believe thresholds, from the threshold of modern technologies limned by Nadar's jokes (the telegraph pole running through the timeless pasture) to the spatial threshold of the Salon.

The reproductive relations at work in "Nadar Jury" are bound up with the spatial imaginary of the exhibition, as the caricature converts the journal page into Salon wall. The application of color as seen in the June 4 "Nadar Jury" and toyed with in the proof made such a fiction particularly seductive. Because color reproduction in the press was a rarity, color dissociates the caricature from the realm of the press multiple.[44] The caricatures cease to be viewed as reproductions; they are literally miniature paintings.[45] The vibrant wash, unlike most modern color-printed images, has an appreciable materiality. The wash sits atop the page, pooling or squashing at the margins, reflecting light differently with a tacky sheen.

It finally makes sense that Nadar/Darjou's caricatural canvases were labeled "By Hamon" and not *d'après*, curiously refusing the usual decorum around reproduction credit. "By Hamon" is, in itself, a punchline. The reader encounters

in the caricature not a copy mediated by chemical transfer or lithographic skill, but the hand of a comic "Hamon," hanging on the wall of the journal page.

As many historians of nineteenth-century France have described, journal culture and new spaces of urban modernity such as the boulevard shared certain qualities: the constant proffering of novelties, the desultory and competing demands on attention, the requirement of a certain set of navigational skills.[46] Salon caricature is a strikingly explicit illustration of the imbrication of readership and spectatorship, the moment when the journal page announces its transformation into a spectacular arena, calling its layout a "promenade" and demanding the reader's assent imaginatively to occupy a particular place. This sense of the page as place set the terms for Salon caricature's singular framing of its own reproductive relations, its desire to heighten the physicality of the imaginary promenade and the pretense of the drawing as painting, desires which work against the rapidity, convertibility, and dematerialization of the press image.

Nadar's placement of canvases does not depict the Salon wall as it was hung; instead, like the administrators of the Salon, Nadar-Jury has the power to rehang the event. Nadar's maquette, then, shares the diminutive, speculative materiality of a curator's maquette, an imagined staging. Its doll-house quality—the moving and gluing of little paintings on a pretend wall—emphasizes that while we may be able to speak of transfer processes dematerializing the final product, the production side of Salon caricature was still in 1859 slowed by the crossing of the thresholds between old and new media.

The Possibilities of the Relief-Processed Line

The press expanded between the 1860s and the 1880s thanks to improved paper-handling technology, the development of distribution networks and points of sale (notably the kiosk), increasing literacy and from 1866 the loosening of censorship enforcement.[47] Most consequential for the story of Salon caricature was, as Tom Gretton succinctly describes, the transformation of *gillotage* from a chemical "handicraft" technique to a photographic one: "In the 1870s, Charles Gillot (Firmin's son) combined [*gillotage*] with photography, making an acid-resistant photographic image of a line or chalk-manner drawing on a zinc litho plate, and then etching down the white areas to produce relief-printing surfaces."[48]

The 1870s ushered in the era of photomechanical illustration, confusingly still sometimes referred to as *gillotage*.[49] Prints need not be converted from other graphic media (e.g., lithography) but instead line drawings were produced

for photo-report to the zinc plate, with no thought of a middle-man and with *gillotage*'s tonal limitations and autographic freedom in mind.

The development of new image technologies in the 1870s changed the way caricaturists produced their images, but despite the increasing availability of photomechanical reproductions in the press, the evidence suggests that Salon caricaturists still worked off direct contact with originals. When the caricaturist Stop (Louis Pierre Gabriel Bernard Morel-Retz, 1825–1899) took over Salon caricature in the *Journal amusant* from Bertall in 1872, he introduced himself as a jester led by a *diable boiteux* or lame devil, a supernatural guide to Parisian sites (Figure 4.1).[50] We can imagine that

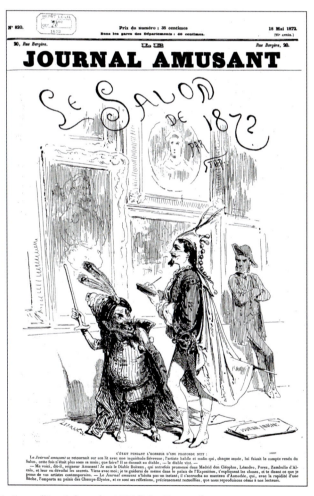

Figure 4.1 Stop, "Le Salon de 1872," *Le Journal amusant*, May 18, 1872, cover. Line-block print. Bibliothèque nationale de France

Stop, a former student of the painter Charles Gleyre at the Académie des beaux-arts and therefore a well-trained copyist, proceeded at the Salon as his caricature suggests, sketching in a little carnet. Painter and illustrator Émile Bayard (1868–1937) recalled having seen Stop do exactly that, not at the Salon but in painters's studios:

> I recall having seen Stop in many studios the day before the *vernissage*, an album in his hand, cold, proper, planted in front of the canvas, visualizing the work in an impassive glance, reflecting a little, and immediately sketching his vision of the glimpsed comedy, which he did not even tell to the artist, who was a little anxious or simply curious.[51]

The Salon caricature that Stop produced for the *Journal amusant* in the 1870s and 1880s, benefiting from the rapidity of photomechanical processes, expanded as the Salon expanded and as faithful Salon reproduction appeared in greater quantities elsewhere. In the 1860s, illustrated magazines such as *Le Monde illustré* and *L'Illustration*, which remained dedicated to Salon-reproduction for their upmarket consumers, regularly reproduced between twenty and forty Salon pictures; in the 1870s–1890s, as they experimented with new formats and techniques, the number of reproductions after Salon paintings could hover in the single digits or reach peaks of 80–100.[52] At their most productive, these magazines were still outpaced by Salon caricature, which is further evidence that caricaturists had to work directly off contact with original canvases (they "reproduced" paintings that simply were not reproduced elsewhere).

In the case of the *Journal amusant*, the abandonment of color-printing in the 1870s suggests a deliberate desire to ramp up speed and scale. Whereas "Nadar-Jury" covered nearly ninety works in two issues in 1859, Stop between 1872 and 1898 regularly covered between 130 and 200 works, spread across four to six consecutive weeks. For consistency and scale, to my knowledge no journal or album publisher beat *Le Journal amusant* in these years, but it was not the only enterprise to demonstrate the value of Salon caricature's information function. A Nantes-based publisher in 1872, for example, produced a seven-album series of Salon caricature covering nearly 150 works at the city's Exposition des beaux-arts.[53]

Turn to a typical page from Stop's "Visite au Salon de 1877," one of a suite of eight installments that monopolized the *Journal amusant* in May and June 1877, covering 213 works (Plate 25). Stop applies his pen-drawing, reproduced

via line-block (a photomechanical relief process for line drawings) with reliable, sequential precision to his graphic "visite."

At first glance, particularly in comparison with "Nadar Jury," Stop's "Visite" lacks any tonal range between unmodulated black and the blank page. The top-left caricature on the page represents Étienne-Prosper Berne-Bellecour's *Dans la tranchée …* (In the Trenches …) (Plate 26),[54] a depiction of an episode from the final days of the Franco-Prussian war. Mysterious letters in Stop's caricature mark the joints of the ruler-traced structures behind the soldiers. The caption explains that these are mathematical notations, awarding Berne-Bellecour a prize for "trigonomic painting" ("peinture trigonométrique"): "It's perfect.—There's not a shadow in the picture." ("C'est parfait.—Il n'y a pas une ombre au tableau.") Berne-Bellecour's flatness and precision had been noted by critics. He had developed these qualities in response to rapid on-site sketching during the war, his training in the Academic studios of Picot and Barrias, and his work as a photographer. One critic, invoking Berne-Bellecour's "implacable" flattening precision not as modernist experiment but as a kind of martial vision, wrote in 1872 that Berne-Bellecour saw through the "wrong end of the spyglass," but an "excellent" spyglass.[55]

"Not a shadow" is a strange joke about a scene that takes place in a ditch. To convert Berne-Bellecour's trench into a flattened blueprint, Stop drains away all the mottled mud that dominates the picture but which line-block would have difficulty trying to capture. The organic mess removed, Stop reveals in Berne-Bellecour's painting a schematic calculation of flatness and its interruption, of solid planes and sudden punctures—notably the dark tunnel at left, and the entrance to the central cave. Line-block does not permit Stop to saturate space with pooled or smudged effects, so he closes off these punctures with hatched grills, like gates, heightening the flattened effect. The reduction of graphic means does not correlate to a reductive or less insightful analysis in caricature. Stop draws attention to Berne-Bellecour's device of the pitched roof, whose gable end is completely parallel to the picture plane and punched through with a dark triangle—it is, as Stop points out, a résumé of the canvas as a whole, the key to solving for its variables.

The "Marchand de Vins" sign at the center of Stop's caricature seems like a joke—as if he has misread the trench as a *cave-à-vins*. Yet with some scrutiny, the viewer will find the same sign in the canvas, stenciled in rust colors on a muddy post of the central lean-to. Surely this incongruous sign attracted Stop to the canvas as subject—its inclusion seems like the move of a caricaturist. But Stop also savored how the stenciled letters lent themselves to the joke of a flattened surface,

a joke that ultimately revealed a sentimental calculus at the heart of the picture. The "Marchand de Vins" sign was the central device of an emotional ambush. Alighting on the text is a jarring moment of reorientation, from horizontal to vertical, from image to text, from muddy depth to surface clarity, from wartime present to peacetime past. The viewer's realization that this trench was not always a trench, that the death and boredom it hosts are radical perversions of a life of normal trade and pleasure is a sudden puncture—poignant, in the truest sense.

In the caricature immediately beneath that of *In the Trenches*, Stop extends the trigonometry joke to another scene from the Franco-Prussian war, Alfred de Neuville's *La passerelle de la gare de Styring—bataille de Forbach, le 6 août 1870* (The Footbridge at Styring Station—Battle of Forbach, August 6 1870).[56] Still dotted with capital-letter variables, the caricature turns railway lines into abstract line segments that ruthlessly organize the picture, and at the same time string up its inhabitants. As in the caricature above, here Stop's mathematic blueprints exploit his medium's own inability to produce shadow, own ineluctable linearity to induce an awareness of those traits in his subjects. The emphasis on medium here is all the more remarkable for Stop's complete disregard of highly sensitive, politically volatile subject matter.[57] The bandage-bound body of the gunner, the young dead of a recent trauma: these are garbled or ignored by the revelations of a line obsessed with line.

My own analysis here is similarly guilty of slicing through the subject of battle painting and its relation to the press image, only to focus on the particularly explicit way in which these military paintings prompted Stop to work his medium. But Stop's geometric joke, generated by these paintings of the Franco-Prussian war, extends lastly to a landscape, a scene outside of Rome by the landscape painter Armand Bernard (1829–1894),[58] subtitled by Stop "Cubic painting" ("Peinture cubique"). "Cubic" as a descriptor comes from what Cham and Huart called the "combination" of the qualities of the caricaturist and the painter, from Stop's ruthless analytic line applied to Bernard's stolid log pile of a landscape.

Of course there is nothing prescient about Stop's identification of "cubic painting." If Salon caricature created, as Denys Riout described, a privileged field for pictorial experimentation,[59] what is significant about Stop's arrival at "cubic painting" is that the very language came not from an accusation about something in the canvas alone but from a persistent exploration of Stop's own stark, abstracting line as an algebraic operation, applied to a range of canvases. Stop found a joke in giving that line an analytic function, particularly applied to an ordinary, even awkward, landscape. Not all of Stop's caricatures were as reflective about medium as the three just discussed (on this page, his caricatures of Louise Abbema's *Portrait de Mme D …* and of Jean-Jacques Henner's *Saint*

Jean are both puns), but this sample has shown how when the press underwent what Kaenel rightly described as a loss of material specificity, caricaturists found inventive ways to make the flattened or dematerialized medium part of—even at times the essence of—their comedy.

Benjamin's version of nineteenth-century media built toward a historical moment in which photography and film could be indispensable instruments of bourgeois critique. The "dematerialization" of the image would lead to a revolutionary overthrow of the bourgeois possession of cult value. Yet photographic technology did not significantly decrease the price of illustrated journals or widen their reach until the 1890s.[60] The *Journal amusant*'s 17-franc subscription price in 1859, for example, had not decreased by 1898.[61] As this chapter has explored, photomechanical processes did not "detach" the work of art from the "sphere of tradition," but instead facilitated surprising mobility between the values, interests, and experiences of the traditional fine arts (painting and printmaking), photography, and those of caricature. Salon caricature was not made or unmade by photography but retained its value precisely as an imperfect reproduction, sometimes analytic, always comic.

Just as the reproduction of fine art in the press managed a tension between its art function and its news function, so Salon caricature exploited its rapidity and expressive means to make laugh but also to show readers the Salon as soon as it opened, to bring them across the threshold of the event. (Recall that "Nadar Jury" reached *Journal amusant* readers in 1859 two weeks before the faithful reproductions.) Lithography and photography are not the most meaningful technologies for understanding Salon caricature. Lithography and wood engraving brought Salon caricature to its first audiences; *gillotage* and then photomechanical technologies facilitated its expansion and acceleration in the press between 1855 and 1880. The collaborative montage practice behind "Nadar Jury" gave way to Stop's lone devil scribbling quickly for photomechanical report to the page. Yet as a deeper examination of Stop's scribbling reveals, the dematerialized line contributed to the development of new visual vocabularies for caricature and its figuration of painting.

This chapter has taken a broad view of reproductive technology and its shaping of Salon caricature's possibilities in the 1840–1880 period. The next chapter extends this investigation, but focuses closely on a comparison between two caricaturists, Cham and Honoré Daumier. Within the same journal, in the same years, with the same range of technical possibilities, these two caricaturists developed contrasting modes of graphic criticism and became conflicting models of art-historical subject.

Notes

1 Cham and Louis Huart, "Revue véridique, drolatique et charivarique du Salon de
 1845, illustré par Cham," *Le Charivari*, April 19, 1845; "Revue drolatique du Salon
 de 1846 illustré par Cham," *Le Charivari*, April 17, 1846; "Le Salon de 1847 illustré
 par Cham," *Le Charivari*, April 1, 1847; "Le Salon de 1847 illustré par Cham," *Le
 Charivari*, April 9, 1847.

2 "… toutes les qualités de Delacroix combinées avec celles de Cham." "Le Salon de
 1847 illustré par Cham," *Le Charivari*, April 9, 1847, 4.

3 William M. Ivins, Jr., *Prints and Visual Communication* (New York: Da Capo Press,
 1969), 61.

4 Cham, "a adopté un genre de croquis un peu indécis, un peu tourmenté,
 plissoté, qui ne dessine sans doute pas grandchose, mais qui laisse deviner toutes
 les beautés qu'on voudra." Cham and Louis Huart, "Revue véridique, drolatique
 et charivarique du Salon de 1845, illustrée par Cham," *Le Charivari*, April 19,
 1845.

5 "Notre grand artiste Cham a rendu avec son talent ordinaire, que dis-je !
 extraordinaire, les effets merveilleux …." Cham and Louis Huart, "Revue drolatique
 du Salon de 1846 illustré par Cham," *Le Charivari*, April 17, 1846, 4.

6 "A [*sic*] propos de peinture de genre, nous devons mentionner de charmantes toiles
 de Diaz, qui sont plus que jamais d'une éblouissante couleur. Pour prouver à Diaz
 tout le cas qu'il fait de son talent notre ami Cham avait dessiné, d'après l'un des
 tableaux de cet artiste une charge que le graveur s'est plu à massacrer. Ce qui nous
 prive du plaisir de le faire passer à la posterité. Je plains la posterité !" *Le Charivari*,
 April 9, 1847, 3.

7 Walter Benjamin, "The Work of Art in the Age of Its Technological Reproducibility
 (second version)," trans. Edmund Jephcott, Howard Eiland et al., ed. Howard
 Eiland and Michael W. Jennings, *Walter Benjamin: Selected Writings, vol. 3: 1935–38*
 (Cambridge, MA: Belknap Press, 2002), 101–33, 104.

8 Benjamin, "The Work of Art," 102.

9 Ivins, *Prints and Visual Communication*. Ivins's influential thesis, first published in
 1953, imports Benjamin's notion of photographic fulfillment to a longer history of
 prints and printmaking. In Ivins's story, the history of visual communication frees
 itself from the "distorting services" and "subjective difficulties" of the engraver
 (121–2) in its progress toward photography's triumphant communication of "exactly
 repeatable pictorial statements" (1–3). In the domain of the press, Ivins sees the
 invention of the half-tone screen at the end of the nineteenth century as the final
 liberation from "syntax," 128.

10 Stephen Bann, *Parallel Lines: Printmakers, Painters and Photographers in Nineteenth-
 Century France* (New Haven and London: Yale University Press, 2001), 9. On
 Benjamin, see pp. 7–11, 15–17. Benjamin's account also undergirds Richard

Terdiman's analysis of nineteenth-century press lithography as a privileged "counter-discourse." Terdiman, *Discourse/Counter-discourse: The Theory and Practice of Symbolic Resistance in Nineteenth-Century France* (Ithaca, NY: Cornell University Press, 1985), 149–97.

11 "Ces charges suggestives qui donnaient satisfaction au goût du public qu'elles représentaient fidèlement, croyons-nous, montreront l'évolution accomplie dans l'opinion." Théodore Duret, "Préface," in *Courbet selon les caricatures et les images*, ed. Charles Léger (Paris: P. Rosenberg, 1920), 2–3.

12 Benjamin, "Work of Art," 102.

13 Bann, *Parallel Lines*, 16. Bann extends this analysis in *Dinstinguished Images: Prints in the Visual Economy of Nineteenth-Century France* (New Haven and London: Yale University Press, 2013).

14 Tom Gretton, "'Un Moyen Puissant de Vulgarisation Artistique'. Reproducing Salon Pictures in Parisian Illustrated Weekly Magazines c.1860–c.1895: From Wood Engraving to the Half Tone Screen (and Back)," *Oxford Art Journal* 39, no. 2 (August 2016): 285–310, 306 and Gretton, "Difference and Competition: The Imitation and Reproduction of Fine Art in a Nineteenth-Century Illustrated Weekly News Magazine," *Oxford Art Journal* 23, no. 2 (January 2000): 145–62.

15 Anne-Claude Ambroise-Rendu, "Du dessin de presse à la photographie (1878–1914): Histoire d'une mutation technique et culturelle," *Revue d'histoire moderne et contemporaine* 39, no. 1 (January 1, 1992): 6–28, 10.

16 Ambroise-Rendu, "Du dessin de presse," 1, 18, 26.

17 For an integrated summary of the development of image technology alongside other aspects like text matrices and paper handling, see Gilles Feyel, "Les transformations technologiques de la presse au XIXe siècle," in *La Civilisation du journal: Histoire culturelle et littéraire de la presse française au XIXe siècle*, ed. Dominique Kalifa, Philippe Régnier, Marie-Ève Thérenty and Alain Vaillant (Paris: Nouveau Monde, 2011), 98–139.

18 On wood engraving and the expansion of the illustrated press, see Patricia Mainardi, *Another World*, 73–118 and Remi Blachon, *La gravure sur bois au XIXe siècle. L'âge du bois debout* (Paris: Éditions de l'amateur, 2001).

19 François Arago, "Rapport à la Chambre des députés," July 3, 1839, in *La Photographie en France : textes & controverses, une anthologie, 1816–1871*, ed. André Rouillé (Paris: Macula, 1989), 36–9.

20 Ibid., 37.

21 Mary Warner Marien, *Photography: A Cultural History* (London: Laurence King, 2002), 23. Carol Armstrong has likewise examined the early photographic image's affective range in *Scenes in a Library: Reading the Photograph in the Book, 1843–1875* (Cambridge, MA and London: MIT Press, 1998).

22 Thierry Gervais, "L'Illustration photographique. Naissance du spectacle de l'information, 1843–1914," PhD thesis, EHESS, 2007, 33–4.

23 On Delacroix and reproduction see Bann, *Parallel Lines*, 116 and Christophe
 Leribault and Fiona Le Boucher, "De Raphaël à Delacroix: l'artiste face aux
 reproductions photographiques," in *Delacroix et la photographie*, ed. Christophe
 Leribault and Fiona Le Boucher (Paris: Musée du Louvre, 2008), 109–20. Michèle
 Hannoosh cites Delacroix's dissatisfaction with photographic reproduction of his
 works in 1853. Hannoosh, "Théophile Silvestre's 'Histoire des Artistes Vivants:'
 Art Criticism and Photography," *The Art Bulletin* 88, no. 4 (2006): 729–55, 733. On
 photography's failures as a comic subject in the press, see Érika Wicky, "Caricatures
 de photographies et photographies caricaturales: La critique photographique dans
 la presse (1850–1870)," in *L'Image railleuse: La satire visuelle du XVIIIe siècle à nos
 jours*, ed. Laurent Baridon, Frédérique Desbuissons, and Dominic Hardy (Paris:
 Publications de l'Institut national d'histoire de l'art, 2019), web.

24 Grand-Carteret, *Les mœurs et la caricature en France*, 552.

25 The grid or *macédoine* used by Cham adapted Salon caricature to the preexisting
 format of the *Revue comique de la semaine*. On the *revue comique* see David Kunzle,
 Cham: The Best Comic Strips and Graphic Novelettes (Mississippi: University of
 Mississippi Press, 2019), 45.

26 Darjou contributed to *Le Charivari, Le Journal amusant, La Lune, L'Éclipse,* and *Le
 Grelot* (see Grand-Carteret, *Les mœurs et la caricature en France*, 635). An undated
 photograph of Darjou by Nadar carries the title "Darjou, peintre." Bibliothèque
 nationale de France, département Estampes et photographie, FT 4-NA-235 (2).

27 Jillian Lerner discusses Nadar's public self-fashioning across media in "Nadar's
 Signatures: Caricature, Self-Portrait, Publicity," *History of Photography* 41, no. 2
 (2017):108–25, 111. On Nadar's self-trademarking, see Anne McCauley, *Industrial
 Madness,* 116–21.

28 "*Peint par* HAMON, *lithographié par* DAMOURETTE." "Le Salon de 1859," *Le
 Journal amusant,* June 18, 1859, cover. Italics in original.

29 On these journals, see Nancy Ann Roth, "'L'Artiste' and 'L'Art Pour L'Art': The New
 Cultural Journalism in the July Monarchy," *Art Journal* 48, no. 1 (April 1, 1989):
 35–9.

30 *Gillotage* was originally not a photographic process but a chemical transfer. It was
 used as the basis for photochemical transfer processes that became common in the
 press around 1870. Jules Adeline, "Procédé Gillot," *Les arts de reproduction vulgarisés*
 (Paris: Librairies-imprimeries réunies, 1894), 126–34.

31 "Toutes ces découvertes accélèrent la perte d'identité des techniques d'impression
 traditionellement regroupées en trois grandes classes: les procédés en creux, en relief,
 et les procédés chimiques (lithographie). Métamorphosés par les applications de la
 galvanoplastie puis de la photographie, les arts graphiques entrent dans le règne de la
 convertibilité absolue. Depuis les années cinquante, il devient en effet possible de
 traduire, ou plutôt de transférer un dessin ou une gravure sur presque tous

les supports possibles, dans les trois catégories précitées, à l'image de la
« paniconographie » qui, comme l'indique sa racine grecque, se veut universelle. Plus
exactement, elle est unifiante au sens où elle supprime toute spécificité aux œuvres
qui subissent son traitement." Philippe Kaenel, *Le Métier d'illustrateur 1830–1880:
Rodolphe Töpffer, J.J. Grandville, Gustave Doré* (Génève: Droz, 2005), 100. (My
translation.)

32 The negative effects of *gillotage* and similar processes on lithographic quality were
no secret. "Relief prints were often 'muddy', lacking much of the subtlety found in
the lithographs from which they were made …. Because of this, Philipon … offered
collectors the opportunity of purchasing separately the lithographs after which
the illustrations in the press had been made." Douglas W. Druick, *La Pierre Parle:
Lithography in France, 1848–1900: Text Panels and Labels for the Exhibition. Ottawa,
National Gallery of Canada, May 1-June 14, Montreal Museum of Fine Arts, July
9–August 16, Windsor Art Gallery, September 13–October 14* (Ottawa: National
Gallery of Canada, 1981), 39.

33 On photographic reproduction of fine art see McCauley, *Industrial Madness*,
265–300; Isabelle Jammes, *Blanquart-Évrard et les origines de l'édition photographique
française* (Geneva: Droz, 1981); Laure Boyer, "Robert J. Bingham, photographe
du monde de l'art sous le Second Empire," *Études photographiques* 12 (November
2002); Pierre-Lin Renié, "The Battle for a Market: Art Reproductions in Print and
Photography from 1850 to 1880," in *Intersections: Lithography, Photography and the
Traditions of Printmaking*, ed. Kathleen Stewart Howe (Albuquerque: The University
of New Mexico Press, 1998), 41–53; and Anthony Hamber, *A Higher Branch of the
Art: Photographing the Fine Arts in England, 1839–1880* (Amsterdam: Gordon and
Breach, 1996).

34 As Tom Gretton notes of art-reproduction in the press, from "the early 1860s the
draughtsman-artists might very well use a photograph of the painting as the primary
resource for the drawing, but, because of the limited spectral sensitivity of the
photographic emulsions then available, they would have to refer also to the painting
itself so that their contour drawing and crosshatching more closely communicated
the tone and forms of the original." Gretton, "Un Moyen Puissant de Vulgarisation,"
292.

35 Early Salon caricature defined itself as having been sketched sur place, as in Bertall's
Salon de 1843 (see Chapter 2); in an issue of *Les Guêpes* that was essentially an album
of Salon caricature, Alphonse Karr describes entering the Salon to find "M. Bertall
occupé à faire ses vignettes" ("M. Bertall busy making his sketches"), *Les Guêpes au
Salon* (Paris: J. Hetzel, Warnod & Cie, 1847), 8. In 1852, Nadar wrote a letter to Jules
de Goncourt asking him to accompany him at the Salon to make decisions about
which works to caricature: "Il y a plusieurs points sur lesquels je ne puis me decider
seul, et vous le comprendrez quand nous en aurons causé sur les lieux." ("There are

several points on which I cannot decide alone, and you'll understand when we've discussed it on site.") Letter from Nadar to Jules de Goncourt, March 1852 (Bibliothèque nationale de France, NAF 22471, f.3). Reprinted in Pierre-Jean Dufief, "Correspondance Goncourt-Nadar," in *Cahiers Edmond et Jules de Goncourt* (n°8, 2001): 213–27, 219. Evidence from the 1870s of the Salon caricaturist Stop working *in situ* is discussed later in the chapter.

36 Originals held at the Petit Palais, Musée des beaux-arts de la Ville de Paris, catalogue number PPD04618 (1–3).

37 The copy of the published version of this issue held in the Bibliothèque nationale de France is in black and white; I have not found a published copy printed in color.

38 As in the June 4 "Nadar Jury" discussed above, *dessins* are credited to Nadar and Darjou, text by Nadar. Because Nadar was responsible for captions, and the proof shows the writer actively engaged in editing, crossing out, and composing, it is probable that Nadar worked on this proof directly.

39 On the role of studio orality in art historiography, see Mark Ledbury, "Trash talk and buried treasure: Northcote and Hazlitt," *The Journal of Art Historiography* 23 (December 2020), 1–21 and Ludmilla Jordanova, "Picture-Talking: Portraiture and Conversation in Britain, 1800–1830," in *The Concept and Practice of Conversation in the Long Eighteenth Century, 1688–1848*, ed. Katie Halsey and Jane Slinn (Newcastle: Cambridge Scholars Pub, 2008), 151–69.

40 Daniel Casey, canvas no. 503, *Cruautés des Thurings de l'armée d'Attila* (Cruelties of the Thurings of Attila's Army) subtitle: *They put to death more than two hundred young girls* (*Ils ont fait mourir deux cents jeunes filles*).

41 "montage, n. and adj." OED Online. Accessed December 2021. Oxford University Press.

42 Jillian Lerner, "Nadar's Signatures," 125.

43 Ibid., 125.

44 Color illustration became more widespread with photomechanical techniques in the 1880s and 1890s. See Annie Renonciat, "Les couleurs de l'édition au XIXe siècle: 'Spectaculum horribile visu'?" *Romantisme* 157, no. 3 (2012): 33–52, 43–4, and for a list of nineteenth-century color techniques, 48–52.

45 *Le Journal amusant* published Salon caricature in color until 1867. Other journals that published Salon caricature in color (often only on the cover) include *Le Grelot, La Lune, Le Hanneton, Le Monde pour rire, La Gill-Revue, La Parodie, Le Bouffon,* and *La Chronique illustrée.*

46 Richard Terdiman argues that the nineteenth-century newspaper converted the citizen into a consumer, information into a commodity, sold with the "ordered disorganization" pioneered in parallel by the department store. *Discourse/Counter-Discourse,* 117–48. Tom Gretton describes how illustrated journals in the 1850–1880 period "found ways of rewarding the activities of lookers rather than readers": "like

the Boulevard, [the journal] offered to those who participated in it a powerful and seductive vision of a commodified modernity." Tom Gretton, "Difference and Competition," 147. Michèle Hannoosh also compares the nineteenth-century consumption of caricature to urban flânerie. Michele Hannoosh, *Baudelaire and Caricature: From the Comic to an Art of Modernity* (University Park, PA: Pennsylvania State University Press, 1992), 4.

47 See note 17, above. On the development of new genres and readers, and the press under the Franco-Prussian war and the commune, see *Histoire générale de la presse française. Tome II. De 1815 à 1871*, ed. Claude Bellanger (Paris: Presses Universitaires de France, 1969), 283–383. Between 1832 and 1865, no more than two significant illustrated satiric journals were launched annually; 1866 saw thirteen new illustrated satiric journals, eleven in 1868, nine in 1869. Philippe Roberts-Jones, *La presse satirique illustrée entre 1860 et 1890* (Paris: Institut français de presse, 1956), 13.

48 Tom Gretton, "Signs for Labour-Value in Printed Pictures after the Photomechanical Revolution: Mainstream Changes and Extreme Cases around 1900," *Oxford Art Journal* 28, no. 3 (January 1, 2005): 373–90, 375.

49 On the history of photomechanical illustration, see Estelle Jussim, *Visual Communication and the Graphic Arts: Photographic Technologies in the Nineteenth Century* (New York: R. R. Bowker Co, 1974) and Gerry Beegan, *The Mass Image: a Social History of Photomechanical Reproduction in Victorian London* (New York: Palgrave Macmillan, 2008).

50 The *Diable boiteux* (Lame Devil) was a supernatural guide to Paris who recurred in nineteenth-century literature. See Priscilla Parkhurst Ferguson, *Paris as Revolution: Writing the Nineteenth-Century City* (Berkeley: University of California Press, 1994), 48, 59–63, and Jillian Lerner, "A Devil's-Eye View of Paris: Gavarni's Portrait of the Editor," *Oxford Art Journal* 31, no. 2 (2008): 235–50.

51 "Nous nous souvenons d'avoir vu Stop dans maints ateliers, la veille du vernissage, un album à la main, froid, correct, planté devant un tableau, envisageant d'un coup d'œil impassible l'œuvre, réfléchissant un peu, et aussitôt croquant sa vision du comique entrevu, qu'il ne communiquait même pas à l'artiste, un peu anxieux ou simplement curieux." Émile Bayard, *La Caricature et les caricaturistes* (Paris: C. Delagrave, 1900), 218.

52 Gretton, "Un Moyen Puissant de Vulgarisation," 290–1.

53 Arthur (Arthur des Varannes), *Exposition des beaux-arts, Nantes. Livret Illustré, album caricatural, par Arthur, 1ère—7e livraison* (Nantes: Imprimerie Soudée, 1872). BnF, département des estampes et de la photographie, Kc MAT 11a.

54 *Dans la tranchée;– mort du sous-lieutenant Michel, Tirailleur de la Seine, à Boulogne-sur-mer (Janvier, 1871).*

55 "Il regarde les choses et les gens par le petit bout de la lorgnette; or, sa lorgnette est excellente, d'une clarté inaltérable, d'une implacable précision." Georges Lafenestre, "Le Salon de 1872," in *L'art vivant: La peinture et la sculpture aux Salons de 1868–1877* (Paris: G. Fischbacher, 1881), 194–306, 278.

56 The canvas was once held at the Musee Péronne, now Musée Danicourt but is presumed destroyed in the First World War.

57 The year 1877 saw the removal from the Salon of a painting related to the war, on the grounds that it jeopardized French-German rapprochement. On the volatility of Franco-Prussian war imagery at the Salon, see Bertrand Tillier, "The Impact of Censorship on Painting and Sculpture, 1851–1914," in *Out of Sight: Political Censorship of the Visual Arts in Nineteenth-Century France*, ed. Robert Justin Goldstein (New Haven; London: Yale University Press, 2013), 79–103, 88–9. See also Robert Lethbridge, "'Painting out' (and 'Reading in') the Franco-Prussian War: Politics and Art Criticism in the 1870s," *Journal of European Studies* 50, no. 1 (March 2020): 52–9.

58 The canvas, no. 179 at the Salon of 1877, was shown as *A Ponte Nomentano;—environs de Rome* (At the Nomentano Bridge; — near Rome). Stop's caricature suggests that the canvas now held at the Musée Ingres Bourdelle, Montauban, under the title *Campagne à la sortie du village de Norma* is either the canvas originally shown at the Salon, or a study for/after it. Bernard was the subject of a 2007 exhibition, *Armand Bernard (1829–1894): peintre paysagiste*, Bourg-en-Bresse, Musée royal de Brou, March 17–June 17, curated by Marie-Anne Sarda and Jérôme Pontarollo. I thank M. Pontarollo for his help in locating the work.

59 Riout, "Salons Comiques," 60–1.

60 Tom Gretton notes that by the "second half of the 1890s," photography had reduced the cost of illustration and expanded its reach: "line-blocks cost about 10 percent of what an equivalent-sized wood engraving had cost ten years before; and newspapers were regularly printing half-tone reproductions of photographs." Gretton, "Difference and Competition," 145.

61 *Le Journal amusant* would not have been widely consumed by Paris's working classes who earned around 3–5 francs per day in the Second Empire and early Third Republic. (Wages increased by just over 2 percent for men and 2.8 percent for women annually between 1852 and 1882.) Roger Price, *People in Politics in France, 1848–1870* (Cambridge: Cambridge University Press, 2004), 286. On the expanding reach of the press, see also Gilles Feyel and Benoît Lenoble, "Commercialisation et diffusion des journaux au XIXe siècle," in *La Civilisation du journal: Histoire culturelle et littéraire de la presse française au XIXe siècle*, ed. Dominique Kalifa, Philippe Régnier, Marie-Ève Thérenty, and Allain Vaillant (Paris: Nouveau Monde, 2011), 181–212.

Gravity and Graphic Medium
in Cham and Daumier

During their near-coeval lifetimes and since their deaths, Cham and Daumier have made an irresistible, near-comic pairing of opposites, biographically as individuals and aesthetically in the work they produced. Even their bodies seemed to be molded for comparison by the hand of a laughing creator—Cham tall and wiry, Daumier a leaden heap.

The two artists published caricatures in many of the same journals and albums, notably *Le Charivari* where they overlapped for almost thirty years (1843–1872). Despite their professional proximity, writers have articulated Cham and Daumier's formal divergence as caricaturists in terms of character, conjuring nearly incommensurable ideas of artistic subjectivity. In an ironic twist, Cham, the son of a count, has become a figure in the history of modern visual culture, a "popular" artist par excellence, a forefather of the comic strip and graphic narrative. Meanwhile, Daumier, artisan-class and staunchly Republican, has entered the artistic élite of modernist discourse and the museum, his name mentioned in the same breath as Rodin and Matisse, his canvases plotting the course of modern art on the walls of the Musée d'Orsay.

Daumier participated in the invention of Salon caricature in 1840 with two single-image caricatures posing as reproductive lithographs after paintings (see Chapter 1), but then abandoned it entirely.[1] The genre of Salon caricature that subsequently developed could not have been more foreign to Daumier's self-constitution as a seeing subject through lithography. A comparative analysis of their Salon-sited caricature rescues Cham from an undeserved reputation for lightness without art-historical significance and sheds new light on Daumier's comedy of visual obstruction and interference. At the same time, a remarkable,

unpublished album of caricatures and other drawings by an anonymous amateur shows how Cham provoked interaction and engagement from his readers, not merely laughter.

The Grain of Sand and the Rock Cliff

Albert Wolff, who knew Cham and Daumier at *Le Charivari*, where he was an editor from 1859 and regularly wrote captions for Daumier,[2] devoted a chapter of his 1886 memoir *La gloire à Paris* to Cham. Wolff's account echoes those of his contemporaries, including Henri Béraldi[3] and the painter Jean-Léon Gérôme.[4] For Daumier,

> the lithographic crayon becomes a weapon of battle; ... this is how he reaches the heights of the grotesque, aided by a prodigious science and an art so great at constructing a human body that sometimes his work makes one dream of the great masters of the past.
>
> The caption was an extra that most often ingenious friends improvised under the drawing; all the value of the work was in the crayon.
>
> Daumier ... hates the bourgeois, and he has only one desire, to portray him as particularly unattractive; ... he also carries at the bottom of his heart a political passion Daumier, like a fairground Hercules, seizes his contemporaries and throws them so heavily on the ground that one hears their bones crack.
>
> He [Cham] will not be conserved in collections, like the lithographs of Gavarni and Daumier, and yet he is one of the premier caricaturists of the century, maybe the most popular of the three
>
> ... Cham strolls across Parisian life without bitterness and without passion, laughing at everything ... ; the crayon is always ready, the wit always alert, with a natural good humor and a great well of goodness that attracted many friends What gave a particular charm to this beautiful unsilenceable humor, it's that it seemed unconscious with Cham; ... he seemed surprised to have said anything witty.[5]

These are men of different mettle with the politics to match, as Wolff goes on to counter Daumier's ardent republicanism with Cham's casual monarchism. Daumier glowers, Cham laughs. Daumier is taciturn and isolated, Cham attracts friends and revels in good company.[6] Daumier's silence falls equally on his lithographs, where captions are a superfluity ("hors d' œuvre") and usually the work of wittier friends, while unsilenceable ("intarissable") Cham is unable to stanch the overflow of his verbal wit. Value in Cham's œuvre straddles text and

image such that stripped of their captions, his caricatures would not take their place in the ranks of French art. For Daumier, "all value lies in the crayon."

Wolff conjures his reader's aggregate memory of Daumier's physiognomic science, invoking the formal properties of Daumier's style, the lithographic chiaroscuro that sculpts Daumier's bourgeois pot-bellies and his saucer-eyed maids. Meanwhile, nothing on Cham's art or science, just his hapless, involuntary laughter. Daumier deploys physiognomy; Cham displays it, as he is "one of the most curious physiognomies of the great city."[7] In part of Wolff's text not cited above, he performs a physiognomic reading of Cham's own face and body, the moustache evidence of his military sympathies—he had studied in the studio of Charlet and loved the figure of the French footsoldier. Wolff made Cham a symptom of Parisian life as much as an agent of its depiction. In contrast to Daumier's timelessness, Cham is the quintessential product of his time.

Michel Melot has traced the process by which the posthumous literature on Daumier created a sanitized, symbolic "republican" by emphasizing and conjoining the classicism of his drawing with notions of oppositional "force" or "power," all present in Wolff's 1886 account.[8]

As for Cham, scholars have productively sought to demonstrate *why* Cham has slipped out of the art historical record, rather than to suggest how he might be reinserted.[9] Wolff's assessment of Cham—which resembles Béraldi's and Gérôme's—has been difficult to dislodge: the weighty, volumetric, physiognomic form that Wolff saw in Daumier (and which critics likened to Michelangelo, Rubens, and Rembrandt)[10] could be washed clean of the street and enter the museum. Meanwhile Cham's artistic qualities did not suffice to tempt anyone's hagiographic impulses. Already in 1879 a critic wrote that he "amused imbecile reactionaries with bad [*incorrects*] drawings."[11] Even for Champfleury, lifelong defender of folk and popular art, Cham was not to be spoken of in the same sentence as Daumier, which would be "to compare the grain of sand ... to the rock cliff."[12]

More damning than the disparagements of critics has been their silence. Cham may have enjoyed greater popularity than Daumier during their lifetimes, but after their deaths monographs and exhibitions devoted to Daumier have multiplied, including the important catalogue raisonné of his œuvre assembled by Hazard and Delteil in 1904,[13] while Felix Ribeyre's 1883 biography of Cham was the last work devoted to the artist until a reprint of his literary parodies was published in 2003.[14]

It has been hard to see Cham's drawing—disparaged already during his lifetime—as anything other than lacking, because of this comparison with

Daumier: lacking physiognomic science and the weight of volumetric depiction, lacking moral gravitas and political conviction (political and aesthetic "inconsistency" were linked already by critics in the 1870s).[15] We accept the account of Cham's artistic subjectivity as merely light, merely laughing—so comic, in fact, that art history cannot make it a stable object for description or analysis. Cham is too contingent, whereas Daumier's twin tethers to the premodern classicism of the Old Masters and to the future modernists in his debt[16] rescue him from the limits of his own time.

This comparison was never fair, because it defined draftsmanship as the "powerful science of physiognomy,"[17] which Wolff identified in Daumier, the modeling of the figure central to classicism and persistent in, for example, the sculptural modernism of Rodin. Cham could never have sustained a critical elevation to classicism because his drawing "showed little regard for academic orthodoxy."[18] This chapter shifts the comparison to a different ground: from that of physiognomic science, to comic vision. Both artists relished and specialized in representing the Salon (and other sites of exhibition), albeit in radically different modes. If writers believed that caricature gave its viewers access to these different notions of artistic subjectivity—the reactionary, weightless laugher and the grave moral anchor—then how did the two figure themselves as spectators, as *critiques pour rire*?

Cham's Open Form

Ségolène Le Men has analyzed the nineteenth-century cliché of Daumier as the "Michelangelo of caricature," arguing that a generative principle of "intermediality" ("intermedialité") allows Daumier "to invest his work in lithography with his experience as a sculptor, painter, and draftsman."[19] Although Cham trained alongside painters in the studio of Paul Delaroche, Cham, unlike other Salon caricaturists such as Oulevay, Doré, Stop, and Gill, never submitted to the Salon. He never, as far as we know, sculpted. Yet I propose that "intermediality" is a generative principle of Cham's work as much as Daumier's. Cham does not invest caricature with the formal qualities of painting or sculpture. Instead, in the genre of Salon caricature his wood-engraving acts as a comic imposter of other media and in turn invites remaking in other media.

Most Salon caricaturists laid out their miniature comic canvases on the journal page to recall a Salon *cimaise* or hung wall, as discussed in Chapter 4, in the case of "Nadar Jury." Cham, on the other hand, assimilates the chaotic hang

of the Salon wall to the rectilinear grid of nine or twelve small vignettes known as a *macédoine*, a format he developed in 1844 for his signature "Chronique de la semaine," disparate scenes of the week's events. (See the *macédoine* in Figure 5.1, discussed below.) Cham did not diverge from this format between his first solo Salon caricature in 1851 until his last in 1878.

The *macédoine*, which permitted the reader to navigate in any direction, differed from the left-right picture stories by Rodolphe Töpffer that Cham had begun his career by copying (his role as the French copyist of Swiss Töpffer is largely responsible for his place in the geneology of the comic strip).[20] Yet at the same time, borrowing from the language of comics, Cham inserts a "gutter space" between paintings in his Salon caricature *macédoines,* zones not to be read as empty wall but as interstices. Hillary Chute and Patrick Jagoda describe the role

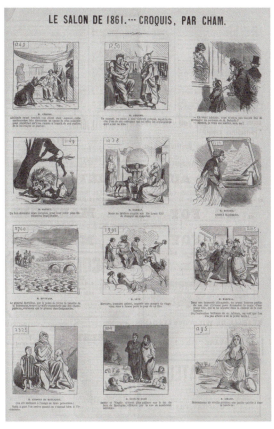

Figure 5.1 Cham, "Le Salon de 1861. Croquis par Cham," *Le Charivari*, May 16, 1861. Wood engraving. Bibliothèque nationale de France

of the gutter space as "interstices that are components of meaning for the reader to fill in or choose to ignore. For this reason, comics ... is a form that gestures at robust readerly involvement; it actively solicits through its constitutive grammar the participant's role in generating meaning."[21] Cham's career-long preference for the *macédoine* highlights, at the fundamental level of the template, how Cham relinquishes control of the reader's direction and invites reader participation.

Cham did not develop a particularly distinctive personal style, unlike, say, the attenuated grace of Gavarni. It is perhaps for this reason that Baudelaire ignores him in "Quelques caricaturistes français" ("Some French Caricaturists," first published in 1857).[22] Cham did not leave enough for critics to lavish language on. Cham was born of plagiarism—at the start of his career he plagiarized the albums of Rodolph Töpffer for the Maison Aubert, and likewise found himself vulnerable to it, as an imposter named Japhet produced an album nearly identical to Cham's after his death.[23] When he began drawing for *Le Charivari*, his single-page lithographic caricatures (as opposed to his wood-engraved vignettes—he produced both) imitated Daumier's hand, and he returned to this Daumier-esque style throughout his career when the subject required.[24]

This stylelessness, in addition to his ability to copy another's hand, must have played into his evident enjoyment of Salon caricature, which he produced more of than anyone except possibly Bertall. Salon caricature, as I've argued across the book, made comedy of the doubling of paint and caricature in a single image, in a single line. But one could equally describe that doubling as a splitting of unitary authorship. For example in a typical installment of Salon caricature from 1861 (Figure 5.1) Cham's name appeared at the top ("Croquis, par Cham") while individual painters's names appear under each canvas (M. Gérome [*sic*], M. Hamman, M. Marchal, etc.) a dual attribution that underlines Salon caricature's comic conceit perfectly.

But in Cham's *macédoines* until around 1870, there is a third author. Cham had a particularly close relationship with Gilbert, his wood engraver from at least 1848 until 1870, around which date most journals including *Le Charivari* adopted the *gillotage* process, which cut out the engraver by transferring drawings to zinc for etching. In a press version of the illustrator-engraver partnerships more associated with the romantic book (Achille Deveria-Thomson or Tony Johannot-Porret) or indeed of historic painter-engraver pairings such as Raphael-Raimondi or Rubens-Bolswaert, Cham had his own dedicated engraver in Gilbert.[25] Ribeyre's 1883 biography of Cham reports that "Gilbert exclusively had the job of engraving the wood drawn on by Cham. All the journals that published Cham's sketches needed the burin of Gilbert, and when Cham moved

to other reproductive means the poor man saw his work disappear."[26] In several undated letters from Cham's personal correspondence likely from the *gillotage* era, he tries to secure work for Gilbert and his daughter, also a wood-engraver, whom he describes as starving.[27]

Gilbert represents a last layer of witnessing and repicturing, one that was not purely mechanical (in fact, fallibly human, in his attachment to Cham). John Grand-Carteret, looking back over Cham's work, noted that Gilbert's engravings were "veritable little masterpieces."[28] It was rare for the invisible figure of the engraver to appear in accounts of nineteenth-century press caricaturists. Historiography's retention of Gilbert in the case of Cham attests to the space that Cham provided for his engraver to share in the making of the final image.

The question of the value of Cham's drawing, deemed "bad" (*incorrect*) already in his lifetime and disparaged ever since especially compared to Daumier, becomes more complex when Gilbert comes out of hiding in the historical account of Cham's work. (Find him underfoot, for example, in the caricature after Gérôme's *Deux augures* [Two Augurs], top row center.) Cham's drawing is drawn to be not just copied but interpreted by his wood engraver; his own pairing of witness and draftsman will undergo yet another process of reception and remaking. Indeed, while it is a commonplace that Daumier's work suffered with the rise of *gillotage*, it has not been noticed that Cham's did, too, although not for the same reason. Gilbert brought a rectilinear discipline to Cham's drawing, which becomes more loopily scribbled post-*gillotage*.

Cham's relation to color also factors into his open, split artistic subjectivity. Many Salon caricaturists, including Bertall, Nadar, and André Gill, used color—mostly printed via stencil or hand-tinted by a colorist—in their Salon caricature. Color, in its material analogy to paint, heightened the caricaturist's double-portrayal of caricaturist and painter. Color increased the value of the image, bringing something of painting's luxury to the reader, could be sold for a premium, and attracted the eye at kiosks.[29]

At the same time, color opened up possibilities for new effects. In an 1869 issue of André Gill's *La Parodie* (Plate 27), Gill ironically depicts painting in black and white while giving sculpture a moss-green wash.[30] The play of color off a colorless ground gives the portrait bust, already drawn like an anvil, added heft and dimension. Read as verdigris the green wash connotes exposure to the elements over time, lending sculpture age and physical durability that stand in contrast to painting's brittle contemporaneity. Nowhere in Cham's thirty-three-year career of caricaturing canvases does Cham use color—not in his albums,

which remained one franc throughout his lifetime, and not in any of his journal caricature, for *Le Charivari* or elsewhere.

I propose that Cham deliberately avoided color in order to maintain the fundamental freedom of his comic convertibility: he could proffer his miniature canvases as paint, as burin reproduction, as ink sketch, and as photograph. In contrast to the medium-specificity of Daumier's lithography as I discuss it below, Cham embraced what we might call medium-promiscuity: a line that could announce itself as paint or engraving or get a laugh for being carved under the title *The Salon Photographed by Cham*.[31]

Finally, Cham's captions were pithy and to the point. They unlocked the joke of the image, rarely exceeding one sentence. Cham was almost never tempted to use the captions as a place to smuggle in the verdicts of the *salonnier*, which would have slowed the speed of reading and the rhythmic pop of his equal-sized, thinly framed pictures.

For John Grand-Carteret, Salon caricature was a genre that provoked critical reflection rather than imposing judgments, either positive or negative. "While perusing [Salon caricature], one makes his mental reflections: 'It is indeed so,' say some, 'it is not that,' think others, and one sees pass before one's eyes a Salon caricatured, the counterpart of the official Salon previously visited."[32] Grand-Carteret wrote this assessment in 1888, nearly a decade after Cham's death, describing an openness to interpretation and a prompt to insert one's own contrary opinion. Cham, as a foundational figure in Salon caricature, modeled this openness for his followers in the genre.

In several instances, evidence has survived of how Cham's readers's response was not only a "mental reflection" but a material record of their own reception. Cham invited the reader to insert herself into the cracks in his authorial voice, pairing reception and graphic output in a mirroring of the caricaturist. In a handmade and unpublished twenty-eight-page album entitled "Le Salon de 1861 par Cham et un amateur" (The Salon of 1861 by Cham and an Amateur),[33] the self-entitled amateur has cut out select Salon caricatures by Cham published in *Le Charivari* that year[34] and pasted them into hand-bound pages that are approximately the size and format of Cham's one-franc albums of Salon caricature. The "amateur" has also copied several paintings and interspersed his drawings with Cham's caricatures[35]—he opens his album with his own ink sketch after Armand-Dumaresq's *Épisode de la bataille de Solferino* (Episode from the Battle of Solferino), (Figures 5.2 and 5.3).[36] As if intuiting Cham's generative method, the amateur works in graphite and then ink, although his composition labors to represent the original painting more comprehensively.[37]

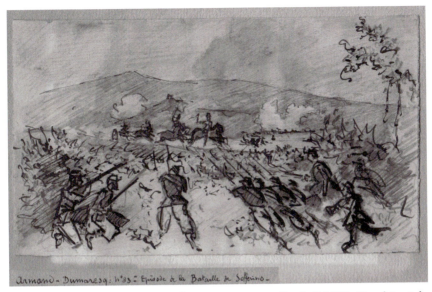

Figure 5.2 "Salon de 1861 par Cham et an amateur," n.d. (1861?). Graphite, ink, pasted-in newsprint. Robert B. Haas Family Arts Library, Yale University

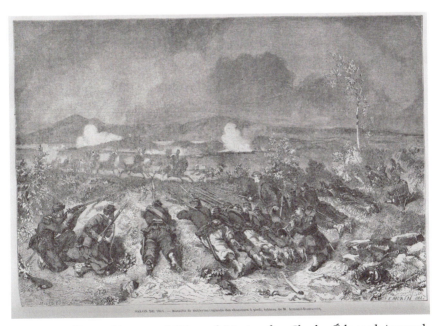

Figure 5.3 Henry Linton and Edmond Morin after Charles-Édouard Armand-Dumaresq, "Bataille de Solferino," *Le Monde illustré*, May 5, 1861. Wood engraving. Bibliothèque nationale de France

The amateur engages with Cham in a number of different ways. He pastes Cham's caricature of Jean-Louis Hamon's *l'Escamoteur* (The Illusionist) with his own version of the canvas below (Plates 28 and 29). Cham's version cuts off the right side of Hamon's more than three-meter-long canvas, converting the girls dazzled by the conjurer's tricks into budding art students inspired by a bust of Ingres. While infantilizing Hamon as a young *Ingriste*, Cham's caricature, turning its inhabitants into amateurs themselves, draws attention to Hamon's painting as a kind of studio exercise. Hamon's chain of varied figures—young and old, male and female, exhibiting a range of emotions—is itself a display of figure studies, like pages from a studio notebook, and therefore a useful model in turn for copying. Perhaps unsurprisingly, the amateur's version is a sincere attempt to sketch the general composition. Irreverent Cham is nonetheless pasted in as a companion for this studious amateur, who makes the caricaturist a guide to his own sincere attempt at graphic reproduction.

On another page of the album, the amateur pastes a caricature by Cham of Antoine Rivoulon's *Bataille de la Tchernaïa (Crimée); épisode du pont de Tracktir, 16 âout, 1855* [Battle of Chernaya (Crimea): episode from the bridge of Tracktir, August 16, 1855], visible in Richebourg's 1861 photograph (Figures 5.4 and 5.5).[38] The amateur decides he can improve on Cham's caption and writes his own pithier one at the bottom of the caricature.[39]

The amateur's rewriting of Cham's caption challenges the long-standing reading of Cham, articulated by Wolff above, as a caricaturist whose drawing would lose all value without his text. Rivoulon's canvas, in attempting to represent an entire regiment, crammed the picture with a vast quantity of soldiers viewed from above. Threaded through with mist, their many heads looked, as Cham observed, like a plateau of proliferating spores. Hence Cham's caption has the General stalling to cross a valley full of poisonous mushrooms.

The drawing depends on *a* caption, if not necessarily Cham's. For the amateur, who we can guess had seen the original at the Salon, judging from his careful study of the paintings shown there, the image is not meaningless without Cham's text. In fact, he can do away with Cham's particular language. Instead, he sees the picture as a prompt for captioning, a game. In the amateur's version ("count the number of heads simply as a distraction"), the General and his men, taking a break from the battle, have turned Cham's landscape into their own game— importantly, a game of seeing and naming.

Cham invited readers to mimic his own material interventions, in both written and pictorial zones. The amateur plays both the sincere newcomer to the studio, engaged in the pedagogical foundation of copying copies, and the smart-

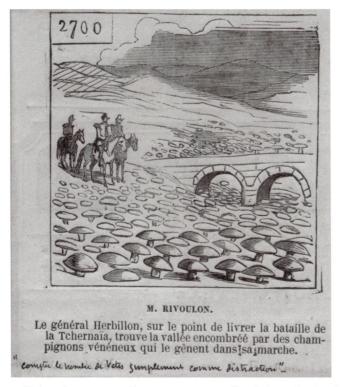

Figure 5.4 "Salon de 1861 par Cham et an amateur," n.d. (1861?). Graphite, ink, pasted-in newsprint. Robert B. Haas Family Arts Library, Yale University

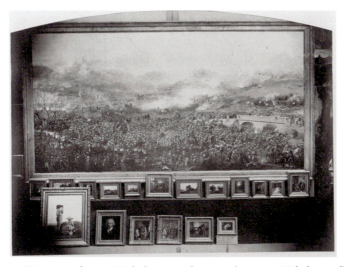

Figure 5.5 Pierre Ambroise Richebourg, *Photographies par Richebourg* [hall des sculptures et cimaises du Salon de 1861], 1861. Photograph. 42 x 53 cm. Bibliothèque nationale de France

aleck journal editor, punching up punch lines without apology. Improving upon, competing with, ultimately testing his own interpretation against Cham's, the amateur remakes on every level, including the final level of the album itself. Cham's split authorial voice and his open form provoke in his reader a response that is itself a pictorial record of reception, the simultaneous representation of artist and viewer, consumer and critic, hand and eye.

As I've discussed, Michel Melot and David Kunzle have provided compelling explanations for how and why Cham was sidelined by art history. My aim here is to anchor these historians's institutional and economic arguments in an account of Cham's self-styled subjectivity as an artist. Cham did not possess Daumier's skill as a draftsman, lithographer, sculptor, and painter. But this album suggests that Cham's "bad drawing" was not merely a lack of skill or the result of an overemphasis on the caption at the expense of visual depth, nor that it represented a light, laughing gaiety that was contrary to serious thought. After all, the amateur uses the framework of Cham's drawings for his own serious attempts to study Salon paintings in ink and pencil. If Cham resists elevation to great art, it is surely, in addition to the reasons cited by Kunzle and Melot, because the intermediality at play in his work depended upon a fracturing and dispersal of his own artistic and critical subjectivity. Cham was lacking as an artist only according to a definition of the artist that demands stylistic individuality and heroic self-assertion, a definition strongly on the rise in the second half of the nineteenth century and culminating in the twentieth century, one according to which Cham was simply a weak draftsman with a superficial wit.

Once we understand Cham's form as open, his style and authority multiple and mobile, Wolff's assertion that Cham's comedy "seemed unconscious," that he was "without passion," essentially without agency, can be understood as something of an accurate formal analysis. Wolff describes a man without a center, without a core, with superficial proclivities but no conviction—this explains why he focuses on the physiognomic description of Cham's exterior. The same language could be applied to Cham's Salon caricature: it initiates a game rather than expressing a conviction. Meanwhile, in contrast to Cham's disaggregated authorship and his dematerialized, medium-promiscuous line, Daumier's embodiment in vision, intense subjectivity, and personal style were read as passion, agency, and gravity.

These observations do not detract from Cham's important legacy in the history of comic books and narrative pictures, but they suggest that this is not his sole legacy, since nothing could be less of a coherent picture-story than the jumble of excisions and addenda that is "The Salon of 1861 by Cham and an Amateur". The

"incorrectness" of Cham's line serves the joke of his medium-promiscuity and, already schematic and collaborative, invites comparative looking, verbal riffing, and a willing intervention.[40]

Daumier at the Salon

This is not the place to take stock of Daumier's rich relation to the Salon in its entirety—as others have noted, a profound awareness of art history and contemporary painting and sculpture run underneath Daumier's caricature, occasionally remaining a subterranean source, occasionally erupting in explicit reference or citation.[41] His lifelong interest in the depiction of spectators also attracted him to the Salon and, along with similar subjects (the theater,[42] sky-gazing[43]), participates in a broader nineteenth-century interest in depicting states of heightened attention.

Yet more so than in images of theater-goers or sky-gazers, Daumier's vision of Salon-spectatorship is subject to blind spots and occlusions. The comparison with Cham, who provides hyperbolic access to the painting, inviting readerly participation and manipulation, highlights in Daumier an underappreciated emphasis on the difficulty of embodied vision, particularly at the public exhibition.

The efforts by a broad range of critics, from the early liberal republicans, to the collector-scholars of the twentieth century, to make Daumier a painter and to detach him from the exigencies of the press, have obscured the extent to which Daumier's lithography was shaped by dialogue with other caricaturists and writers in the journal and in the press at large.[44] It is instructive that after 1841, as the genre of Salon caricature proliferated around him and in the journals that employed him, Daumier never once experimented with producing a *Salon pour rire*. And yet, as the final examples in this chapter show, Daumier's depictions of the Salon share ground with Salon caricature, acknowledge the conditions of spectatorship that helped to motivate Salon caricature, and indeed may have responded to its provocations.

Lithography's Partiality

While Cham's miniature paintings offered themselves to the reader in neat grids of nine or twelve, navigable in any direction by whim, Daumier preserves the spectatorial chaos of the Salon wall, its cluttered hang remaining intact and heaped

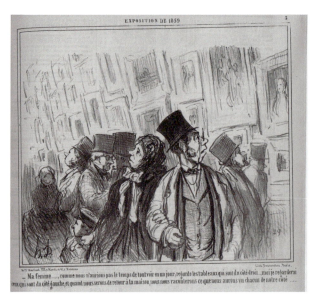

Figure 5.6 Honoré Daumier, "Ma femme … …, comme nous n'aurions pas le temps de tout voir en un jour; regarde les tableaux qui sont du côté droit …, moi je regarderai ceux qui sont du côté gauche, et quand nous serons de retour à la maison, nous nous raconterons ce que nous aurons vu chacun de notre côté … … " *Le Charivari*, April 18, 1859. Lithograph. Bibliothèque nationale de France

weightily upon spectators. In "Ma femme … " ("My wife …," Figure 5.6) from Daumier's 1859 Salon series published in *Le Charivari*,[45] a family is disoriented by the hazy, cobbled grid of painting that mounts atop them—the husband proposes to his wife that they split the Salon, each viewing half. In such moments, lithographic activity itself, sometimes thick like a gritty glaucoma or falling in a thin rain, might be read as a graphic metaphor for interference and confusion.

In contrast to Cham's dematerialization of the image and disaggregation of self, Daumier chooses scenarios in which the unitary, roving body can be mapped in relation to its surrounding space. In "Se posant en connaisseurs" (Posing as Connoisseurs) (Figure 5.7) from his 1852 *Charivari* series "Le Public du Salon," Daumier turns a corner, entering into a gallery at the Palais Royal, so that we feel he might brush the elbow of the man at right while corralled into the free space at left. Antithetical to the "medium promiscuity" I described in Cham, Daumier bores deep into lithography's specific capacities, even redefining those capacities.[46] Yet Daumier's lithographic view of the Salon never delivers unproblematic access to painting or sculpture, often providing only hints, shadows, and parts. For example, in "Posing as Connoisseurs," all of the

usually invisible trussing and mounting on the back of the canvas reveals itself to the viewer; yet, the face of the canvas remains a mystery.

As many have noted, sculpture plays an important part in Daumier's caricature.[47] However, among the prints published under Daumier's Salon series, over 70 percent are about or depict painting, while only about 17 percent are about or depict sculpture.[48] The centrality of the sculptural manifests rather in how the caricatural encounter lends painting the qualities of sculpture (weight, volume, tactility). In "Posing as Connoisseurs," the painting viewed from behind is treated like a sculpture, reaching into the viewer's space. While there is much to say about Daumier's alignment of lithography with the plastic and tactile,[49] what emerges in the comparison with Cham is that Daumier imports to his redepiction of painting the partiality that sculpture enforces on a viewer. In contrast to the plenary availability of the pictorial surface to full view and full re-depiction (exploited and enjoyed by Cham), looking at a sculpture from a point in space only ever yields a partial view.

Louis Gallait's *Last Honors:* Seen and Unseen

Visual obstruction dominates Daumier's approach in a rare instance in which he and Cham caricatured the same specific canvas. In *Le Charivari* in 1852, Cham and

Figure 5.7 Honoré Daumier, "Se posant en connaisseurs," *Le Charivari,* April 24, 1852. Lithograph. National Gallery of Art, Washington, DC. Corcoran Collection (Gift of Dr. Armand Hammer)

Daumier represented Belgian painter Louis Gallait's *Derniers honneurs rendus aux comtes d'Egmont et de Hornes* (Last Honors Rendered to the Counts Egmont and Hornes) (Plate 30), a scene of two sixteenth-century Belgian counts decapitated for participating in resistance to Spanish rule.[50]

Gallait caused a scandal at the Salon of 1852 with *Last Honors*, which was hung at eye level, allowing visitors a gruesome proximity to the severed heads, starkly framed against white pillows.[51] The painter based his depiction on detailed study of the head of a man half an hour after his execution, as he attested in an inscription on the canvas, cutting through the historical fiction to offer contact with contemporary death.[52]

Cham and Daumier both found humor in the canvas's unequal distribution of visual interest. Most of the canvas was a historical genre backdrop while a small portion in the lower corner was magnetically terrifying. In Daumier's "Laisse-moi regarder encore un peu, papa!" ("Let me look a little more, papa!") (Plate 31),[53] spectators swarm the painting. The only part of the canvas that Daumier reveals to the reader of the caricature—the farthest upper-right-hand corner—is merely one of Gallait's own sixteenth-century spectators. He squeezes the Salon viewers and the viewer of the lithograph alike out of the action.

Daumier's "Let me look a little more ... " thematizes visual obstruction on several levels. The father hoists his son, straining to see, who blocks his father's vision. There are no clear vectors of vision among the other spectators's cratered eyes and lost profiles. A sole, mysterious figure at the back of the melée turns away from the canvas to face the viewer of the lithograph in spectacles that Daumier renders opaque.

Taking exactly the opposite approach, Cham imaginatively engages in the kind of cropping and cutting that he encouraged readers to do. He presents the severed heads, denied to Daumier's viewers, with no obstructions, from Gallait's mob or the assembled Salon-goers, and he does so not once but twice in the same *macédoine* (Plate 32). We can almost speak of a zooming effect: in the left-hand vignette ("COMTE D'EGMONT ... "), Cham slices out the canvas-within-a-canvas of the severed heads and enlarges them as if they constituted the entirety of the original painting. He invents a framed headboard that suggests, almost as a liminal image, that the original canvas consists only of these heads. The vignette to the right of it ("Médecin specialement attaché ...," ["Doctor specially posted ... "]) maintains this zoomed-in cropping, with no concern for the reversed orientation, further schematizing the heads as they move from one vignette to the next in the macédoine, manipulable and mobile.[54]

Cham's viewers, like graphic VIPs, have unfettered access to the canvas; the Salon mob has been removed for them. They are cursory stand-ins who map the range of possible reactions (the men, not moved at all, discuss the cost of entry while the woman, too moved, passes out). In contrast, Daumier suspends vision, locating it specifically in the straining body, as the caption reinforces. The boy attests that the "torture" of the poor count "causes me a great deal of pain" while the father retorts that his own arms are breaking.[55]

Cham and Daumier ultimately make similar jokes, using the same comic device of pictorial rhyming. Cham's contemporary spectators's paired heads rhyme with the scowling decapitated ones. The contemporary bourgeois are, in their obvious parallelism, degraded, trivialized descendents of the heroic counts. Similarly, the father's profile in Daumier's "Let me look a little more … " repeats the profile of the Belgian spectator in the corner of the canvas. Just as Cham's spectators are modern derivatives of the dead counts, Daumier's are modern derivatives of the historical onlookers.

So much has been made of Cham's gaity versus Daumier's gravity; yet, their jokes here are structurally similar. The Gallait comparison, then, allows us to see more clearly how the differences between the two come down to the way graphic medium manifests visual reception. It makes visible Daumier's effort to lodge Salon-spectatorship in a body, with all its physiogloglical vulnerabilities (fatigue, strain) and limitations (distance, obstruction)—an effort that is absent from Daumier's scenes of art-lovers communing with their prints in the privacy of their homes or in intimate print shops.[56] Daumier's investment in visual strain and obstruction runs counter to the recalcitrant nineteenth-century characterization of him as "Renaissance man" whose vision—classical, informed by the techniques of the old masters—represented knowledge about its subjects.[57] As Melot has described, posthumous critics combined Daumier's "power" with his classical drawing to create an alloy that was symbolically oppositional but sanitized of real politics. Daumier's caricature exerted force; as Wolff wrote, it cracked bones. It has been difficult therefore to see Daumier not only applying physiognomic science to a body's exterior, but projecting himself to its interior; not only as "mobile and panoptic device"[58] but as limited perambulatory body; not only cracking bones but inhabiting them.

In contrast to Daumier's voyeuristic presence in the omnibus or at the theater, where spectators in a momentary loss of self-possession become vulnerable to the caricaturist's keen, active eye, Daumier's Salon-sited lithographs deny their readers superiority over the subjects they see. As "Let me look a little more, papa!" exemplifies, those subjects include children and women as often as the

male connoisseurs who experience part-blinding. Remarkably, half of Daumier's Salon series take up couples and families, not merely laughing at the family unit from a distance but wedging perception in the lived intimacy between couples, literally in the case of "Ma femme … " (Figure 5.6), where husband and wife take on stereoscopy as a marital project (husband as left eye, wife as right).

One particular caricature from Daumier's 1859 Salon series, "Viens donc …" ("Come along …, " Figure 5.8), offered uncharacteristic access to a complete canvas. The Parisian pharmacist, tugged along by his wife, is convinced that "this canvas no doubt represents the trial of a new medicine."[59] The painting swells toward the pharmacist like a sculpture, a move that would usually result, in Daumier's hands, in the canvas's part-occlusion.[60] But strangely, in this case, the sculptural canvas remains fully in view, a bas-relief tilted toward the viewer. Just as Cham subtly manipulated the framing of Gallait's heads, Daumier, through a confusion of painted and carved frame, encourages the perception of the cupid's wing as emerging dimensionally outside the frame.

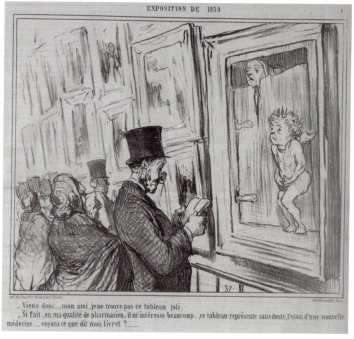

Figure 5.8 "—Viens donc …, mon ami, je ne trouve pas ce tableau joli. —Si fait, en ma qualité de pharmacien, il m'intéresse beaucoup …, ce tableau représente sans doute, l'essai d'une nouvelle médecine. …. voyons ce que dit mon livret?" *Le Charivari*, June 21, 1859. Lithograph. Bibliothèque nationale de France

Daumier may have seen this particular cupid animated before he submitted his own version to *Le Charivari*. Although Daumier gives no clues to the canvas's identity and indeed it has not, to my knowledge, been named by art historians, it is unmistakably Jean-Louis Hamon's *Amour en visite* (Love's Visit), which Nadar had prominently caricatured on the cover of *Le Journal amusant* just over two weeks prior (Plate 21).[61] Nadar had made the little cherub into a twofold menace, politically (he held a copy of the pro-Empire *La Patrie*) and sexually (the suggestion that cupid might use the stick to force his way in, which the caption exclaims is "shocking!") Daumier's cupid is as far from Nadar's as one could imagine—not menacing but menaced; instead of trying to break further into the canvas, Daumier's cupid is shut out. If Daumier's "Viens, donc … " was a response to Nadar's version, it represented a desire, like that of the amateur scratching out Cham's caption, to spin an entirely new joke off the same subject.

Daumier's selection of Hamon's picture, which was not a Salon scandal, and his curious, atypical re-depiction of the full canvas, suggests that Nadar may have baited him into redepicting it. Perhaps Nadar only led him to *Love's Visit* and showed him the comic potential, opening up, as Cham had for his readers, games of seeing and naming. Daumier's pharmacist can easily be read as a jab at the stock bourgeois who can only perceive art through the filter of his trade. But when the painting's identity and its life in the press come to light, the pharmacist is also, like a reader of Salon caricature, in thrall to a comically disobedient imagination.

As Elizabeth Childs has described, *Le Charivari* operated as a polyvocal assembly where "diversity of speech" is "the ground of style."[62] There is much more to say about how Daumier's representation of vision with its attendant vulnerabilities was shaped by this diversity. The role of written critics like Louis Leroy, whose comic dialogues in 1859 for example conjured Salon spectatorship as a dreamscape in which paintings sprung to life, also deserves attention.[63] For the present purpose, these moments of both contrast and rapprochement between Cham and Daumier remind us that they generated their divergent models of artistic subjectivity in relation to each other and to shared precedents like Nadar.

History may have proved Cham's model of graphic subjectivity continuous with more interactive and "low"-cultural platforms like comics, and even with today's rampant cultures of digital manipulation and meme-creation, while Daumier's density and delimitation, his interrogation of perception itself belong to a history of modern painters. Nevertheless, during the years of their graphic output, their antithetical models both relied on and responded to

Salon spectatorship as vulnerable to disorientation and difficulty. Cham gave his readers a fantastical power to manipulate the objects of their gaze, while Daumier heightened and shared their limitations. The next chapter explores how spectatorial difficulty at the Salon was a fundamental motive for Salon caricature, which can be mined for a better understanding of the exhibition as a chaotic psycho-perceptual and physical challenge.

Notes

1 Honoré Daumier, "Le Salon de 1840. Ascension de Jésus-Christ," *La Caricature*, April 26, 1840. Republished in *Le Charivari*, April 1, 1841. "*PELERINAGE DE ST. ROCH. d'après le tableau original de PÉTRAL VILERNOMZ.*" *La Caricature,* April 5, 1840; republished in *Le Charivari,* April 7, 1841. See Chapter 1.

2 Gustave Toudouze, *Albert Wolff: histoire d'un chroniqueur parisien; portrait par Bastien Lepage* (Paris: V. Havard, 1883), 115.

3 Henri Béraldi, *Les graveurs du XIXe siècle; guide de l'amateur d'estampes modernes*, t.4 (Paris: L. Conquet,1886), 75–81.

4 Jean-Léon Gérôme, "Cham," preface to *Les folies parisiennes; Quinze années comiques, 1864–1879* (Paris, C. Lévy, 1883), 7–16.

5 … chez lui, le crayon lithographique devient une arme de combat; … c'est ainsi qu'il atteint le summum du grotesque, tout en étant servi par une science prodigieuse et par un art si grand de construire un corps humain que, parfois, son œuvre fait rêver aux grands maîtres anciens. Ici, la légende devient un hors-d'œuvre que, le plus souvent, des amis ingénieux improvisaient sous le dessin; toute la valeur de l'œuvre est dans le crayon.

 Daumier … déteste le bourgeois, et il n'a qu'un désir, c'est de le montrer particulièrement déplaisant; … il porte aussi au fond du cœur une passion politique …. Daumier, comme un Hercule de la foire, saisit ses contemporains et les jette si lourdement sur le sol, qu'on entend craquer les os.

 On ne le conservera pas [Cham] dans les collections, comme les lithographies de Gavarni et de Daumier, et cependant il devient l'un des premiers caricaturistes de ce siècle, peut-être le plus populaire des trois. …

 Cham se promène à travers la vie parisienne sans amertume et sans passion, riant de tout ….[L]e crayon est toujours prêt, l'esprit toujours en éveil, avec une bonne humeur naturelle et un large fond de bonté qui lui attirait toutes les amitiés. … Ce qui donnait un charme tout particulier à cette belle humeur intarissable, c'est qu'elle semblait inconsciente chez Cham; … il semblait tout surpris d'avoir dit un mot d'esprit." Albert Wolff, *La gloire à Paris* (Paris: Victor-Havard, 1886), 80–5.

6 Félix Ribeyre describes Cham's regular and lively dinner parties of artists and writers, listing many in his wide social circle. *Cham : Sa vie et son œuvre* (Paris: Librairie Plon, 1884), 251–6.

7 " … une des plus curieuses physionomies de la grande ville." Wolff, *La gloire à Paris,* 78.

8 "As far as Daumier was concerned, the notion of quality was established on two criteria: on the one hand, a taste for 'power' allied, on the other, with 'correction' in drawing." Melot and Neil McWilliam, "Daumier and Art History: Aesthetic Judgment/Political Judgment," *Oxford Art Journal* 11, no. 1 (1988): 3–24, 10.

9 David Kunzle has argued that fate was in the form. The mere fact that Cham published over 40,000 drawings in the press compared to Daumier's 4,000 challenges any would-be Delteil to catalogue Cham's œuvre. Kunzle, *History of the Comic Strip,* 72–99. See also Elizabeth Childs, *Daumier and Exoticism: Satirizing the French and the Foreign* (New York: Peter Lang, 2004), 27–33.

10 Henri Béraldi compiled a list of artists (mostly Old Masters but also the lithographer Charlet and "The Flemish") to whom critics had compared Daumier in *Les Graveurs du XIXe siècle,* t. 5 (Paris: L. Conquet, 1885–1892), 100–1. Ségolène Le Men provides a modern resumé of such comparisons in "Le 'Michel-Ange de la caricature,'" *Daumier: L'écriture du lithographe [catalogue de l'exposition présentée à la Bibliothèque nationale de France, site Richelieu, du 4 Mars au 8 Juin 2008]* (Paris: Bibliothèque nationale de France, 2008), 21–30, 21.

11 "Cham … amusait les réactionnaires imbéciles avec des dessins incorrects." J. Bérard, *La Marseillaise,* 1879. Quoted in Melot and McWilliam, "Daumier and Art History," 10.

12 Claude Bellanger cites an article by Champfleury in *Le Charivari* from July 18, 1867 in which the following comparison appears: "On ose à peine prononcer le nom de Cham à côté de Daumier; ce serait comparer le grain de sable au rocher de la falaise." *Histoire Générale de la presse française,* t. II, ed. Claude Bellanger (Paris: PUF, 1969), 303. This citation has been repeated elsewhere, e.g., by Childs, *Daumier and Exoticism,* 33. I have not been able to locate any such article in *Le Charivari* on that date or in its proximity. However, a slightly different version of the phrase appears in Champfleury's *Histoire de la caricature moderne* (Paris: E. Dentu, 1885), 175: "On ose à peine prononcer le nom de Cham à côté de Daumier; ce serait comparer le grain de sable de la plage au rocher de la falaise."

13 Loys Delteil and Nicolas-Auguste Hazard, *Catalogue raisonné de l'œuvre litographié de Honoré Daumier* (Orrouy: N. A. Hazard, 1904). For a list of Daumier exhibitions between 1845 and 1999, see *Daumier, 1808–1879,* 588–93. Updated records of exhibitions and a comprehensive bibliography can also be found at Daumier.org.

14 Bertrand Tillier, *Parodies littéraires: précédé par Cham, le polypier d'images* (Paris; Jaignes: Phileas-Fogg; La Chasse au Snark, 2003). David Kunzle has addressed the historiography of Cham, most recently in *Cham: The Best Comic Strips and Graphic Novelettes, 1839-1862* (Mississippi: University Press of Mississippi, 2019). Cham, prolific as he was, has provided a wealth of imagery, which has been useful to scholars as social/historical data. Hollis Clayson, e.g., discusses Cham as "exceptionally inventive" in his comic treatment of modern street lighting. Clayson, "Bright Lights, Brilliant Wits: Electric Light Caricatured," in *Illuminated Paris: Essays on Art and Lighting in the Belle Époque* (Chicago and London: University of Chicago Press, 2019), 55–98, 66. Elizabeth Childs noted Cham's racial insensitivity in *Daumier and Exoticism*, and Darcy Grigsby has more forcefully drawn attention to the racism running through his social caricature in "Cursed Mimicry: France and Haiti, Again (1848–1851)," *Art History* 38, no. 1 (2015): 68–105 and "Still Thinking about Olympia's Maid," *The Art Bulletin* 97, no. 4 (2015): 430–51. My discussion of Cham in this chapter, and in the book more generally, does not constitute a defense of the artist or his use of caricature against these characterizations. On the contrary, an account of Cham's approach, his specificity as a caricaturist, his attention to superfice, and what this chapter describes as his "open form" will be necessary to better understand Cham's production and marketing of racist imagery and racial stereotype in this period.

15 Melot and McWilliam, "Daumier and Art History," 10.

16 Scholars have located Daumier's influence widely across art history. See, for example, Ada Ackerman, *Eisenstein et Daumier: des affinités électives* (Paris: Armand Colin, 2014). Melot cites the German interest in Daumier which comes out of the link with expressionism ("Daumier and Art History," 19–20) while Le Men cites Daumier's impact on illustrators, including André Gill, Caran d'Ache, Steinlen, Forain, and Toulouse Lautrec, and painters, including Courbet, Manet, Degas, Cezanne, Rouault, Picasso, Esnor, Nolde, and Bacon; Le Men, "Daumier and Printmaking," *Daumier, 1808-1879*, 32–45, 44–5. Édouard Papet traces sculptural debts to Daumier in Rodin, Hœtger, Dalou, and Giacometti, "He also does Sculpture," *Daumier, 1808–1879*, 46–59, 58–9.

17 It is important to distinguish between the Lavaterian physiognomy that I identified as an "engine" of Salon caricature in Chapter 3 and the "physiognomic science" associated with Daumier. The former was a method first for analyzing people and then for schematically drawing them which emerged from Johann Casper Lavater's *Physiognomic Fragments* and related works in the early nineteenth century. In contrast, Daumier's "physiognomic science" was understood as a mastery of the volumetric modeling of the figure that is central to classicism.

18 Melot and McWilliam, "Daumier and Art History," 7.

19 " … à invester son œuvre de lithographie de son expérience de sculpteur, de peintre, et de dessinateur." Ségolène Le Men, "Le 'Michel-Ange de la caricature,'" 21.

20 See Patricia Mainardi, *Another World*, 119–57; David Kunzle, *The History of the Comic Strip*, 72–99; and *Father of the Comic Strip: Rodolphe Töpffer* (Jackson, MI: University Press of Mississippi, 2007), 143–54. On the correspondence between Cham and Töpffer, see *Bande dessinée: son histoire et ses maîtres*, ed. Thierry Groensteen (Paris and Angoulême: Skira Flammarion, 2009), 231–9.

21 Hillary Chute and Patrick Jagoda, "Comics & Media," *Critical Inquiry. A Special Issue: Comics & Media*, ed. Hillary Chute and Patrick Jagoda (Chicago: University of Chicago Press, 2014), 1–10, 4.

22 Charles Baudelaire, "Quelques caricaturistes français," *Le Présent*, October 1, 1857. Reprinted in *Œuvres complètes*, t.II, ed. Claude Pichois (Paris: Gallimard, 1976), 544–63. Baudelaire wrote about Carle Vernet, Pigal, Charlet, Daumier, Monnier, Grandville, Gavarni, Trimolet, Traviès, and Jacque.

23 Amédée de Noé took the pseudonym Cham, one of the sons of Noah, in reference to his surname, which translates as "of Noah." The pseudonym "Japhet," a reference to one of Cham's brothers in the Bible, is an open joke about the album as a plagiarism of Cham. See Japhet, *Le Salon pour rire de 1883* (Paris: Imprimerie Nilson, 1883).

24 See, for example, *Album du siège par Cham et Daumier* (Paris: Bureau du Charivari, 1871), containing all single-page lithographic caricatures in which Cham's hand takes on the characteristics of Daumier's.

25 On the partnerships engendered by wood-engraved book illustration, see Remi Blachon, *La gravure de bois au XIXe siècle. L'âge du bois debout* (Paris: Éditions de l'amateur, 2001), 53.

26 Félix Ribeyre, *Cham: sa vie et son œuvre* (Paris: Librairie Plon, 1884), 249.

27 NAF 14903, collection Ancante, F 15 -17.

28 " … de veritables petits chefs-d'œuvre …." John Grand-Carteret, *Les mœurs et la caricature en France*, 348. He notes a significant difference between those engraved by Gilbert and Clément, another engaver.

29 See discussion of color in Chapter 4. John Grand-Carteret described how the new journals that cropped up after 1866 used a four-color wash on their covers to stand out at kiosks. Grand-Carteret, *Les mœurs et la caricature en France*, 380.

30 André Gill, *La Parodie. Le Salon, par Gill et Oulevay*, July, 1869. The paintings caricatured are *Prométhée* by Gustave Moreau, *La vue du village* by Frédéric Bazille, *Une maladresse* and *Surpris par l'orage* by Firmin Girard, and *L'amour et la veuve* by Albert Lambron. The sculpture is a bronze buste entitled *portrait de Mlle O.N …*.by Henri Cros.

31 Cham, *Le Salon de 1865 photographié par Cham* (Paris: Arnaud de Vresse, 1865), *Le Salon de 1866 photographié par Cham* (Paris: Arnaud de Vresse, 1866).

32 "Tout en parcourant [les Salons caricaturaux], l'on fait ses réflexions mentales: 'C'est bien ça,' disent les uns, 'ce n'est pas cela,' pensent les autres, et l'on voit ainsi défiler sous ses yeux un Salon caricaturé, contre-partie du Salon officiel précédemment visité." John Grand-Carteret, *Les mœurs et la caricature en France*, 552.

33 "Salon de 1861 par Cham et un Amateur" ([s.l: s.n, 1861). Yale Special Collections Art Library, N5066 C43 (LC).

34 These caricatures were cut out of Cham's Salon caricature as published in *Le Charivari* on May 16, May 19, May 26, and May 30, 1861. Cham's Salon caricature that year was later collected and published as *Cham au Salon de 1861. Album de soixante caricatures* (Paris: Martinet, 1861).

35 Although the album is anonymous, I use a masculine pronoun in referring to the author since "amateur" is masculine.

36 The painting is on permanent loan to the École militaire de Paris from the musée du Chateau de Versailles. The only currently available photograph of the canvas is partly illegible; therefore, I include a contemporary wood engraving after the canvas, published in *Le Monde illustré*, May 4, 1861, 274.

37 Cham's interest in prompting his reader's active engagement may have motivated his choice of canvas. Julia Thoma notes that, at 3.66 x 6 meters and staged to include the spectator in an ambush, "[*The Battle of Solferino*] was perceived as radical" because of "the heightened involvement it triggered in the viewer." See Julia Thoma, *The Final Spectacle: Military Painting under the Second Empire, 1855–1867* (Berlin and Boston: De Gruyter, 2019), 250.

38 The original is held by the Musée des beaux-arts de Beaune. At the present time the museum is unable to unroll the canvas for photography.

39 Cham's caption: "Le général Herbillon, sur le point de livrer la bataille de la Tchernaia, trouve la vallée encombrée par des champignons vénéneux qui le gêne dans sa marche." ("General Herbillon, about to surrender the battle of Tchernaia, finds the valley jammed with poisonous mushrooms which block his progress.") The amateur's caption: "'Compter le nombre de têtes simplement comme distraction.'" ("Count the number of heads simply as a distraction.")

40 This album is not the sole testament to such a reaction on the part of a reader. In the archives compiled by the Société des arts décoratifs at the end of the nineteenth century, a reader cut Cham's caricatures out of journals and colored them in with wax crayon; an album at the Smithsonian institute is colored in with what looks like gouache and signed in multiple locations by the owner. Institut Néerlandais, Fondation Lugt, 1990-A. 476. Cham, *Olla Podrida* (Paris: Vresse, 1859), Smithsonian American Art Portrait Gallery Rare Book, NC1499.C44O45.

41 See Michael Pantazzi, "Notes on Daumier and His Imaginary Museum," *Daumier: Visions of Paris*, ed. Catherine Lampert, Ann Dumas, and Sarah Lea (London: Royal Academy of Arts, 2013), 27–31.

42 The subject of theater spectatorship had a strong precedent in British caricaturists admired by Daumier. See Jim Davis, "Looking and Being Looked At: Visualizing the Nineteenth-Century Spectator," *Theatre Journal* 69, no. 4 (2017): 515–34.

43 See my "Cham, Daumier and Sky-Gazing in Nineteenth-Century France," in *Looking and Listening in Nineteenth-Century France,* ed. Martha Ward and Anne Leonard (Chicago: Smart Museum of Art, University of Chicago, 2007), 27–37.

44 Elizabeth Childs's analysis, following Bakhtine, of the "heteroglossia" of caricatural discourse in *Le Charivari* is essential. Childs, *Daumier and Exoticism*, 16–21. Richard Terdiman also emphasizes Daumier's lithography as a "floating collaboration," *Discourse/Counter-Discourse: The Theory and Practice of Symbolic Resistance in Nineteenth-Century France* (Ithaca, NY: Cornell University Press, 1985), 182.

45 "Wife, since we won't have enough time to see everything in a day; you look at the pictures on the right while I look at the ones on the left, and when we get home, we'll each tell what we've seen on our side." *Le Charivari*, April 18, 1859.

46 Michael Twyman describes the attempt by lithographers between around 1820 and 1835 to turn lithography from a linear art—one that borrowed the hashmarks of engraving—to a tonal one. Skill in ink wash or watercolor could not be transferred to lithography, because the darkness of the ink that the lithographer applied did not dictate the darkness of the print. The ink's quotient of grease dictated how much pigment would be absorbed by the stone and that quotient was invisible to the naked eye. Daumier was among those who helped to define lithography's tonal and volumetric capacity. Twyman, "Improvements and Search for Tonal Technique," *Lithography, 1800–1850: The Techniques of Drawing on Stone in England and France and Their and Their Application in Works of Topography* (London: Oxford University Press, 1970), 132–63. Daumier was not alone in expanding lithography's range or exploring graduated tone: Note Charlet's "manière noire," Eugène Isabey's washes, Isidore Deroy's foggy landscapes, and Devéria's *modelé*. Michel Melot, "Daumier dans l'histoire de France," in *Daumier: l'écriture du lithographe*, 31–38, 33.

47 Édouard Papet, "He also does sculpture," *Daumier, 1808–1879,* 46–59. Arsène Alexandre reported in his biography of the artist that Daumier taught himself to draw by looking at the sculptures in the Louvre. Arsène Alexandre, *Daumier* (Paris: Les Éditions Rieder, 1928), 20.

48 Bracketing the non-comic "Salon de 1834" and the two-plate "Salon de 1840," those series are: "Le Public du Salon" (*Le Charivari*, April–May 1852); "Salon de 1857" (*Le Charivari*, June–August 1857); "Exposition de 1859" (*Le Charivari*, April–June 1859); "Croquis pris à l'exposition" (*Le Charivari*, May–June 1864); "Le Public à l'exposition" (*Le Journal amusant*, June 1864); "(Un) Croquis pris au Salon" (*Le Charivari*, May–June, 1865); "Au Salon" (*Le Charivari*, May 1866).

49 As Jacqueline Lichtenstein has observed, "modern" critics like Baudelaire and the Goncourts in the mid-nineteenth century despised sculpture ("[s]culpture as they see it is too antipictorial to be anything other than antimodern") but realigned

qualities previously associated with sculpture, including the tactile and plastic, with painting. Jacqueline Lichtenstein, *The Blind Spot: An Essay on the Relations between Sculpture and Painting in the Modern Age*, trans. Chris Miller (Los Angeles: Getty Publications, 2008), 135–63, 149. For Baudelaire in particular, Daumier's lithography exemplified the modern alignment of the pictorial and the plastic (note Baudelaire's cryptic assertion that Daumier's drawing was "naturellement colorié." Baudelaire, "Quelques caricaturistes français," 557.

50 Cham's caricatures after Gallait's painting appeared in *Le Charivari* on April 18, 1852 ("Le Salon de 1852.—Croquis par Cham"). Daumier's two prints about Gallait appeared in the series "Le Public du Salon" on April 28 ("Le danger de faire voire à des enfants … ") and May 29, 1852 ("Laisse-moi regarder encore un peu, papa … ").

51 The placement of the canvas is visible in the photograph taken by Gustave Le Gray, *Salon de 1852, Grand Salon mur nord* (salted paper print from a paper negative, Musée d'Orsay).

52 *L'Invention du passé: Histoires de cœur et d'épée en Europe, 1802–1850*, t. II, ed. Stephen Bann and Stéphane Paccoud (Paris: Éditions Hazan, 2014), 275.

53 "Let me look a little more, papa!.. The torture of this pour Count Egmont causes me a great deal of pain.—You ought to pity the torture of your poor father whose arms are breaking from holding you in the air!" *Le Charivari*, May 29, 1852.

54 Cham's sketches show that he dictated the order of his vignettes within the macédoine. See for example RF 23618-RF24028, Louvre, cabinet des dessins (album of Cham's ink sketches on paper).

55 See note 53.

56 On this series, see *Daumier, 1808–1879*, 394–410. E.g., *The Print Collector* (*L'amateur d'estampes*, 1860–1862, watercolor, Maison DI-137) and *The Connoisseur* (*Un amateur*, 1864–1866, pen and ink, wash, watercolor, Conté crayon and gouache over black chalk, Maison D-370).

57 Jonathan Crary has decribed a broad reconfiguration of vision across disciplines in the first half of the nineteenth century in which "vision became located in the empirical immediacy of the observer's body." Such a conception of vision is strongly anticlassical, supplanting a "camera obscura" model with its "guarantees of authority, identity and universality." Crary, *Techniques of the Observer: On Vision and Modernity in the Nineteenth Century* (Cambridge: MIT Press, 1990), 24.

58 Philippe Kaenel describes Daumier as a "mobile and panoptic device" ("dispositive panoptique et mobile") in "Daumier 'au point de vue de l'artiste et au point de vue moral,'" in *Daumier: L'écriture du lithographe*, 41–51, 41.

59 "Come along, my dear, I don't find this painting pretty.—Indeed, but in my capacity as pharmacist, it interests me a great deal …., this canvas represents no doubt the trial of a new medicine …. Let's see what my livret says?" From the series "Exposition de 1859," *Le Charivari*, June 21, 1859.

60 See, for example, "Regardez donc un peu où ils ont niché mon cadre! […]," from the series "Exposition de 1859," *Le Charivari*, April 20, 1859, in which Daumier provides access to a long stretch of the wall but chokes out visibility of the canvases with comically thickened frames.

61 "Nadar Jury," *Le Journal amusant*, June 4, 1859.

62 Childs, *Daumier and Exoticism,* 19.

63 Louis Leroy, "Le Charivari au Salon de 1859," installments appeared between April 18 and June 7, concurrent with Daumier's "Exposition de 1859" series. Leroy is best known as having invented the name "impressionist" in one of his comic dialogues. Little has been written about him, although the detractors of caricature grouped him in as a related agent of reactionary hostility. E.g., "Ce vieillard prématuré inventa une forme de lazzis dialogués, et depuis vingt ans lance sur le pauvre monde des clous à sabot qu'il s'imagine être des pointes … " "This premature geezer invented a form of heckling in dialogue, and for twenty years has thrown at the poor world clog studs which he thinks are spikes." Edmond Bazire, *Manet* (Paris: A Quantin, 1884), 40–1.

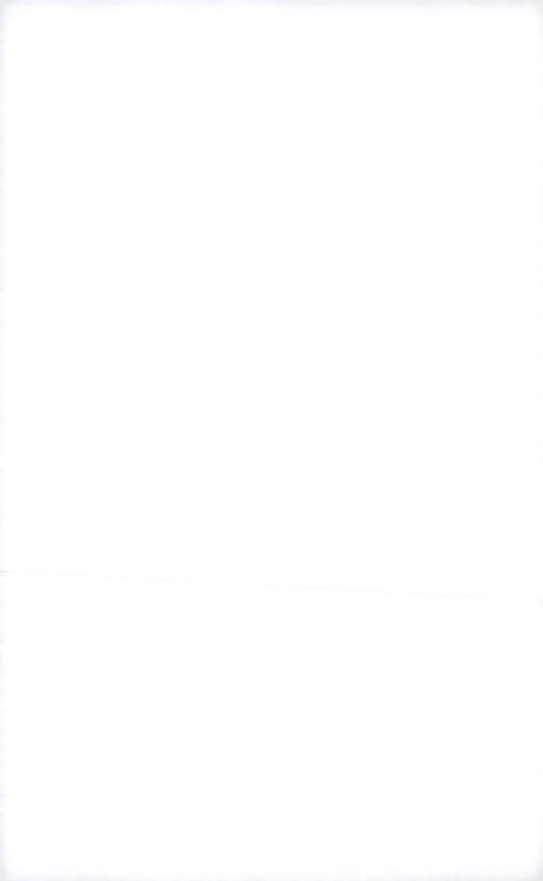

Caricature and Comic Spectacle
at the Paris Salon

This chapter argues that Salon caricature thrived as a response to the perceptual and intellectual challenges of the public exhibition in the Second Empire and early Third Republic, providing valuable insight about the Salon-as-spectacle that other media do not (e.g., written criticism, photography). The caricaturist, photographer, author, and aeronaut Nadar was particularly reflective about the challenging visuality of the Salon, and about the graphic medium's response to its challenges.[1] Although Nadar was not a painter himself, he was an informed observer of contemporary art as well as a collector.[2] Every Salon caricaturist responded differently to the perceptual chaos of the Salon, but Nadar's sensitivity to caricature as a visual technology makes him a particularly useful guide to the changing spectatorial conditions of the exhibition.

Nadar Jury in 1852 and 1853

Nadar produced Salon caricature albums in 1852, 1853, and 1857 and for the *Journal amusant* in 1859 and 1861. Perhaps this aspect of his output has not attracted attention because his photographic practice has dominated the literature, and, as I discuss in Chapter 4, Salon caricature did not rely on photographic sources.[3]

Nadar began his career as a caricaturist in the 1830s and quickly developed a specialty in the genre of group portraiture.[4] He first took up Salon caricature in the course of attempting to fund his monumental portrait series *Panthéon-Nadar*, of which only a single, large format lithograph of famous authors materialized in 1854.[5] In 1852 he joined the aristocrat Charles de Villedeuil's

arts journal *L'Éclair* hoping to use it as a platform to sell subscriptions for the *Panthéon*. *L'Éclair* published several installments of Nadar's Salon caricature alongside Salon criticism by the Goncourt brothers (Villedeuil's cousins). Those installments of caricature were later collected in a thirteen-page wood-engraved album. The cover of the *Album du Salon de 1852*—a corona of portrait heads of artists (Figure 6.1)—further casts this project as an announcement of the *Panthéon*, as does its interior attention to portraiture, the subject of about half the vignettes. In sum, the 1852 *Nadar Jury* grew out of a calculated partnership. In return for embellishing the rather humorless *L'Éclair* and the conservative writing of the Goncourts, Nadar promoted precisely what his *Panthéon* would offer: Nadar as portrait caricaturist and adjudicator of cultural value.

Still in the most intense phase of mounting his *Panthéon,* Nadar returned to Salon caricature in 1853 with a different publisher and more ambition. The thirty-eight-page *Nadar Jury au Salon de 1853* boasted sixty to eighty drawings but now included textual commentary on 800 works, nearly half the number exposed. The album again pegged its value to Nadar's *Panthéon*, which it

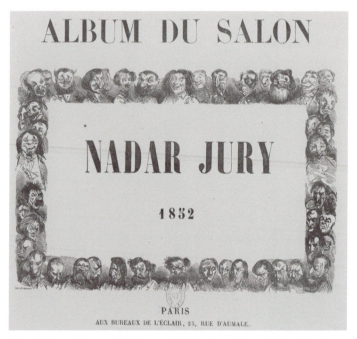

Figure 6.1 Nadar, *Album du Salon de 1852. Nadar Jury*, 1852. Wood engraving. 17.2 cm × 20.1 cm. Bibliothèque nationale de France

advertised on the back cover, echoing it in title and conception. In both projects the print page represented an imaginary space, dense with display (caricatural group portraits had at times been called *galleries* or *musées*), celebrity conferred or confirmed by the comically self-aggrandizing Nadar.

Whereas the *Panthéon Nadar* ultimately failed to include textual notices on each caricatured celebrity,[6] in *Nadar Jury au Salon de 1853* he commented on hundreds of works, taking over the role played by the Goncourts in his previous Salon caricature for *L'Éclair*. Although the brothers were no longer part of the project, Nadar in 1853 opens the album as serious written Salon criticism did, with a philosophical preamble. In it he argues for the special capacity of artist as critic, lending to the reader the conviction of the artist, "he who *sees* as he *makes*."[7] But he quickly admitted "these are indeed big words and … I am giving myself pretty pedantic and dogmatic airs (which I hate so much!) for a cheap, passing little book, put together in eight days and signed by a caricaturist."[8]

Nadar took a four-year hiatus from Salon caricature but returned to the genre with a notably different emphasis, dropping the pretension that he possessed a privileged artistic-critical vision. In 1857 the exhibition moved permanently to the Palace of Industry, and the new conditions of the exhibition corresponded to a new conception on Nadar's part of the comic critic.

Comedy and Chaos at the Salon

From the moment the Salon was converted from an academic ritual to a public event in the mid-eighteenth century, the Salon attracted, in Thomas Crow's words, a "temporary collection of hopelessly heterogeneous individuals."[9] This itself was always fodder for comic responses, as this social heterogeneity was exacerbated by the art that surrounded it: the rube became more of a rube, the connoisseur more pretentious.

While the Salon was an arena in which visual art could be decoded differently by different viewers,[10] the very ability of artists to invert hierarchies attested to the credibility of those hierarchical categories. But as others have described, the stability of that hierarchy was threatened over the course of the century as the visibility of history painting, the highest-status genre, decreased in direct proportion to state subsidy, while the more commercially viable lower genres surged (public support for history painting ran almost entirely dry by 1870).[11] *Le Charivari*'s Taxile Delord lamented the disappearance of "l'art sérieux" at the Salon of 1850, where "the immense canvases that aspire [*ont la prétention*]

to represent the historic pages of the revolution are at most genre scenes."[12] (Cham's Salon caricature followed a few weeks later in the journal.) Critics describe more than just a numbers game: Surrounded by representations of the contemporary, scenes from history and mythology struggled to retain credibility.

The combination of a rapid expansion of the Salon—from 1,755 works in 1852 to 7,289 in 1880—and its increasing genre anarchy has been examined as the political and economic victory of a liberal capitalist "art market." But mapping these problems onto the infrastructure of the Palace of Industry reminds us that this dissolution of hierarchies was not merely a catalyst for the depoliticization of modern art[13] or the emergence of the dealer-critic system.[14] The Second Empire Salon existed as a densely sensory ritual and as the primary context that many painters imagined for their work. A great deal of written criticism during the Second Empire and early Third Republic concedes that the Salon has become a challenge to perception and concentration—often described pejoratively as "spectacle"—for *others*.

The idea of the Salon as spectacle sits uneasily with the literature on urban modernity and modern visual culture.[15] As Richard Wrigley has observed, the *flâneur*, the specialist of modern leisure consumption, rarely engaged with the Salon, whose "underlying coercive or programmatic ethos" was "inimical" to flanerie's detachment.[16] Rather than relying on definitions of spectacle that attach more accurately to other sites, or to an experience of modernity associated with the fin-de-siècle, I intend the term "spectacle" as contemporary *salonniers* used it: a distracting or compelling sight, associated with commercial attractions outside the realm of art.[17] Rather than a smooth, seductive, or seamless illusion, Salon spectacle entailed chaos, meaninglessness, strangeness, and laughter. A pervasive habit of the conventional art criticism of these years uses vulnerability to spectacle to divide the crowd into good spectators (focused, serious, often critics, artists, or specialists) and bad spectators (prone to distraction and laughter, non-specialist, often women). An example from a conservative critic in 1852: "the crowd adjusted its eyes to the spectacle of the false and the ugly," while the "talented artists and distinguished amateurs" were able to find a path [*chemin*].[18] Nadar, in his 1853 album, adopted this convention in vaunting himself as an artist-guide who could navigate 1,800 works unlike those who would go "idiotic or mad."[19]

Not all written criticism adopted this superiority; there was a strain of anti-criticism that readily admitted to the Salon's perceptual challenges. Fernand Desnoyers, for example, declaimed in his *La peinture en 1863: Salon des refusés*,

"I do not want to become an art critic."[20] This apostasy permits him to associate the impossibility of criticism and the inhospitable conditions of the Salon: "If I had the intention of becoming an art critic and to *do the Salon* frequently, I would prefer … to make the rounds of all the studios a few days before the exhibition …. I would see better. Nothing is more discordant than this pile of painting. Just below a serious [*grave*] painting a grotesque one grimaces."[21] In addition to remarking on the comically divergent appeals to the spectator of various paintings—a juxtaposition that brings the paintings mischievously to life, as one painting "grimaces" beneath another—Desnoyers complained of the physical effects of the Salon, the dried throat, the sore neck, the glare of the daylight that strained the eyes. These are effects the critic must surmount or deny but which the comic critic opens by admitting.

Nadar Jury in 1857: Caricature as Magic Lantern

Nadar returned to Salon caricature with *Nadar Jury au Salon de 1857*, which attempted remarkable comprehensiveness with 1,000 commentaries (out of 3,474 total works) and 150 vignettes. And yet it anticipated the comic anti-criticism of Desnoyers, as Nadar reframed his position in relation to the spectacular conditions of the Salon. He opened the album with a dialogue between himself and the critic Théophile Gautier about disorientation and confusion.[22] Already ceding critical authority to the polyvocality of the dialogue, the interlocutors's ideas intertwine, as the text neglects to identify which speaker is which, prefiguring the album's interest in effects of disorientation.

The conversation begins already in motion: "I depart from the church of Notre Dame de Lorette,"[23] Nadar zigzagging ("faisant le lacet") down a street of commercial picture sellers.[24] Overexposure to paintings for sale leaves the men sick, asking, "Has it not happened to you, to find your vision blurred, heart weakened, and stomach churned … ?"[25] When this happens, "you would slit the throat of ten mistresses to come back to earth and rest your eyes on a stock-broker."[26] The other replies, "On a stock-broker, and on a horse, too. On a carriage, on a candy store, or a seller of newspapers, on anything which makes life real, brutal."[27] Nadar (or his interlocutor) diagnoses himself with "Color Sickness" (*Mal de Couleur*), a madness resulting from exposure to too much seductive pigment that leads them to fantasize about disturbing crimes of passion.

"Color Sickness" is a pathology that induces caricatural perception of the Salon. It is a shocking and strange construction, that a sudden femicidal spree ("you would slit the throat of ten mistresses") is not the beginning of insanity but, in the comic album to follow, of sanity. It brings the men "back to earth," back to the "real" of the stock market and the news kiosk. Although the proliferation of the nude had not yet attained the levels of the 1860s, the "mistresses" they would gladly dispatch recall the venuses, courtisanes, and nudes of Salon painting. The overabundance of painting—like too many mistresses, overly demanding, pretending to purity but acting out of financial self-interest—made Nadar and his imagined interlocutor yearn for a realm of unvarnished exchange value.

Nadar asks, "Yet is this no more than the little question of a physical fatigue, an animal irritation? But what are painters for?"[28] Nadar was invested in painting: he came of age among the Romantic generation of the 1830s, was close with painters like Celestin Nanteuil and Gustave Doré, and admired Delacroix above all.[29] "What good are painters?" asks how the work of a painter can articulate to a spectator, when the experience of it is so perceptually overwhelming that the viewer will seek the comfort of—seek "to rest one's sight on"—an openly transactional figure like the stockbroker.

The dialogue continues with a dizzying turn in which the men imagine *all the painting in the Western world*, listing in a dense accumulation all the museums and galleries they can name, even the possibility of unseen painting in bourgeois homes. Why paint anew, they wonder, why invest any energy in this process of needless accumulation? Having conjured the existence of all the painting they can possibly hold in their troubled minds, on the point of renouncing it, Nadar/Gautier recalls—"was it at the Salon of 45 or 46?"—a Virgin by Tassaert, a "strange, completely modern little Virgin" with a "hairstyle of 1830."[30]

After describing how violently he wanted to possess this Virgin, Nadar/Gautier enters the Salon ("Attaquons … "). He is pulled back into the exhibition by the possibility of communing with painting as he remembers it during the July Monarchy Salons. Nadar maps the Salon's historic transformation from small-scale Academic ritual to immense public marketplace along a route of female virtue from Virgin to prostitute, from intimate communion to clamoring seduction.

This descent from communion to chaos tracks an exacerbation and not a rupture instigated by the 1857 move and subsequent expansion of the exhibition—Tassaert's July Monarchy Virgin struck Nadar as a contemporary woman, and although he could not afford her then, she had been available to purchase. He even sketches her as something of a *grisette*—"a little skinny and

sickly" with "quite a working-class feeling."[31] Painting itself was never pure, but in Nadar's memory of the Salon ten years prior, its fictions could be believed.

The 1857 album opened with an image that likewise announced both disorientation and commercial spectacle: Nadar (recognizable with his wild hair and springy legs) operating a magic lantern (Figure 6.2). In the "phantasmagoric" magic lantern shows that emerged in the late eighteenth century, transparencies made of painted glass were slipped over the aperture of a black box containing a light in a dark room, casting an image on the wall for spectators immersed in darkness. As Terry Castle has described, the immersion of the spectator in the darkness, the "bizarre, claustrophobic surroundings, the … rapid phantom-train of images, the disorientation and powerlessness of the spectator" contributed to the long life of the magic lantern in the gothic imaginary.[32] The key to the metaphor of the magic lantern was the thrilling "powerlessness" of the spectator who could not see and therefore not rationalize the source of the image.

Figure 6.2 Nadar, *Nadar Jury au Salon de 1857*, 1857, cover. Wood engraving. Bibliothèque nationale de France

While the magic lantern had long been a symbol for caricatural depiction in general[33] and for Nadar's group portraiture in particular,[34] it is unusual to see the caricaturist depicting himself inserting the lantern slide into the apparatus—highlighting not its phantasmagoric effect but its behind-the-scenes operation.

Typically, the metaphor of a cast or projected image for caricature articulates that the portrait caricature is indexical, directly produced by the sitter like a shadow (as in the title vignette for *La Silhouette* [Figure 3.2]). Nadar holds the slide in his hand, underscoring the illusion not as magically indexical but as hand-manipulated and produced. The frontispiece itself poses as magic lantern slide, with its silhouette shapes blacked out, as if the reader could in turn play the role of slide operator, manipulating the object in her hands. With reference to the spectacular entertainments of the boulevards, Nadar's metaphor of the magic lantern casts Salon paintings as ghost-like and immaterial, and yet as part of a thrilling illusion possessed and activated by the viewer's hand. It reverses the order of production: the caricature, rather than ape the paintings, is their source. The lens, rather than take in the image like a camera, projects it out. The disorienting effects of the Salon were not an unintended interference for Nadar-as-caricaturist, but, like a boulevard lantern show, the very spectacle that one sought at the exhibition.

In the album's opening image, Salon administrator Philippe de Chennevières distributes telescopes to a Salon mob represented as disembodied hands (Figure 6.3). Chennevières (with a prominent "N" on his sleeve) is a stand-in for Nadar, the administrator of his own graphic *Salon*. As such, he doles out the technology that will restore vision to these blind, groping hands.

The caricature that follows in the 1857 album distinguishes itself through its relentless insistence on the hand. Turning to the interior of the album, take for example Nadar's caricature of William-Adolphe Bouguereau's *L'Amour* (Love) (Figure 6.4) a large-scale allegorical panel meant to decorate a private salon. Referring to the painting as "wax cut-outs"[35] Nadar depicts the painter's/caricaturist's hand holding a pair of scissors. The hands, oriented as a reader would hold the album, prevent the reader from conceptualizing the image as a large-format painting; they shrink and harden the painting to the album's and also to the lantern-slide's scale. The resulting black silhouette recalls Nadar's lantern-slide frontispiece.

The album maintains an emphasis on hard, small, manipulable commodities—pots, dolls, puppets, toys, shoes—frequent iconography of Salon caricature to be sure, but with new valences in this album. Nadar's caricature of Gustave Courbet's *Les Demoiselles des bords de la Seine* (Women on the Banks of the Seine) (Figure 6.5) converts the women into wooden dolls with hinged joints, on

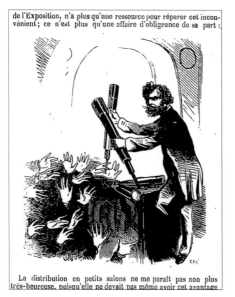

Figure 6.3 Nadar, *Nadar Jury au Salon de 1857*, 1857, page 2. Wood engraving. Bibliothèque nationale de France

Figure 6.4 Nadar, *Nadar Jury au Salon de 1857*, 1857, page 47. Wood engraving. Bibliothèque nationale de France

the surface an accusation of simplicity or primitiveness. The very facture of the caricature, with its exaggerated striations and uneven, thick strokes (recalling German woodcuts), may seem to accuse Courbet's facture of coarseness. But in the context of the album's interest in the hand, the visible facture and the conversion of the figures to handheld dolls reinforce the sense of the image's scale and the linked materialities of wood engraving and wooden toys.

Bertrand Tillier has described the prominent signature at the bottom-center of the caricature—"Courbet (et Nadar)"—as an "unmasking of the charlatanism" of Courbet, whom Nadar thereby mocks as "the caricaturist of his own painting."[36] While I agree with Tillier on Nadar's recruitment of Courbet to the realm of the graphic, what does it mean in this particular case to be the caricaturist of one's own painting? Nadar emphasizes the painting's thick madeness and the sense of Courbet's canvases as carved (note that the usual location of the painter's signature, at bottom right, is not replaced by Courbet/Nadar but by the name of the wood engraver, Ecosse). Nadar's textual analysis, rather than unmask

Figure 6.5 Nadar, *Nadar Jury au Salon de 1857*, 1857, page 5. Wood engraving. Bibliothèque nationale de France

Courbet, describes the artist as limited by his own materiality, a work "all of the hand" ("œuvre toute de main").[37]

Nadar puts the hand-manipulated illusions of the magic lantern on a continuum with the handmade images of caricature. The two are related instances of the "technological image," described by Tom Gunning as "not only images produced by technological means (such as mechanically produced tapestries or prints …) but images that owe their existence to a device and are optically produced by it rather than simply reproduced."[38] Gunning uses the frame of the "technological image" to discuss handheld optical toys like the thaumatrope, a printed paper disc with images on both sides that "fuse" in the mind of the viewer when the disc is spun. Nadar's overarching joke in 1857—that painting is merely an illusion "produced" in the viewer's mind, and caricature is its handheld source—makes Salon caricature something of an optical toy, like a printed paper thaumatrope. Such toys took simple visual data—scant graphic figures, animals and objects that share much with the visual vocabulary of Salon caricature— for their raw material. Their potential for animation or contagion could be activated by the rapid motion of the device and the persistence of retinal impressions. Moving between the daunting, distant glut of paintings and their handheld "sources," Nadar's readers seized and activated the potential comedy of the pictures on the wall.

Laughter at the Salon

In the 1857 album, Nadar explicitly identified traces of caricature not in Courbet but in Jean-Léon Gérôme. He sensed in the painter a "slight caricatural tendency" and added that the observation was neither criticism nor praise.[39]

It was more often criticism. Critics in the Second Empire noted with alarm tremors of comedy on the walls of the Salon. Even Gautier, former defender of rebellious Romantics and Nadar's imagined companion to the 1857 Salon, warned in 1869 that "painting is a serious art, which does not make jokes [*qui n'a pas le petit mot pour rire*] and it is with extreme reserve that it may venture a comic point."[40] Gautier sensed that painters were attempting jokes, and the comic press that hosted Salon caricature agreed. Quatrelles (Ernest L'Épine), a reviewer at the *Vie parisienne*, the quintessential urbane, snickering illustrated journal of the Second Empire, suggested in 1868 that one attended the Salon for the purpose of laughter: "What then do we like? That which astonishes us, that which makes us laugh, and most of all that which is *meublant* [suitable for furnishing]."[41] Astonishment and laughter, spectacle and the comic, go hand in hand, the union facilitated by the value-leveling of bourgeois commerce.

Among written critics, the report of laughter at the Salon should be scrutinized as polemicizing rhetoric, a symptom of bad spectatorship that a discerning critic is all too happy to diagnose. In his review of the Salon of 1859 Alexandre Dumas invites the reader to "look at this crowd, laughing with its big, unintelligent laugh, pointing out certain characters [in the painting] with a big, dumb finger."[42] For the writer, laughter erupts on only one side of a fault line between ignorant and knowing, bourgeois and artist, those led to laugh by the delirious spectacle and those who can combat or surmount it.

Dumas sees the susceptibility to spectacle demonstrated behaviorally at the Salon:

> Go to the Salon and there you will see the bourgeois pass by laughing, young people stop and throw themselves loudly back, the ladies of rue Breda rush over hopping like little birds; but … you will see the artists stop, lean in on the iron railing, speak quietly and religiously, making linear demonstrations with the tip of their finger.[43]

Those who experience the Salon as fleeting, fast-paced, superficial, and hilarious are marked by sex, age, and class: the bourgeois, the young, and the economically precarious woman ("rue Breda" maps her as a *lorette*, an archetypal prostitute[44]). In contrast, artists summon powers of concentration that allow them to select, isolate, and commune with a painting intimately and seriously—a relationship to painting that Nadar in his 1857 album had historicized as a memory of the July Monarchy Salons. Dumas reveals his skewed interpretation in these two descriptions of finger-pointing; he interprets nearly the same gesture as a dumb prod in the case of the "crowd," a mimed exegesis in the case of the artist. With their "linear demonstrations," moving through space like script, the artists's clarity and concentration invoke a writerly kinship with Dumas the critic.

Taken together, these conflicting etiologies of laughter at the Salon evoke the threat of the comic as ambient and systemic. Nadar seems unsure of the source of the comic: Was it really there or was it "[his] own disposition" that alerted him to it?[45] The comic is, in these accounts, a potential hanging at the threshold of the viewer's experience, waiting to be activated, not produced by a single artistic tendency or a single tranche of the public but generated by the conditions of the exhibition.

Painting as Superficial, Mobile, Contemporary

I do not take Nadar's Salon caricature as evidence of a rupture in the experience of the Salon. Issues of glut, incoherence, and "anarchy"—the term was used

already in 1827[46]—plagued the Salon throughout the century. Nevertheless the Salon's move to the Palace of Industry in 1857 exacerbated the tension between the Salon's putative coherence and perceptual chaos, and represented a symbolic and sensory shift for the institution. Théodore Duret later identified 1857 as the moment that laughter became a habitual problem at the Salon, the result, he lamented, of its transformation into a broad public spectacle.[47] Compared to the royal solidity of the Louvre, which represented both prestige and a material connection to the history of art, this new exhibition hall, at 260 meters long by 105 meters wide, spanned by a glass roof and ringed by two stories of galleries, struck some commenters as visibly transitory.[48] Edmond About, crossing the courtyard at the center of the Palace of Industry at the Salon of 1864, noted that the "eye worries" at the obvious rootlessness of rosebushes bolted in sand.[49]

At the Louvre, where the Salon had occurred since its inception until 1848, either works were temporarily displaced during the exhibition or temporary fabric had been laid over the permanent collection and the Salon paintings hung on top. By 1852 the critic Gustave Planche laments a Salon flooded with minor genres;[50] yet twenty years earlier, the same critic described how the status of such genres had been vouchsafed by their physical connection to tradition: "Who would dare to complain when he sees that the portrait or the landscape that he has sent is attached precisely in the same place as a Rubens or a Murillo?"[51] Tradition and stability literally underpinned the contemporary paintings that the Salon displayed at the Louvre.[52] At the Palace of Industry, on the contrary, rather than see contemporary painting layered atop masterpieces from the history of art, a Salon spectator would see a painting hung in a gaping nave or ancillary aisles where weeks earlier she had seen horses jumping, and weeks later she would see a trade show of products from the colonies.

The perceptual challenges of the Salon had been a subject of Salon caricature since its earliest days. In 1853 Cham drew a caricature of a man exiting the Salon, that year an affair of 1,768 works held provisionally at the Menus-Plaisirs.[53] This typical bourgeois, recognizable in his black coat and hat, tries to rub the afterimage of the Salon out of his eyes. The caption reads: "Feeling of vertigo one feels generally leaving the painting exhibition" (Figure 6.6).[54]

The same motif of tumbling, diagonal canvases appears nearly twenty years later, in June of 1872 in *La Vie parisienne,* in a two-page spread entitled "Une pluie de chefs-d'œuvre" ("A Rainfall of Masterpieces") (Figure 6.7).[55] By 1872 the motif represents no longer memory or aftershock, but an encounter with the exhibition itself, as *La Vie parisienne*'s caricaturist encountered 4,000 more works in the new sun-filled palace than Cham had faced in 1853. The cascade motif has been exacerbated and exploded across two pages in a spread. The

Figure 6.6 Cham, *Revue du Salon de 1853 par Cham,* 1853. Detail. Wood engraving. National Gallery of Art Library, Washington, DC

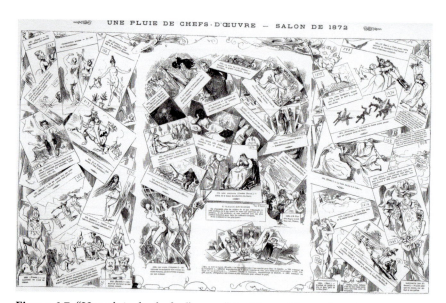

Figure 6.7 "Une pluie de chefs-d'œuvre," *La Vie parisienne,* June 8, 1872, 360–1. Relief-etching (Yves & Barret). Bibliothèque nationale de France

anonymous caricaturist scatters thirty-five canvases helter-skelter across the large-format journal.[56]

"A Rain of Masterpieces" sacrifices some of the individual legibility of each caricatured canvas and the pacing of the "gutter space" to simulate for the reader the Salon's effect of confusion and immersion, as the canvases fill the page to the brim. Canvases have equal weight, which is to say none at all. They are paper-thin, and their corners are curling inwards like ticket stubs (Figure 6.8). A gust of wind could rearrange them, just as paintings were indeed rehung halfway through the duration of the exhibition.

"Rainfall of Masterpieces" was a product of Yves & Barret,[57] a relief process like *gillotage* (discussed in Chapter 4) that permitted fast, freehanded drawing—free of the traces of middlemen and their labor characteristic of wood-engraving and lithography.[58] One has to consider to what extent Salon caricaturists were responding to changes in the experience of the Salon or merely to their own newfound compositional freedom in the 1860s–1870s; did they aim to conjure the Salon's dematerialization, or were they simply experiencing their own parallel dematerialization? The answer is surely both. The artist of "A Rainfall of Masterpieces" emphasizes the flimsiness of painting not only with scale and glut, with his own rapidity and thinness, but with illusions like torn and curled-over

Figure 6.8 "Une pluie de chefs-d'œuvre," *La Vie parisienne*, June 8, 1872, 360–1, detail. Relief-etching (Yves & Barret) Bibliothèque nationale de France

edges; similar versions of this motif used repoussoir effects like little beetles and spiders to further emphasize the transitory weightlessness of Salon painting.[59]

Nor does the availability of *gillotage* alone account for the caricaturist's interest in contagion and animation. Recall how Fernand Desnoyers, who had given up on the possibility of criticism at the Salon, imagined in 1863 that the proximity of a "serious" painting would make a grotesque one "grimace." Similarly, in *La Vie parisienne*'s swirl of canvases, proximity brings caricatured canvases to life. Images interrupt one another in their chaotic layering, where brittle borders are easily broached. A stiff cuirassier hoisted out of Gustave Doré's *Le massacre des innocents* (Massacre of the Innocents) kicks Alexis Mossa's startled allegory of the Republic (Figure 6.8).

If "A Rainfall of Masterpieces" asserted painting as flat and mobile, all of its depicted contents (real and allegorical, ancient Roman and modern French) existing and interacting in a continuous present, then the caricature's formal resemblance to spreads on fashion and the theater in the same journal further thinned the Palace's glass border between a sanctioned sphere of aesthetic autonomy and Paris's spectacular culture at large.

For example, "La Saison à Paris—Théâtres—Modes. Étrangers et Étrangères" (The Season in Paris—Theaters—Fashion. Foreigners") (Figure 6.9) appeared

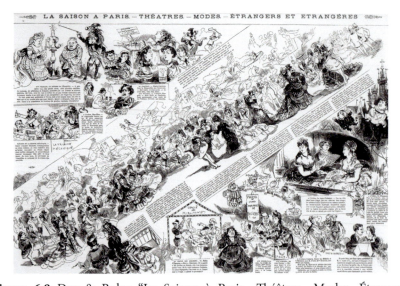

Figure 6.9 Dey & Roby, "La Saison à Paris—Théâtres—Modes. Étrangers et étrangères," *La Vie parisienne*, June 1, 1872, 344–5. Relief-etching (Yves & Barret). Bibliothèque nationale de France

one week before "A Rain of Masterpieces" in *La Vie parisienne* and resembled it in its chock-filled vertiginous layout, done in the same relief process.[60] "The Season in Paris" collapsed theater and fashion into one dense arena, in which spectators were indistinguishable from actors. Just as the Salon's painted figures behaved like contemporary Parisians engaged in self-display, so caricaturists blurred the line between Huguenots and tourists, between the historical fictions of the stage and their modern consumers.

Tradition, Copy, and Conflict

At the spectacular Salon, paintings tumbled in a timeless present, but tradition was hardly forgotten. It ran rampant in the form of copy and citation. The role of copy and citation in the tradition of French painting constitutes the subject of a great deal of art historical literature, but it is clear that the issue of copying as pedagogy and practice enters a crisis particularly in the 1860s.[61]

Questions of legitimacy plagued citation: as art-historical category liquidated and was drawn upon according to caprice, citation looked like parody, or theft. (Zacharie Astruc's 1859 entry on a painting by Louis Georges Brillouin: "Hola! Terburg! Hola! Metzu [*sic*]! Your house is being robbed!"[62]) Art-historical citation occurred among a wash of contemporary subjects, which made the fictions of history and mythology appear superficial—mere ridiculous costuming, mere shocking nudity. In 1857 Edmond About noticed that the never-ending walls of the Salon at the Palace of Industry contained such a density of faces that one felt one was encountering a contemporary urban crowd.[63]

A photograph by Pierre Ambroise Richebourg of a gallery wall from the Salon of 1861 illustrates the comic potential of art-historical pastiche on the crowded and chaotic walls of the Palace of Industry (Figure 1.1). At the right of the photograph we see a painting of a woman in a black gown and white ruff by a student of Léon Cogniet named Jean-François Gose titled *Sortie de l'église, au XVIe siècle* (Leaving Church, Sixteenth Century). This is a typical example of the vogue for Spanish old masters. The sixteenth-century pastiche in the pose and format—stiff costuming, stark palette—come into comic juxtaposition with the neighboring portraits, particularly that of a contemporary doctor with his young daughter on the other side of the vertical row of tondos. Stranger, a pendant to both the Spanish Christian mother and the sentimental father and child, is a demonic satyr prodding a nymph.[64] The Catholic mother's tight face and defiant pose appear less internally demanded

by the precedent of Spanish painting than externally demanded by the unholy images at her flanks.

The infelicitous juxtaposition seen in the Richebourg photograph was partially the fault of the practice, begun in 1861, of hanging the Salon according to painter's last name alphabetically. In this transitory glut of arbitrarily arranged variety and particularly of contemporary portraiture and genre painting, it became difficult to control or stanch the possible contagion of one painting by the implications of its neighbor.

Nadar was in his final year of Salon caricature in 1861, filling four consecutive issues of the *Journal amusant* with his "Nadar Jury." He selected *Leaving Church* from among that year's 4,102 works, remaking the painting as a playing card, again activating awareness of the handheld (Figure 6.10).[65] The playing card was equally a token of café culture, a cheaply printed, industrially produced paper

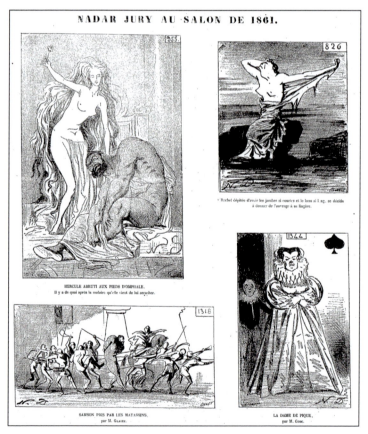

Figure 6.10 Nadar and Darjou, "Nadar Jury au Salon de 1861," *Journal amusant,* July 6, 1861. Gillotage. Bibliothèque nationale de France

trinket, as depthless as *La Vie parisienne*'s paper stubs. Consistent with Salon caricature's conventions, Nadar did not merely replicate on the journal page the juxtapositions that he found on the wall. Instead, like a card-player, he moved *Leaving Church*, now an Ace of Spades, into a new set. Nadar's rehang preserves the proximity of the scowling, buttoned-up noble to dangerous, bare-breasted women, all of the painting's neighbors—a Rachel who'll be calling on her linen-seller, an Omphalle engaged in dentistry, Samson and some dancers—coexisting in an imagined present.

Nadar and the anonymous caricaturist of "A Rainfall of Masterpieces" both understand the perception of Salon painting as mobile—Nadar's magic lantern metaphor invoked a "rapid phantom-train of images" just as "A Rainfall of Masterpieces" animated the exhibition's "feeling of vertigo" as a swirl of paper. For the *Vie parisienne*, which maintained a detached irony in its articles, the graphic experience of navigating the disorienting spectacle of the Salon is nevertheless a delight—whimsical, conducive to snarky hilarity (it was *La Vie parisienne*'s reviewer in 1868 who admitted going to the Salon to laugh).[66] Nadar's album is equally comic, but his caricature is more continuous with Cham's distressed spectator from 1853 (Figure 6.6) who was disturbed by the Salon, suffering a psychopathology prompted by painting's overload, like Nadar's *Mal de Couleurs*. Recall Nadar's Salon spectators in the 1857 album, clamoring for some sort of technical aid with panicked, outstretched hands. Caricature will continue to deliver its imagined visual technologies to daunted spectators: André Gill brings a telescope to the Salon in 1875,[67] Stop brings a magic lantern in 1879,[68] Robida's *Le Vingtième siècle* (The Twentieth Century, 1883) imagines spectators comfortably touring the Louvre from a "circular tramway"[69] mounted with cameras that create an instant physical replica for viewers to possess.

The preface to *Nadar Jury au Salon de 1857* read like a defection from the Salon until the last moment, when the memory of a single painting by Tassaert pulled the caricaturist back in: "Attaquons." Salon caricature in Nadar's hands was not anti-art or anti-institutional—far from it. Yet, at the same time, he accepted that there was no subject position above or beyond the perceptual challenges of the mass public exhibition: all painting was animated and spectral. All spectatorship was productively immersed and disoriented. Instead of fantasizing about clarity, Nadar delighted in comic madness. In contrast to critics who understood laughter at the Salon as the loss of self-possession in the face of a disorienting spectacle, Nadar grounded that spectacle in the handmade and handheld, in painting to-laugh-at, securely possessed.

Notes

1 Stephen Bann has described Nadar's awareness of "mutation in the conditions of historical experience brought about by changing visual technologies," arguing for example that Nadar conceived of memories from the 1830s in terms of the lithographic. Bann, "'When I Was a Photographer': Nadar and History," *History and Theory* 48, no. 4 (December 1, 2009): 95–111, 97, and "Nadar in Retrospect," *Distinguished Images: Prints in the Visual Economy of Nineteenth-Century France* (New Haven and London: Yale University Press, 2013), 87–120.

2 Philippe Néagu, "Nadar and the Artistic Life of his Time," *Nadar*, ed. Maria Morris Hambourg (New York: Metropolitan Museum of Art, 1995), 59–76 and Bann, *Distinguished Images*, 107–9.

3 Bann has sought to redress an academic and curatorial tendency to separate Nadar's photographic practice from his other graphic and literary experiments (*Distinguished Images*, 89–90); for further efforts to reintegrate Nadar's photographic portraiture with work in other media, see *Esprit Créateur* 59, no. 1 (Spring, 2019), special issue "*Portraitomanie* and Intermediality in Nineteenth-Century France," ed. Érika Wicky and Kathrin Yacavone.

4 On Nadar's early group portraiture, see Loïc Chotard, *Nadar. Caricatures et photographies* (Paris: Maison de Balzac, 1990), 34–48.

5 Chotard, "Histoire de la grandeur et la décadence du Panthéon-Nadar," in *Nadar. Caricatures et photographies*, 66–85.

6 Chotard suggests that the absence of text played a large part it the failure of the *Panthéon. Nadar. Caricatures et photographies,* 80.

7 " … l'artiste même qui *voit* comme il *fait.*" Italics in original. Nadar, *Nadar Jury au Salon de 1853* (Paris: J. Bry aîné, 1853), 1.

8 "Il n'est que temps de m'apercevoir que voilà de bien grands mots et que je me donne des airs pas mal pédants et dogmatiques (que je hais tant!) pour un méchant petit livre de passage, broché en huit jours et signé par un caricaturiste." Nadar, *Nadar Jury au Salon de 1853*, 1–2.

9 Thomas Crow, *Painters and Public Life in Eighteenth-Century Paris* (New Haven: Yale University Press, 1985), 3.

10 See, for example, Crow's argument that David's *Oath of the Horatii* simultaneously satisfied the conventional demands of Academic painting and galvanized a revolutionary public. Thomas Crow, "David and the Salon," in *Painters and Public Life in Eighteenth-Century Paris*, 211–54. On the Salon's fractured public see also Richard Wrigley, *The Origins of French Art Criticism: From the Ancien Régime to the Restoration* (Oxford: Oxford University Press, 1993), particularly 97–119.

11 For an account of the fortunes of history painting in relation to the Salon, see Patricia Mainardi, *The End of the Salon: Art and the State in the Early Third Republic*

(Cambridge: Cambridge University Press, 1993), especially Ch. 1, "Pictures to See and Pictures to Sell," 9–35.

12 Taxile Delord, "Le Salon de 1850," *Le Charivari*, January 6, 1851, 2. "L'art sérieux, le grand art, la peinture historique, n'existent plus en France Ces immenses toiles qui ont la prétention de représenter les pages historiques de la révolution sont tout au plus des tableaux de genre."

13 This is Mainardi's account in *Art and Politics of the Second Empire: The Universal Expositions of 1855 and 1867* (New Haven: Yale University Press, 1987).

14 Harrison and Cynthia White, *Canvases and Careers: Institutional Change in the French Painting World with a New Foreword and a New Afterword* (Chicago: University of Chicago Press, 1993).

15 Many accounts of Parisian modernity circumvent the Salon entirely including David Harvey, *Paris, Capital of Modernity* (London: Routledge, 2003); Patrice Higonnet, *Paris, Capital of the World*, trans. Arthur Goldhammer (Cambridge: Belknap Press, Harvard University Press, 2002); Karen Bowie, ed., *La modernité avant Haussmann: Formes de l'espace urbain à Paris, 1801–1853* (Paris: Éditions Recherche, 2001); Hazel Hahn, *Scenes of Parisian Modernity: Culture and Consumption in the Nineteenth Century* (New York: Palgrave Macmillan, 2009); and Rosalind Williams, *Dream Worlds: Mass Consumption in Late Nineteenth-Century France* (Los Angeles and Berkeley: University of California Press, 1982). Indeed even histories that consider painting and artistic enterprise in relation to the experience of modernity do not explore the Salon as site, including Mary Gluck, *Popular Bohemia: Modernism and Urban Culture in Nineteenth Century Paris* (Cambridge: Harvard University Press, 2005) and T.J. Clark, *The Painter of Modern Life: The Art of Manet and His Followers* (New York: Knopf, 1984). Histories of spectacular culture and accounts of modern spectacle look to origins in the panorama, department store, and wax museum rather than the Salon, for example, Maurice Samuels, *The Spectacular Past: Popular History and the Novel in Nineteenth-Century France* (Ithaca, NY: Cornell University Press, 2005) and Vanessa Schwartz, *Spectacular Realities: Early Mass Culture in Fin-de-siècle Paris* (Berkeley: University of California Press, 1998).

16 Richard Wrigley, "Unreliable Witness: The *Flâneur* as Artist and Spectator of Art in Nineteenth-Century Paris," *Oxford Art Journal* 39, no. 2 (August 2016): 267–84, 270.

17 On the relationship between nineteenth-century spectacle and the theory of spectacle developed by Guy Debord and the Situationist International in the 1950s and 1960s, see Maurice Samuels, 12–13. The ways in which nineteenth-century commentators on the Salon wielded the term "spectacle," my point of departure, contradict many of the term's later interpretations. For example, Vanessa Schwartz, focusing on fin-de-siècle consumer culture, characterizes Parisian popular spectacles such as panoramas and wax museums as "realist" forms which "attempted to render an increasingly complex and diversified urban space more legible and transparent."

Schwartz, *Spectacular Realities*, 2. Spectacle at the Second Empire and early Third Republic Salon constituted not a transparent or legible representation of daily life but a productively disorienting one.

18 "… la foule habituait ses regards au spectacle du faux et du laid; son goût naturel se viciait par l'éducation mauvaise que lui donnaient ses yeux." "Les artistes de talent et les amateurs distingués auraient peu à peu désappris le chemin." Alphonse de Calonne, "Salon de 1852," *Revue contemporaine*, April–May 1852, 135.

19 " … étranglé, idiot, ou fou." Nadar, *Nadar Jury au Salon de 1853*, 2.

20 "Mais je ne veux pas devenir critique d'art." Fernand Desnoyers, *La peinture en 1863: Salon des refusés* (Paris: Azur Dutil, 1863), 9. See also Zacharie Astruc, *Les 14 stations du Salon : 1859 ; suivies d'un récit douloureux* (Paris: Poulet-Malassis et De Brosse, 1859).

21 "Si j'avais l'intention de devenir critique d'art et de *faire le Salon* souvent, j'aimerais mieux, je crois, faire une tournée dans tous les ateliers quelques jours avant l'Exposition …. [J]e verrais mieux. Rien n'est plus discordant que cet amas de peinture. Au-dessous d'un tableau grave grimace un tableau grotesque." Desnoyers, *Salon des refusés*, 9. Italics in the original.

22 Gautier wrote a supportive article about Nadar's *Panthéon* in his journal *La Presse* (June 7, 1853); Nadar photographed and caricatured Gautier a number of times in the 1850s–1860s, e.g., 1855 photograph of Gautier, Museum of Modern Art, Object no. 542.2009; 1858 chalk and gouache caricature of Gautier, Bibliothèque nationale de France, département Estampes et photographie, RESERVE BOITE ECU-NA-88; carte de visite photograph, 1860s, collection Musée Carnavalet.

23 "Je pars de l´église Notre Dame de Lorette … " Nadar, *Nadar Jury au Salon de 1857: 1000 comptes rendus, 150 dessins* (Paris: Librairie Nouvelle, 1857), 1.

24 Rodolphe Töpffer, inspired by the aimlessness of alpine hiking, published his first *voyage en zigzag* in 1844, generating the print-culture topos of the "zigzag" or digressive, meandering story. See Kunzle, *Father of the Comic Strip: Rodolphe Töpffer* (Jackson, MS: University Press of Mississippi, 2007), 114. In 1856 Théophile Gautier had published a collection of "meandering" art criticism entitled *Caprices et zigzags* (Paris: L. Hachette, 1856). *Zigzags à la plume et à travers l'art*, a short-lived art review prominently featuring Salon caricature, appeared in 1876. Bibliothèque nationale de France, département Sciences et techniques, FOL-V-630.

25 " … ne t'arrive-t-il pas, dis, de te trouver aussi l'œil trouble, le cœur affadi et l'estomac barbouillé … ?" *Nadar Jury au Salon de 1857*, 1.

26 "Quand ça vous prend, on égorgerait dix maîtresses pour prendre terre tout de suite et reposer sa vue sur un boursier." *Nadar Jury au Salon de 1857*, 1.

27 "Sur un boursier, et sur un cheval aussi, sur une voiture, sur une boutique de confiseur ou de marchand de journaux, sur n'importe quoi de ce qui fait la vie réelle, brutale." *Nadar Jury au Salon de 1857*, 1.

28 "Encore ceci n'est-il que la toute petite question d'une fatigue physique, d'une
 irritation animale; mais à quoi servent les peintres?" Nadar, *Nadar Jury au Salon de
 1857*, 1.

29 Néagu, "Nadar and the Aristic Life of his Time," 59–76.

30 "Mais te rappelles-tu (était-ce au Salon de 45 ou de 46?) un ravissant petit Tassaert.
 Ça représentait une *Sainte Vierge allaitant l'enfant Jésus*." "Cette étrange petite Vierge
 toute moderne ….."; "une coiffure de 1830." *Nadar Jury au Salon de 1857, 2*. Nicolas
 Tassaert's *La Sainte-Vierge allaitant l'Enfant-Jésus* was shown at the Salon of 1845.

31 " … une pauvre petite fille un peu maigre et chétive," "d'un sentiment bien
 populaire," *Nadar Jury au Salon de 1857, 2*.

32 Terry Castle, "Phantasmagoria: Spectral Technology and the Metaphorics of
 Modern Reverie," *Critical Inquiry* 15, no. 1 (October 1, 1988): 26–61, 43. The term
 "phantasmagoria" was adapted by both Walter Benjamin and Theodor Adorno, via
 Marx, to describe illusory experiences of capitalism; Benjamin applied the metaphor
 of the phantasmagoria to modernity's illusions of freedom and security that obscured
 the pervasive logic of exchange-value; for Adorno it described an illusory experience
 of modern commodity culture which made invisible the means of production, and
 by extension images which hide or deny their made-ness. The sense of the Salon
 as "phantasmagoric" suggested by Nadar reflects his awareness of the exhibition's
 illusions of aesthetic purity or symbolic coherence and its function as a marketplace.
 On Adorno and the phantasmagoria, see Crary, *Techniques of the Observer,* 132–3.
 On Benjamin's application of "phantasmagoria" to nineteenth-century Paris, see
 Priscilla Parkhurst Ferguson, *Paris as Revolution: Writing the Nineteenth-Century
 City* (Berkeley and Los Angeles: University of California Press, 1994), 108–9.

33 On the magic lantern as metaphor in French print culture, see Jillian Lerner, *Graphic
 Culture: Illustration and Artistic Enterprise in Paris, 1830–1848* (Montreal: McGill-
 Queen's University Press, 2018), 65–7 and Ségolène Le Men, "Une lithographie de
 Daumier en 1869, *Lanterne magique ! ! !*," *Revue d'histoire du XIXe siècle* 20/21 (2000):
 13–37. On the magic lantern in a longer media history, see Le Men, ed., *Lanternes
 magiques: tableaux transparents* (Paris: RMN, 1995); Laurent Mannoni, *The Great
 Art of Light and Shadow: Archaeology of the Cinema* (Exeter: University of Exeter
 Press, 2000); R. Crangle et al., eds., *Realms of Light: Uses and Perceptions of the Magic
 Lantern from the 17th to the 21st Century* (London: The Magic Lantern Society, 2005);
 Helen Weston, "The Politics of Visibility in Revolutionary France: Projecting on the
 Streets," in *A History of Visual Culture: Western Civilization from the 18th to the 21st
 Century,* ed. Jane Kromm and Susan Bakewell (Oxford: Berg, 2010), 18–29. Richard
 Wrigley notes that already during the empire, comparisons were made between the
 Salon and panoramas, spectacles, and magic lantern shows. Wrigley, *The Origins of
 French Art Criticism*, 53.

34 Nadar first published portrait caricature, rows of cultural celebrities, under the title
La Lanterne magique des artistes, journalistes, peintres, musiciens, etc. in the *Journal
pour rire*, January 24, 1852. On this series and its relation to Nadar's *Panthéon*
and his eventual photographic practice, see Anne McCauley, *Industrial Madness:
Commercial Photography in Paris, 1848–1871* (New Haven and London: Yale
University Press, 1994), 111–13.

35 "… ces découpages à la cire ne sont que des gros dessins enluminés … " Nadar,
Nadar Jury au Salon de 1857, 47.

36 "Dans cette perspective, les caricatures de signatures semblent sceller et démasquer
le charlatanisme de Courbet." "Ne serait-il pas plutôt le caricaturiste (qui s'ignore)
de sa propre peinture ?" Bertrand Tillier, "La signature du peintre et sa caricature:
l'exemple de Courbet," *Sociétés & Représentations* 25, no. 1 (2008): 79–96, 91. Further
context for these signature games is that signature-substitution was a regular aspect
of graphic reproduction in the press. See Tom Gretton, "'Un Moyen Puissant de
Vulgarisation Artistique'. Reproducing Salon Pictures in Parisian Illustrated Weekly
Magazines c.1860–c.1895: From Wood Engraving to the Half Tone Screen (and
Back)," *Oxford Art Journal* 39, no. 2 (August 2016): 285–310.

37 Nadar, *Nadar Jury au Salon de 1857*, 14.

38 Tom Gunning, "Hand and Eye: Excavating a New Technology of the Image in the
Victorian Era," *Victorian Studies* 54, no. 3 (August 2012): 495–516, 499–500.

39 " … légère tendance caricaturale," *Nadar Jury au Salon de 1857*, 10.

40 "La peinture est un art sérieux, qui n'a pas le petit mot pour rire et c'est avec une
réserve extrême qu'il faut y hasarder une pointe comique. " Théophile Gautier,
"Salon de 1869, V," *L'Illustration*, June 5, 1869, 363–6, 364.

41 "Qu'aimons-nous donc? Ce qui nous étonne, ce qui nous fait rire, et surtout ce qui
est *meublant*." Quatrelles (Ernest L'Épine), "Le Salon carré à l'exposition," *La Vie
parisienne*, May 9, 1868. Italics in original.

42 "La foule s'arrête devant ce tableau; mais il y a foule et il y a foule. Tournez le dos au
tableau, et regardez cette foule-la, riant de son gros rire inintelligent, se montrant
certains personnages avec un grand doigt bête …." Alexandre Dumas, *L'art et les
artistes contemporains au Salon de 1859* (Paris: Librairie Nouvelle, 1859), 45.

43 "Allez au Salon et là vous verrez les bourgeois passer en riant, les jeunes gens s'arrêter
et se renverser bruyament en arrière, les demoiselles de la rue Breda accourir en
sautillant comme des bergeronnettes; mais … vous verrez les artistes s'arrêter,
s'incliner sur la barre de fer, causer bas et religieusement entre eux en faisant des
démonstrations linéaires avec le bout de leur doigt …." Dumas, *L'art et les artistes*, 10.

44 "Lorette": "Nom qu'on donne à certaines femmes de plaisir, qui tiennent le milieu
entre la grisette et la femme entretenue, n'ayant pas un état comme la grisette,
et n'étant pas attachées à un homme comme la femme entretenue." *Dictionnaire de la
langue française*, t. 3, ed. Émile Littré (Paris: Hachette, 1873).

45 "Est-ce une disposition d'état à moi particulière qui me fait suivre dans M. Gérôme comme une légère tendance caricaturale … ?" Nadar, *Nadar Jury au Salon de 1857*, 10.

46 Marie-Claude Chaudonneret, "Les artistes vivants au Louvre (1791–1848): du musée au bazar," in *"Ce Salon à quoi tout se ramène": Le Salon de peinture et de sculpture, 1791–1890*, ed. James Kearns and Pierre Vaisse (Bern: Peter Lang, 2010), 7–22, 15.

47 Théodore Duret, *Histoire de Édouard Manet et de son œuvre* (Paris: Carpentier et Fasquelle, 1906), 58. Duret's writing on laughter and the Salon is explored in depth in Chapter 7.

48 The building was indeed transitory: it was demolished in 1897 to make room for the Grand Palais, another dazzling glass-and-iron exhibition site built for the 1900 Universal Exposition.

49 "L'œil s'inquiète par instinct à la vue d'un rosier planté dans le sable." Edmond About, *Salon de 1864* (Paris: Librairie de L. Hachette, 1864), 51.

50 Gustave Planche, "Salon de 1852," in *Etudes sur l'école française (1831–1852), peinture et sculpture*, t. 2 (Paris: Michel Lévy Frères, 1855), 287–330, 313.

51 "Qui oserait se plaindre en voyant que le portrait ou le paysage qu'il a envoyé est attaché précisément à la même place qu'un Rubens ou un Murillo?" Planche, "Salon de 1831," *Études sur l'école française (1831–1852), peinture et sculpture*, t.1, 1–172, 7–8.

52 On the ideological significance and institutional tensions of the Louvre as site of both contemporary Salon and historical museum, see Chaudonneret, "Les artistes viviants au Louvre."

53 On the peripatetic Salon years between the Louvre and the Palace of Industry, see Arnaud Bertinet, "La question du Salon au Louvre 1850–1853," in *The Paris Fine Art Salon/ Le Salon, 1791–1881*, ed. James Kearns and Alister Mill (Oxford: Oxford University Press, 2015), 241–56.

54 "Sensation de vertige que l'on éprouve généralement en sortant de l'exposition de peinture." Cham, *Revue du Salon de 1853 par Cham* (Paris: Charivari, 1853).

55 Anonymous, "Une pluie de chefs-d'œuvre," *La Vie parisienne*, June 8, 1872, 360–1. (The authors of this caricature are not identified in the caricature itself or in the journal's table of contents.)

56 *La Vie parisienne* measures 34 by 52 cm; Cham's album measures 18 by 24 cm.

57 Yves & Barrett is listed under "Photogravure" in Alfred de Lostalot, *Les Procédés de la Gravure* (Paris: Quantin,1882), 184.

58 On the disappearance of the distinctions between printmaking techniques in illustration, see Philippe Kaenel, *Le Métier d'illustrateur 1830–1880: Rodolphe Töpffer, J.J. Grandville, Gustave Doré* (Génève: Droz, 2005), 100; see also my discussion of photochemical and photomechanical processes, and their impact on Salon caricature, in Chapter 4. On the impact of this disappearance on the treatment

of images in the illustrated press, see Tom Gretton "Signs for Labour-Value in Printed Pictures after the Photomechanical Revolution: Mainstream Changes and Extreme Cases around 1900," *Oxford Art Journal* 28, no. 3 (January 1, 2005): 373–90.

59 See, e.g., Hix et Fleury, "Une promenade au Salon," *La Vie parisienne,* May 21, 1870, 406–7.

60 Dey & Roby, "La Saison à Paris—Théâtres—Modes. Étrangers et étrangères," *La Vie parisienne,* June 1, 1872, 344–5.

61 In 1863 the École des beaux-arts became the center of public debates about the role of copy in the academic curriculum. On the debate and subsequent reforms, see Alain Bonnet, *L'Enseignement des arts au XIXe Siècle: La réforme de l'école des beaux-arts de 1863 et la fin du modèle Académique* (Rennes: Presses universitaires de Rennes, 2006). On the fundamental role of copying in the Academy, see Albert Boime, *The Academy and French Painting in the Nineteenth Century* (New Haven, CT: Yale University Press, 1986). Richard Shiff describes a crisis of "imitation" and "copy" as a condition of the emergence of modernist originality in "The Original, the Imitation, the Copy, and the Spontaneous Classic: Theory and Painting in Nineteenth-Century France," *Yale French Studies,* no. 66 (1984): 27–54. On the dynamics of copy and citation in the School of David and early Romanticism, see Thomas Crow, *Emulation: David, Drouais and Girodet in the Art of Revolutionary France* (New Haven, CT: Yale University Press, 2006). On the semiotics of citation in French academic tradition, see Norman Bryson, *Tradition and Desire: From David to Delacroix* (Cambridge: Cambridge University Press, 1984). On Manet's emergence amidst a crisis of copy and citation in Second Empire painting, see Michael Fried, *Manet's Modernism, or, the Face of Painting in the 1860s,* (Chicago: University of Chicago Press, 1996), particularly Chapter 1, "Manet's Sources." See also Marc Gotlieb, *The Plight of Emulation: Ernest Meissonier and French Salon painting,* (Princeton: Princeton University Press, 1996).

62 "Hola! Terbourg! Hola! Metzu! On pille votre maison!" Zacharie Astruc, *Les 14 stations du Salon,* 203.

63 Edmond About, *Nos artistes au Salon de 1857* (Paris: Hachette, 1858), 6.

64 The canvas is *Nymphe et Satyre* (Nymph and Satyr) by Félix-Henri Giacomotti.

65 "Nadar Jury au Salon de 1861," *Journal amusant,* July 6, 1861, 4.

66 See note 41, above.

67 André Gill, "*Le Salon de 1875*—"Distribution des récompenses"" ("Salon of 1875—Distribution of Awards"), *L'Éclipse,* May 9, 1875, discussed in the Introduction).

68 *Le Journal amusant,* May 17, 1879.

69 "le tramway circulaire," Robida (Albert Robida), *Le Vingtième siècle* (Paris: Georges Decaux, 1883), 48.

7

Salon Caricature and the Making of Manet

"La Queue du chat, ou la charbonnière des Batignolles" ("The Cat's Tail, or the Coal-Woman of the Batignolles") (Figure 7.1), Bertall's caricature after Édouard Manet's *Olympia*, is one of the best-known examples of Salon caricature, reproduced in, among other works, T.J. Clark's essay "Olympia's Choice" (1984)[1] and in the Manet catalogue raisonnée published in 1975.[2]

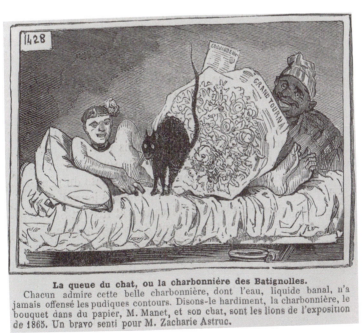

Figure 7.1 Bertall, "La queue du chat, ou la charbonnière des Batignolles," from "Le Salon, par Bertall," *L'Illustration*, June 3, 1865. Detail. Wood engraving. University of Chicago Library

Looking at Bertall's "Coal-Woman" in isolation, it is easy to imagine that it originally illustrated a critical text about *Olympia*, or that it was part of a larger mobilization of mockery against Manet, given the obvious surface reduction of painterly skill and sensibility to exaggerated scratchwork. This is how the caricature has circulated for modern viewers, in this excised, isolated form in art-historical literature and more recently in the form of Google image and art-database search results.

However, if we look at the caricature as originally published in 1865 in the wood-engraved weekly *L'Illustration* (Figure 7.2), Bertall's repicturing of Manet

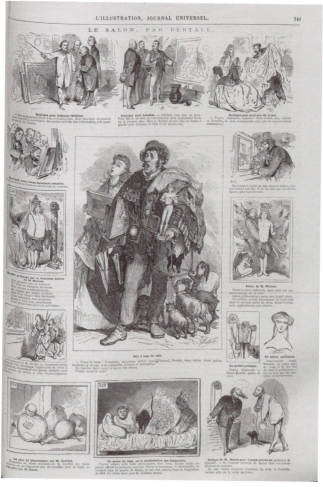

Figure 7.2 Bertall, "Le Salon, par Bertall," *L'Illustration*, June 3, 1865. Wood engraving. University of Chicago Library

is more complicated than mere mockery. Bertall's *Olympia* is part of a larger layout of Salon caricature framing an image of a street vendor hawking samples of the contents of the exhibition, hollering the availability of "Greeks, Romans, Flemish, old costumes, old ladies"—"Come and get 'em."[3] If this installment of Salon caricature has an overriding concern, it is not to indict Manet's sooty nude, but to indict the commercial nature of the exhibition as a whole. As the prior chapter discussed, the Salon had evolved from a private ritual of seventeenth-century academicians to a massive marketplace where, as state patronage of the arts had waned across the nineteenth century, painters vied for consumer attention.

The caricature accuses the exhibition of crass commercialism, and already Manet's *Olympia* escapes this censure. Bertall groups Manet with Gustave Courbet, whose *Proudhon et ses enfants* (Proudhon and his Children), a portrait of the socialist philosopher with his two girls playing in gravel by a stoop, is caricatured to the left of *Olympia*. The caption under Bertall's version of *Proudhon* linked the two artists in a joint refusal of the Salon's pandering: "At least this one [Courbet], you can't accuse him of working toward a sale. No more than Manet."[4] If the Salon has been converted into a flea market for polished pastiches by painters trying to make a living, Manet, Bertall observes, has put himself outside that economy.

It is a truism in the late-nineteenth-century writing on Édouard Manet that he was the subject of public laughter. Particularly in the period between Manet's death in 1883 and the first decade of the twentieth century, the early years of his ratification as the father of modernist painting, it was important to critics, notably Théodore Duret (1838–1927), to point to public laughter as evidence of a broad public's inability to understand the formal challenges presented by Manet. For some of these critics, Duret in particular, Salon caricature was a material trace of that laughter.

The writing about Manet from the turn of the twentieth century, which strongly coalesced around a formalist and later formalist-modernist account of the artist, had no cause to reassess the report that an expanded public for art at the Salons of the Second Empire and early Third Republic laughed at Manet out of bafflement. In fact, such an account in retrospect reaffirmed the notion that Manet was at the head of a modernist canon or tradition and the public derision met by Cubism, various forms of Abstraction and Abstract Expressionism in the course of the century only attested to Manet's parentage of that tradition. For example, George Heard Hamilton, author of *Manet and His Critics* (1954), the first "criticism and reception" study of Manet, conjured caricaturists as

bad or "negligible" critics who served only as "lightning rods for opposition."[5] Their target was a Manet that Hamilton characterized as a proxy for modernist innovation *tout court*.

Today, on the other side of an explosion in studies in Visual Culture and of an enormous body of literature critiquing the exclusionary, teleological modernist canon, the fact that Salon caricature is overwhelmingly cited in relation to artists later understood as "modernist"[6] has inadvertently shored up the perception of Salon caricature as a persecutor of future modernists, primarily Manet.

Laurent Baridon and Martial Guédron have suggested as recently as 2011 that painters who became the "great heroes of the modernist and formalist interpretation of modern art" were the most quantitatively targeted and the subject of the "most vivid" caricature.[7] They also assert that "derision of [Manet's and Courbet's] works often includes sexual connotations," as if this were exceptional, whereas in truth sexual innuendo pervaded caricature of all artists, particularly academic nudes.[8] A conclusion such as Baridon and Guédron's must be based on exposure to caricatures like Bertall's "Coal-Woman," and others after the *Olympia*, examined in isolation and taken out of context.

The truth is that Salon caricature did not historically fulfill the role of Manet's dedicated tormenter. As this book has traced, Salon caricature emerged in the early 1840s, twenty years before Manet's first Salon submissions. Then, during the years of Manet's contested Salon submissions in the 1860s and 1870s, caricaturists did not quantitatively focus on Manet more than they did on, for example, Gustave Moreau or Jean-Léon Gérôme, the former an eccentric but in many ways traditional history painter and the latter a pillar of the academy.[9] In 1865, the year Manet's *Olympia* and his *Jésus insulté par les soldats* (Jesus Mocked by the Soldiers) caused real controversy at the exhibition, Manet was arguably the subject of more textual commentary, serious and comic, than other painters (see, for example, Louis Leroy in *Le Charivari*)[10] but not of caricaturists's attention. If we look at the three main journals to feature Salon caricature regularly, *Le Charivari*, *Le Journal amusant*, and *La Vie parisienne*, in 1865 Gustave Moreau and Louis-Frédéric Schutzenberger were caricatured more frequently, while Whistler, Protais, and Saint-François were caricatured as much.[11] In fact, many of the caricatures after paintings by Manet that have since been excised and circulated as Salon caricature were published in 1867, in response to the retrospective that Manet staged at a site on the Place de l'Alma concurrent with the Universal Exposition, and not, in fact, upon their initial public reception at the Salon.[12]

Yet Baridon and Guédron are right on one crucial point: caricaturists are often at their most "vivid," insightful, or profound when treating Manet.

How were the paintings of Manet, if not *more* of a subject for caricaturists, then a *different* or *particular* kind of subject for caricature? What is Manet's relationship to the caricature that graphically refigured his canvases—among many others—throughout his career? Understanding Manet as a comic subject illuminates the myth of public laughter that has attended the history of Manet's reception. It is important to give a historical reckoning to this primal scene of public mockery, as it echoes through the history of modernist and avant-garde reception, from Cubism to Abstract Expressionism, to events like the Turner Prize today.[13]

If the early momentum in Manet scholarship was toward a formalist-modernist account (culminating in the writings of Clement Greenberg),[14] then in the 1960s Michael Fried and Theodore Reff complicated the picture by turning not only to how Manet fashioned images but from what material, examining a Manet managing a dizzying and conflicting array of sources.[15] A growing literature over the past twenty years has mined Manet's relation to those sources not just as nationalities or art-historical lineages but as aspects of a particular material culture.[16] These thinkers have sought to reconsider Manet as deeply, even primarily, concerned with a culture of reproduction and multiples. Yet this important work has yet to consider Manet's relation to caricature as a whole, and not merely as an illustrated aspect of the critical aggregate prompted by a handful of controversial canvases. Given that Salon caricature is also a form of reproduction, a quintessential artifact of the Parisian image economy, and, as I'll argue, a source for Manet's painting, this examination seems long overdue.

This chapter considers not only the caricature of Manet but the recurring association, in the early historiography of the artist, of Manet with laughter, with public laughter at the site of reception and its relation to the laughter provoked by comic images after his canvases. Caricature and laughter should not be uncritically elided; yet, many writers who described public laughter, including Théodore Duret and Charles Léger, described Salon caricature as the vehicle for it or as the prompt for it.[17] In their telling, Salon caricature graphically incarnates the jeering that echoed down the parquet at the Salons of the 1860s and 1870s.

My contention is that Salon caricaturists were drawn to Manet's paintings not because they found him baffling, or because they knew the public would find them baffling, but because Manet was at the forefront of a rapprochement between comic press art and painting.[18] Caricaturists were interested in how Manet adopted aspects of comic strategy, and further, they paid attention to Manet as mock-caricaturist in a social or professional sense, as an image-maker in a new world of multiples with new ranges of affective intent. Caricaturists

could see Manet, more explicitly than other painters, strategizing in paint, and this gave them fodder to imagine his strategies gone wrong.

Critics accused Salon caricaturists of blindness, but on the contrary caricaturists were able to identify, exaggerate and name aspects of Manet's painting that written critics, for reasons of decorum, convention, or ideology, could not. Salon caricature's persistent reputation as the pillory of modernists has obscured a wealth of potential data that scholars have only begun to explore. For example, the servant woman Laure plays a pivotal role in Bertall's "Coal-Woman of the Batignolles." In his caption, Bertall oddly names Manet among the subjects of the painting ("The coal woman, the bouquet in some paper, M. Manet and the cat"),[19] as if Manet appeared visually in the canvas along with *Olympia* and her props. Bertall substitutes Manet's name for that of Laure whom the caricature otherwise represents without naming. Laure, passed over by most written critics, is central to Bertall's caricature, a proxy for Manet, a presentational figure, the conduit for the transaction between viewer and painting/prostitute.[20]

Returning to the early historiography of Manet, this chapter aims first to show how Salon caricature was characterized as uncomprehending of, even blind to, the art it comically copied. Salon caricature, according to its description in early Manet literature, was a verbal art—even a vocal one—but not characterized with any attention to its pictorial qualities or material quiddity. Salon caricature testified to a growing divide between a mass public unable to appreciate developments in art and a core of educated sympathizers. Duret and his followers described a growing chasm in significance between the narrative, sentimental, and affective aspects of painting, and its "formal" qualities, its pure facture.[21] Bad spectators—laughter was often their tell—sought the former; sensitive viewers attended to the latter.

Understanding the role Salon caricature was forced to play in the story of modernism's emergence in the public sphere therefore does more than clear the way of old prejudices, but sheds light on the mechanisms used by some critics and historians to deny the possibility of a mass public for the highest art in ways that would influence later writers, notably Clement Greenberg. (As Michael Fried has noted, in Duret's 1884 writing on Manet "nearly all the elements of a 'Greenbergian' formalist-modernist point of view were not only clearly articulated but also specifically brought to bear on Manet's paintings").[22] My analysis of the writing on Manet after his death in 1883 by Edmond Bazire, Duret, and others will show how the ratification of this model of criticism, and Manet as its

exemplary object, relied on the concomitant repudiation of press caricature and the identification of laughter with illegitimate spectatorship.

I then discuss a series of caricatures, *not* widely reproduced, after canvases by Manet that underscore the rapprochement of painting and caricature at the dawn of pictorial modernism in Paris, an era in which Duret would have us believe that the two arts could share nothing.

The Enemy of All Artistic Minds

Only a year after Manet's death in 1883, a major retrospective of his work was held at the École nationale supérieur des beaux-arts in Paris, accompanied by a first monograph on the painter written by the naturalist art critic Edmond Bazire (1846–1892).[23] In *Manet*, Bazire describes a compulsively talented artist, daunted both by the studio system that tried to cut him to its conventions and then by a public, including a chorus of journeyman critics, that could not understand him. Bazire singled out caricaturists as among Manet's most venal critics. At the hanging of *Épisode d'une course de taureaux* (Incident in a Bullring) and *Les Anges au tombeau du Christ* (Angels at the Tomb of Christ) at the Salon of 1864, "the caricaturists launched their jokes. Bertall, the persistent enemy of all artistic minds, joined Cham and Randon …. But the most irritated was *Le Charivari*. This journal occupies a distinguished place among Manet's brutal detractors."[24] (*Le Charivari*, as we have seen in prior chapters, was an early and consistent publisher of Salon caricature.)

Bazire describes a Manet baffled and wounded by these jokes, in the end harmful to the painter: "That's how a powerful talent can be interrupted in its growth, slowed in its momentum, if it does not have the power within itself to take the stings of mockery and the failed little satires of the retrograde."[25] Some artists, Bazire insists, renounce art in the face of this crushing incomprehension.

Art critic Théodore Duret, who became a porte-parole for the Impressionists, was one of Manet's most powerful defenders. Among the early writings on Manet, his *Histoire de Édouard Manet et de son œuvre*, first published in 1902 but incorporating work published in the 1880s, remained the most significant. Although it is difficult now to imagine a time when there was a dearth of Manet scholarship, Duret's *Histoire de Édouard Manet* remained the authoritative work on the artist for nearly half a century.[26]

Duret, who first published on Manet in the same period as Bazire,[27] was shaped by the same pressures to frame Manet as a tenacious naturalist with a singular vision, persecuted by cultural institutions and criticism.[28] Like Bazire,

Duret's monograph reported that a vast majority misunderstood and laughed at Manet, while a small circle of knowing supporters sustained him. The book is written as if addressing these supporters, an élite interested in facture and technique, while Duret explicitly expresses the conviction that important modern art cannot be understood by a mass public. With this specialist intonation, Duret grounds his account of compulsive and malevolent public laughter in both institutional changes in the Salon as exhibition and in a fuller description of Manet's qualities as a painter.

As a painter, it was Manet's relation to subject matter that baited the public. Manet, according to Duret, had ceased to provide a narrative spool around which to wind the attentions of sentimental people, and because they cannot concentrate on paint itself—"the public only seeks and almost only ever sees in a work the anecdote that can be found"—the public balks when anecdote is not provided.[29]

Yet, in *Histoire de Édouard Manet*, Duret senses that there is something strange in the idea that a broad public reacted to the sight of paint qua paint with *laughter*—bafflement is more believable; but why laughter? He takes the example of *Le Balcon* (The Balcony, 1869) a scene of three urbane Parisians at their window: "It seems strange that such a scene could cause, at first sight, hilarity."[30] Maybe there was something obvious to titter at in the nude *Olympia*, but in the case of *The Balcony*, Duret understood that he might meet skepticism in claiming that such a picture set the public off in peals of compulsive laughter.[31]

The answer Duret provides is that the crowd does not laugh at what it sees but at what it *does not see*—it laughs at what is missing. This "broad public" has a physiologically conditioned inability to focus on painting itself: "The intrinsic merit of painting," Duret insists, "[t]he artistic value of the beauty of line or the quality of color, essential things for the artist or the real connoisseur, remain beyond the comprehension of passers-by."[32] The non-expert gaze, impatient and mobile, searches for story and is denied it, instead given the unassimilable data of "particularities of facture."[33] The laughter, then, Duret would have us believe, is the nervous counterpart of a kind of blindness. He imagines that they literally cannot see "facture" and, in the absence of the narrative data that they *can* assimilate, they see nothing, and therefore laugh.

Duret also gave an institutional explanation for the laughter faced by Manet that lay blame squarely at the feet of classes newly experiencing leisure time and cultural enfranchisement in the Second Empire. Duret framed Manet as the first innovative painter to emerge after the Salon's move to the Palace of Industry on the Champs-Eysées in 1857. Duret represented the move as a shift from an event

attended by a "restrained public, composed of artists, connoisseurs, people of letters, *gens du monde*" to an affair where the broad public [*le peuple tout entier*] came into direct contact with painters and now pretended to pronounce upon them.[34] Manet, he claimed, was the first "original" painter to face this newly mass crowd [*foule*].[35] Logically, then, laughter must emanate from those beyond the "restrained," educated public, from "any old coachman, streetsweep or waiter," as Duret described those influenced by the press to heap scorn on Manet. These are the "classes [*milieux*] where there is no capacity to form a proper opinion on matters of art,"[36] and where, Duret explains, the caricaturists found ready vessels in which to pour their colorful poison.

Duret, like Bazire, singled out caricaturists as among the most pernicious forces faced by the painter, characterizing them as the correlate of the expanded public for painting. Little journals handed over art criticism to "journeyman writers or johnny-come-latelys," nonexperts whose only reflex, like streetsweeps and waiters, was "the most vulgar attacks."[37] It was in these ranks that caricature was situated, and like the intellectually ill-equipped public it represented, caricature was *unseeing*: "The illustrated journals and the caricature papers, before having examined anything, threw themselves into a raft of caricatures and grotesque drawings, as offensive as possible."[38]

It is a curious aspect of both Bazire and Duret's descriptions of caricaturists that they are not given separate consideration as visual artists. In Duret's account, caricature's particular power is always yoked to "the press," or "second-string journals," not to their visual appeal. It is important that the caricaturists be denied any experience of the painting—he posits that they make their caricatures *before looking at the canvases* which, given Salon caricature's fundamental premise of comic copy, is patently absurd.

But Duret's story was that the public *could not see* Manet—they laughed at what *was not present* in Manet, what Manet denied them—story, subject, sentiment. If caricature represented that public laughter transparently (or goaded it: Duret is unclear on this point), caricature itself would have to be described, like the people it represented, as incapable of seeing Manet, incapable of paying attention to "the intrinsic merit of painting, … the beauty of lines or the quality of color."[39]

Caricature and the Intrinsic Merit of Painting

As discussed in Chapter 1, the earliest comic reproductions of Salon paintings encouraged a kind of close looking that simulated for the viewer the experience

of the painter. By the 1880s, forty years into Salon caricature's establishment as a genre, caricaturists and painters had settled into certain amicable habits before the exhibition. In contrast to Duret's image of a caricaturist who caricatures without seeing the original, Émile Bayard described the Salon caricaturist Stop, also a painter and etcher,[40] attending artists's studios the night before the Salon: "cold, proper, planted in front of the canvas, visualizing the work in an inscrutable glance."[41] Stop was, like a studio master, impassive and authoritative, an exemplar of visual acuity.

Duret did not invent the Salon critic's self-justifying device of dividing spectators into "connoisseurs" and the non-specialist or uninitiated public— differences in critical capacity appear already as comic subject and genuine concern in writing about the Salon in the *ancien regime*.[42] But it is at least strange if not willfully misleading, given the proximity of caricaturists to the world of painters (more on that momentarily), to place caricaturists among the uninitiated. Like Stop, most caricaturists had trained in painters's studios, where a major aspect of academic pedagogy was the graphic copy of painting. Further, painters and Salon caricaturists, given their shared student days, were often friends; some Salon caricaturists submitted paintings to the exhibition, as did Stop himself, as well as Henri Oulevay and André Gill. And Duret, given his proximity to Manet, must have been aware that some Salon caricaturists, far from representing outsiders to art (the "johnny-come-latelys" that Duret lamented among the expanded critical ranks), were consummate insiders.

Henry Oulevay (1834–1915) for example circulated between painting and press art, socializing with friends of Manet including James Abbott McNeil Whistler. Oulevay produced Salon caricature between 1861 and 1869, targeting among others the group portraits of Henri Fantin-Latour.[43] In 1861 the painter Carolus-Duran depicted Oulevay and Fantin as mirrors of each other in a double-portrait against a black ground (Figure 7.3).[44] One critic in 1865 noted the shared intelligence that coursed through Oulevay's painting and caricature, writing in response to Oulevay's canvas at the Salon that year, "I already knew the incisive humoristic wit of M. Oulevay, his *Salon pour rire* of 1863 indicated remarkable *rapprochements* between the works of Daubigny *pere* and *fils*; they were little strikes of the needle that really had their value."[45]

Yet if it seems obvious that caricaturists were specialists who looked carefully at painting and that even the least trained or gifted caricaturist would have to base his version on visual data, Duret nevertheless aligned it with the non-specialist and illegitimate spectators of French painting because of its association with—its conflation with—laughter. In subsequent monographs published in

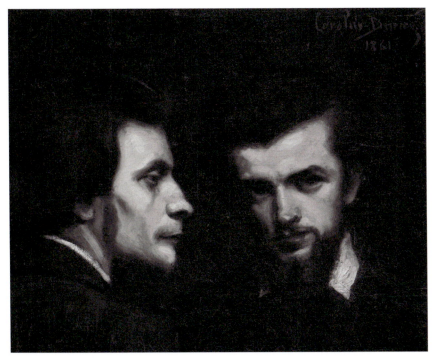

Figure 7.3 Carolus-Duran, *Fantin Latour et Oulevay*, 1861. Oil on canvas. 76.6 cm × 62.9 cm. Paris, Musée d'Orsay. Photo © RMN-Grand Palais (Musée d'Orsay) / Michel Urtado

the 1920s–1930s by Duret's followers, this divide between the "connoisseurs" and laughers deepens further.[46] This is the period that sees the elevation of a coterie of writers, particularly Baudelaire, as Manet's allies, men interested in *form*, in contrast to a confounded and hysterical public, rebuffed in their search for familiar narratives.

It is instructive to see the gears of this revisionist machine turn, in which writers like Baudelaire, partisans of Manet, are cranked above a "low" press. In his *Édouard Manet* (1931) the writer and curator Charles Léger cites a letter from Baudelaire to Champfleury: Baudelaire wrote that he was struck by "the joy of all these imbeciles who believe Manet is lost."[47] Léger names Baudelaire's "imbeciles" as "the Chams, the Bertalls, caricaturists of all stripes …, " who "had a field day at the expense of *Olympia* and its painter, to the applause of the public."[48]

Baudelaire considered caricature and comic art essential to modernity as he defined it and it is implausible that he would have referred to Cham, Bertall, or

caricaturists in general as "imbeciles."[49] Likewise, Champfleury, as the author of four volumes on the history of caricature, who saw it as a powerful instrument of popular will, would not have been sympathetic to such a characterization. Léger's authoritative substitution of Cham, Bertall et al. for Baudelaire's unnamed "imbeciles," is not a case of misinterpretation, but evidence of Léger's conviction of the immiscibility of high and low, exhibition and street, lyric poet and graphic press artist, in Manet's milieu. It is worth dredging up this early and mid-century scholarship to be reminded that the creation of a poetic élite of Manet apologists required, preposterously, the concomitant repression of meaningful links between painting and journalism, "the press," and caricature first and foremost.

Léger groups "caricaturists of all stripes" and "journalists of all ranks": the vilification of the popular required that caricature be understood not as a form of pictorial or graphic information, but of bad writing or hack criticism. (Léger never refers to caricaturists drawing; along with their fellow "journalists," they "had a field day".) In order to reshape caricature as jeer, writers like Duret and Léger had to disembody it and excise it from its material context and complexity.[50] Meanwhile, as I argue in Chapter 4, caricaturists actively worked to draw attention to their materiality as an overarching source of comedy.

Because, for the first writers on Manet, caricature had to be seen as non-pictorial and as distant from, if not opposed to, painting, no champion of Manet in the first sixty years of scholarship could have analyzed the ways that caricature and painting were beginning to resemble each other, to share more, possibly even to communicate via the press imagery that painters consumed and the painting that press artists shot back at them in comic form.

Taking Sides with the Inkwell

Returning to the moment when the Salon caricaturist was faced with a plenitude of choice, how did Manet figure for the caricaturist as a potential subject among many? A significant collection of pre-publication ink sketches after canvases by a Salon caricaturist survives in one case, that of Cham at the Salon of 1864.[51] It is likely, given the sheer number of canvases caricatured in an extremely fast, scant graphite, that Cham did some sketching at the Salon and returned home to firm up his impressions in ink.

From among the 3,468 works at the Salon in 1864, Cham selected about thirty canvases including *L'Aurore* (Dawn), by Jean-Louis Hamon (Plates 33 and 34); a painting of three horses in muddy brown huddled against a lean-to by the

German-born orientalist and battle painter Adolphe Schreyer (Plates 35 and 36); and a painting by a thirty-two-year-old Édouard Manet, of a bullfighter, dead in an arena (Plates 37 and 38).

Cham's caricature after Manet's *Épisode d'une course de taureaux* (Incident in a Bullring) was all about ink: "Manet, dissatisfied with his color merchant, has decided only to use [*prend le parti de ne plus se servir que de*] his inkwell from now on." The expression *prendre parti* can mean "to decide," but also "to take sides." Cham's Manet takes sides against painting and with the black-and-white, rapidly contoured contemporary reporting of the press artist.

In the case of Hamon's *L'Aurore*, Cham represented the subject more or less accurately (a female figure inhaling the scent of a flower), taking a half-hearted jab at the color in the caption. Schreyer's scene of horses, on the other hand, provoked in Cham a deliberate misreading/misrepresentation of the portrayal of depth in oil paint: he collapsed the painter's depiction of three horses receding in space into one three-headed monster. Cham's treatment was no crueler, no more mocking of Manet than his treatment of the other two artists, and yet there is something different in kind, a seizing on a kindred quality between himself and Manet that was absent from the other two. In his caricature of Manet's bullfighter, Cham's ink merged with Manet's black paint, and the caption only shored this up: Manet had decided to use—sided with—the inkwell, the tool of a caricaturist.

As is evident from Cham's activities at the Salon of 1864, Salon caricaturists took stock of the Salon as a whole—Hamon, Schreyer, and Manet all came in for comic treatment. In fact, that year, Cham published caricatures of paintings by nearly thirty different painters, most of whom have been forgotten by or occupy very little place in art history. The ultimate destination for Cham's sketch after Manet's *Incident in a Bullring* was a page of caricatures in *Le Charivari* laid out in a grid of twelve (Figure 7.4—find Hamon's and Schreyer's canvases in the same grid).[52] The grid equalizes the impact of each vignette, whose quick captioning serves an accelerated reading, rich in sequential laughs. Just as viewers experienced the Salon as a glut of pell-mell imagery, so readers encountered the caricatural Salon as a dense spread of jostling names and pictures. It was structurally impossible, within the grid, for Manet to stand out as a special or exemplary case of mockery, pillory, or attention; Manet among the others participated in a plenary "Salon to laugh at."

The subject matter available to painting resembled press imagery ever more in the post-Romantic era, as various definitions of "realism" incorporated subjects from contemporary life. At the same time traditional academic values

Figure 7.4 Cham, "Une promenade au Salon. Croquis par Cham," *Le Charivari*, May 22, 1864. Wood engraving. Bibliothèque nationale de France

of chiaroscuro, rounded form and *fini* (polished, varnished finish) gave ground to emphases on sketch- and print-aesthetics and other experiments in flatness and shorthand. Several early accounts of Manet, including Bazire's initial one, repeated that Thomas Couture, Manet's first studio master, saw in Manet's dogged "naturalism" an echo of the press subject and, as a warning, told the painter, "You'll be the Daumier of 1860!"[53]

The formal rapprochement between painting and caricature was accompanied by an increasing resemblance between the activities of press artist and studio artist. In the second half of the nineteenth century, painters worked under

conditions that resembled ever more those of caricaturists. Financially, painters found themselves on the open market, as state commissions evaporated and the Salon became, to the chagrin of many critics, a marketplace for self-promotion and sale, a fact mocked in Bertall's 1865 Salon caricature for *L'Illustration* (Figures 7.1 and 7.2).

In Cham's 1864 caricature of Manet's bullfight, Manet battles his "color merchant" and openly strategizes about the production of his images. In contrast, Cham does not invoke Schreyer or Hamon when captioning his caricatures of their paintings. Their painted subjects are animated by the text ("this sins with color", "a three-headed horse is abandoned")[54] but their creators are never named, never enter the scene. Schreyer and Hamon do not have the same comic potential as decision-making agents.

The Manet that Cham invokes in the caricature of the bullfight, on the other hand, is plugged into a modern economy. Rather than work collectively in a studio mixing pigment, he works in isolation with tubes purchased from a color merchant. His conception of painting is not strictly bound by genre convention: What was after all *Incident in a Bullring?*—portrait or landscape? Realism or exoticism? (Manet's second canvas at the Salon of 1864, *Angels at the Tomb of Christ*, presented the same problems, defying the conventions of both religious painting and realist subject matter in its admixture of the two.) The irrefutable contemporaneity of Manet's subjects, and their conflation of typical genres, was another way, therefore, that the painter seemed to "take sides" against painting and with caricature, press art, or reportage.

For Cham in 1864, Manet in particular was painting like a caricaturist. But the accusation that painting in general had begun to court the caricatural ricocheted around Salon reviews in the Second Empire. Critics described this problem as a systemic feature of an unmanageably large and chaotic public art exhibition. The complaint was that as painters jockeyed for attention in the ever-growing mass exhibition of the Salon, they deliberately sought to attract or divert viewers— "spectators"—by becoming more caricatural. In the words of one critic at the Salon of 1863,

> it is difficult to cross the numerous rooms of the Palace of Industry without being attracted by a great majority of canvases that, either by the shocking tone of color or by their irresistible charm, force the spectator to stop a moment. How, in effect, to pass indifferent before the witty canvases of M. Biard? How not to smile at the English misadventure of M. Droz? How not to be amused by the Rabelasian scene of M. Comte?[55]

According to this critic, the pressure to stand out—to manufacture originality—pushes painters to attempt a seductive hilarity. That hilarity has many varieties, from picaresque misadventure to Dutch genre humor to François-Auguste Biard's particular brand of caricature-in-paint (Biard's hilarity was noted at many of his Salon appearances; yet while Biard has been forgotten, it is Manet whose name has come down to us as the era's laughing stock).[56] This perspective on a Salon systemically pressuring painters to venture comedy—contra Bazire or Duret, who represented Manet alone laughed at by the crowd—requires us to ask how Manet might have been painting for an exhibition context in which various kinds of comic affect had entered the pictorial strategies of many Salon painters.

Was, then, Manet experimenting with aspects of comic imagery? Nothing could be further from Biard's "wit"—convoluted narratives in picturesque form—than Manet's stark refusal of story or sentiment. Laughter infected the relation between canvas and spectator in ways that require case-by-case analysis. The important point here is the perception among critics that painters were received as comic in various ways by particular tranches of the public (some "smile" in front of Droz while others are "amused" by Comte) by deploying different kinds of comic form.

Although it is arguably responsible for creating the most lasting links between Salon caricature and Manet in the minds of contemporary art historians, T.J. Clark's essay "Olympia's Choice" noted the current of comedy that rippled through Manet's *Olympia*. Reproducing Bertall's "The Coal-Woman of the Batignolles" among other caricatures, Clark showed convincingly with exhaustive citation of the written critical record that the conventional Salon critics suffered from blindness and aphasia (they "seem not to be able to see or describe") while caricaturists's versions identified precisely the transactionality and materiality of *Olympia*, as comedy: "On one or two occasions, that mode [caricature] allowed *Olympia*'s story to be told more or less in full."[57] Clark saw that rather than project laughter at an undeserving screen, caricaturists magnified the comedy Manet deliberately produced.[58]

Clark observed that *Olympia* "nearly obeys the rules—to the point, we might think, of uneasy parody."[59] Manet's version of the Second Empire nude had been updated, thrown into the present, made transactional and self-aware: this is precisely how Salon caricature treated nudes—as naked and contemporary. See, for example, a two-page spread, the fourth installment of caricatures of the Salon of 1863 in *La Vie parisienne* entitled "Folichons" (Frolics) (Figure 7.5),[60] a roundup of the Salon nudes that year. All are put in underwear for decency's

Figure 7.5 Marcelin, "Le Salon de 1863—4e série: Les Folichons," *La Vie parisienne*, no. 349, 1863, page 234. Gillotage. Bibliothèque nationale de France

sake (already suggesting their nudity as nakedness). The caption under the first Venus reads "No childbirth was more miserable," describing the "poor goddess" as a "twisted Venus."[61] The next figure advertises the use of a new rubber in ballooning, another is drunk, another group work as laundresses, and Paris offers a golden apple to a goddess who contracts in gastric pain, hiding herself in embarrassment.

These caricatures may, to some degree, perform the misreading of painting by a consumer who can only understand art in the petty terms of contemporary life. But let us return to the image that I identified at the outset of this study as one of the first examples of Salon caricature proper, targeting an individual painting in an illustrated journal: Raymond Pelez's 1842 "Aquatic Fantasy," originally published in *Le Charivari* (Plate 3). It is striking to see the extent to which one of the first examples of Salon caricature is a direct ancestor of *Olympia*. The lithograph converts a painting of a psychologically

vacant orientalist nude into a self-aware Parisian prostitute with a bad poem for a pendant, a rebus of coded accessories, and a challenging, direct gaze. By the 1860s Salon caricature had firmly established, nearly as subgenre (as the round-up of "Frolics" suggests), the art of converting pure, allegorical, mythological and historical nudes into contemporary women with troubled, vulnerable bodies, self-awareness and self-possession, and experience of sex, sickness, and work.

Clark was right to see comedy in Manet, "parody" of genre in his contemporary nude. I would add that Manet's "parody" must have emerged from awareness of the iconography of Salon caricature going back to the 1840s. The history of Salon caricature—hundreds of examples of timeless female nudes given specific, contemporary class associations, and sexual and physical realities (as joke, of course)—would have, for twenty years before *Olympia*'s appearance, conditioned viewers to see Manet's intervention as a kind of Salon caricature cycled back onto the exhibition's walls. Salon caricature must be seen as having participated in the generation of Manet's *Olympia* rather than merely responding to it in a scandalous aftermath.

Manet, Our Murderer

If caricature's misreadings of the classical nude satirized viewers themselves to some extent as petty and prurient, then we have to consider the dimension, untouched in Duret, of Parisian readers's self-conception as consumers of art through caricature. Until this point, I have adopted Duret's manner of speaking of "the public" as a monolith, "*le public tout entier*," including the great, undifferentiated public for caricature. This conception of "the public" as faceless, mass, merely laughing, already implies that caricature is generalized and superficial. But if we turn to a caricature after Manet from a little-known 1868 album, we see how the identification of specific audiences complicates the nature of the laughter elicited.

L'Épatouflant Salon du Havre (The Astounding Salon of Le Havre) by the caricaturist Stock is an often-biting, coded, Parisian view of a provincial exhibition, the 1868 regional Salon at Le Havre. While it was common to depict the caricaturist as a sallying devil, Stock's self-depiction on the cover of the album, with its details of the harbor of Le Havre, emphasizes his alighting in the city from afar (Plate 39).[62] Although competitive in price with the standard 1-franc album, Stock's *Astounding* Salon is highlighted with what

is likely hand application of vibrant washes in rust, turquoise, and a dark red so thick that it often blocks out the relief-etched lines beneath.

In his caricature after Manet's *Le Torero mort* (Dead Toreador), Stock props up the body of the toreador on various instruments including a drafting desk and a stool, so that the toreador dangles across the threshold of a three-dimensional empty rectangular frame (Plate 40). A thick red wash fills in the toreador's cape and pools from under his arm. Hand-applied color usually stayed within clearly demarcated lines—a color-by-numbers schema facilitated rapid and uniform copying. Stock's thick red wash falls from the toreador's rib freehand, unbound by line, a passage that is painterly to the exact measure that it accuses the painter of violence.

The caricaturist's emphasis on blood is an invention on his part: in Manet's canvas, the matador's wound is all but imperceptible, the corpse sterile against its flat ground.[63] Oulevay, who targeted the body of the toreador in an 1864 "Salon pour rire" in the *Monde illustré*, ignored blood altogether, representing the brown smudge under the toreador's shoulder, Manet's only indication of a wound, as shadow.[64] Stock's insistence on physical violence and copious, bright blood references the violence enacted by Manet on the original canvas and not in the depiction. After its original 1864 exhibition at the Paris Salon (the occasion for Cham's caricature discussed above, Plate 37), Manet sliced the body of the toreador from the former *Incident in a Bullring* and retitled the resulting canvas *Dead Toreador*. Manet also painted out the bull behind the body of the toreador; therefore, the bull now sits, in Stock's caricature, outside the new frame. The adjustable frame along with the drawing desk and stool are tools that one might find in a painter's studio, underscoring the managing of the corpse-as-subject as the clumsy labor of a Manet painter/murderer.

The caption compares Manet's *Dead Toreador* to recent works by the painter Jean-Léon Gérôme. Gérôme, fresh off a "lugubrious series" of paintings of dead men (the death of Caesar, an episode from the life of Napoleon Bonaparte, a contemporary duel), neglected to kill the toreador, leaving Manet to finish the job; it is "under the brush of Manet" that he dies.[65] Stock's treatment of Manet's *Dead Toreador* requires an awareness of the exhibition history of the canvas (and of the recent exhibition history of Gérôme, whose paintings are not caricatured here), rewarding the Parisian reader/Salon-goer for her keen memory of the 1864 Paris Salon and its afterlife in the illustrated press.

Although the Le Havre exhibition's organizers had hoped to highlight the indigenous talent for northern seascapes, the event was flooded with canvases sent from Parisian painters. Stock caricatures some of the local painters (Aillaud,

Cassinelli) but even the Northerners are known to him from having shown in Paris first. For example, Stock targets the canvases of Claude Monet, then based in Le Havre but whose *Camille,* a portrait of the painter's wife, was first shown at the Paris Salon of 1866.

Again in the case of Monet's *Camille,* the *Astounding Salon of Le Havre* delights in spying on the stars of the Paris Salon in this new context—reframed, as it were, by a different kind of exhibition, one to which Monet's wife has snuck illicitly (Plate 41). Stock reimagines Monet's wife, a well-dressed Parisian lady, like Manet's toreador, not as a canvas re-viewed but as a body caught crossing through a frame. The caption warns her that "to return too late is, in Paris, to expose one's self to the odors of Richer, [Louis] Veuillot, and Co."[66]

Stock catches Parisian painters's protagonists in the midst of re-framing, exposing painters for the way they sneak between exhibitions, managing their images differently for Paris and the North. Ultramontane journalist Veuillot had published *Les Odeurs de Paris* (The Odors of Paris) the year before, in which he indicted Second Empire moral dissipation and political corruption, using the metaphor of Baron Haussmann's recently renovated sewers.[67] The reference to "Richer" is to Richer and Co., Paris's leading producer of *poudrette,* a fertilizer made of human waste—an analogy for artistic repackaging and sale. Madame Monet crosses the frame back to Paris, taking her mask off, as if in this provincial show of mostly seascapes, she might have presented herself as somehow clean or innocent, but she now returns to the big city, a place evoked, with the naming of Veuillot and Richer, as filthy and compromising, as much for painters as for women who "come home late."

Stock's jokes of reframing and representation link Manet and Monet, not as baffling innovators but as agents engaged in risky forms of self-positioning in a marketplace that requires them to knife their own canvases and soil their spouses. Note how the conditions of Manet's hilarity are shared between Gérôme on the one hand and Monet on the other, artists with widely divergent relations to a later history of modernist interpretation. However, in this moment, they bleed into each other as comic subjects for a sophisticated audience aware of recent Salon histories and their echoes in the illustrated press.

Caricature's comedy here is not an expression of bafflement at or hostility to contemporary pictorial challenges presented by Manet or Monet but rather as a sign of knowing. For Bazire and Duret, laughter was a mark of superficial, non-expert spectatorship. Duret would have seen Stock's caricature after Manet's *Toreador* and excised and anthologized it as another "vulgar attack." Yet Stock's *Astounding Salon* shows us that laughter also identifies insiders. This

representation of Manet was a shibboleth, a report sent from outside Paris back to Parisians, part of an album with references to their hometown exhibitions, their homegrown journalism, the shared references of their humor as community-making. Veuillot may have intended his *Odors of Paris* as a moral wake-up call. But for Stock, this fresh vision of Parisians as corrupt, decadent, and dirty (Veuillot's book was newly published) was a quick, hilarious, contemporary way for his readers to identify as a collective.

It was a convention of Salon-critical rhetoric throughout the second half of the nineteenth century to identify laughter as the sign of those in thrall to the spectacle of the Salon and unable to muster the real critic's self-possession and selective focus (discussed in depth in Chapter 6). Duret and Bazire, on the model of Émile Zola before them, described laughter as a lack of self-possession, a nervous attack or compulsion. In stark contrast, Baudelaire described laughter in his 1855 "On the Essence of Laughter" as the product of extraordinary self-possession. If for some, laughter was the sign of bad spectatorship, Baudelaire put *himself* among the laughers, describing how a virgin fresh from paradise would alight in Paris, enter the Palais-Royal (then a bazaar), and stumble upon "a caricature," he writes, "plenty appetizing for us, full of bile and rancor, as a bored and perspicacious civilization knows how to make."[68] Far from the monolithic mockery Duret would have us believe laughter entailed, this modern, Parisian understanding of laughter was textured with a wider experience of journal culture, status awareness, vernacular language, and gossip. Caricature produced a laughter which, even when cabalistic or menacing, was also *knowing*. And it belonged to—was one of the skills of—the Parisian who, for Baudelaire and for Stock, found community, including superiority over others (innocents from abroad, provincials from the North), in laughter as a sign of shared fallenness, corruption, and filth.

There is one account of Manet, published in 1924 but written in response to the claims made by Duret and his followers, which describes laugher as a sign of belonging and not as a symptom of hostility. The painter Jacques-Émile Blanche (1861–1942) claimed to have been acquainted in Paris as a young painter-in-training with an aging Manet, and he contested much of Duret's account of Manet.[69] Although he knew Manet when the painter was in his last years and Blanche was very young, he claims to have nevertheless been aware of a *boulevardier* culture of conversational humor informed by the press, an *esprit mousseux* (sparkling wit) in which Manet was steeped.[70]

Blanche's is a portrait of a painter who laughs, who understands his role in a thoroughgoing culture of laughter, refracted through social life and journal-

reading alike. Such an image is worlds away from Bazire and Duret's self-serious Manet, whose overriding characteristic was sincerity and whose only response to the comic rhetoric of the press was to be stymied and hurt.

Blanche's account of Manet chimes with a larger shift in the publication and reception of caricature in the later 1860s and 1870s. The repression of caricature loosened after 1866, in the "concessionary" period of Napoleon III's reign, and censorship was finally abrogated in the press laws of 1881. These changes, along with the continuing expansion of the illustrated press and its market specialization, saw caricature used increasingly as homage or as a badge of participation in specialized sub-cultures. These sub-cultures developed around specific journals, cafés, and eventually around the social-artistic clubs of fin-de-siècle Paris such as the Incohérents, the Hydropaths, and the Société du Bon Bock. The latter, a social and drinking club that produced albums of graphic art including caricature, was founded in 1875 by the printmaker Émile Bellot and took its name from Manet's 1873 Salon success *Le Bon Bock*, demonstrating how Manet functioned again as a shibboleth for the self-identification of a Parisian group, as the figurehead for the proximity of graphic artists and painters, and as a complex symbol of comic homage.

As an illustration of this shift in caricature's ability to signal belonging, we turn again to the work of Stock. In 1874, two works of Manet's were accepted at the Salon, *Le Chemin de fer* (The Railway), an oil painting, and *Polichinelle*, listed as a watercolor but in fact a black-and-white lithograph hand-painted in gouache and watercolor (Plate 42).[71] A depiction of Manet's *Polichinelle* stands monumentally over a miniaturized collage of caricatured Salon canvases in Stock's "Revue du Salon" for 1874 (Plate 43), which was made, according to a dedication to Manet across the top of the page, "under the inspiration of your astounding Polichinelle."[72]

Polichinelle was an ambiguous figure, a staple violent buffoon from the *commedia dell'arte* tradition. It was widely suspected that Manet's *Polichinelle* was a veiled caricature of the second President of the Republic, Patrice MacMahon, a reactionary famous for fierce retaliation against the communards.[73] Whether Manet intended the brutal and impulsive Polichinelle with his bushy moustache and military accessories as a caricature of MacMahon, the image was *read* as such when Manet attempted to have it published in a Parisian journal, and it was rejected by government censors.[74]

Stock, working with a range of four color washes over a stark black relief-etched armature, meets Manet's *Polichinelle* with remarkable precision in its copy of the checkerboard coloration. Manet's original, similar in scale, used the

same narrow range of blue, red, yellow, and green. This particular range of four-color wash was common in the illustrated press and given that Manet submitted it for publication, the painter may have specifically used this palette for that reason, or as a reference to the familiar aesthetic of the color-illustrated press that had emerged in the late 1860s.[75] Stock's "caricature after" Manet is more of a spirited study than a caricature—an animation, even, that diverges only in giving Manet's Polichinelle a sweeping physical gesture of the arm. Ironically, Stock's copy, as "caricature after," permitted the painter the genuine diffusion that censorship denied him. With his caricature, Stock volunteered as engraver to Manet's painter.

The placement of Manet's *Polichinelle* in the layout was also significant to readers familiar with Salon caricature spreads. It was a convention of Salon caricature to depict a jester or imp as an allegory for the caricaturist or the journal (a convention on display for example in "Folichons," Figure 7.5, discussed above). Here, Stock substitutes Manet's own scabrous buffoon for that guiding allegory, essentially substituting Manet for himself. This represents an apogee of the rapprochement between caricaturist and painter, even a union of the two, in their materiality and their symbolic role. Manet here is not a subject made comic; rather, the comedy of his own Polichinelle is imported intact from the real Salon, where it was badly hung and difficult to see, into a new position of visibility and status.

But if Manet is a standout subject here, look to the right side of the page, where the painters mocked under the sign of Polichinelle concede to the mockery: "Do as you like, sir," is the handwritten instruction of Léon Bonnat, whose own canvas Stock caricatures among the melée. In 1874, a journal still had to receive written permission from an individual to publish a caricature of his or her likeness. But it was not legally necessary to acquire or publish permission to caricature a work of art. Therefore, these voluntary autographs highlighted a desired complicity of the painters in their own comic remaking. It is possible that the painters were shown a proof of the original design to approve, as the orientalist painter Anatole de Beaulieu's autograph specifically references Stock's placement of the *Polichinelle* within the layout. The painter submits to the amoral clown as the patron saint of Salon painting in a Salon given over to laughs: "Ô Polichinelle! Patron of serious men"[76]

The case of Stock's *Polichinelle* crystallizes the misinterpretation—even willful obfuscation—of Manet's relation to the comic by the critics of the 1880s and the precedent they set for Manet's canonization over the following decades. Bazire, who could not see caricature as anything but hostile and could not see caricature's shared foundations with painting, also preposterously refused to see the caricatural

in *Polichinelle*, even when censorship identified it as such. Bazire described the lithograph in his 1884 *Manet* as a sanitized, charming symbol of Manet's profound Frenchness ("This Polichinelle is not Italian, he's French" and his "insolences and brutality have not crossed the Alps").[77] The absurdity of ridding Manet's work of any traces of comedy is at its most visible in the case of this polyvalent comic image of the Polichinelle, the very image that for Stock—and for Manet's fellow painters, importantly—symbolized the legitimacy of caricatural form, in painting, where Manet made it a priority, and as a record of reception, even for "serious men."

Duret associated laughter at the exhibition with the working classes, the *milieux* encapsulated by his description of the "coachman, streetsweep or waiter," those understood by the state to be most susceptible to caricature[78] and whom Duret agreed were manipulated by it. An untitled album containing caricatures after paintings by Manet (Figure 7.6) demands consideration of the

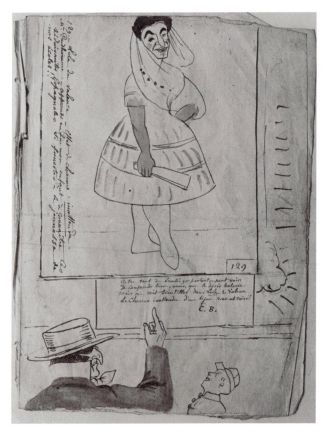

Figure 7.6 Untitled [album of caricatures after paintings by Manet]. Photograph, nineteenth to early twentieth century, after a drawing, c. 1863. Bibliothèque nationale de France

class bias at work in the repudiation of journal caricature by the defenders of Manet.[79] Unpublished, the album was produced in response not to the Salon but to a private event, Manet's early career retrospective mounted in March 1863 at the Galerie Louis Martinet on the Boulevard des Italiens. Étienne Moreau-Nélaton (1859–1927), the artist, historian, and major donor to the Bibliothèque nationale de France, reported that the album was "collected by Philippe Burty and conserved among his papers."[80] Burty and Duret were allies in many respects including in their support of the young painters who would become the Impressionists, and of Manet. Influenced by Duret, Burty described Manet's work as "not made for the crowd," because "not easily comprehensible."[81]

Returning to the unpublished album collected by Burty, the style of the anonymous caricaturist does not resemble that of any major contributors to the illustrated press. Indeed the lack of specific passages of *charge*, the nonexistent staging, and the absence of punchy captions indicate the hand of an amateur. Full of in-jokes, with references to poems by Victor Hugo and Baudelaire, the text unfolds as a lightly erotic Spanish "novel," as Moreau-Nélaton described, "whose heroes would be the *Absinthe Drinker*, who listens to the *Old Musician*, and the *Young Woman Reclining in Spanish Costume*."[82] The caption imagines the *Woman Reclining* in an *hotel garni* in Granada in an agitated state of melancholy after entertaining a lover, while the stock bourgeois character M. Prudhomme warns a young schoolboy against Spanish seducers.

Why do these images demand a consideration of class? Because they show that Burty and likely others in his circle, which included Duret, did indeed understand and enjoy Manet as a comic subject, but that they could only do so in a way that sheltered that enjoyment from the class associations of public laughter and journal caricature. The album transcribed their laughter within the padded, domesticated walls of Martinet's gallery, open to the public but frequented by an educated clientele who consumed specialized art journalism and prints.[83] Circulated hand to hand among connoisseurs and critics, the caricature of painting could thus be enjoyed only when reframed as premodern, as a Renaissance studio game from before caricature's public life.

In its entanglement of poetry and caricature, and in its place at the heart of a circle of critics and aesthetes, the album brings to mind the etching projects supported by the Société des aquafortistes (founded 1862, of which Burty was a member), including *Eaux-fortes modernes* (1862–1867), Burty's *Sonnets et eaux-fortes* (1869), and perhaps most of all the portfolio of Manet's etchings after his paintings, "Huit gravures à l'eau-forte par Manet" (1862), published by Alfred

Cadart.[84] Carol Armstrong has explored in depth the relay between Manet's paintings and etchings in 1863: In them, "Manet was Velasquez ... filtered through Goya ... and then caricatured"[85] This is an oddly apt description for Burty's album that filtered Manet's canvases through a melancholy and romantic Spanish lens and then caricatured them. There is much more to say about the overlap between caricature and the etching revival in the 1860s, but this moment of extraordinary proximity shows that the resistance to Salon caricature on the part of Manet's advocates was, as Blanche wrote, "for the needs of a cause."[86]

Even when we can imagine Burty and his circle consuming the album as a rarefied pastime rather than a popular diversion, shameful associations hovered about the album. At some point, it entered the Martinet dossier at the hands of a woman, who attached this letter to it: "It is a veritable pleasure to send you this notebook Excuse me if I do not sign. It is modesty [*pudeur*] which restrains me."[87] Here, among the illicit laughers, emerges the first material record of a woman laughing at Manet—not illegitimate, ignorant, or superficial, not bird-brained like Dumas's hopping *lorettes*[88] or venal, as Duret would have it, sizing up Manet's dresses,[89] but a member of a circle of insiders, a link in an august chain of possession, and, thankfully, a careful conservator.

Conclusion

Cham's 1864 caricature of Manet's bullfight saw Manet using the tools of a caricaturist, and made sport of the resemblance between painting and caricature. In casting Manet as a caricaturist, Cham reframed Manet's canvas, cutting out the colorful arena, prefiguring the cropping that Manet himself would execute for its next display, in 1868. I do not propose that Manet cropped the canvas in response to Cham, only that Cham thought the bullfighter alone made a better caricature; the same move, for Manet, constituted a better painting.

Those writing on Manet in the early twentieth century looked at Salon caricature with an eye toward the concatenation of formal breakthroughs—hermetic, purist—that would constitute modernist art history. But one could write an alternative history of twentieth-century art that, rather than repressing caricature, is rooted in it: As Michèle Hannosh has written, "[f]rom the radically caricatural methods of Courbet, Manet and Degas ... to the Cubist play with representation and the distortion, irreverent humor, uncanniness, and license characteristic of twentieth-century forms, modern art has been dominated by the ... caricatural."[90]

As this book has argued, Salon caricature has plenty of significance outside of a history of modernism. However, *within* an alternative history of modernism as outlined above, these caricatures of Manet would be key evidence of the fluidity of pictorial values between painting and caricature in the 1860s and 1870s.

Laughter is hard to categorize with any generality—the monolithic presence of public laughter is one of the most suspect aspects of Duret's and Bazire's accounts. Interrogating the comic image by image as this chapter has done, it is clear that in the Second Empire and early Third Republic, Manet's works had the power to activate multiple cultures of laughter around painting and its reception at the public exhibition—including on the part of those that publicly decried comic responses to the Salon. These cultures of laughter had nothing to do with the blind public mockery attributed to them by later critics and should instead be interrogated for their keen kindred vision of painting, their evidence of community-formation through reception, and the pressures they exerted on painting's morphology in the contested years of modernist emergence.

Notes

1 T.J. Clark, "Olympia's Choice," in *The Painter of Modern Life: The Art of Manet and His Followers* (New York: Knopf, 1984), 79–146. Clark's argument is glossed, and Bertall's "Coal-Woman" is reproduced, in the textbook *Modernity and Modernism: French Painting in the Nineteenth Century*, ed. Francis Frascina, Nigel Blake, Briony Fer, et al. (New Haven and London: Yale University Press in Association with the Open University, 1993), 25.

2 *Édouard Manet: Catalogue raisonné*, ed. Denis Rouart and John Wildenstein (Lausanne: Bibliothèque des arts, 1975), cat. no. 310.

3 "Voyez la vente! Demandez! Faites-vous servir! Grec, Flamand, Romain, vieux habits, vieux galons Voyez, voyez la vente!" "Le Salon, par Bertall," *L'Illustration*, June 3, 1865, 341.

4 "Au moins celui-là on ne l'accusera pas de travailler pour la vente. – Pas plus que M. Manet." Bertall, "Le Salon, par Bertall."

5 George Heard Hamilton, *Manet and His Critics* (New Haven: Yale University Press, 1954), 17. Hamilton also wrote a widely used textbook on modern art and had an influential career training art historians and curators at Yale University and later at the Sterling and Francine Clark Institute. George Heard Hamilton, *Painting and Sculpture in Europe, 1880–1940* (New Haven: Yale University Press, 1967) is still in print, in its 6th edition (1989).

6 E.g., Dianne W. Pitman, *Frédéric Bazille: Purity, Pose and Painting in the 1860s* (University Park: Pennsylvania State University Press, 1998); Bridget Alsdorf, *Fellow Men: Fantin-Latour and the Problem of the Group in Nineteenth-Century French Painting* (Princeton, NJ: Princeton University Press, 2012); and André Dombrowski, *Cézanne, Murder, and Modern Life* (Berkeley and Los Angeles: University of California Press, 2013).

Recent scholarship on Courbet has consistently cited Salon caricature, e.g., *Gustave Courbet*, ed. Dominique de Font-Réaulx (New York: Metropolitan Museum of Art, 2008); *Courbet à Neuf! Actes du colloque international organisé par le musée d'Orsay et le Centre allemand d'histoire et de l'art à Paris les 6 et 7 décembre 2007*, ed. Mathilde Arnoux, Dominique de Font-Réaulx, Laurence des Cars, et al. (Paris: Editions de la Maison des sciences de l'homme, 2007); Petra Chu, *The Most Arrogant Man in France: Courbet and Media Culture* (Princeton, NJ: Princeton University Press, 2007); and *Courbet: Mapping Realism: Paintings from the Royal Museums of Fine Arts of Belgium and American Collections*, ed. Jeffrey Howe (Chestnut Hill, MA: Boston College, McMullen Museum of Art, 2013). For an exception to the association between Salon caricature and proto-modernists, see Martha Lucy, "Cormon's 'Cain' and the Problem of the Prehistoric Body," *Oxford Art Journal* 25, no. 2 (2002): 109–26.

7 "Il faut d'ailleurs relever que les œuvres et les artistes auxquels revient la place la plus significative quantitativement au sein de ce corpus sont aussi ceux qui essuient les charges les plus vives." Laurent Baridon and Martial Guédron, "Caricaturer l'art: usages et fonctions de la parodie," in *L'art de la caricature*, ed. Ségolène Le Men (Paris: Presses universitaires de Paris-Ouest, 2011), 87–108, 96.

8 "Ce n'est sans doute pas un hasard si, dans ce panthéon, Courbet et Manet occupent les premiers rangs et si la dérision de leurs œuvres comprend souvent les connotations sexuelles." Baridon and Guédron, "Caricaturer l'art," 96.

9 On Moreau's attempts to renew history painting, see Peter Cooke, *History Painting, Spirituality and Symbolism* (New Haven: Yale University Press, 2014). Although Gérôme possessed a secure place in the official establishment, becoming a professor at the École des beaux-arts in 1864, his interpretation of history painting was often controversial. See John House, "History without Values? Gérôme's History Paintings," *Journal of the Warburg and Courtauld Institutes* 71 (2008): 261–76. Gérôme has been the subject of revived interest in recent decades for his relationship to modern visual culture, including photography and cinema. See *The Spectacular Art of Jean-Léon Gérôme: 1824–1904*, ed. Laurence Des Cars, Dominique de Font-Réaulx, and Édouard Papet (Paris: Skira, 2010) and *Reconsidering Gérôme*, ed. Scott Allan and Mary G. Morton (Los Angeles: J. Paul Getty Museum, 2012).

10 E.g., Louis Leroy on *Olympia* and *Jesus Insulted* in *Le Charivari*, June 10, 1865 & May 11, 1865, and in *Le Journal amusant* May 27, 1865. See Clark's comprehensive list of critical commentary, *The Painting of Modern Life*, n. 8, 281–3.

11 Cham caricatured fifty-eight works for *Le Charivari* in 1865, targeting Manet's
 Olympia once. Bertall in *Le Journal amusant* caricatured sixty-three works, targeting
 Manet's *Olympia* and *Jesus Insulted* each once; Hadol in *La Vie parisienne* caricatured
 108 works, including a comprehensive round-up of "Les Portraits de femmes" on
 May 20 and 27, and did not caricature any of Manet's works. In comparison to the
 three instances of caricatures after Manet's canvases, Moreau's were caricatured
 seven times, Schutzenberger's five times, and those of many painters, including
 Gérôme, Meissonier, Jundt, Fromentin, Protais, Sant-François, and Whistler, were
 caricatured three times or more. Cham, "Promenades au Salon," *Le Charivari*, May
 14, May 18, May 21, May 28, and June 9, 1865. Bertall, "Promenade au Salon de
 1865," *Journal amusant*, May 27 and June 10, 1865. Hadol, "Promenades au Salon,"
 La Vie parisienne, May 13, May 20, May 27, June 3, June 10, 1865; "Les Portraits de
 femmes à l'exposition," May 20 and May 27.

12 Randon (Gilbert Randon), "L'Exposition d'Édouard Manet," *Le Journal amusant*, no.
 600, June 29, 1867, 6–8.

13 For a sample of such mockery from midcentury, see *A Child of Six Could Do It:
 Cartoons about Modern Art*, ed. George Melly (London: Tate Gallery, 1973), and
 Jean Lipman, *Art about Art* (New York: Dutton, 1978).

14 See for example "The Crisis of the Easel Picture," in Clement Greenberg, *The
 Collected Essays and Criticism*, vol 4., ed. John O' Brian (Chicago: University of
 Chicago Press, 1994), 222; "Abstract Art," ibid, vol. 1, 201; and "Modernist Painting,"
 ibid., vol. 4, 86–9. See also Carol Armstrong's synopsis of Greenberg's writing on
 Manet in *Manet Manette* (New Haven: Yale University Press, 2002), xi, and n. 3–4,
 318–19.

15 Michael Fried, "Manet's Sources," *Artforum* 7 (March 1969): 28–82, revised and
 expanded in *Manet's Modernism, or the Face of Painting in the 1860s* (Chicago:
 University of Chicago Press, 1996); Theodore Reff, "'Manet's Sources': A Critical
 Evaluation," *Artforum* 8 (September 1969): 40–8.

16 E.g., Carol Armstrong, *Manet Manette*; Anne Higonnet, "Manet and the Multiple,"
 Grey Room 48, Multiplying the Visual: Image and Object in the Nineteenth Century
 (Summer 2012): 102–16; Darcy Grimaldo Grigsby, "Still Thinking about Olympia's
 Maid," *The Art Bulletin* 97, no. 4 (2015): 430–51; and Anne Coffin Hanson, "Manet's
 Subject Matter and a Source of Popular Imagery," *Art Institute of Chicago Museum
 Studies* 3 (1968): 63–80.

17 Another reason to consider laughter in Manet historiography via caricature is
 that in the years of Salon caricature's rise and indeed for decades after, caricature
 and laughter were often understood to explain or constitute each other. See,
 e.g., Baudelaire's "De l'essence du rire et généralement du comique dans les arts
 plastiques" (1855), *Œuvres complètes*, t. II (Paris: Gallimard, 1976), 525–43;
 Arsène Alexandre, *L'art du rire et de la caricature* (Paris: Librairies-Réunies, 1892);
 and Paul Gaultier, *Le rire et la caricature* (Paris: Hachette, 1906). See Michela

Lo Feudo, "Penser le rire au XIXe siècle à travers les Histoires de la caricature," *Le rire moderne*, ed. Alain Vaillant and Roselyne de Villeneuve (Nanterre: Presses universitaires de Paris Nanterre, 2013), 313–33 and Bertrand Tillier, "La Caricature et le rire des mésalliances," *Revue française de psychanalyse* 81, no. 1 (2017): 17–32.

18 Manet's own published output as a caricaturist consists of a single *portrait-charge* of his friend Émile Ollivier in the journal *Diogène* in 1860; however as Therese Dolan argues, elements of this caricature anticipate later strategies of Manet's painting. Dolan, "Manet's *Portrait-Charge* of Émile Ollivier," *Print Quarterly* 17, no. 1 (2000): 17–26.

19 "… la charbonnière, le bouquet dans du papier, M. Manet et son chat...." "Le Salon, par Bertall."

20 Darcy Grigsby has reframed the servant woman in terms of the ongoing enfranchisement of Black people, and anxieties about their status not as abstract other but as precariously employed Parisians, following the abolition of slavery in France's colonies only fifteen years earlier. Bertall's slippage of Laure for Manet in a larger caricatural spread about the transactionality of paint supports Grigsby's argument, and is of a piece with the *Journal amusant* cover from the same year by Bertall cited by Grigsby in which the servant woman joins others in pandering to an allegorical figure of the exhibition as preening courtesan. Bertall, "Heureuse tendance de la peinture et des arts […]," *Journal amusant*, May 27, 1865. Grigsby, "Still Thinking about Olympia's Maid." On Laure, see also Denise Murrell, *Posing Modernity: The Black Model from Manet and Matisse to Today* (New Haven: Yale University Press, 2018), (7–30).

21 In *Manet's Modernism*, Michael Fried noted Duret's description of a contrast between "journalistic art critics, bent on judging pictures according to subject matter" and a "class of viewers whom [Duret] described as connoisseurs, amateurs and collectors" (414). Fried accepted Duret's description of this divide in competence. In fact, Fried amplified Duret's assertion as evidence of a larger shift away from the press's a-priori ideologically biased criticism and toward, in the 1860s and 1870s, the possibility of a "more contemplative or 'disinterested' criticism" (414). Duret's formalist criticism of the 1880s was hardly "disinterested," and Duret's claims about sensibility to "the intrinsic quality of painting itself" had an exclusionary class bias that motivated his hostility to caricature.

22 Fried, *Manet's Modernism*, 415.

23 Edmond Bazire, *Manet* (Paris: A Quantin, 1884).

24 "Les caricaturistes inaugurèrent leurs plaisanteries. Bertall, l'ennemi persistent de tout créateur, s'unit à Cham et à Randon. Le *Tintamarre*, qui est pour l'art élevé,

haussa les épaules. Mais le plus irrité était le *Charivari*. Ce journal occupe une place distinguée parmi les détracteurs impitoyables de Manet." Bazire, *Manet,* 40. Bazire's citation of Randon suggests that, writing about Salon caricature retrospectively from the 1880s, he had mixed up Randon's 1867 caricatures after Manet's solo exhibition on the Place de l'Alma with earlier Salon caricature. Randon's full two-page spread in *Le Journal amusant* in 1867 generated a large quantity of caricatures after Manet's canvases that have later been mistaken as evidence of caricatural hostility to Manet at the Salon. See note 12, above.

25 "Et voilà comment un talent puissant peut être interrompu dans son expansion, ralenti dans son élan, s'il n'a en lui la force qui brave les piqûres de la moquerie et les petites satires manquées des retardataires." Bazire, *Manet,* 41.

26 On the publication of George Heard Hamilton's *Manet and His Critics* in 1954, one reviewer wrote, "It is regrettable that there is no substantial work in English treating the first artist who can be called a modern since Duret's *Histoire de Edouard Manet et de son œuvre*" Alfred Werner, "*Manet and His Critics* by George Heard Hamilton," *College Art Journal* 14, no. 4 (Summer, 1955): 392–4, 392.

27 Théodore Duret, "Manet," in *Critique d'avant-garde* (Paris: G. Charpentier, 1885), 117–28.

28 Michael Orwicz has described how in the early Third Republic social signifiers later associated with avant-gardism (independence, revolt) in fact "became the official language of the State," as Antonin Proust and other liberals wanted to marginalize the Academy in artistic training and promote individuality. But this emphasis on individuality is "the discourse of a new liberal ideology, in which private initiative, individuality, stylistic diversity and competition are all encouraged as part of the State's initiative to expand, diversity and differentiate the art market in the attempt to develop a liberal economy." Orwicz, "Reinventing Édouard Manet," in *Art Criticism and its Institutions in Nineteenth-Century France,* ed. Michael Orwicz (Manchester: Manchester University Press, 1994), 122–45, 136.

29 "Car le public ne cherche et ne regarde presque jamais dans une œuvre, que l'anecdote qui peut s'y laisser voir." Théodore Duret, *Histoire de Édouard Manet et de son œuvre* (Paris: Charpentier et Fasquelle, 1906), 148.

30 "Il semble étrange qu'une telle scène pût causer, à première vue, de l'hilarité." Duret, *Histoire de Édouard Manet,* 94.

31 Manet's *Balcony* has been understood as an early example of the kind of refusals that came to characterize Manet's modernism: ambiguous social relations, illegible spatial relations, freedom from literary or other sources. André Dombrowski draws on period caricature, including caricatures after Manet's *Balcony*, to reposition

the canvas's various refusals within new social regulations of the private sphere. "Living on Manet's *Balcony*, or the Right to Privacy," in *Is Paris Still the Capital of the Nineteenth Century? Essays on Art and Modernity: 1850–1900*, ed. Hollis Clayson and André Dombrowski (London and New York: Routledge, 2016), 235–56.

32 "Le mérite intrinsèque de la peinture, la valeur d'art due à la beauté des lignes ou à la qualité de la couleur, choses essentielles pour l'artiste ou le vrai connaisseur, restent incompris et ignorés des passants." Duret, *Histoire de Édouard Manet,* 148.

33 "L'interêt a y prendre résidait évidemment dans la valeur en soi de la peinture et dans les particularités de la facture. Mais ce sont là des points qui échappent au public, à peu près en tout temps, et qui échappent entièrement au public de cette époque en présence de Manet." Duret, *Histoire de Édouard Manet*, 94. Jonathan Crary argues that accounts of modernist rupture have relied on assumptions of a bifurcation of vision into normative and advanced. Crary, *Techniques of the Observer: On Vision and Modernity in the Nineteenth Century* (Cambridge: MIT Press, 1990), 4–5. These critical assumptions about differential responses to Manet correspond to dualist models of vision that developed earlier in the century. For example, the work of Pierre Flourens and Arthur Schopenhauer distinguished special capacities of isolation and attention in "men of genius" over and against the instinctual, muscular vision of "common, ordinary man." *Techniques*, 82–3.

34 "… un public restreint, composé d'artistes, de connoisseurs, de gens de lettres et de gens du monde," Duret, *Histoire de Édouard Manet*, 57–8.

35 Duret, *Histoire de Édouard Manet*, 58.

36 "Quand on le prononçait [le nom Manet], n'importe quel cocher, balayeur ou garçon de café pouvait dire: Ah ! oui, Manet ! je connais, en se représentant tout de suite un artiste excentrique et dévoyé. Dans ces milieux ou la capacité manque pour se former une opinion propre sur les choses d'art, les jugements ne peuvent venir que du dehors et sont donnés par les couches supérieures et la presse." Ibid., 261.

37 "… des écrivains de rencontre ou aux premiers venus," "les attaques les plus grossières." Duret, *Histoire de Édouard Manet*, 108.

38 "… les journaux illustrés et les feuilles de la caricature, avant d'avoir rien examiné, se livraient à un débordement de charges et de dessins grotesques, aussi offensants que possible." Duret, *Histoire de Édouard Manet*, 108.

39 "… le mérite intrinsèque de la peinture, la valeur d'art due à la beauté des lignes ou à la qualité de la couleur." Duret, *Histoire de Édouard Manet*, 148.

40 Stop's undated carte-de-visite portrait depicts him in orientalized costume holding a palette and painting at an easel. [Recueil.] Célébrités du XIXe siècle (1860–1880). Bibliothèque nationale de France, département Estampes et photographie, 4-NA-109 (14). Stop and Manet both contributed etchings to Cadart's *Eaux-fortes modernes* series (1863–1867). See Stop, "Un Marché Italien," *Eax-fortes modernes 1865*, vol. 3 (Paris: Cadart, 1865), plate 130.

41 "… froid, correct, planté devant un tableau, envisageant d'un coup d'œil impassible l'œuvre …." Emile Bayard, *La Caricature et les caricaturistes* (Paris: C. Delagrave, 1900), 218. Stop's Salon caricature is discussed in Chapter 4; Bayard's description of Stop at work is cited in full on page 110.

42 Richard Wrigley, *The origins of French art criticism: From the Ancien Régime to the Restoration* (Oxford: Clarendon Press, 1993), 89.

43 Bridget Alsdorf repeatedly identifies Salon caricature's analysis of Fantin-Latour as sophisticated and complex in *Fellow Men*, 31–3, 52–5, 141–2, 165–6.

44 *Fantin-Latour et Oulevay*, Carolus-Duran (Charles Auguste Émile Durand), 1861, Musée d'Orsay. Oulevay studied at the École des beaux-arts in Paris and exhibited at the Salon between 1865 and 1880.

45 "Je connaissais déjà l'esprit incisive de l'humoriste M. Oulevay, son *Salon pour rire* de 1863 indiquait de singuliers rapprochements entre les œuvres de MM Daubigny père and fils; c'était de petits coups d'épingle qui avait bien leur mérite. Mais voilà que tout à coup il devient sérieux. Bravo ! Monsieur M. Oulevay, voilà de la vraie peinture, pleine de charme attractif que possède tout art fin et délicat." Gonzague Privat, *Place aux Jeunes, causeries critiques sur le Salon de 1865* (Paris: F. Cournol, 1865), 67.

46 See, e.g., Paul Valéry and Paul Jamot, *Exposition Manet 1832–1883* (Paris: Musée de l'Orangerie, 1932) and Charles Léger, *Édouard Manet* (Paris: Éditions G. Crès & Cie, 1931).

47 "Manet a un fort talent, un talent qui restera …. Ce qui me frappe aussi: c'est la joie de tous ces imbéciles qui le croient perdu." Cited in Léger, *Édouard Manet*, 8.

48 "Ces *imbéciles:* les Cham, les Bertall, caricaturistes de tout poil, journalistes de tout ordre, dans sa grande et dans sa petite presse, s'en donnèrent à cœur joie aux dépends d'*Olympia* et de son peintre, aux applaudissements du public." Léger, *Édouard Manet*, 8.

49 On Baudelaire and the comic, see Michèle Hannoosh, *Baudelaire and Caricature: From the Comic to an Art of Modernity* (University Park, PA: Pennsylvania State University Press, 1992), and Chapter 2 of the present volume.

50 Léger's 1931 history of Manet may now be largely forgotten, but Léger was also the editor of the first anthology of Salon caricature, published in 1920, and dedicated solely to caricatures after Courbet. The volume, *Courbet selon les caricatures et les images* (Paris: P. Rosenberg, 1920) was prefaced by none other than Duret. Although Courbet preceded Manet, Manet was the figure around which an art-historical conception of Salon caricature coalesced and was then applied to Courbet. As Petra Chu, Klaus Herding, and Bertrand Tillier have rightly pointed out, Courbet had a relationship to caricature that was more about what we might call celebrity, the shaping of a public persona. A much higher ratio of caricatures takes on his personal appearance, particularly his body (later, his politics, his participation in the Commune and his participation in the toppling of the Vendome column). On Courbet and caricature, see Introduction, notes 25 and 26.

51 Louvre, département des arts graphiques, RF 23618–RF 24029.

52 "Une Promenade au Salon.—Croquis par Cham," *Le Charivari*, May 22, 1864. Manet's *Incident in a Bullring* is in the second row from top, center.

53 "Souvent … il répétait, de méchante humeur, – Manet ! Ce sera le Daumier de 1860!" Bazire, *Manet,* 6.

54 "… ceci pêche par la couleur …"; "[c]heval à trois têtes abandonné …."

55 "Il est difficile de traverser les nombreuses salles du Palais de L'Industrie sans être attiré par une grande majorité des tableaux qui, soit par les tons éclatants de leur couleur, soit par leur cachet irrésistible, forcent le spectateur à s'arrêter un instant. Comment, en effet, passer indifférent devant les caricatures spirituelles de M. Biard ? Comment ne pas sourire de la mésaventure de l'Anglais M. Droz? Comment ne pas être égayé par la scène rabelaisienne de M. Comte?" Charles Gueullette, "Revue de l'art ancien et moderne," *Les beaux-arts*: *revue nouvelle*, May 15, 1863, 296–30, 299.

56 On Biard, see Pedro de Andrade Alvim, "Le monde comme spectacle: L'œuvre du peintre François-Auguste Biard (1798–1882)," PhD dissertation, Université de Paris, Panthéon Sorbonne, 2001.

57 Clark, "Olympia's Choice," 144.

58 Clark also noted how the caricaturists picked up on repressed signals of contemporary class: he cited Bertall's labeling the prostitute the "wife of a cabinetmaker" in one caricature, placing *Olympia* in "the world of the *faubourgs* and the working class" ("Olympia's Choice," 87–8). Clark noted that in calling her "dirty," Bertall precisely picked up on a detail of facture: the film of dusty gray which, in place of traditional chiaroscuro, covers the figure, accumulating at the edges of the body and in passages of more complex modeling like the hands and the ankles.

59 Clark, "Olympia's Choice," 136.

60 Marcelin, "Le Salon de 1863—4e série: Les Folichons," *La Vie parisienne*, no. 349, 1863, 234–5. Anne McCauley briefly discusses this caricature as evidence that contemporary critics at the Salon of 1863 noted the overwhelming presence of nudes as a general phenomenon, and were not primarily or exclusively scandalized by the nude in Manet's *Le Bain*, now known as *Le Déjeuner sur l'herbe*. McCauley's conclusions about the Salon of 1863 and Manet's role therein parallel my own conclusions about how Salon caricature after Manet has been isolated and excised: "By isolating observations by Salon critics about this painting and by relying on later, primarily Third Republic, biographies of Manet, art historians have often failed to register the stylistic clichés and political and aesthetic agendas that underlay all critical and biographical writing." Anne McCauley, "Sex and the Salon: Defining Art and Immorality in 1863," in *Manet's Le Déjeuner sur l'herbe*, ed. Paul Tucker (Cambridge: Cambridge University Press, 1998), 38–74, 38.

61 "Aucun enfantement fut plus pénible, car la pauvre déesse se tord les cheveux, les bras, les jambes; ce n'est pas la Venus à la tortue, c'est la Venus tordue." Marcelin, "Le Salon de 1863—4e série: Les Folichons." The canvas caricatured is no. 33, Amaury Duval's *La Naissance de Vénus* (The Birth of Venus).

62 Stock, *L'Épâtouflant Salon du Havre*, 1868. On Salons in Le Havre, see *Salons et expositions, Le Havre: répertoire des exposants et liste de leurs œuvres, 1833–1926*, ed. Gérard Bonnin (Paris: l'échelle de Jacob, 2013). On Manet's strategies at provincial exhibitions, see Nancy Locke, "Manet Exhibits in Lyon in 1869," *The Burlington Magazine* 150, no. 1262 (May 2008): 322–5.

63 On Manet's bloodless bodies, see André Dombrowski, *Cézanne, Murder and Modern Life* (Berkeley and Los Angeles: University of California Press, 2013), 28–9.

64 Henri Oulevay, "Au Salon de 1864," *Le Monde illustré*, May 28, 1864, 349.

65 "Le Torero, oublié dans la lugubre série de Gérôme, expire sous le pinceau de Manet." Stock, *L'Épâtouflant Salon du Havre*, 4.

66 "Rentrer trop tard, c'est, à Paris, s'exposer aux odeurs de Richer, Veuillot et Cie." Stock, *L'Épâtouflant Salon du Havre*, 8.

67 Louis Veuillot, *Les Odeurs de Paris* (Paris: Palmé, 1867). On Veuillot's journalism, see Michel Fontana, "Louis Veuillot [1813–1883]," in *La Civilisation du journal: Histoire culturelle et littéraire de la presse française au XIXe siècle*, ed. Dominique Kalifa, Philippe Régnier, Marie-Ève Thérenty, and Alain Vaillant (Paris: Nouveau Monde, 2011), 1177–84.

68 "Or, un jour, Virginie rencontre par hasard, innocemment, au Palais-Royal, aux carreaux d'un vitrier, sur une table, dans un lieu public, une caricature! une caricature bien appétissante pour nous, grosse de fiel et de rancune, comme sait les faire une civilisation perspicace et ennuyée." Baudelaire, "De l'essence du rire…," 529.

69 E.g., Blanche disputed Duret's account of Manet's embattlement: "La légende bien banale de ses insuccès, de ses difficultés à conquérir une notoriété honorable, fut grossie, sinon fabriquée, pour les besoins d'une cause." "The well-worn legend of his lack of success, of his difficulties in achieving a respectable reputation, were exaggerated, if not fabricated, for the needs of a cause." Jacques-Émile Blanche, *Manet* (Paris: F. Rieder, 1924), 7–8.

70 Ibid., 50–1.

71 There is some debate as to which version was shown at the Salon. See Juliet Wilson-Bareau, *Manet, Monet and the Gare St. Lazare* (New Haven: Yale University Press, 1998), 163, 190, notes 144, 196. The illustration provided is a seven-color lithograph made by Manet on the model of his original Salon submission.

72 "Permettez-moi, cher maître de vous dédier cette Revue faite sous l'inspiration de votre espatouflant [*sic*] Polichinelle.—Stock." Stock, "Revue du Salon par Stock."

73 On the comic valences of Polichinelle in relation to Manet's painting in the early 1870s, see Margaret Werth, "A Laughter of the Look: Manet, Mallarmé, Polichinelle,

and the Salon Jury in 1874," in *Is Paris Still the Capital of the Nineteenth Century? Essays on Art and Modernity, 1850–1900,* ed. Hollis Clayson and André Dombrowski (London and New York: Routledge, 2016), 96–108.

74 Adolphe Tabarant, "Une histoire inconnue du 'Polichinelle,'" *Le Bulletin de la vie artistique* (September 1923): 365–9.

75 On the recognizable genre of the satiric journal with a cover illustrated in a three- or four-color wash, see John Grand-Carteret, *Les mœurs et la caricature en France,* 380–1.

76 "Ô Polichinelle! Patron des hommes sérieux" "Revue du Salon par Stock."

77 "Ce Polichinelle n'est pas Italien, il est bien Français." "... ses insolences et ses brutalités n'ont point franchi les Alpes." Edmond Bazire, *Manet,* 84–5.

78 Fear of caricature's reach to what a minister in 1835 called the "lower classes of people" motivated censorship throughout the century. Robert Justin Goldstein, "The Debate over Censorship of Caricature in Nineteenth-Century France," *Art Journal* 48, no. 1 (1989): 9–15, 9.

79 Bibliothèque nationale de France, département des Estampes et de la photographie, 4-YB3-2012 (18).

80 "... recueilli par Philippe Burty et conservé parmi ses papiers." Moreau-Nélaton donated a photographic copy of the album to the BnF. He attests that the wife of bibliophile Maurice Tourneux (1849–1917) passed the album to him. Moreau-Nélaton, *Manet raconté par lui-même,* 47.

81 "Sa peinture n'est pas faite pour la foule. M. Manet procède par des parti-pris trop voulus pour que son système soit ... facilement comprehensible." Burty, "Le Salon III," *Le Rappel* (May 1870), quoted in Gabriel Weisberg, *The Independent Critic: Philippe Burty and the Visual Arts of Mid-Nineteenth-Century France* (New York: Peter Lang, 1993), 132.

82 "Elle imagine un roman dont les héros seraient le *Buveur d'absinthe,* qui écoute le *Vieux musicien,* et la *Jeune femme couchée en costume espagnole.*" Étienne Moreau-Nélaton, *Manet raconté par lui-même,* 47.

83 On the cultivation of the private gallery space in contrast to the Salon, see Martha Ward, "Impressionist Installations and Private Exhibitions," *Art Bulletin* 73 (December 1991): 599–622.

84 On these activities see Janine Bailly-Herzberg, *L'eau-forte de peintre au dix-neuvième siècle: la Société des Aquafortistes, 1862–1867* (Paris: L. Laget, 1972).

85 Carol Armstrong, *Manet Manette,* 96. Further, Manet's "portfolio of aquatints made that filtering and caricaturing his signature, while reversing the order of painting to print and replacing it with a logic of print to painting" (96). Armstrong's description of Manet's founding of originality in mechanical reproduction—not just the persistence but the concentration of "aura" in the graphic multiple—shares a great deal with Salon caricature's comic propositions about the residence of the painter's originality in the graphic miniature. "The age of the decline of 'aura,' famously

diagnosed by Walter Benjamin as a consequence of mechanical reproduction, was at the same time the moment of the efflorescence and apogee of aura, predicated on the mechanical reproduction" (90).

86 Blanche, *Manet*, 7–8.

87 "Je me fais un véritable plaisir de vous envoyer ce cahier … Excusez-moi si je ne signe pas. C'est la pudeur qui me retient. " She signs "une de vos admiratrices," indicating her gender.

88 See Chapter 6, page 160.

89 See Chapter 3, page 88.

90 Hannoosh, *Baudelaire and Caricature*, 330. See also Bertrand Tillier, "Du caricatural dans l'art du XXe siècle," *Perspective* 4 (2009), 538–58.

Conclusion

It is difficult to describe the end of Salon caricature. As promised in the Introduction, I have focused on the 1840–1880 period, the emergence of Salon caricature through the end of the official Salon, because there is a coherence to the graphic corpus across these years, before several factors contribute to the genre's transformation. Those factors include the dawn of what we can truly call a mass press, the proliferation of photographic image culture, and importantly, the fracturing of the exhibition landscape into many Salons. Salon caricature does not so much decline as it takes new cultural forms in graphic art, film, and exhibition parody. Although no one has yet traced Salon caricature's specific legacies in the early avant-gardes, surely the art-parody of Dada and Cubism drew on its repertoire of jokes and its culture of antic, collective repicturing. The history of the ludic fin-de-siècle societies, particularly the Incohérents, is a promising point of contact with the avant-gardes.[1]

The "end of the Salon" in 1880 was ultimately a financial and administrative change. As Pierre Vaisse has argued, against the grain of modernist narratives in which the innovative Impressionists finally triumph over a conservative state, 1880 did not represent a rupture in the experience of the event: "[S]ame place, same dates, same general appearance …."[2] The "mainstream salons" remained well-attended, artistically vital and economically important into the pre-war period.[3] The press's continued efforts to reproduce Salon art also attest to the relevance of these events.[4]

However, when the Salon fractured into several different salons, particularly in 1890 with the founding of the Société nationale des beaux-arts, the important precondition of one shared public forum for art began to disappear. A final example of Salon caricature from its last years demonstrates the consequences of this fracturing, among other fundamental changes in its context and production.

A chromolithographic cover illustration by Albert Guillaume, titled "Le Salon Fantaisiste" ("The Fanciful Salon"), was published as a supplement to *Le Figaro* in 1894 (Plate 44)—an example of illustration's expanded reach to general-interest papers.

Guillaume's Salon is "fanciful" or "far-fetched" in two respects. First, it patches together an imagined salon from paintings exhibited at the Salons of the Société des artistes français and the Société national des beaux-arts.[5] But its caricatures of paintings are also fantastical: the redepiction of painting is conditioned by an explosion in cartoon activity, from comics to children's literature and advertisement. Guillaume, illustrator of the "Fanciful Salon," worked as a comic press artist and also produced brightly colored lithographic advertisements for theaters and dance halls, skating rinks and Vichy water.

Guillaume does not pursue the fiction of the "threshold," of the spatial imaginary that had been essential to Salon caricature. There is no single place that he can propose as the site of an imagined "promenade, and the text by Grosclaude promises not to have set foot in either Salon." Further, unraveling the perceptual doubling, "le Salon Fantaisiste" is the collaboration of a writer (Grosclaude) and illustrator, a return to the partnerships that marked the early days of the genre, before its conventional fictions had coalesced (e.g., Cham and Huart, Bertall and Alphonse Karr, Pelez and Baudelaire et al.). One understands this stylish, sophisticated, integrated layout not as a chain of reception and remaking—engraving repicturing ink repicturing painting—but as "images," complex industrial products of photo-technical processes.

There is a third level of fantasy to the "Fanciful Salon," beyond the nostalgia for the defunct genre of Salon caricature and the era that sustained it (the text laments, "In the old days, there was a sole Salon"[6]). The second page of the "Fanciful Salon" changes the joke slightly, and calls itself a "salon de la mode," promising to reproduce paintings that interest ladies, converting its fantasies into consumer desires. Grosclaude and Guillaume recuperate the closest caricatural subject they can find to the shared Salon of yore: the commercial fair or trade show (also referred to as a "salon").

For the period that this book has covered, I have tried to show several things. First, Salon caricature was never primarily oppositional, even when it presented itself as an attack on painting. It emerged from within a mixed society of artists and illustrators, who shared training, pictorial references, and economic conditions.

Second, I have been keen to show that Salon caricature is not reducible to opinion, language, or negative (or positive) criticism, but that it demands to be analyzed as a multivalent pictorial operation. Printmaking, press art, and

painting shared a system of signs, increasingly proximate iconographies, and a certain legibility conditioned by public familiarity with the physiognomic.

John Grand-Carteret described Salon caricature as "monotonous," meaning that once it struck on its genre conventions, they remained fixed. But he acknowledged that within this template there was room for individuality and change. From early in its history, for example, the joke of converting the figural subject of a painting into a doll recurred frequently. Yet, recurring jokes, as I have tried to show, can be understood like motifs. There is no reason to read such recurrence as a limited or narrow engagement with painting, as opposed to an accretion of meaning, or an indication of dialogue. Rather, Salon caricature developed a comic iconography, motifs that were worked and reworked—this book has left many unexplored—taking on new meaning. Bertall turned Galimard's *Junon jalouse* (Jealous Juno) into a doll; Nadar did the same with Courbet's *Demoiselles des bords de la Seine* (Women on the Banks of the Seine). It was a long-standing Salon-caricatural motif, but I argued that it had new meaning in the context of Nadar's exploration of the handheld in that particular album. The association of comedy with superfice that we saw in the writing of Théodore Duret has residual currency. This book has attempted to show the potential for depth even beneath jokes that sell themselves as simple.

Guillaume's 1894 "Fanciful Salon" issues from an era in which the halftone screen was a well-integrated technology and photographic illustration was cheaply available. And yet, a satisfying account of Guillaume's Salon would want to explore the sophisticated chromolithographic parameters of his print in relation to contemporary painting, particularly to painting's own expansion of color effects.[7] This book has attempted to show how Salon caricature, as an art about art, was also an art about reproductive possibilities. Sometimes caricaturists were keen to draw attention to their own media—think of Stop in Chapter 4 using his stark lines to X-ray military painting and landscape—and sometimes they simply worked within the given limits. In any case, the analogy of graphic illustration to painting that hangs over the enterprise of Salon caricature makes it an important site for considering graphic relations in the nineteenth century, and also encourages art historians who use Salon caricature consider its material specificity.

I hope that this book will help facilitate the use of Salon caricature by art historians in their own research. The major journals that I discuss are now mostly available online, while albums and more ephemeral journals are increasingly being digitized. While scholars of nineteenth-century art have most often cited

caricature as part of aggregate critical reactions to single paintings, the final three chapters of this book have demonstrated that Salon caricature can be used as evidence in a range of ways. In Chapter 5, I explored how Salon caricature's particular fiction as a graphic vehicle for vision might allow us to rethink models of nineteenth-century artistic subjectivity and how those models have been historicized. Chapter 6 took up Salon caricature as a visual technology, arguing that it can be explored for a better understanding not only of individual artists but of the exhibition, its systemic problems and the conditions of spectatorship. The final chapter used Salon caricature as evidence of how caricaturists and journal-readers alike saw themselves in relation to Manet and as consumers of paint and print.

For Salon caricaturists, as I explored in Chapter 7, there was a meaningful difference between Manet and, say, the néo-grec Jean-Louis Hamon. I do not argue that Salon caricature levels distinctions entirely between painters later labeled modernists and those understood as either conventional or conservative, otherwise outmoded, or simply forgotten. However, Salon caricature made connections more than it defined or reinforced boundaries. It attributed a particularly modern flatness to under-examined battle painters, deliberately conflated Gérôme and Manet, boiled painting down to its bones (Baudelaire, after all, figured it as a poetic cannibal) to show the structural similarities beneath odalisques and grisettes, allegories and martyrs, the works of the notorious and the nobodies. This vision is perhaps the most promising aspect of Salon caricature for an era inclined to reassess old hierarchies. As Nadar wrote in 1857 at the threshold of his graphic Salon: "Attaquons."

Notes

1 Both Luce Abélès and Catherine Charpin see the Incohérents as the direct descendants of Salon caricature. See Luce Abélès et al., *Arts Incohérents, académie du dérisoire* (Paris: Réunion des Musées Nationaux, 1992) and Catherine Charpin, *Les Arts Incohérents (1882–1893)* (Paris: Syros/Alternatives, 1990). Daniel Grojnowski has explored links between the fin-de-siècle ludic cultures and the early avant-gardes. Grojnowski, "Anticipations," *Aux commencements du rire moderne: L'esprit fumiste* (Paris: José Corti, 1997), 255–315. "Les incohérents régénèrent le bon vieux principe des Salons caricaturaux diffusés par la presse. Ils en perpétuent la tradition parodique en la haussant au niveau d'une véritable exposition en trois dimensions." "The incohérents regenerated the good old principle of the Salon caricature

diffused by the press. They perpetuated the parodic tradition in raising it to the level of a real exhibition in three dimensions." Charpin, *Les Arts Incohérents*, 16.

2 "… même lieu, mêmes dates, même aspect général," Pierre Vaisse, "Réflections sur la fin du Salon official," in *"Ce Salon à quoi tout se ramène": Le Salon de peinture et de sculpture, 1791–1890,* ed. James Kearns and Pierre Vaisse (Bern: Peter Lang, 2010), 117–38, 119. See also Vaisse, *La Troisieme Republique et les peintres* (Paris: Flammarion, 1995) and Patricia Mainardi, *The End of the Salon: Art and the State in the Early Third Republic* (Cambridge: Cambridge University Press, 1993).

3 See for example Patricia Leighten's exploration of the intersection of Salon painting, graphic satire and anarchist politics in the fin-de-siècle and early twentieth century. Leighten, *The Liberation of Painting: Modernism and Anarchism in Avant-Guerre Paris* (Princeton, NJ: Princeton University Press, 2013). On the avant-guerre Salon, see particularly 17–20.

4 The attention of illustrated magazines "suggests that the annual Salon remained intensely interesting, enduringly important, to the wide and largely bourgeois reader/viewership of these magazines long beyond the Salon's 'terminal' decline and marginalisation (in the weltanschauung of the avant-garde)." Tom Gretton, "'Un Moyen Puissant de Vulgarisation Artistique'. Reproducing Salon Pictures in Parisian Illustrated Weekly Magazines c.1860-c.1895: From Wood Engraving to the Half Tone Screen (and Back)," *Oxford Art Journal* 39, no. 2 (August 2016): 285–310, 289.

5 From the Salon du Société des artistes français: Théobald Chartran, Léon Bonnat, and Antoine Vollon. From the Salon du Société nationale des beaux-arts: Émile Friant, Carolus-Duran, Pierre Puvis de Chavannes, and J.A. MacNeill Whistler.

6 "Jadis, il n'y avait qu'un unique Salon." Grosclaude and Albert Guillaume, "Le Salon Fantaisiste," *Le Figaro. Supplément illustré*, May 12, 1894, 2.

7 Laura Anne Kalba, *Color in the Age of Impressionism: Commerce, Technology, and Art* (University Park, PA: Penn State Press, 2018).

Bibliography

Unpublished Sources

Bibliothèque nationale de France
 Fonds Nadar, NAF 24262—MF 16604. Nadar, correspondence.
 Fonds Ancante, NAF 14903, F 15–17. Cham, correspondence.
Petit Palais, Musée des Beaux-Arts de la Ville de Paris
 PPD04618 (1–3). Unpublished maquettes.
Fondation Lugt
 Inventaire 1990 A 476. Caricatures by Cham, cut out and colored-in.
Robert B. Haas Family Arts Library, Yale University
 "Salon de 1861 par Cham et un Amateur," ([s.l: s.n, 1861). N5066 C43 (LC).
Musée du vieux Montmartre
 BN25. Unpublished maquette, André Gill.
 Folder I – Années de jeunesse– 1851–1860. Gill, early copies.
Louvre, département des arts graphiques
 RF 23618 - RF24029. Drawings by Cham.
Smithsonian American Art Portrait Gallery Rare Book Library
 Cham, *Olla Podrida* (Paris: Vresse, 1859). Album by Cham colored in gouache and signed by readers. NC1499.C44O45.

Published Sources

Abélès, Luce and Catherine Charpin, eds. *Arts Incohérents, académie du dérisoire.* Paris: Réunion des musées nationaux, 1992.

About, Edmond. *Nos artistes au Salon de 1857.* Paris: Hachette, 1858.

Ackerman, Ada. *Eisenstein et Daumier: des affinités électives.* Paris: Armand Colin, 2014.

Adeline, Jules. *Les Arts de reproduction vulgarisés.* Paris: Librairies-imprimeries réunies, 1894.

Album du Salon de 1843 : collection des principaux ouvrages exposés au Louvre reproduits par les peintres eux-mêmes ou sous leur direction […]; texte par Wilhelm Ténint. Paris: Challamel, 1843.

Alexandre, Arsène. *Daumier.* Paris: Les Éditions Rieder, 1928.

Alexandre, Arsène. *L'art du rire et de la caricature.* Paris: Libraries-Réunies, 1892.

Allan, Scott, and Mary G. Morton, eds. *Reconsidering Gérôme.* Los Angeles: J. Paul Getty Museum, 2012.

Allard, Paul. "Satire des moeurs et critique sociale dans la caricature française de
 1835–1848." In *La Caricature entre république et censure: L'Imagerie satirique en
 France de 1830 à 1880: Un discours de résistance?* edited by R. Rütten, R. Jung, and G.
 Schneider, 171–81. Lyon: Presses Universitaires Lyon, 1998.

Alsdorf, Bridget. *Fellow Men: Fantin-Latour and the Problem of the Group in Nineteenth-
 Century French Painting*. Princeton, NJ: Princeton University Press, 2012.

Alvim, Pedro de Andrade. "Le monde comme spectacle: L'oeuvre du peintre François-
 Auguste Biard (1798–1882)," PhD dissertation, Université de Paris, Panthéon
 Sorbonne, 2001.

Ambroise-Rendu, Anne-Claude, "Du dessin de presse à la photographie (1878–1914):
 Histoire d'une mutation technique et culturelle." *Revue d'histoire moderne et
 contemporaine* 39, no. 1 (1992): 6–28.

Arago, François. "Rapport à la Chambre des députés." In *La Photographie en France
 : textes & controverses, une anthologie, 1816–1871*, edited by André Rouillé, 36–9.
 Paris: Macula, 1989.

Armstrong, Carol. *Scenes in a Library: Reading the Photograph in the Book, 1843–1875*.
 Cambridge, MA and London: MIT Press, 1998.

Armstrong, Carol. *Manet Manette*. New Haven: Yale University Press, 2002.

Arthur (Arthur des Varannes). *Exposition des beaux-arts, Nantes. Livret illustré, Album
 caricatural, par Arthur. 1ère - 7e livraison*. Nantes: Imprimerie Soudée, 1872.

Astruc, Zacharie. *Les 14 stations du Salon: 1859; suivies d'un récit douloureux*. Paris:
 Poulet-Malassis et de Broise, 1859.

Atherton, Herbert M. *Political Prints in the Age of Hogarth; a Study of the Ideographic
 Representation of Politics*. Oxford: Clarendon Press, 1974.

Bailly-Herzberg, Janine. *L'eau-forte de peintre au dix-neuvième siècle: la Société des
 Aquafortistes, 1862–1867*. Paris: L. Laget, 1972.

Bann, Stephen. *Distinguished Images: Prints and the Visual Economy in Nineteenth-
 Century France*. New Haven and London: Yale University Press, 2013.

Bann, Stephen. *Parallel Lines: Printmakers, Painters and Photographers in Nineteenth-
 Century France*. New Haven and London: Yale University Press, 2001.

Bann, Stephen. "'When I Was a Photographer': Nadar and History." *History and Theory*
 48, no. 4 (December 1, 2009): 95–111.

Baridon, Laurent, and Martial Guédron. *Corps et arts: physionomies et physiologies dans
 les arts visuels*. Paris: L'Harmattan, 1999.

Baridon, Laurent, and Martial Guédron, *L'art et l'histoire de la caricature*. Paris:
 Citadelles & Mazenod, 2006.

Baridon, Laurent, and Martial Guédron, "Caricaturer l'art: Usages et fonctions de la
 parodie." In *l'art de la caricature*, edited by Ségolène Le Men, 87–108. Paris: Presses
 universitaires de Paris-Ouest, 2011.

Baudelaire, Charles. *Œuvres complètes*, tome 2. Nouvelle ed., Bibliothèque de La Pléiade,
 edited by Claude Pichois. Paris: Gallimard, 1976.

Baudelaire, Charles, Théodore de Banville and Vitu. *Le Salon caricatural : critique en vers et contre tous: illustré de soixante caricatures dessinées sur bois*. Paris: Charpentier, 1846.

Bayard, Émile. *La caricature et les caricaturistes*. Paris: C. Delagrave, 1900.

Bazire, Edmond. *Manet*. Paris: A. Quantin, 1884.

Beffroy de Reigny, and Louis-Abel. *Marlborough au Salon du Louvre*. Paris: Académie royale de peinture et de sculpture, 1783.

Beegan, Gerry. *The Mass Image: a Social History of Photomechanical Reproduction in Victorian London* (New York: Palgrave Macmillan, 2008).

Bellanger, Claude, ed. *Histoire générale de la presse française. Tome II. De 1815 à 1871*. Paris: Presses universitaires de France, 1969.

Benjamin, Walter. *Walter Benjamin: Selected writings, vol. 3: 1935–1938*. Translated by Edmund Jephcott, Howard Eiland et al., edited by Howard Eiland and Michael W. Jennings. Cambridge, MA: Belknap Press, 2002.

Béraldi, Henri. *Les graveurs du XIXe siècle; guide de l'amateur d'estampes modernes*. Paris: L. Conquet, 1885.

Bertall. *Le Salon de 1843 (ne pas confondre avec celui de l'artiste-éditeur Challamel, éditeur-artiste.) Appendice au livret, représenté par 37 copies par Bertal [sic]*. Paris: Ildefonse Rousset, 1843.

Bertall. "Revue Comique du Salon de Peinture, de Sculpture, d'Architecture, etc., etc., etc. […]." *Le Journal pour rire*, July 28, 1849.

Bertall. "Le Salon dépeint et dessiné par Bertall." *Le Journal pour rire*, July 16, 1853.

Bertall. "Le Salon, par Bertall." *L'Illustration*, June 3, 1865.

Bertall. *Le Grelot au Salon: le Salon de 1872 / dépeint et dessiné par Bertall*. Paris: n.p., 1872.

Bertinet, Arnaud. "La question du Salon au Louvre 1850–1853." In *The Paris Fine Art Salon/ Le Salon, 1791–1881*, edited by James Kearns and Alister Mill, 241–56. Oxford: Oxford University Press, 2015.

Blachon, Remi. *La gravure sur bois au XIXe siècle: L'âge du bois debout*. Paris: Éditions de l'Amateur, 2001.

Blanche, Jacques-Émile. *Manet*. Paris: F. Rieder, 1924.

Boime, Albert. *The Academy and French Painting in the Nineteenth Century*. New Haven, CT: Yale University Press, 1986.

Bolter, Jay David, and Richard Grusin. *Remediation: Understanding New Media*. Cambridge: MIT Press, 2000.

Bonnet, Alain. *L'Enseignement des arts au XIXe Siècle: La réforme de l'école des beaux-arts de 1863 et la fin du modèle Académique*. Rennes: Presses universitaires de Rennes, 2006.

Bonnin, Gérard, ed. *Salons et expositions, Le Havre: répertoire des exposants et liste de leurs œuvres, 1833–1926*. Paris: l'échelle de Jacob, 2013.

Borggreen, Gunhild, Maria Fabricius Hansen, and Rosanna Tindbaek, eds. *Dead or Alive! Tracing the Animation of Matter in Visual Culture*. Aarhaus: Aarhaus University Press, 2020.

Bouillon, Jean-Paul, ed. *La Critique d'art en France 1850–1900: Actes du colloque de Clermont-Ferrand 25, 26 et 27 mai 1987*. Clermont-Ferrand: Université de Saint-Étienne, 1989.

Bouillon, Jean-Paul, ed. *La Promenade du critique influent : Anthologie de la critique d'art en France, 1850–1900*. Paris: Hazan, 1990.

Bowie, Karen, ed. *La modernité avant Haussmann: Formes de l'espace urbain à Paris,1801–1853*. Paris: Éditions Recherche, 2001.

Boyer-Brun, Jacques-Marie. *Histoire des caricatures de la révolte des Français*. Paris: Imprimerie du Journal du Peuple, 1792.

Boyer, Laure. "Robert J. Bingham, photographe du monde de l'art sous le Second Empire." *Études photographiques*, no. 12 (November 1, 2002): 127–41.

Bryson, Norman. *Tradition and Desire: From David to Delacroix*. Cambridge: Cambridge University Press, 1984.

Castle, Terry. "Phantasmagoria: Spectral Technology and the Metaphorics of Modern Reverie." *Critical Inquiry* 15, no. 1 (October, 1998): 26–61.

Cate, Phillip Dennis, and Mary Shaw, eds. *The Spirit of Montmartre: Cabarets, Humor, and the Avant-garde, 1875–1905*. New Brunswick, NJ: Jane Voorhees Zimmerli Art Museum, 1996.

Chabanne, Thierry. *Les Salons Caricaturaux*. Paris: Editions de la Réunion des musées nationaux, 1990.

Chadefaux, Marie-Claude. "Le Salon caricatural de 1846 et les autres Salons caricaturaux." *La Gazette des beaux-arts* (1968): 161–76.

Chagniot, Claire. *Baudelaire et l'estampe*. Paris: Presses de l'Université Paris-Sorbonne, 2016.

Cham. *Revue du Salon de 1853 par Cham*. Paris: Charivari, 1853.

Cham. *Olla Podrida*. Paris: Arnauld de Vresse, 1859.

Cham. *Cham au Salon de 1861. Album de soixante caricatures*. Paris: Martinet, 1861.

Cham. *Cham au Salon de 1863*. Paris: Maison Martinet, 1863.

Cham. *Cham au Salon de 1863: deuxième promenade*. Paris: Maison Martinet, 1863.

Cham. *Le Salon de 1865 photographié par Cham*. Paris: Arnauld de Vresse, 1865.

Cham. *Le Salon de 1866 photographié par Cham*. Paris: Arnauld de Vresse, 1866.

Cham. *Salon de 1868. Album de 60 caricatures*. Paris: Arnauld de Vresse, 1868.

Cham. *Douze années comiques, 1868–1879*. Paris: C. Lévy, 1882.

Cham. *Les folies parisiennes: quinze années comiques, 1864–1879*. Paris: C. Lévy, 1883.

Cham and Louis Huart. "Revue véridique, drolatique et Charivarique du Salon de 1845, illustré par Cham." *Le Charivari*, April 19, 1845.

Cham and Louis Huart. "Revue drolatique du Salon de 1846 illustré par Cham." *Le Charivari*, April 17, 1846.

Cham and Louis Huart. "Le Salon de 1847 illustré par Cham." *Le Charivari*, April 1, 1847.

Cham and Louis Huart. "Le Salon de 1847 illustré par Cham." *Le Charivari*, April 9, 1847.

Cham and Honoré Daumier, *Album du siège par Cham et Daumier*. Paris: Bureau du Charivari, 1871.

Champfleury. *Histoire de la caricature moderne*. Paris: Dentu, 1865.

Charpin, Catherine. *Les Arts Incohérents (1882–1893)*. Paris: Syros/Alternatives, 1990.

Chaudonneret, Marie-Claude and Neil McWilliam. "1848: 'La République des Arts.'" *Oxford Art Journal* 10, no. 1 (1987): 59–70.

Childs, Elizabeth. *Daumier and Exoticism: Satirizing the French and the Foreign*. New York: Peter Lang, 2004.

Chotard, Loïc. *Nadar. Caricatures et photographies*. Paris: Maison de Balzac, 1990.

Chu, Petra. *The Most Arrogant Man in France: Courbet and Media Culture*. Princeton, NJ: Princeton University Press, 2007.

Chute, Hillary, and Patrick Jagoda. "Comics & Media." In *Critical Inquiry. A Special Issue: Comics & Media*, edited by Hillary Chute and Patrick Jagoda, 1–10. Chicago: University of Chicago Press, 2014.

Clark, T. J. *The Painter of Modern Life: The Art of Manet and His Followers*, 3rd edition. Princeton: Princeton University Press, 1989.

Clark, T. J. *The Absolute Bourgeois: Artists and Politics in France, 1848–1851*. Princeton: Princeton University Press, 1988.

Clayson, Hollis. *Paris in Despair: Art and Everyday Life Under Siege (1870–1871)*. Chicago: University of Chicago Press, 2002.

Clayson, Hollis. *Illuminated Paris: Essays on Art and Lighting in the Belle Époque*. Chicago: University of Chicago Press, 2019.

Cohen, Margaret. "Panoramic Literature and the Invention of Everyday Genres." In *Cinema and the Invention of Everyday Life*, edited by Leo Charney and Vanessa R. Schwartz, 227–52. Berkeley: University of California Press, 1995.

Cohen, Ted. *Jokes: Philosophical Thoughts on Joking Matters*. Chicago: University of Chicago Press, 2001.

Cooke, Peter. *Gustave Moreau: History Painting, Spirituality and Symbolism*. New Haven and London: Yale University Press, 2014.

Cowling, M. C. *The Artist as Anthropologist: The Representation of Type and Character in Victorian Art*. Cambridge: Cambridge University Press, 1989.

Cozens, Alexander. *Principles of Beauty Relative to the Human Head*. London: James Dixwell, 1778.

Crangle, R. et al, eds. *Realms of Light: Uses and Perceptions of the Magic Lantern from the 17ᵗʰ to the 21ˢᵗ Century*. London: The Magic Lantern Society, 2005.

Crary, Jonathan. *Techniques of the Observer: On Vision and Modernity in the Nineteenth Century*. Cambridge: MIT Press, 1990.

Crow, Thomas. *Painters and Public Life in Eighteenth-Century Paris*. New Haven: Yale University Press, 1985.

Crow, Thomas. *Emulation: David, Drouais and Girodet in the Art of Revolutionary France*. New Haven: Yale University Press, 2006.

Cuno, James. "Charles Philipon and La Maison Aubert: The Business, Politics and Public of Caricature in Paris, 1820–1840" PhD diss., Harvard University, 1985.

Cuno, James. "Charles Philipon, the Maison Aubert, and the Business of Caricature in Paris, 1829–41." *Art Journal* 43, no. 4 (1983): 347–54.

Daumier raconté par lui-même et par ses amis, edited by Pierre Courthion. Vésenaz-Genève: P. Cailler, 1945.

Daumier, 1808–1879, edited by Henri Loyrette et al. Ottawa: National Gallery of Canada, 1999.

Davis, Jim. "Looking and Being Looked at: Visualizing the Nineteenth-Century Spectator". *Theatre Journal* 69, no. 4 (2017): 515–34.

Dayot, Armand. *Les Maîtres de la caricature française au XIXe siècle*. Paris: Maison Quentin, 1888.

de Calonne, Alphonse. "Salon de 1852." *Revue contemporaine*, April–May 1852.

de Man, Paul. *Blindness and Insight: Essays in the Rhetoric of Contemporary Criticism*, second edition, revised and reprinted. London: Routledge, 2005.

de Plancy, J. Collin. *Dictionnaire infernal : répertoire universel des êtres, des personnages, des livres, des faits et des choses qui tiennent aux esprits [...], 6e éd.* Paris: H. Plon, 1863.

de Font-Réaulx, Dominique, ed. *Gustave Courbet*. New York: Metropolitan Museum of Art, 2008.

de Lagenevais, F. (Frédéric de Mercey.) "Le Salon de 1849." *Revue des deux mondes*. Tome 3 (1849): 559–93.

de Lostalot, Alfred. *Les procédés de la gravure*. Paris: Quantin, 1882.

Delécluze, Étienne-Jean. *Louis David, son école & son temps: souvenirs*. Paris: Didier, 1855.

Delord, Taxile. "Le Salon de 1850." *Le Charivari*, January 6, 1851.

Delouche, Denise. "Le tableau et sa caricature: les œuvres de Courbet vues par les caricaturistes." In *L'Image par l'Image*, n.p. Rennes: GRAC, Université de Rennes-II, 1983.

Delteil, Loys, and Nicolas-Auguste Hazard, *Catalogue raisonné de l'œuvre lithographié de Honoré Daumier*. Orrouy: N. A. Hazard, 1904.

Denise Murrell. *Posing Modernity: The Black Model from Manet and Matisse to Today*. New Haven: Yale University Press, 2018.

Des Cars, Laurence, et al., eds. *The Spectacular Art of Jean-Léon Gérôme: 1824–1904*. Paris: Skira, 2010.

Desbuissons, Frédérique. "La chair du Réalisme: Le corps de Gustave Courbet." In *Courbet À Neuf!* edited by Mathilde Arnoux, Dominique de Font-Réaulx, Laurence des Cars, Stéphane Guégan, and Scarlett Reliquett, 65–82. Paris: Éditions de la Maison des sciences de l'homme, 2010.

Desbuissons, Frédérique. "The Studio and the Kitchen: Culinary Ugliness as Pictorial Stigmatisation in Nineteenth-Century France." In *Ugliness: The Non-Beautiful in Art and Theory*, edited by Andrei Pop and Mechtild Widrich, 104–21. London: I.B. Tauris, 2016.

Desnoyers, Fernand. *La peinture en 1863: Salon des refusés*. Paris: Azur Dutil, 1863.

Dey & Roby. "La Saison à Paris—Théâtres—Modes. Étrangers et étrangères," *La Vie parisienne*, June 1, 1872, 344–5.

Documenting the Salon: Paris Salon Catalogs 1673–1945, edited by John Hagood, Yuriko Jackall, Kimberly A. Jones, and Yuri Long. Washington, DC: National Gallery of Art Library, 2016.

Dolan, Therese. "Manet's *Portrait-Charge* of Émile Ollivier," *Print Quarterly* 17, no. 1 (2000): 17–26.

Dombrowski, André. *Cézanne, Murder, and Modern Life.* Berkeley and Los Angeles: University of California Press, 2013.

Dombrowski, André. "Living on Manet's Balcony, or the Right to Privacy." In *Is Paris Still the Capital of the Nineteenth Century? Essays on Art and Modernity: 1850–1900,* edited by Hollis Clayson and André Dombrowski, 235–56. London and New York: Routledge, 2016.

Druick, Douglas W. *La Pierre Parle: Lithography in France, 1848–1900. Text Panels and Labels for the Exhibition: Ottawa, National Gallery of Canada, May 1–June 14, Montreal Museum of Fine Arts, July 9–August 16, Windsor Art Gallery, September 13–October 14.* Ottawa: National Gallery of Canada, 1981.

Dumas, Alexandre. *L'art et les artistes contemporains au Salon de 1859.* Paris: Librairie Nouvelle, 1859.

Duranty, Edmond. "La caricature et l'imagerie pendant la guerre de 1870–71 en Allemagne, en France, en Belgique, en Italie et en Angleterre." *La Gazette des beaux-arts* t.5 (Feb. 1 & Apr. 2, 1872): 155–72; 322–43; and t.6 (Nov. 1, 1872): 393–408.

Duranty, Edmond. "Sur la physiognomie." *Revue Libérale* 11 (July 25, 1867): 499–523.

Duranty, Edmond. *La nouvelle peinture : à propos du groupe d'artistes qui expose dans les galeries Durand-Ruel.* Paris: E. Dentu, 1876.

Duret, Théodore. *Critique d'avant-garde.* Paris: G. Charpentier, 1885.

Duret, Théodore. *Histoire de Édouard Manet et de son œuvre.* Paris: Charpentier et Fasquelle, 1906.

Elleinstein, Jean, ed. *Histoire de la France contemporaine 1789–1980.* Paris: Éditions sociales, 1978–1981, 30.

Erre, Fabrice. *Le pouvoir de la satire: deux siècles de presse satirique, de la Révolution à Charlie.* Paris: Dargaud, 2018.

Farrant, Tim. "La vue d'en face? Balzac et l'Illustration." *L'Année balzacienne* 12, no 1 (2011): 249–71.

Farwell, Beatrice. *The Charged Image: French Lithographic Caricature 1816–1848.* Santa Barbara: Santa Barbara Museum of Art, 1989.

Ferguson, Priscilla Parkhurst. *Paris as Revolution: Writing the Nineteenth-Century City.* Berkeley and Los Angeles: University of California Press, 1994.

Fort, Bernadette. "The Voice of the Public: The Carnavalization of Salon Art in Prerevolutionary Pamphlets." *Eighteenth-Century Studies* 22, no. 3 (1989): 368–94.

Fortescue, William. *France and 1848: The End of Monarchy.* London and New York: Routledge, 2005.

Freedberg, David. *The Power of Images: Studies in the History and Theory of Response.* Chicago: University of Chicago Press, 1989.

Fried, Michael. "Manet's Sources." *Artforum* 7 (1969): 28–82.

Fried, Michael. *Manet's Modernism, or, the Face of Painting in the 1860s.* Chicago: University of Chicago Press, 1996.

Gaultier, Paul. *Le rire et la caricature.* Paris: Hachette, 1906.

Gautier, Théophile. "Salon de 1869, V." *L'Illustration,* June 5, 1869, 363–6.

George, M. Dorothy. *Hogarth to Cruikshank: Social Change in Graphic Satire.* London: Allen Lane, Penguin, 1967.

Gervais, Thierry. "L'Illustration photographique. Naissance du spectacle de l'information, 1843–1914." PhD thesis, EHESS, 2007.

Gill, André, and Oulevay. *La Parodie. Le Salon de 1869 par Gill et Oulevay.* July, 1869.

Gluck, Mary. *Popular Bohemia: Modernism and Urban Culture in Nineteenth-Century Paris.* Cambridge: Harvard University Press, 2008.

Goldstein, Robert Justin. "Nineteenth-Century French Political Censorship of Caricature in Comparative European Perspective." *Law and Humanities* 3, no. 1 (2009): 25–44, 42.

Goldstein, Robert Justin. *Censorship of Political Caricature in Nineteenth-Century France.* Kent, OH: Kent State University Press, 1989.

Goldstein, Robert Justin. "The Debate over Censorship of Caricature in Nineteenth-Century France." *Art Journal* 48, no. 1 (1989): 9–15.

Gombrich, E. H. and Ernst Kris. "The Principles of Caricature." *British Journal of Medical Psychology* 17 (1938): 319–42.

Gombrich, E. H. and Ernst Kris. *Caricature.* Harmondsworth: Penguin, 1940.

Gombrich, E. H. "On Physiognomic Perception." *Daedalus* 89, no. 1 (1960): 228–41.

Gotlieb, Marc. *The Plight of Emulation: Ernest Meissonier and French Salon painting.* Princeton: Princeton University Press, 1996.

Gotlieb, Marc. *The Deaths of Henri Regnault.* Chicago: University of Chicago Press, 2016.

Graham, John. *Lavater's Essays on Physiognomy: A Study in the History of Ideas.* Bern: Peter Lang, 1979.

Grand-Carteret, John. *Les moeurs et la caricature en France.* Paris: À la Librairie Illustrée, 1888.

Greenberg, Clement. *The Collected Essays and Criticism,* vols 1 and 4, edited by John O' Brian. Chicago: University of Chicago Press, 1994.

Gretton, Tom. "Difference and Competition: The Imitation and Reproduction of Fine Art in a Nineteenth-Century Illustrated Weekly News Magazine." *Oxford Art Journal* 23, no. 2 (2000): 145–62.

Gretton, Tom. "Signs for Labour-Value in Printed Pictures after the Photomechanical Revolution: Mainstream Changes and Extreme Cases Around 1900." *Oxford Art Journal* 28, no. 3 (2005): 373–90.

Gretton, Tom. "'Un Moyen Puissant de Vulgarisation Artistique'. Reproducing Salon Pictures in Parisian Illustrated Weekly Magazines c.1860–c.1895: From Wood Engraving to the Half Tone Screen (and Back)." *Oxford Art Journal* 39, no. 2 (2016): 285–310.

Grigsby, Darcy Grimaldo. "Cursed Mimicry: France and Haiti, Again (1848–1851)." *Art History* 38, no. 1 (2015): 68–105.

Grigsby, Darcy Grimaldo. "Still Thinking about Olympia's Maid." *The Art Bulletin* 97, no. 4 (2015): 430–51.

Groensteen, Thierry, ed. *Bande dessinée: son histoire et ses maîtres*. Paris; Angoulême: Skira; Flammarion, 2009.

Grojnowski, Daniel. *Aux commencements du rire moderne: L'esprit fumiste*. Paris: José Corti, 1997.

Grosclaude and Albert Guillaume. "Le Salon Fantaisiste." *Le Figaro, Supplément illustré*, May 12, 1894.

Grose, Francis. *Rules for Drawing Caricatures, with an Essay on Comic Painting*. London: Samuel Hooper, 1789.

Gueullette, Charles. "Revue de l'art ancien et moderne." *Les Beaux-arts: revue nouvelle*, May 15, 1863, 296–30.

Gunning, Tom. "Hand and Eye: Excavating a New Technology of the Image in the Victorian Era." *Victorian Studies* 54, no. 3 (2012): 495–516.

Hahn, H. Hazel. *Scenes of Parisian Modernity: Culture and Consumption in the Nineteenth Century*. New York: Palgrave Macmillan, 2009.

Hamber, Anthony. *"A higher branch of the art": photographing the fine arts in England: 1839–1880*. Amsterdam: Gordon and Breach, 1996.

Hamilton, George Heard. *Manet and His Critics*. New Haven: Yale University Press, 1954.

Hamilton, George Heard. *Painting and Sculpture in Europe, 1880–1940*. New Haven: Yale University Press, 1967.

Hannoosh, Michèle. *Baudelaire and Caricature: From the Comic to an Art of Modernity*. University Park, PA: Penn State Press, 1992.

Hannoosh, Michèle. "Théophile Silvestre's 'Histoire des Artistes Vivants:' Art Criticism and Photography." *Art Bulletin* 88, no. 4 (2006): 729–55.

Hanson, Anne Coffin. "Manet's Subject Matter and a Source of Popular Imagery." *Art Institute of Chicago Museum Studies* 3 (1968): 63–80.

Hart, Katherine. "Physiognomy and the Art of Caricature." In *The Faces of Physiognomy: Interdisciplinary Approaches to Johann Caspar Lavater*, edited by Ellis Shookman, 125–38. Columbia, SC: Camden House, 1993.

Harvey, David. *Paris, Capital of Modernity*. London: Routledge, 2003.

Herbert, Robert L. "Seurat and Puvis de Chavannes." *Yale Art Gallery Bulletin* 25, no. 2 (1959): 22–9.

Herding, Klaus. *Courbet: to Venture Independence*. Translated by John William Gabriel. New Haven: Yale University Press, 1991.

Higonnet, Anne. "Manet and the Multiple." *Grey Room* 48 (2012): 102–16.

Higonnet, Patrice. *Paris, Capital of the World*. Translated by Arthur Goldhammer. Cambridge: Belknap Press, 2002.

Hofmann, Werner. *Caricature from Leonardo to Picasso*. London: John Calder, 1957.

House, John. "Toward a 'Modern' Lavater? Degas and Manet." In *Physiognomy in Profile: Lavater's Impact on European Culture*, edited by Melissa Percival and Graeme Tytler, 180–97. Newark: University of Delaware Press, 2005.

House, John. "History without Values? Gérôme's History Paintings." *Journal of the Warburg and Courtauld Institutes* 71 (2008): 261–76.

Howe, Jeffrey, ed. *Courbet: Mapping Realism: Paintings from the Royal Museums of Fine Arts of Belgium and American Collections*. Chestnut Hill, MA: Boston College, McMullen Museum of Art, 2013.

Ivins, William M. *Prints and Visual Communication*. New York: Da Capo Press, 1969.

Jaime, Auguste. *Musée de la caricature*. Paris: Delloye, 1838.

Jal, Auguste. *Esquisses, croquis, pochades, ou, tout ce qu'on voudra sur le Salon de 1827*. Paris: A. Dupont, 1827.

Jammes, Isabelle. *Blanquart-Évrard et les origines de l'édition photographique française*. Geneva : Droz, 1981.

Japhet. *Le Salon pour rire de 1883*. Paris: Imprimerie Nilson, 1883.

Jeanneney, Jean-Noël. *Le Duel : Une passion française, 1789–1914*. Paris: Seuil, 2004.

Johnson, Geraldine. *Sculpture and Photography: Envisioning the Third Dimension*. Cambridge: Cambridge University Press, 1998.

Jordanova, Ludmilla. "Picture-Talking: Portraiture and Conversation in Britain, 1800–1830." In *The Concept and Practice of Conversation in the Long Eighteenth Century, 1688–1848*, edited by Katie Halsey and Jane Slinn, 151–69. Newcastle: Cambridge Scholars Pub, 2008.

Jussim, Estelle. *Visual Communication and the Graphic Arts; Photographic Technologies in the Nineteenth Century*. New York: R. R. Bowker Co, 1974.

Kaenel, Philippe. *Le Métier d'illustrateur 1830–1880: Rodolphe Töpffer, J.J. Grandville, Gustave Doré*. Génève: Droz, 2005.

Kaenel, Philippe. "Daumier 'au point de vue de l'artiste et au point de vue moral.'" In *Daumier: L'écriture du lithographe [catalogue de l'exposition présentée àla Bibliothèque nationale de France, site Richelieu, du 4 Mars au 8 Juin 2008]*, edited by Valérie Sueur-Hermel, 41–51. Paris: Bibliothèque nationale de France, 2008.

Kalifa, Dominique, Philippe Régnier, Marie-Ève Thérenty, and Alain Vaillant, eds. *La civilisation du journal. Histoire culturelle et littéraire de la presse française au XIXe siècle*. Paris: Nouveau Monde, 2011.

Karr, Alphonse, and Bertall. *Les Guêpes au Salon. Les Guêpes illustrées*. Paris: Hetzel, Warnod & Cie, 1847.

Kearns, James. *Théophile Gautier, Orator to the Artists: Art Journalism in the Second Republic*. London: Legenda, 2007.

Kearns, James, and Alister Mill, eds. *The Paris Fine Art Salon / Le Salon, 1791–1881*. Bern: Peter Lang, 2015.

Kerr, David S. *Caricature and French Political Culture 1830–1848: Charles Philipon and the Illustrated Press*. Oxford: Clarendon Press, 2000.

Kunzle, David. *Cham: The Best Comic Strips and Graphic Novelettes*. Jackson, MI: University Press of Mississippi, 2019.

Kunzle, David. "Cham, the 'popular' Caricaturist." *Gazette des beaux-arts* vol 96 (1980): 214–24.

Kunzle, David. *Father of the Comic Strip: Rodolphe Töpffer*. Jackson, MI: University Press of Mississippi, 2007.

Kunzle, David. *History of the Comic Strip*. Vol. 2, *The Nineteenth Century*. Berkeley: University of California Press, 1990.

L'Illustration. "Beaux Arts—Salon de 1843." March 25, 1843.

L'Illustration. "Caricatures per Bertall." May 13, 1843.

Lafenestre, Georges. *L'art vivant: La peinture et la sculpture aux Salons de 1868–1877*. Paris: G. Fischbacher, 1881.

Langbein, Julia. "Cham, Daumier and Sky-Gazing in Nineteenth-Century Paris." In *Looking and Listening in Nineteenth-century France*, edited by Martha Ward and Anne Leonard, 27–37. Chicago: Smart Museum of Art, University of Chicago, 2007.

Laurent-Jan, Ralph. *Le Salon de 1839*. Paris: Beauger & Cie, 1839.

Lavater, Johann Caspar. *L'art de connaître les hommes par la physionomie* […], tome 1 - tome 6. Edited by Moreau de la Sarthe. Paris: Depélafol, 1820.

Le Men, Ségolène. "Le 'Michel-Ange de la caricature.'" In *Daumier: L'écriture du lithographe [catalogue de l'exposition présentée àla Bibliothèque nationale de France, site Richelieu, du 4 Mars au 8 Juin 2008]*, edited by Valérie Sueur-Hermel, 21–30. Paris: Bibliothèque nationale de France, 2008.

Le Men, Ségolène, ed. *Pour rire!: Daumier, Gavarni, Rops: L'invention de la silhouette*. Namur: Musée Félicien Rops; L'Isle-Adam: Musée d'art et d'histoire Louis-Senlecq; Paris: Somogy Editions d'Art, 2010.

Le Men, Ségolène, and Bargiel Réjane, eds. *L'affiche de librairie au XIXe siècle*. Paris: Réunion des musées nationaux, 1987.

Le Men, Ségolène, Luce Abélès, and Nathalie Preiss-Basset, eds. *Les Français peint par eux-mêmes: Panorama social du XIXe siècle*. Paris: Réunion des musées nationaux, 1993.

"Le Salon de 1859," *Le Journal amusant*, June 18, 1859.

Ledbury, Mark. "Trash Talk and Buried Treasure: Northcote and Hazlitt." *The Journal of Art Historiography* 23 (December 2020): 1–21.

Léger, Charles. *Courbet, selon les caricatures et les images*. Paris: P. Rosenberg, 1920.

Léger, Charles. *Édouard Manet*. Paris: Éditions G. Crès & Cie, 1931.

Leribault, Christophe, and Fiona Le Boucher, eds. *Delacroix et la photographie*. Paris: Musée du Louvre, 2008.

Lerner, Jillian. "Nadar's Signatures: Caricature, Self-Portrait, Publicity." *History of Photography* 41, no. 2 (2017): 108–25.

Lerner, Jillian. *Graphic Culture: Illustration and Artistic Enterprise in July Monarchy France, 1830–1848*. Montreal: McGill-Queen's University Press, 2018.

Leroy, Louis, "Salon de 1865. III." *Le Charivari*, May 11, 1865.

Leroy, Louis. "Salon de 1865. XIV." *Le Charivari*, June 10, 1865.

Lethbridge, Robert. "'Painting out' (and 'Reading in') the Franco-Prussian War: Politics and Art Criticism in the 1870s." *Journal of European Studies* 50, no. 1 (2020): 52–9.

Lethève, Jacques. *La caricature et la presse sous la IIIe République*. Paris: Armand Colin, 1986.

Lichtenstein, Jacqueline. *The Eloquence of Color: Rhetoric and Painting in the French Classical Age*. Translated by Emily McVarish. Berkeley: University of California Press, 1993.

Lichtenstein, Jacqueline. *The Blind Spot: An Essay on the Relations between Sculpture and Painting in the Modern Age*, translated by Chris Miller. Los Angeles: Getty Publications, 2008.

Lilley, Ed. "Daumier and the Salons of 1840 and 1841." *The Burlington Magazine* 154, no. 1309 (2012): 248–50.

Lilley, Ed. "On the Fringe of the Exhibition: A Consideration of Some Aspects of the Catalogues of the Paris 'Salons.'" *Journal for Eighteenth-Century Studies* 10, no. 1 (1987): 1–12.

Lipman, Jean. *Art about Art*, New York: Dutton, 1978.

Lo Feudo, Michela. "Penser le rire au XIXe siècle à travers les Histoires de la caricature." In *Le rire moderne*, edited by Alain Vaillant and Roselyne de Villenueve, 313–33. Nanterre: Presses universitaires de Paris Nanterre, 2013.

Locke, Nancy. "Manet Exhibits in Lyon in 1869." *The Burlington Magazine* 150, no. 1262 (2008): 322–5.

Lucy, Martha. "Cormon's 'Cain' and the Problem of the Prehistoric Body." *Oxford Art Journal* 25, no. 2 (2002): 109–26.

MacNamidhe, Margaret. *Delacroix and his Forgotten World: The Origins of Romantic Painting*. London and New York: I.B. Tauris, 2015.

Mainardi, Patricia. *Art and Politics of the Second Empire: The Universal Expositions of 1855 and 1867*. New Haven and London: Yale University Press, 1987.

Mainardi, Patricia. *The End of the Salon: Art and the State in the Early Third Republic*. Cambridge: Cambridge University Press, 1993.

Mainardi, Patricia. "The Invention of Comics." *Nineteenth-Century Art Worldwide* 6, no. 1 (2007). www.19thc-artworldwide.org/spring07/145-the-invention-of-comics.

Mainardi, Patricia. *Another World: Nineteenth-Century Illustrated Print Culture*. New Haven and London: Yale University Press, 2017.

Mannoni, Laurent. *The Great Art of Light and Shadow: Archaeology of the Cinema*. Exeter: University of Exeter Press, 2000.

Marchandiau, Jean-Noël. *L'Illustration 1843–1944. Vie et mort d'un journal*. Toulouse: Éditions Privat, 1987.

Marien, Mary Warner. *Photography: A Cultural History*. London: Laurence King, 2002.

Marx, Karl. *The Eighteenth Brumaire of Louis Bonaparte*. In *Marx's "Eighteenth Brumaire": (Post)modern Interpretations*, edited by Mark Cowling, 19–112. London: Pluto Press, 2002.

McCauley, Anne. *Industrial Madness: Commercial Photography in Paris, 1848–1871*. New Haven and London: Yale University Press, 1994.

McCauley, Anne. "Sex and the Salon: Defining Art and Immorality in 1863." In *Manet's Le Dejeuner sur l'herbe*, edited by Paul Tucker, 38–74. Cambridge: Cambridge University Press, 1998.

McLees, Ainslie Armstrong. *Baudelaire's Argot Plastique*. Athens, GA: University of Georgia Press, 1989.

McPhee, Constance C. and Nadine Orenstein. *Infinite Jest: Caricature and Satire from Leonardo to Levine*. New York: Metropolitan Museum of Art, 2011.

McWilliam, Neil, ed. *A Bibliography of Salon Criticism from the July Monarchy to the Second Republic, 1831–1851*. Cambridge: Cambridge University Press, 1991.

McWilliam, Neil, Vera Schuster, and Richard Wrigley, eds. *A Bibliography of Salon Criticism in Paris from the "Ancien Régime" to the Restoration, 1699–1827*. Cambridge: Cambridge University Press, 1991.

McWilliam, Neil. *Dreams of Happiness: Social Art and the French Left, 1830–1850*. Princeton, NJ: Princeton University Press, 1993.

Melly, George, ed. *A Child of Six Could Do It: Cartoons about Modern Art*. London: Tate Gallery, 1973.

Melot, Michel. *L'oeil qui rit: le pouvoir comique des images*. Fribourg/Paris: Office du livre/ Bibliothèque des arts, 1975.

Melot, Michel. *Daumier: L'art et la République*. Paris: Archimbaud, 2008.

Melot, Michel. "Daumier dans l'histoire de France." In *Daumier: L'écriture du lithographe [catalogue de l'exposition présentée àla Bibliothèque nationale de France, site Richelieu, du 4 Mars au 8 Juin 2008]*, edited by Valérie Sueur-Hermel, 31–8. Paris: Bibliothèque nationale de France, 2008.

Melot, Michel, and Neil McWilliam. "Daumier and Art History: Aesthetic Judgment/ Political Judgment." *Oxford Art Journal* 11, no. 1 (1988): 3–24.

Melzer, Françoise. *Seeing Double: Baudelaire's Modernity*. Chicago: University of Chicago Press, 2011.

Mitchell, W. J. T. *What Do Pictures Want?: The Lives and Loves of Images*. Chicago: University of Chicago Press, 2005.

Modernity and Modernism: French Painting in the Nineteenth Century, edited by Francis Frascina, Nigel Blake, Briony Fer, et al. New Haven and London: Yale University Press in Association with the Open University, 1993.

Montagu, Jennifer. *The Expression of the Passions: The Origin and Influence of Charles Le Brun's "Conférence sur l'expression générale et particulière."* New Haven: Yale University Press, 1994.

Nadar. *Nadar Jury au Salon de 1853: album comique de 60 à 80 dessins coloriés, compte rendu d'environ 6 à 800 tableaux, sculptures, etc.* Paris: J. Bry aîné, 1853.

Nadar. *Album du Salon de 1852. Nadar Jury*. Paris: Aux Bureaux de L'Éclair, 1852.

Nadar. *Nadar Jury au Salon de 1857 : 1000 comptes rendus, 150 dessins*. Paris: Librairie Nouvelle, 1857.

Nadar and Darjou, "Nadar Jury au Salon de 1859," *Le Journal amusant*, June 4, 1859.

Nadar and Darjou, "Nadar Jury au Salon de 1859," *Le Journal amusant*, July 16, 1859.

Nadar and Darjou, "Nadar Jury au Salon de 1861," *Le Journal amusant*, July 6, 1861.

Nead, Lynda. *The Haunted Gallery: Painting, Photography, Film c 1900*. New Haven: Yale University Press, 2007.

Néagu, Philippe. "Nadar and the Artistic Life of His Time." In *Nadar*, edited by Maria Morris Hambourg, 59–76. New York: Metropolitan Museum, 1996.

O'Brien, Laura. *The Republican Line: Caricature and French Republican Identity, 1830–1852.* Manchester: Manchester University Press, 2015.

Orwicz, Michael. "Reinventing Édouard Manet." In *Art Criticism and Its Institutions in Nineteenth-Century France,* edited by Michael Orwicz, 122–45. Manchester: Manchester University Press, 1994.

Oulevay, Henri. "Au Salon de 1864." *Le Monde illustré,* May 28, 1864, 349.

Parent-Lardeur, Françoise. *Les Cabinets de lecture: La lecture publique à Paris sous la Restauration.* Paris: Payot, 1982.

Pearl, Sharrona. *About Faces: Physiognomy in Nineteenth-century Britain.* Cambridge, MA: Harvard University Press, 2010.

Percival, Melissa. *The Appearance of Character: Physiognomy and Facial Expression in Eighteenth-Century France.* Leeds: W.S. Maney for the Modern Humanities Research Association, 1999.

Percival, Melissa. "Johann Caspar Lavater: Physiognomy and Connoisseurship." *Journal for Eighteenth-Century Studies* 26, no. 1 (2003): 77–90.

Percival, Melissa, and Graeme Tytler, eds. *Physiognomy in Profile: Lavater's Impact on European Culture.* Newark: University of Delaware Press, 2005.

Philipon, Charles, and Louis-Joseph Trimolet. "Le dedans jugé par le dehors." *Le Musée Philipon,* vol. 2, no. 10 (1841): 73–8.

Pitman, Dianne W. *Frédéric Bazille: Purity, Pose and Painting in the 1860s.* University Park, PA: Pennsylvania State University Press, 1998.

Planche, Gustave. *Études sur l'école française (1831–1852), peinture et sculpture,* tome 1–tome 2. Paris: Michel Lévy, 1855.

Porterfield, Todd, ed. *The Efflorescence of Caricature, 1759–1838.* Farnham, Surrey; Burlington, VT: Ashgate, 2011.

Price, Aimée Brown. "Puvis de Chavannes's Caricatures: Manifestoes, Commentary, Expression." *Art Bulletin* 73, no. 1 (1991): 119–40.

Price, Roger. *People and Politics in France, 1848–1870.* Cambridge: Cambridge University Press, 2004.

Privat, Gonzague. *Place aux jeunes, causeries critiques sur le Salon de 1865 […].* Paris: F. Cournol, 1865.

Quatrelles (Ernest L'Épine). "Le Salon carré à l'exposition." *La Vie parisienne,* May 9, 1868, 325–7.

Randon (Gilbert Randon). "L'Exposition d'Édouard Manet." *Le Journal amusant,* June 29, 1867, 6–8.

Rauser, Amelia. *Caricature Unmasked: Irony, Authenticity, and Individualism in Eighteenth-Century English Prints.* Newark: University of Delaware Press, 2008.

Reff, Theodore. "'Manet's Sources': A Critical Evaluation." *Artforum* 8 (September 1969): 40–8.

Renié, Pierre-Lin. "The Battle for a Market: Art Reproductions in Print and Photography from 1850 to 1880." In *Intersections: Lithography, Photography and the Traditions of Printmaking,* edited by Kathleen Stewart Howe, 41–53. Albuquerque: The University of New Mexico Press, 1998.

Renonciat, Annie. "Les couleurs de l'édition au XIXe siècle: '*Spectaculum horribile visu*'?" *Romantisme* 157, no. 3 (2012): 33–52.

Ribeyre, Félix. *Cham : sa vie et son œuvre*. Paris: Librairie Plon, 1884.

Riout, Denys. "Les Salons Comiques." *Romantisme* 75 (1992): 51–62.

Roberts-Jones, Philippe. *La presse satirique illustrée entre 1860 et 1890*. Paris: Institut français de presse, 1956.

Roberts-Jones, Philippe. *De Daumier à Lautrec. Essai sur l'histoire de la caricature française entre 1860 et 1890*. Paris: Les Beaux-arts, 1960.

Rose, Margaret. *Parody: Ancient, Modern and Post-Modern*. Cambridge: Cambridge University Press, 1993.

Rose, Margaret. *Pictorial Irony, Parody and Pastiche: Comic interpictoriality in the arts of the 19th and 20th centuries*. Bielefeld: Aisthesis Verlag, 2011.

Rosenberg, Raphael. "De la blague monochrome à la caricature de l'art abstrait." In *L'art de la caricature*, edited by Ségolène Le Men, 27–40. Paris: Presses Universitaires de Paris-Ouest, 2011.

Roth, Nancy Ann. "'L'Artiste' and 'L'Art Pour L'Art': The New Cultural Journalism in the July Monarchy." *Art Journal* 48, no. 1 (1989): 35–9.

Rouart, Denis, and John Wildenstein, eds. *Édouard Manet: Catalogue raisonné*. Lausanne: Bibliothèque des arts, 1975.

Samuels, Maurice. *The Spectacular Past: Popular History and the Novel in Nineteenth-Century France*. Ithaca, NY: Cornell University Press, 2005.

Sangsue, Daniel. *La Parodie*. Paris: Hachette, 1994.

Schlesser, Thomas, and Bertrand Tillier. *Courbet face à la caricature: Le chahut par l'image*. Paris: Kimé, 2007.

Schwartz, Vanessa R. *Spectacular Realities: Early Mass Culture in Fin-de-Siècle Paris*. Berkeley: University of California Press, 1998.

Shaw, Jennifer L. *Dream States: Puvis de Chavannes, Modernism and the Fantasy of France*. New Haven and London: Yale University Press, 2002.

Shelton, Andrew Carrington. "Ingres Versus Delacroix." *Art History* 23, no. 5 (2000): 726–42.

Shiff, Richard. "The Original, the Imitation, the Copy, and the Spontaneous Classic: Theory and Painting in Nineteenth-Century France". *Yale French Studies* 66 (1984): 27–54.

Shortland, Michael. "The Power of a Thousand Eyes: Johann Caspar Lavater's Science of Physiognomical Perception." *Criticism* 28, no. 4 (1986): 379–408.

Stafford, Barbara Maria. *Body Criticism: Imaging the Unseen in Enlightenment Art and Medicine*. Cambridge, MA: MIT Press, 1991.

Stephens, Sonya. *Baudelaire's Prose Poems: The Practice and Politics of Irony*. Oxford: Oxford University Press, 2000.

Stoichita, Victor. "Johann Caspar Lavater's 'Essays on Physiognomy' and the Hermeneutics of Shadow." *RES: Anthropology and Aesthetics* 31 (1997): 128–38.

Stoichita, Victor. *The Pygmalion Effect: From Ovid to Hitchcock*, translated by Alison Anderson. Chicago: University of Chicago Press, 2008.

Tabarant, Adolphe. "Une histoire inconnue du 'Polichinelle.'" *Le Bulletin de la vie artistique* (September 1923): 365–9.

Terdiman, Richard. *Discourse/Counter-discourse: The Theory and Practice of Symbolic Resistance in Nineteenth-Century France*. Ithaca: Cornell University Press, 1985.

Teyssèdre, Bernard. *Roger de Piles et les débats sur le coloris au siècle de Louis XIV*. Paris: La Bibliothèque des Arts, 1957.

The "Writing" of Modern Life: The Etching Revival in France, Britain, and the U.S., 1850–1940, ed. Elizabeth K. Helsinger. Chicago: Smart Museum of Art, University of Chicago, 2008.

Thoma, Julia. *The Final Spectacle: Military Painting under the Second Empire, 1855–1867*. Berlin and Boston: de Gruyter, 2019.

Tillier, Bertrand. *La Républicature: La caricature politique en France, 1870–1914*. Paris: CNRS, 1997.

Tillier, Bertrand. *Parodies littéraires: précédé de Cham, Le polypier d'images*. Paris; Jaignes: Phileas-Fogg; La Chasse au Snark, 2003.

Tillier, Bertrand. *À la charge! La caricature en France de 1789 à 2000*. Paris: Les Éditions de l'Amateur, 2005.

Tillier, Bertrand. "La signature du peintre et sa caricature : l'exemple de Courbet." *Sociétés & Représentations* 25, no. 1 (2008): 79–96.

Tillier, Bertrand. "Du caricatural dans l'art du XXe siècle." *Perspective* 4 (2009): 538–58.

Tillier, Bertrand. "The Impact of Censorship on Painting and Sculpture, 1851–1914." In *Out of Sight: Political Censorship of the Visual Arts in Nineteenth-Century France*, edited by Robert Justin Goldstein, 79–103. New Haven: Yale University Press, 2012.

Tillier, Bertrand. "La caricature et le rire des mésalliances." *Revue française de psychanalyse* 81, no. 1 (2017): 17–32.

Tillier, Bertrand. "Gargantua, géant de papier? Migrations visuelles et jeux d'échelles," *Romantisme* 187, no. 1 (2020): 28–43.

Töpffer, Rodolphe. *Essai de physiognomie*. Geneva: Schmidt, 1845.

Töpffer, Rodolphe. *Enter: The Comics. Rodolphe Töpffer's "Essay on physiognomy" and "The true story of M. Crépin."* Edited and translated by E. Wiese. Lincoln, NE: University of Nebraska Press, 1965.

Toudouze, Gustave. *Albert Wolff: histoire d'un chroniqueur parisien; portrait par Bastien Lepage*. Paris: V. Havard, 1883.

Twyman, Michael. *Lithography, 1800–1850: The techniques of drawing on stone in England and France and their application in works of topography*. London: Oxford University Press, 1970.

Tytler, Graeme. *Physiognomy in the European Novel: Faces and Fortunes*. Princeton, NJ: Princeton University Press, 1982.

"Une pluie de chefs-d'œuvre." *La Vie parisienne*, June 8, 1872, 360–1.

Vaisse, Pierre and James Kearns, eds. *"Ce Salon à quoi tout se ramène": Le Salon de peinture et de sculpture, 1791–1890*. Bern: Peter Lang, 2010.

Vaugeois, Dominique and Ivanne Rialland, eds. *L'Écrivain et le spécialiste: Écrire sur les arts plastiques au XIXe et au XXe siècles [actes du colloque, Paris, Maison de la recherche de l'Université de Paris-Sorbonne, 22–23 janvier 2009]*. Paris: Éditions Classiques Garnier, 2010.

Veuillot, Louis. *Les Odeurs de Paris*. Paris: Palmé, 1867.

Waller, Susan. *The Invention of the Model: Artists and Models in Paris, 1830–1870*. New York: Ashgate, 2006.

Ward, Martha. "Impressionist Installations and Private Exhibitions." *Art Bulletin* 73, no. 4 (1991): 599–622.

Ward, Martha. "From Art Criticism to Art News: Journalistic Reviewing in Late Nineteenth-Century Paris." In *Art Criticism and Its Institutions in Nineteenth-Century France*, edited by Michael Orwicz, 162–81. Manchester: Manchester University Press, 1994.

Ward, Martha, and Christopher Parsons, eds. *A Bibliography of Salon Criticism in Second Empire Paris*. Cambridge: Cambridge University Press, 1986.

Wechsler, Judith. *A Human Comedy: Physiognomy and Caricature in 19th Century Paris*. Chicago: University of Chicago Press, 1982.

Weisberg, Gabriel. *The Independent Critic: Philippe Burty and the Visual Arts of Mid-Nineteenth-Century France*. New York: Peter Lang, 1993.

Werth, Margaret. *The Joy of Life: The Idyllic in French Art, circa 1900*. Berkeley and Los Angeles: University of California Press, 2002.

Werth, Margaret. "A Laughter of the Look: Manet, Mallarmé, Polichinelle, and the Salon Jury in 1874." In *Is Paris Still the Capital of the Nineteenth Century? Essays on Art and Modernity, 1850–1900*, edited by Hollis Clayson and André Dombrowski, 96–108. London and New York: Routledge, 2016.

Weston, Helen. "The Politics of Visibility in Revolutionary France: Projecting on the Streets." In *A History of Visual Culture: Western Civilization from the 18th to the 21st Century*, edited by Jane Kromm and Susan Bakewell, 18–29. Oxford: Berg, 2010.

White, Harrison and Cynthia. *Canvases and Careers: Institutional Change in the French Painting World with a New Foreword and a New Afterword*. Chicago: University of Chicago Press, 1993.

Wicky, Érika. "Caricatures de photographies et photographies caricaturales: la critique photographique dans la presse (1850–1870)." In *L'image railleuse: La satire visuelle du XVIIIe siècle à nos jours*, edited by Laurent Baridon, Frédérique Desbuissons and Dominic Hardy. Paris: Publications de l'Institut national d'histoire de l'art, 2019.

Wicky, Érika, and Kathrin Yacavone, eds. *Potraitomanie: Intermediality and the Portrait in Nineteenth-Century France*. Special issue, *Esprit Créateur* 59, no. 1 (Spring 2019).

Williams, Rosalind. *Dream Worlds: Mass Consumption in Late Nineteenth Century France*. Los Angeles and Berkeley: University of California Press, 1982.

Wilson-Bareau, Juliet. *Manet, Monet and the Gare St. Lazare*. New Haven: Yale University Press, 1998.

Woodrow, Ross. "Lavater and the Drawing Manual." In *Physiognomy in Profile: Lavater's Impact on European Culture*, edited by Melissa Percival and Graeme Tytler, 71–93. Newark: University of Delaware Press, 2005.

Wolff, Albert. *La gloire à Paris*. Paris: Victor-Havard, 1886.

Wrigley, Richard. "Censorship and Anonymity in Eighteenth-Century French Art Criticism." *Oxford Art Journal* 6, no. 2 (1983): 17–28.

Wrigley, Richard. *The Origins of French Art Criticism: From the Ancien Régime to the Restoration*. Oxford: Oxford University Press, 1993.

Wrigley, Richard. "Unreliable Witness: The *Flâneur* as Artist and Spectator of Art in Nineteenth-Century Paris." *Oxford Art Journal* 39, no. 2 (2016): 267–84.

Yang, Yin-Hsuan. "Les premiers Salons caricaturaux au XIXe siècle." In *L'art de la caricature*, edited by Ségolène le Men. Nanterre: Presses universitaires de Paris Nanterre, 2011.

Zola, Émile, *Écrits sur l'art*, edited by Jean-Pierre Leduc-Adine. Paris: Gallimard, 1991.

Index